PHOTOGRAPHY

Photography explores the photograph in the 21st century and its importance as a media form. Stephen Bull considers our media-saturated society and the place of photography in everyday life, introducing the theories used to analyse photographs and examining the impact of digital technology.

The text is split into short, accessible chapters on the broad themes central to the study and analysis of photography, and key issues are explained and applied to visual examples in each chapter.

Topics covered include:

- the identity of photography
- the meanings of photographs
- photography for sale
- snapshots
- the photograph as document
- photographs as art
- photographs in fashion
- photography and celebrity.

Photography is an up-to-date, clear and comprehensive introduction to debates about photography now and is particularly useful to media, photography and visual culture students.

Stephen Bull is a writer, lecturer and artist. He has written articles for *Creative Camera*, *Photoworks* and *Source: The Photographic Review* and contributed chapters to books including *The Media: An Introduction* and *Joachim Schmid: Photoworks 1982–2007*. He has exhibited at Tate Britain and The Photographers' Gallery, London. He was Course Leader for BA (Hons) Photography at the University of Portsmouth and is Course Leader for Photography at the University for the Creative Arts, Farnham.

ROUTLEDGE INTRODUCTIONS TO MEDIA AND COMMUNICATIONS

Edited by Paul Cobley
London Metropolitan University

This series provides concise introductions to key areas in contemporary communications. Each book in the series addresses a genre or a form of communication, analysing the nature of the genre or the form as well as reviewing its production and consumption, outlining the main theories and approaches that have been used to study it, and discussing contemporary textual examples of the form. The series offers both an outline of how each genre or form has developed historically, and how it is changing and adapting to the contemporary media landscape, exploring issues such as convergence and globalisation.

Videogames
James Newman

Youth Media
Bill Osgerby

News
Jackie Harrison

Internet
Lorenzo Cantoni and Stefano Tardini

Brands
Marcel Danesi

Advertising
Iain MacRury

PHOTOGRAPHY

WITHDRAWN

Stephen Bull

Routledge
Taylor & Francis Group

LONDON AND NEW YORK

First published 2010
by Routledge
2 Park Square, Milton Park, Abingdon, Oxon OX14 4RN

Simultaneously published in the USA and Canada
by Routledge
711 Third Avenue, New York, NY 10017

Routledge is an imprint of the Taylor & Francis Group, an informa business

Typeset in Perpetua and Univers by
Swales & Willis Ltd, Exeter, Devon

British Library Cataloguing in Publication Data
A catalogue record for this book is available from the British Library

Library of Congress Cataloging in Publication Data
Bull, Stephen
Photography / Stephen Bull
 p. cm. — (Routledge introductions to media and communications)
 Includes bibliographical references and index
 1. Photography—Philosophy. 2. Photography—Social aspects.
 3. Photographs—Psychological aspects. 4. Mass media. I. Title.
 TR183.B85 2009 770.1—dc22

ISBN10: 0–415–42918–8 (hbk)
ISBN10: 0–415–42894–7 (pbk)
ISBN10: 0–203–86729–7 (ebk)

ISBN13: 978–0–415–42918–4 (hbk)
ISBN13: 978–0–415–42894–1 (pbk)
ISBN13: 978–0–203–86729–7 (ebk)

CONTENTS

ILLUSTRATIONS

SERIES EDITOR'S PREFACE

There can be no doubt that communications pervade contemporary social life. The audio-visual media, print and other communication technologies play major parts in modern human existence, mediating diverse inter-actions between people. Moreover, they are numerous, heterogeneous and multi-faceted.

Equally, there can be no doubt that communications are dynamic and ever-changing, constantly reacting to economic and popular forces. Communicative genres and modes that we take for granted because they are seemingly omnipresent – news, advertising, film, radio, television, fashion, the book – have undergone alarming sea changes in recent years. They have also been supplemented and reinvigorated by new media, new textualities, new relations of production and new audiences.

The *study* of communications, then, cannot afford to stand still. Although communication study as a discipline is relatively recent in its origin, it has continued to develop in recognizable ways, embracing new perspectives, transforming old ones and responding to – and sometimes influencing – changes in the media landscape.

This series of books is designed to present developments in con-temporary media. It focuses on the analysis of textualities, offering an up-to-date assessment of current communications practice. The emphasis of the books is on the *kind* of communications which constitute the modern media and the theoretical tools which are needed to understand them. Such tools may include semiotics (including social semiotics and semiology), discourse theory, poststructuralism, postcolonialism, queer theory, gender analysis, political economy, liberal pluralism, positivism

(including quantitative approaches), qualitative methodologies (including the 'new ethnography'), reception theory and ideological analysis. The breadth of current communications media, then, is reflected in the array of methodological resources needed to investigate them.

Yet the task of analysis is not carried out as an hermetic experiment. Each volume in the series places its topic within a contextual matrix of production and consumption. Each allows readers to garner an understanding of what that communication is like without tempting them to forget who produced it, for what purpose, and with what result. The books seek to present research on the mechanisms of textuality but also attempt to reveal the precise situation in which such mechanisms exist. Readers coming to these books will therefore gain a valuable insight into the present standing of specific communications media. Just as importantly, though, they will become acquainted with analytic methods which address, explore and interrogate the very bases of that standing.

ACKNOWLEDGEMENTS

Thank you to Paul Cobley for asking me to write this book and for his insightful advice and editing; to Aileen Storry and Sarah Hamilton at Routledge for their assistance and patience; to James Benefield, Solveig Gardner Servian and Caroline Watson for their work on the production of the book; to the University of Portsmouth for providing additional research time and helping to fund the illustrations; to the magazine, journal and book editors who I have worked with during the last 15 years; to my family, friends and colleagues for their belief and support; and to my students, who have taught me a lot.

INTRODUCTION
Photography Now

In the space of one week, seven very different photographs were brought to the attention of the British public:

- For 24 hours it was mistakenly hoped that a snapshot taken on a digital camera by a tourist (and widely reproduced in the mass media) just might show a three-year-old girl who had been missing for over a month since disappearing on a family holiday.
- A member of the British parliament was suspended from his job after posting onto a social networking website a mobile phone photograph showing himself 'blacking up' the face of an assistant, together with a comment emphasising the racist tone of the picture.
- An image of a Japanese video photojournalist apparently shot dead while recording protests in Rangoon, Burma helped to alert the rest of the world to the events in the country's capital.
- A work by an American photographer was removed from an art gallery in Britain because it was feared the picture could be interpreted as child pornography (despite the same photograph having already been shown in many other galleries across the world).
- A photograph of a young actress dressed in lingerie began to appear on billboards in the UK promoting her role as a prostitute in a new TV series, leading to a debate in newspapers and online about whether such images are appropriate for public display.
- A painfully thin fashion model posing naked was shown on posters in Italy advertising a new line of clothes and, according to the image's photographer, raising awareness of anorexia.

- A picture taken by a member of the paparazzi through a car windscreen of Diana, Princess of Wales in 1997 – allegedly just moments before the crash that killed her – was widely reproduced, having been made public for the first time as evidence in a trial investigating her death.

Seven photographs in seven days: each one of them becoming the subject of much debate in the printed and digital mass media. Yet this was not unusual. It could be any week at any time in the early 21st century. Holiday snaps, images on social networking sites, photojournalism, art photography, advertising, fashion photography, paparazzi pictures: more than ever, in all its diverse forms and with all the discussion and analysis it creates, photography is at the centre of our lives.

This book is about photography now – and how it connects to the past. The aim is to give you a comprehensive and comprehensible guide to the subject for the 21st century.

Photography is a fascinating, but sometimes complicated subject – and so the study of photography can involve complicated ideas. These ideas will be introduced and analysed in this book in an understandable way, with key terms explained and applied to example photographs throughout. This book aims to make clear, not to confuse.

Photography is designed to work together with other books that provide histories of the medium, such as Michel Frizot's *The New History of Photography* (1998a) and Mary Warner Marien's *Photography: A Cultural History* (2006). *The Photography Reader* (2003) and *Photography: A Critical Introduction* (2009), both edited by Liz Wells and also published by Routledge, are essential resources for many of the ideas and writings that this book introduces and examines.

THE STRUCTURE OF THIS BOOK

Although the first main chapter of this book begins with an analysis of the conception of photography, generally the book is structured thematically rather than chronologically. Each chapter focuses on a distinct theme and is divided into shorter sections concentrating on different aspects of that theme. Illustrated case studies are referred to in every chapter so that the relevance of the ideas discussed in relation to photographs is clearly demonstrated.

Each chapter of the book also follows on logically from the next so that, while all of them can be 'dipped into' separately and in any order, you can also read the book through in sequence. I indicate where themes and ideas cross over with other chapters so that you can negotiate your

own reading. At the end of the book there is a list of further reading as well as information about other useful resources, such as magazines and websites.

Chapter 2 and Chapter 3 are longer chapters that analyse general issues about how the medium of photography is perceived and the way that photographs communicate. Chapter 2, 'The Identity of Photography', examines key debates about what is seen to define photography as a medium. It begins by considering the historical conditions that led to the idea of photography being conceived. The chapter also compares the different approaches to photography of modernist critics, who focus on what they recognise as the inherent nature of the medium, and postmodern critics, who view photographs as vessels for cultural ideas. The complex but vital relationships between photography and reality and photography and time are then discussed. The materiality of photographs that exist as physical objects is considered and compared to their digital counterparts. The chapter ends by examining the debates around digital photography since the early 1990s and how the identity of the medium may have fundamentally changed as a result of digital technology.

In Chapter 3, 'The Meanings of Photographs', ways in which photographs can be interpreted are examined. The first part of this chapter looks at the application of semiotics: a method that is introduced, explained and applied to visual examples. A specific image is used to debate how the meanings of a photograph can alter according to the changing words, contexts and wider discussion that surround it. The second part of the chapter examines the importance of the viewer in the interpretation of photographic meaning, by considering ideas from psychoanalysis in relation to visual pleasure, the look of the spectator, and the personal interpretation of individual viewers.

Chapter 4 and Chapter 5 focus more closely on the commerciality of photography and the analysis of snapshots. Photographs are used for commercial purposes, such as advertising. Photography itself is also a product that has been systematically marketed since the 19th century. Chapter 4, 'Photography For Sale', looks at debates around these two aspects of the medium. The marketing of photography in its digital form is also considered. The main market for photography is the amateur snapshooter. From an early age the majority of people in the world become used to appearing in and making snaps. Yet this area of photography is all too infrequently analysed. Chapter 5, 'Snapshots', examines studies of popular photography in order to debate the nature and culture of snapshots. Despite the billions of snaps in existence, the subject matter of snapshot photography has been restricted by the marketing of the medium. The chapter considers alternatives to conventional snaps and

debates whether the digital distribution of popular photography online (especially via the culture of social networking) is changing the fundamental nature of the snapshot.

Chapter 6 and Chapter 7 debate the seemingly separate, but closely linked use of photographs as documentation and as art. The perceived connections between photographs and what they depict has meant that the medium has often been used to provide evidence. Chapter 6, 'The Photograph as Document', begins by examining the use of photography for the purposes of portraiture, surveillance and anthropology. The chapter goes on to analyse the development of documentary photography with a focus on the key ideas of objectivity and subjectivity. The documentation of wars and terrorist acts by professional and amateur photographers concludes the chapter. In Chapter 7, 'Photographs as Art', the struggle for the medium to escape its links with fact and be seen as an expressive art form are examined in relation to Pictorialism and modernist 'straight' photography. The chapter also considers the use of photographs by Conceptual artists and postmodern practitioners, which led to photography becoming the medium of choice for many artists. The place of photography in contemporary art galleries is also debated in the chapter, which concludes with an examination of the forms that contemporary art photography takes and debates the critical language used to discuss it.

Chapter 8 and Chapter 9 zoom in further on specific areas of photography that are of particular relevance to contemporary study of the medium: fashion photographs and the portrayal of celebrity. Chapter 8 deals with an area that has become closely associated with photography in the last century: fashion. 'Photographs in Fashion' examines five eras of fashion photography and how the images created in these times relate to wider social issues. The chapter analyses how fashion photographs changed from elitist to accessible images between the 1920s and the 1960s, the move to images of fantasy in the 1970s and the 1980s, the return to 'realism' and the scandal of 'heroin chic' in the early 1990s, with analyses of the use of digital manipulation around the turn of the millennium and the staged images of the 2000s – that often feature celebrities as models – finishing the chapter. Celebrity itself has become a central issue of the 21st century. Chapter 9, 'Photography and Celebrity', examines how photography has played an essential role in the creation of fame. It goes on to consider how, more recently, photography has also been used to show celebrities as merely mortal while, simultaneously, online celebrity allows an instant and fleeting virtual fame to occur in the current 'Age of Mass Celebrity'.

Chapter 10, 'After Photography?', concludes the book by summarising its key ideas and considering the future of photography.

THE IDENTITY OF PHOTOGRAPHY

The word 'photography' has its origins in two Greek terms: 'photo' from *phos* (meaning light) and 'graphy' from *graphe* (meaning writing or drawing). A literal definition of photography is therefore 'writing or drawing with light'. As I will examine in this chapter, the identity of photography could be neatly summed up by this combination of something that occurs naturally (light) with practices created by human culture (writing and drawing).

Nature and culture are central to this chapter. In the first section I will argue that the way nature was thought about in relation to culture became essential to the identity of photography during the time of the medium's conception. Since then, critical approaches to photography have often been informed by two contrasting viewpoints: that of modernism and postmodernism. The second section debates the modernist belief that photography itself has a unique and unchanging nature that can be precisely defined. The third section contrasts this with the postmodern approach that emphasises the various changing cultural roles of the medium. More generally, photographs are understood to have a direct connection to what they depict – providing the impression that they show 'reality'. Photographs are also often seen as being able to preserve a moment in time. The fourth and fifth sections analyse these beliefs. The next section examines the effect that digital technology has had on photography and its perceived relationship to both reality and time. To conclude the chapter I analyse the way that nature is thought about in relation to culture in the digital age and how this has altered the identity of photography in the 21st century.

FIXING THE IMAGE: THE CONCEPTION OF PHOTOGRAPHY

The existence of photography was publicly announced in 1839. Most histories of photography start by pointing out that the origins of the medium lie many centuries prior to this. As the historian Jonathan Crary notes, these books generally regard photography as originating with the *camera obscura* (Latin for 'dark chamber') (Crary 1992: 31; examples of such histories from across the decades include Frizot 1998b; Gernsheim and Gernsheim 1971: 9–16; Lemagny and Rouillé 1987: 10–17; Marien 2006: 1–6; and Newhall 1964: 11–16). Typically, a cutaway diagram from the 1646 book *Ars Magna Lucis et Umbrae* (or *The Great Art of Light and Shadow*) by the German scholar Athanasius Kircher is used to illustrate this line of reasoning. Kircher's diagram of the *camera obscura* shows a large box standing alone in a landscape. Sunlight is depicted as travelling through small holes on two of its sides, and this is projecting inverted images of the world outside into the box, inside which a human figure is seen tracing one of the images from a screen (see Manovich 2001: 106).

Crary argues that the tracing of the projection by hand in order to fix what would otherwise continue as a moving, changing image transmitted live from the outside world took a great deal of skill and time – and seldom occurred. During the 17th and 18th centuries, he contests, the phenomenon of a projected moving image evidenced by the *camera obscura* was far more often used as a spectacular entertainment for audiences to observe (1992: 32–33) (although the history of similar devices goes back hundreds of years earlier, at least to the Middle East in the 11th century; see for example Rosenblum 1997: 192–194). Later in this chapter I will discuss further how Crary sees the *camera obscura* as a very different technology to photography in terms of the relationship between the viewer and the image. For now, it is important to examine why, when and where it was that the rare desire to fix the image made by the *camera obscura* became much more common.

Technologies do not arrive out of the blue. Brian Winston has argued against the idea of technological determinism, which suggests that technologies change the world and our view of it. Instead, he contends, it is the world that changes, creating the need for technologies to come into existence (Winston 1996: 1–3). A case in point is the Enlightenment period. *The Great Art of Light and Shadow* can be seen as part of the Enlightenment, a 17th and 18th century movement in Western thinking that embraced the new practice of science. The very word 'enlightenment' suggests a central idea of the movement: that light could be used to gain knowledge of the world, in order to emerge from the dark ages into a new

era of reason and progress. The world was observed and recorded in books such as Kircher's, as well as encyclopaedias where all known information could be gathered together. This process of observation and classification increasingly involved what Marita Sturken and Lisa Cartwright have referred to as 'the technical mastery of nature' by human culture (Sturken and Cartwright 2001: 115–116). Peter Gay has noted that during the Enlightenment era 'there seemed to be little doubt that in the struggle of man against nature the balance of power was shifting to man' (quoted in Hamilton 1992: 40).

Twenty years after Kircher's book, in the 1660s, artists such as the Dutch painter Jan Vermeer were (almost certainly) using the *camera obscura* to make precisely delineated pictures (see Hockney 2006; Steadman 2002). Many of Vermeer's paintings include maps and globes, suggesting another reason for accurate recording. During the Enlightenment period Western countries were 'discovering' the rest of the world and needed to precisely record what they found in order to study it and – by extension – possess it (see Chapter 6).

By the 18th and 19th centuries, members of the new middle-class that emerged out of the Industrial Revolution were travelling the world, too, and wanted to record what they saw. They also wanted to record what they looked like, themselves, in precise portraits – and to see pictures of their peers in order to 'measure up' to them (see Freund 1982: 8–18; Lemagny and Rouillé 1987: 15; Tagg 1988a). 'In the 19th century, for the first time', Crary notes, 'observable proof became needed in order to demonstrate that happiness and equality had in fact been obtained' (1992: 11). This led to artists such as Jean Auguste Dominique Ingrés employing optical apparatus such as the *camera lucida*, which featured a prism to allow the user to simultaneously see what was in front of them and the surface on which they were drawing, enabling skilled artists to make accurately proportioned portraits of their middle-class subjects.

Although not an artist (and of a higher social status than the middle-classes), the amateur scientist and botanist William Henry Fox Talbot was also using optical devices in the early 19th century in an attempt to record the landscapes and plant life that he saw on his travels. Unfortunately for Talbot, his patience and technical ability as a draughtsman were both limited (he bemoaned the 'time and trouble' it took to use the *camera lucida*) (Talbot 1980). As a result of this frustration, Talbot decided to experiment by coating surfaces with light-sensitive chemical compounds, such as silver halide, to permanently fix the image projected within the *camera obscura* (which by the 19th century existed in a smaller, more portable form). Talbot's aim was to find a way to make accurate pictures quickly and without the need for a skilled hand.

Talbot was far from alone in his endeavour. As the photography historian Geoffrey Batchen has detailed, the desire to spontaneously catch the fleeting image of the *camera obscura* was shared by at least 18 other 'proto-photographers' across Europe and the United States between 1790 and 1839 (Batchen 1997: 24–53). The most famous name on Batchen's list of proto-photographers is that of the French scientist Nicéphore Niépce, who successfully fixed an image onto a metal plate in the mid-1820s (the image, recording the view from Niépce's window, required an exposure time of around seven hours). Although some of the other proto-photographers had also already succeeded in their aim to fix the image by the 1830s, it was in 1839 that Talbot and Louis Jacques Mandé Daguerre (who continued Niépce's work and promoted it after Niépce's death in 1833) made separate official announcements of the existence of their respective processes.

The apparent ease by which precise images could be made by Niépce and Daguerre's process reportedly caused the painter Paul Delaroche to exclaim 'From today, painting is dead!' Although the attribution of this statement to Delaroche is highly debatable (see Gernsheim and Gernsheim 1971: 23; Batchen 1997: 265n), it is nevertheless symptomatic of an opinion voiced by many commentators at the time that this new form of image making would supersede painting as the dominant mode of representation (see for example Scharf 1983: 26–28). Despite the new processes being initially known by a range of names (Daguerre, for example, calling his technique the daguerreotype), it was 'photography' – coined by Sir John Hershel in 1839 itself – that came into general use within a few decades (see Batchen 1997: 100–101; Marien 2006: 15–16).

Batchen has meticulously examined what was happening during the period between 1790 and 1839 when the desire to spontaneously fix the image made by the *camera obscura* became widespread (Batchen 1997). He sees this as a larger issue than the need for the new middle-classes to represent themselves as successful individuals or for explorers and scientists to record the world. Instead Batchen argues that the conception of photography as an idea came about during a time of gradual change in the way the world was thought about. This continued from the Enlightenment period, when nature was shifting from being seen as all-powerful and controlling human action, to something that could come, at least partly, under the control of human culture (Batchen 1997: 54–102). Such a change in thinking was embedded in the very identity of photography during the years of its conception.

The title of Talbot's 1844 book *The Pencil of Nature* (one of the first photographically illustrated publications) concisely summarises this

blending of ideas. The title expresses the idea that 'nature' is something occurring outside of human culture that can be harnessed as part of cultural production (by using light as a 'pencil' to write or draw with) (see also Damisch 1980).

Nearly a century and a half later, in his 1988 book *Keywords*, Raymond Williams demonstrated how 'nature' and 'culture' are two of the most complicated words in the English language by tracing the various definitions they have had over many hundreds of years (Williams 1988: 87–93; 219–224). Despite their complicated histories, these definitions can be broadly summarised in two opposing ideas: 'nature' as something that is unchanging and timeless; and 'culture' as something that derives from human society and is subject to change. Later in this chapter the idea that nature is unchanging will be questioned in relation to shifts in thinking after Williams' book was written. For the moment it is important to conclude this section by summarising that at the time of its conception in the late 18th and early 19th centuries the identity of photography was defined by a shifting mix of ideas about a world where human culture, previously regarded as dominated by nature, was seen to be increasingly in control of natural phenomena.

MODERNISM: THE NATURE OF PHOTOGRAPHY

While the process developed by Niépce and Daguerre resulted in the creation of precise and detailed images fixed onto metal plates, Talbot's initially less distinct pictures made on paper could be turned from negative images to positives by having light shone through them onto another sheet of sensitised paper. The resulting 'negative/positive' process allowed for a potentially infinite amount of copies to be made from a single original negative. With this process, mass reproduction became central to the identity of photography.

In his 1936 essay 'The Work of Art in the Age of Mechanical Reproduction' the German writer Walter Benjamin took stock of the effect of mass reproduction by mechanical means, which by the 1920s and 1930s was happening on a global scale. This was not just in relation to multiple photographs printed from a single negative, but also photographs reproduced in newspapers, magazines and books (such reproduction was also occurring in other media including cinema and recorded sound) (Benjamin 1999). Mechanical reproduction, Benjamin argued, now meant that things normally occupying one specific location were able to exist in many locations simultaneously; often in places that they would not otherwise reach. As well as this, the 'aura' that Benjamin argued a one-off work of art (such as a painting) possesses – through its uniqueness and the

authenticity guaranteed by the trace of the artist's hand — is not present in its photographic reproduction. This meant that the economic value of the original was not present in its reproduction (for more on Benjamin's ideas in this important essay, see Chapters 3, 4, 7 and 9).

Mechanical mass reproduction is a characteristic of the modern world. Although the word 'modern' can be used in general to refer to anything that is new and up-to-date, the term also has a specific, historical meaning. This relates to the period of modernity from (very approximately) the mid-19th to the mid-20th century: a time of rapid and dramatic change as cities expanded outwards and upwards, industries developed and new technologies were invented in the West. The idea of progress is central to modernity. Continuing on from the philosophy of the Enlightenment, the concept of human culture freeing itself from the control of nature also led to individuals being regarded increasingly as people in their own right (see Crary 1992). The full emergence of the idea of subjective individuals with their own minds and viewpoints is a fundamental aspect of the experience of modernity (see also Chapter 3 and Chapter 7).

Charles Harrison and Paul Wood see modernism as the *representation* of this experience of modernity (Harrison and Wood 2003: 128). Similarly, Sturken and Cartwright define the aesthetics (the look) of modernism as a set of styles that emerged from this period; these styles emphasise 'linearity, form, and the mechanical and embrace abstraction over realism' (Sturken and Cartwright 2001: 360). Such a version of modernism owes much to the ideas of American art critic Clement Greenberg, whose writings between the 1940s and the 1960s helped to determine what modernism (in its final stages) was about. In 1960 Greenberg wrote 'Modernist Painting' (Greenberg 2003a), described by Harrison and Wood as the essay that 'has come to typify the modernist critical position on the visual arts' (Harrison and Wood 2003: 773). In it Greenberg defines the characteristics particular to fine art painting that, when put together, separate it from other media.

John Szarkowski is often considered the photographic equivalent of Greenberg (see for example Burgin 1982a: 208–212; Kriebel 2007: 16–17). As well as being a photographer, Szarkowski was curator of photography at New York's highly influential Museum of Modern Art between 1962 and 1991. In books such as *The Photographer's Eye* (first published in 1966 after an exhibition of the same name) he examined a range of photographs in close detail (Szarkowski 2007). In the introduction to *The Photographer's Eye*, Szarkowski describes photography as an organism 'born whole' in the 19th century. Ever since then, he argues, photographers – from complete amateurs to famous professionals

– have been progressively discovering through experimentation the visual characteristics unique to photography.

Like Greenberg, the ultimate aim of most of Szarkowski's work as a curator was to determine the vital properties specific to photography as a medium (Phillips 1989: 41–42). In *The Photographer's Eye* he defined five interdependent characteristics that he saw as combining together to form the fundamental essence of a photograph. These are:

- the thing itself: the apparent ability of the photograph to convincingly record what is in front of the lens
- the detail: photographs draw attention to a fragment of reality to tell a story
- the frame: the relationships between what is in the picture as a result of selection and elimination from reality
- time: the effect the duration of a photograph's exposure has on how it looks
- vantage point: the angle from which a photograph is made.

The modernist approach to photography, as exemplified by Szarkowski's ideas, suggests that the medium has a unique and unchanging nature that is there to be discovered. Under the acknowledged influence of Szarkowski, the photographer Stephen Shore later published a book called *The Nature of Photographs* where, from the title onwards, this idea is made even more explicit (Shore 2007) (see Chapter 7 for further analysis of modernism and art photography).

Szarkowski and Shore concentrate only on aesthetics – the visual content of the image – at the expense of what surrounds the photograph. Time, for example, is examined in *The Photographer's Eye* in relation to how the length of an exposure affects the look of what is within the picture, rather than how the photograph is affected by the passing of time all around it (a point I return to later in this chapter). At its most extreme, writers such as Christopher Phillips have argued, photographic modernism isolates photographs from their surrounding context entirely (Phillips 1989).

POSTMODERNISM: THE CULTURE OF PHOTOGRAPHY

In a reversal of the modernist stance, by the 1970s and 1980s many analysts of photography had turned to the politically aimed writings of the 1920s and 1930s by Benjamin, using them as the basis for an approach to the medium that paid little or no attention to aesthetic content and focused instead on the cultural context of photographs (see Roberts 1998).

To Sabine T Kriebel, looking back on the development of what became known as 'photography theory' in the 1970s and 1980s, the use of such political writings also stemmed from the influence of the dramatic 'social, cultural and political' shifts of the late 1960s which 'radicalised much (but not all) critical thinking about photography, turning the terms of discourse away from its core properties . . . to a concern with the subject in politics and ideology' (Kriebel 2007: 18; see Chapter 3 for definitions of the terms 'discourse' and 'ideology' in relation to photography). In 1982 Victor Burgin edited the book *Thinking Photography*, which he introduced as 'contributions towards photography theory' (Burgin 1982b: 1). The first essay in the book was Benjamin's 'The Author as Producer', which contended that aesthetically pleasing photographs merely reproduced capitalist ideology. Instead, Benjamin argued, photographs should be put to revolutionary use (Benjamin 1982).

Burgin, along with other writers such as Rosalind Krauss, Christopher Phillips, Abigail Solomon-Godeau and John Tagg were informed in their writings by Marxism, feminism and psychoanalysis, which were applied to examine the context of images (Kriebel 2007: 23; see also Chapter 3 for more on the influence of feminism and psychoanalysis). For example, Tagg's essay in *Thinking Photography* examines a photograph by Walker Evans of an American couple re-housed after the US depression of the 1920s. The picture was used by Szarkowski in *The Photographer's Eye* to demonstrate his idea of 'The Thing Itself', but Tagg approaches the photograph very differently: emphasising the historical moment in which it was made and the changing context of the photograph according to how it has been circulated (Tagg 1982; see also Tagg 2009 and Chapter 3).

Edward Welch and J J Long argue that the contributors of the essays that defined the emerging photography theory saw photographs as political weapons, with books such as *Thinking Photography* 'throwing the first brick' not just at the dominant ideology, but also at photographic modernism itself (Welch and Long 2009). Many of these writings about photography were explicitly anti-modernist, following Benjamin by stressing the importance of cultural context and the social uses of photography and deriding the modernist concern with formal aesthetic content (for example Phillips 1989). This is characteristic of a postmodern approach in general; indeed, Batchen refers to the writers as 'postmodern critics' (even though most of the writers concerned would be unlikely to use the term to define themselves) (1997: 4–12). Postmodernism calls into question the universality and progressiveness of modernist ideas. Offering, instead, a more fragmented worldview, it often focuses on social issues rather than aesthetic ones (Sturken and Cartwright 2001:

362–363). With all this in mind, it's no wonder that Kriebel refers to Szarkowski as 'the *bête noire* of postmodern critics' (Kriebel 2007: 16).

However, at its own extreme, Batchen argues, a postmodernist approach to photography criticism is as essentialist as its modernist equivalent. He suggests that writers such as Tagg and Solomon-Godeau see photography as having no intrinsic nature at all. When this approach is taken to its logical conclusion, photographs become empty vessels burdened to carry the messages of those with power (Batchen 1997: 5–6; 20). The writings of Tagg – and particularly his ideas in the 1988 book *The Burden of Representation* (Tagg 1988) – typify the paradigm for Batchen here. The focus of postmodernist criticism, Batchen contends, is outside the photograph: what is in the image itself is ignored and instead the cultural context in which the image is put to use comes to be considered central (see also Jay 1994). Similarly, Gillian Rose has argued that a focus on images' contexts can result in 'an uninterest in images themselves' (Rose 2007: 194).

Batchen, writing from what might be termed a 'post-postmodernist' perspective, argues that the opposition between the modernist focus on the aesthetic nature of the photograph and the anti-aesthetic post-modernist focus on culture can be resolved. Somewhere between the two positions lies the answer. He applies the French philosopher Jacques Derrida's concept of '*différance*' to do this (Batchen 1997: 178–184).

The aspect of *différance* that Batchen concentrates on is the idea that the identity of an object of study simultaneously contains potentially conflicting aspects; indeed the identity of that object actually emerges out of this combination. From such a viewpoint, the identity of photography derives from the nature of photographs themselves (what is fixed inside the frame – the modernist approach) *and* the changing cultural context in which photographs exist (what is outside the frame – the postmodernist approach). Analysing photographs should not simply be a case of choosing either one approach or the other, Batchen argues. Instead the opposing aspects of nature and culture that were embedded within the identity of photography when it was conceived should both be embraced as integral to the medium (1997: 202). For Batchen, photography's identity comes from its inherent differences.

THE THING ITSELF? THE QUESTION OF INDEXICALITY

After its conception, the links between photography, science and nature meant that the medium was regarded as a way of providing evidence of what had been in front of the lens. As Don Slater has noted, photography

was developed in Europe in the early 19th century when cultural ideas from positivist science held sway, focusing on the belief that evidence can be established visually (Slater 1997a: 96–99). This idea of the photograph as providing evidence continued in the modern era. For example, the images of a galloping horse made by Edwaerd Muybridge in the 1870s to settle a bet that horses in motion can have all four hooves off the ground at the same time were accepted as proof in a way that drawings of the same subject would not be (Frizot 1998c: 244–248; Rosenblum 1997: 249–255; Solnit 2003). Similarly, Francis Frith's photographs of pyramids in Egypt made in the 1850s were regarded in the Western world as a guarantee that such structures really existed (see for instance Marien 2006: 126).

This is a point echoed by Susan Sontag in her book *On Photography*, a collection of essays written for *The New York Times Review of Books* during the 1970s where she maintains: 'A photograph passes for incontrovertible proof that a given thing happened. The picture may distort; but there is always a presumption that something exists, or did exist, which is like what's in the picture' (Sontag 1977: 5). This perceived aspect of photography can be traced back to the 19th century, where it is central to the desire to conceive photography, and is exemplified in the 20th century by Szarkowski's idea that photographs depict 'the thing itself', a defining characteristic of photography.

In an essay first published in 1945 called 'The Ontology of the Photographic Image', André Bazin argues that this idea of the photograph as providing proof defines what is unique to photography (its ontology, or fundamental identity) (Bazin 1980: 237–244). Bazin equates the photographic image with what he calls 'the object itself', because:

> No matter how fuzzy, distorted, or discoloured, no matter how lacking in documentary value the image may be, it shares, by virtue of the very process of its becoming, the being of the model of which it is the reproduction; it *is* the model.
>
> (Bazin 1980: 241)

The idea of the photograph as showing reality that Bazin, Sontag and Szarkowski all refer to is also sometimes described as the 'indexicality' of the photograph.

Indexicality is a term from the writings of the American philosopher Charles Sanders Peirce (which scholars began to collect together from the 1930s). Along with Ferdinand de Saussure, Peirce was a pioneer of semiotics: a way of understanding how communication works. Semiotics

centres on the idea of the sign, a basic unit of communication. While Saussure studied how signs function in verbal language (see Chapter 3), Peirce examined the way that we think about signs themselves. He listed many different categories of signs, including a central inventory of ten classifications that are used to define the perceived relationship between the sign and its object (whether real or imaginary) (Cobley and Jansz 1999: 18–35; Lefebvre 2007: 220–244). In photography theory and elsewhere, emphasis is usually placed on three of the categories of signs that Peirce came up with in his 1894 essay 'What is a Sign?' (Peirce 1998). These categories of signs are:

- Indexical
- Iconic
- Symbolic

A sign that is indexical is one that is seen to have a direct physical relationship to its object. Peirce gives the example of how a weathercock is an indexical sign of the direction the wind is blowing. We don't see the wind – indeed we cannot see it – but we interpret the movement of the weathercock as indicating that the wind is blowing in a particular direction. Peirce also gives photographs as an example of indexical signs, because they, too, are interpreted as having a direct connection with the material world (1998: 5–6). As Batchen has put it,

> The camera does more than just see the world; it is also touched by the world. Light bounces off an object or a body and into the camera, activating a light-sensitive [surface] and creating an image. Photographs are therefore designated as indexical signs, images produced as a consequence of being directly affected by the objects to which they refer. It is as if those objects reached out and impressed themselves on the physical surface of the photograph, leaving their visual imprint . . .
>
> (Batchen 2004: 31)

As the statements above from Bazin and Sontag also suggest, a photograph can still be an indexical sign even if it does not look like what it has a material relationship to. For example, a blurred portrait is still indexical to the actual person in the picture, even if they are not recognisable in the photograph, because it has been created directly from that person and could not exist without them (just as the weathercock does not resemble the wind that it is indexical to, but cannot turn without the wind blowing).

More simply, a sign that is iconic resembles (or 'looks like') its object, but need have no material connection to it (a drawing of a person, for example, can be an iconic sign if it has broadly the same shape, colour, proportions, etc. as that person). A sign that is symbolic is not caused by a material relationship to its object, nor does it resemble it; instead it represents its object as according to the habits of its users; for human signs, the most obvious habit is cultural convention. For example, a word may be used to refer to an object with which it has no real relation, but through convention what it signifies is understood (Peirce 1998).

It is important to note that Peirce's approach to signs argues that there is no definitive answer to whether a sign functions as an index, icon or symbol. What is important to Peirce, as a philosopher, is what a sign is *perceived* to be at any given point, because this determines how it functions. Peirce's categories of signs are also not mutually exclusive (see Brunet 2008). A sign can be both indexical and iconic, for example. As David Green and Steve Edwards have both pointed out, Peirce notes that a combination of indexicality and iconicity – where the iconic quality of a photograph is a direct result of its indexicality – is absolutely fundamental to photography (Edwards 2006: 82–83; Green 2007: 245–6). What appears in a photograph, they argue, usually looks like what was physically in front of the lens for the duration of the picture being taken.

The idea of indexicality and how it relates to photography has been the subject of much dispute ever since Krauss applied it to the visual arts in the 1970s (see Krauss 1986a and Chapter 7). It is hardly surprising that such debates have continued; after all Peirce's ideas are about inter-pretation and so the application of his categories to different examples inevitably leads to a range of differing understandings (see for example Elkins 2007 and Fried 2008: 335). Perhaps it is ultimately most useful to remember that all photographs are created as a result of photons, the basic unit in which light is carried and measured. As Michel Frizot has noted, photons bend around objects and, when falling on a light-sensitive surface, affect it according to the quantity of photons (Frizot 2007). Exposure time and shutter speed both alter the quantity of photons, but the basic process does not change.

The question of indexicality, then, is one that has become central to much critical debate on photography. While it is important to understand the key points relating to these arguments, it must also be acknowledged that these debates are unlikely to ever result in a single, unified answer to precisely how the idea of indexicality relates to photographs.

PAST / PRESENT / FUTURE: PHOTOGRAPHY AND TIME

A vital element of Bazin's essay 'The Ontology of the Photographic Image' is the significance of time to the identity of photography. Bazin refers to photographs as snatching what they depict 'from the flow of time' (1980: 238) and 'embalming' the instant, rescuing it from the 'corruption' of time's passing (242).

Building on this idea, time is central to what French writer Roland Barthes identified in his 1980 book *Camera Lucida* as the essence of photography, which he calls, in English translation, the '*that-has-been*' of the photograph (Barthes 2000: 77). By this Barthes means the way that a photograph not only tells us that someone or something definitely existed, or something definitely happened in the past, but also brings that past into the present. It is this distortion of time that can make photographs so compelling, such as the image that Barthes reproduces of the captured conspirator Lewis Payne taken in 1865 looking directly at the camera lens shortly before his execution (Barthes 2000: 96). Payne is now dead, yet he is alive in the image and, as a consequence of the indexicality of the photograph, seems to be staring straight into our eyes as we look at it (see also Fried 2008: 104–106 and Chapter 3 of this book).

Welch and Long have noted the huge influence *Camera Lucida*, which is based on Barthes' contemplation of a photograph of his recently deceased mother, has had on photography theory since its publication (2009: 12–15; see also Chapter 3). Yet the centrality of the book to so much photographic analysis has often led to a mournful, even morbid interpretation of photographs as being only to do with death and the past. As Laura Mulvey has noted, while Bazin sees photographs of people as preserving life, Barthes tends to focus on them as *memento mori*, a reminder of their passing (Mulvey 2006: 60). This has led David Green to lament that 'the cloying melancholia of a post-Barthian era of photographic theory' now haunts not just *Camera Lucida* but critical approaches to 'all photography' (Green 2006: 17).

Green argues instead that the existence of photographs in the present time means that rather than telling us (in Barthes' phrase) '*that-has-been*', photographs can instead be interpreted as representing an eternal present moment, which Green calls the '*this-now-here*'. He also suggests that we could go even further and eliminate ideas of temporality altogether, reducing the essence of photographs to simply showing us '*this*' (which is in fact Barthes' starting point in *Camera Lucida*). Similarly refusing the idea that photography accurately records a moment in time, Batchen has contended that photographs are in fact a poor way of capturing memories as they only represent one sense – the visual – missing out the other

sensory aspects of an experience (sound, touch, taste, smell, temperature, etc.) and replacing them with a two-dimensional substitute (Batchen 2004; I expand on this in Chapter 5).

Yet the idea of capturing an instant has always been central to photography, from the busy Paris boulevard photographed by Daguerre in 1839 – where the necessarily long exposure recorded the crowded street as 'deserted' apart from a stationary man having his shoes polished (Frizot 1998b: 24; see also Ritchin 2009: 181) – to Muybridge's series of horses frozen in motion in the 1870s to Henri Cartier-Bresson's single image from 1932 where a man is captured by the camera in an apparently doomed attempt to leap over a large puddle. Such is the nature of the stilled image that the man will remain forever suspended an inch or so above the water. As Jonathan Friday has noted, because this picture is not part of a sequence it is the viewer who must imagine what came immediately before and, more crucially here, what happened next (Friday 2006: 41).

This photograph is of course the often-reproduced classic example of what Cartier-Bresson himself termed 'the decisive moment', where action is caught at precisely the right fraction of a second to summarise the whole event in an aesthetically balanced image (the way the silhouetted leaping man is visually echoed in the figure of a dancer on a poster in the background is one of the most common ways the latter is demonstrated in discussions of Cartier-Bresson's image) (Cartier-Bresson 1952; Durden 1999; Marien 2006: 258–259). The idea of the decisive moment as it came to be widely accepted (particularly in the field of photojournalism) means recording something that is happening anyway, skilfully grabbing some kind of ordered scene out of the chaos of the ongoing world (see Chapter 6; see also Dyer 2006).

Another way of catching the moment comes with stills grabbed not from life, but from the digital moving image. As David Bate has noted, over 50 years after Cartier-Bresson's formulating of the decisive moment, if someone talks about a 'grabbed' image they are now more likely to mean a screenshot captured from digital video than from life (Bate 2004b: 34; see also Burgin 1991a: 8). For example, in 2007 stills were calculatingly selected from an emotional television interview with Heather Mills during her divorce from Paul McCartney and published the following day in tabloid newspapers in order to portray Mills as if she were ranting and out of control. These new decisive moments are caught via careful editing after the event, rather than as the event happens (see also Mulvey 2006: 66 and Chapter 6).

Margaret Iverson argues that certain types of photographic art have used photography to record actions that are performed for the camera

(Iverson 2007: 91–108; see also Green and Lowry 2003: 47–60). One example of this is the 2006 series *La Chute (The Fall)* where French photographer Denis Darzacq asked dancers to jump into the air in the streets, photographing them as they were in motion (see Figure 2.1). The resulting set of photographs captures the dancers inches above the ground as if in freefall: a response from Darzacq to the trauma of 9/11 and the negative social conditions in certain areas of Paris. Such 'performative' photography is more about the photographing of things staged for the

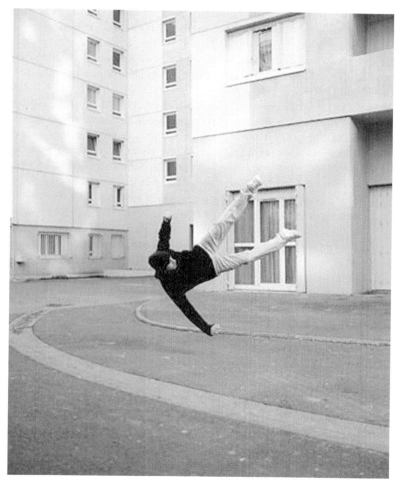

Figure 2.1 Denis Darzacq *Untitled* from the series *La Chute (The Fall)* (2006) © Denis Darzacq. Courtesy Agence Vu.

moment of the picture and with the future in mind rather than snatching a spontaneous instant.

While Iverson focuses primarily on the minority area of art photography (see Chapter 7), the vast majority of photographs made in the world could in fact be seen as performative. As well as art photography, advertising images are carefully staged for the camera, snapshots are perhaps the most systematically acted out of all photographs, and even some 'documentary' images are theatrically staged (see Chapters 4, 5 and 6). The action in all these photographs is planned in advance and performed for the photograph with a clear consideration of how the resulting image will look. The performative event staged for its preservation in the future – the '*this-will-be*' that Barthes also refers to, rather than his more commonly cited idea of '*that-has-been*' – could in fact be regarded as the default mode for the creation of most photographs (see also Ritchin 2009: 56–60).

Many viewers of Darzacq's images initially believe them to be digital montages, the dancers superimposed onto the background of the street (Jauffret 2006: 24–31). They are not – but we think they are because we have become used to seeing digitally altered images. It is no longer a surprise to view photographs such as those in Sam Taylor-Wood's 2004 series *Self Portrait Suspended* where the artist appears to be defying gravity by floating around her studio (the ropes which held her up having been digitally removed from the photographs; see Figure 2.2) (Bright 2005: 30–31). The fictional aspects of these kinds of photographs, if recognised by the viewer, suggest that time in the digitally manipulated photograph does not represent '*that-has-been*' or '*this-will-be*', but rather '*this-never-was*'. The next section examines the debates around the impact of such digital fictions on the indexical, moment-capturing identity of photography: a topic that became central to critical photography theory for much of the late 20th century.

DIGITAL DEBATES: REVOLUTION OR EVOLUTION?

Although the beginnings of digital photography derive from experiments by NASA in the 1960s (see Mitchell 1992: 11–12), it is around 1990 that the implications of digital photographs came to be widely examined (there were some precedents to this in the 1980s (see Brunet 2008: 44)). During 1990 the first edition of Fred Ritchin's book *In Our Image* was published, exhilaratingly subtitled *The Coming Revolution in Photography* (Ritchin 1999). The following year Paul Wombell's edited collection *Photo-Video: Photography in the Age of the Computer* appeared with an accompanying exhibition including such memorable images as a sequence of digitally

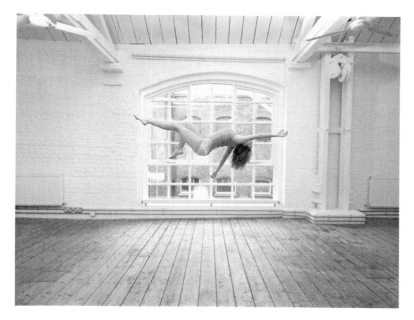

Figure 2.2 Sam Taylor-Wood *Self Portrait Suspended V* (2004) © Sam Taylor-Wood. Courtesy White Cube (London).

manipulated photographs showing British prime ministers since Churchill morphing into their successors (Wombell 1991). And one year later, William J Mitchell's technically thorough and theoretically provocative overview *The Reconfigured Eye:Visual Truth in the Post-Photographic Era* was published (Mitchell 1992).

As has been noted a number of times elsewhere, including by Martin Lister in the introduction to his 1995 collection *The Photographic Image in Digital Culture* (Lister 1995: 1–2), a lot of these early responses to the effects of digital technology on photography argued that it hailed the end of the medium. Often writers paraphrased Delaroche, claiming that 'from today, *photography* is dead!' (for example, Mitchell 1993). Ritchin's book is particularly representative of this approach, using – amongst others – the instance of a photograph published on the cover of the February 1982 issue of *National Geographic* where two pyramids were digitally brought closer together to fit the constraints of the magazine's portrait format (Ritchin 1999: 15). This example, particularly with its recalling of Frith's images from the 1850s which provided evidence of the pyramids for a Western audience, was seen as representative of a significant threat to a photograph's apparent ability to guarantee the accuracy of what it depicts.

In semiotic terms: photography's perceived indexicality was being called into question (Mitchell 1992: 24–28; see also Rubinstein and Sluis 2008), as if the weathercock in Peirce's example was being turned by a motor, not by the wind.

According to Mitchell, claims that analogue photographs show reality fit with the logical, progressive certainties of the adjoining periods of the Enlightenment and modernity from which the conception of photography emerged; whereas the more questionable 'reality' depicted in digital photographs fits a postmodern period of uncertainty. This led him to coin the term 'post-photographic' to suggest the end of an era of photography (see also Chapter 9). The subtitle of Ritchin's book, which describes digital photography as a 'coming revolution', reinforced this idea by suggesting that, at the very least, digital technology was about to turn around the identity of photography entirely.

By the mid- to late 1990s writers such as Batchen and Lev Manovich tempered this feverish approach to digitality as a complete and revolutionary change to photography with a more considered perspective, leading to what could be seen as a second wave in the analysis of digital photography.

In his 1995 essay, 'The Paradoxes of Digital Photography', Manovich made the point that those that saw digital technology as a threat to the reality of analogue photography only ever contrasted digitally manipulated photographs with examples of relatively un-manipulated 'normal' documentary photography (such as the kinds of images usually found in *National Geographic*) (Manovich 2003: 240–245; see also Chapter 6). This type of photography, he argues, is not really 'the norm' as it only represents one area of the medium as a whole. Manovich notes how photographs were cut-up, combined and reassembled from the moment that photography came into being, for example in the cut-and-paste techniques of the Victorian photograph album (see Chapter 5) and the 19th-century montages by Oscar Rejlander such as *The Two Ways of Life* (1857) which combines 30 separate images (see Chapter 7). As he says, 'Digital technology does not subvert "normal" photography, because "normal" photography never existed' (Manovich 2003: 245). From this point-of-view the possibilities that digital technology present for manipulating photographs simply continue the tradition of the manipulated image that has been a major part of photography right from the start (see also Robins 1995).

Taken to its logical conclusion, an approach such as Manovich's could actually reinforce the idea of photographic indexicality in those images that are not regarded as having been manipulated. But Batchen went a step further than Manovich by arguing in 1997 that it is not just retouched and

montaged photographs that are manipulated, but *every single photograph*. Even 'normal' documentary photography involves practices of artifice such as cropping, the use of flash and selecting an exposure time: 'In the mere act of transcribing world into picture, three dimensions into two, photographers necessarily manufacture the image they make' (Batchen 1997: 212). To Batchen digitally manipulated photographs do what photography has always done: depict the world as an altered version of itself. From such viewpoints digital technology can be regarded not as representing a revolution, but as a gradual and continuing evolution in photography – and how it is thought about – since the early 1990s. One of the key aspects of this evolution is the move from photographs as physical objects to digital images, a process that I will examine in the following two sections.

THE PHOTOGRAPH AS OBJECT: MATERIALITY

In an apparent reaction to the decreasing production of physical photographs and their replacement by digital images, during the early 21st century a significant number of writers turned their attention to the photograph as an object. Elizabeth Edwards and Janice Hart argued that photography theory had tended to focus on photographs as if they were two-dimensional images, showing little engagement with the 'materiality' of photographs as three-dimensional objects (Edwards and Hart 2004). Nina Lager Vestberg suggested that postmodern critics concentrated on 'thinking' photography, rarely acknowledging the physical properties of photographs (Vestberg 2008).

In this respect the postmodern photography critics were actually continuing a tradition from their modernist predecessors. While Greenberg discussed the physical support for paint (such as canvas) as one of the defining characteristics of modernist painting (Greenberg 2003a), Szarkowski's own defining of the characteristics of photography in *The Photographer's Eye* did not take physical characteristics into account (Szarkowski 2007; although in his much later book Shore did consider this issue, Shore 2007). Batchen has noted that in the 20th century most historians of modernist photography projected this idea of intangible photographic images into the past, ignoring the physicality of photographic objects, such as the velvet-lined cases that held daguerreotypes (Batchen 2003).

Crary argues that the *camera obscura*, in its dominant form as mass entertainment, presented images to its audience in a non-physical form. Each spectator was physically separated from the image they saw projected on a screen or wall (Crary 1992: 26–66). As I have noted earlier

in this chapter, Crary goes against the idea of continuity between the *camera obscura* and the development of photography that is expounded in most histories of photography. Instead, he contends that the emergence of photography actually represented a significant break from the 'model of vision' exemplified by *camera obscura* (1992: 26–27). With the coming into existence of photography each of the disembodied spectators that had previously had representations of the world presented to them from a distance became an 'embodied observer' with a physical and individual relationship to three-dimensional photographs.

One example Crary gives to clarify this idea is the 1850s craze for the stereograph, a handheld device through which the viewer looks at two almost identical photographs taken from slightly different positions to mimic the location of the eyes in the human head (see also Chapter 4). The illusion of depth created by the two images converging takes place not in the photographs themselves, but in the physical space of the observer's eyes. Further to this, as Linda Williams has pointed out, handheld devices such as the stereograph created a more direct physical connection between the observer and the photograph as the images and viewing apparatus were touched and manipulated in order to control viewing time (Williams 1995). Crary's point is that the image made by the stereograph, like many other optical devices of the time, is dependent upon the physical body of the spectator, rather than being separate from it as in the type of vision suggested by the *camera obscura*. Looking at daguerreotypes – which have to be viewed from a very specific angle in order to be properly seen – produces a similar effect, generally making encounters with such images intimate.

The content of stereographs and daguerreotypes, like so much early photographic imagery, included pictures of the naked human body (Marien 2006: 84). While many of these images were claimed to be 'academic studies' for artists to use as the basis for drawings and paintings, the vast majority were made for what the photography historian Barbara Rosenblum refers to as 'salacious purposes' (Rosenblum 1997: 220). Abigail Solomon-Godeau and Williams have both pointed out that Charles Baudelaire's railing against the public's obsession with the new medium of photography in the 19th century is almost certainly focused on the spread of obscene images, especially those viewed privately via the stereograph (Baudelaire 1980; Solomon-Godeau 1991a: 222; Williams 1995: 4).

Williams also notes how most histories of photography only coyly hint at the amount of pornographic images the medium has produced (for example Frizot 1998d: 270–271). Even though the evidence from many police raids during the 19th century reveals the massive quantities of pornographic photographs made and sold even in the first few decades of

the medium, 'dirty' pictures are generally 'quarantined' from photography history (Solomon-Godeau 1991a; Williams 1995: 12). Despite his insertion of the physical body into the study of photography, Williams notes that Crary still does not address the content of the photographs the embodied observer was now engaging with, nor does he consider the gender and sexuality of the body that observes (Williams 1995: 6–20; see also Salaman 1994a: 18–19). I expand on these issues in Chapter 3.

Edwards and Hart continue the idea of examining the body's relationship to the photographic image by emphasising the physical substance of photographs that exist 'as chemical deposits on paper, as images mounted on a multitude of different sized, shaped and coloured cards' (2004: 1). Photographs in such forms are material objects that are framed, put in albums, stored in envelopes and boxes. They have a front and back, both of which are sometimes altered through the addition of writing or drawing. Printed photographs move around and we move around them: they are touched and felt, passed from hand to hand, pointed to, laughed at, cried over and groaned about, they prompt conversations and poignant silences. As such the study of the materiality of photographs addresses their part in human relations as social objects (Edwards and Hart 2004: 5; Edwards 2009: 39; see also Chapter 5).

Analysing photographs as material objects also extends their indexicality. Considered as objects, photographs relate to other senses that connect them even more closely to the real, physical world. Batchen has discussed this point through his analysis of photographic portraits that have been placed into lockets or frames along with hanks of the subjects' hair (Batchen 2003, 2004; see also Chapter 5). The hair as well as the photograph is an indexical trace of the person. Vestberg has also argued that photographic indexicality does not just adhere to the image, but also to the materiality of the photograph itself, something emphasised by the links with the world made through writing, or institutional stamps, on the backs of photographs. Vestberg also suggests that these personalising aspects make the photographs authentic and unique, providing them with the 'aura' that Benjamin argued the mechanical reproduction could not possess (Vestberg 2008: 50–54; see also Chapter 4).

David Brittain notes that, as physical objects, photographs age and can be damaged and in this respect photographs can be seen as surrogates for their sitters (or the places or moments they depict) (Brittain 2007: 34–35). They can also be damaged – torn, folded, burnt, stained. As a result, the loss of photographs can be traumatic. In *Camera Lucida* Barthes talks about a photograph as an emotional object that gives pleasure, he also sees it as a living organism that is mortal and gets older: 'attacked by light, by humidity, it fades, weakens, vanishes; there is nothing left to do but

throw it away' (Barthes 2000: 93). Yet he finds the discarding of his own photographs as physical entities impossible to do ('too superstitious for that', 2000: 94) because it would be like disposing of life and the photograph as an object of love.

THE PHOTOGRAPH AS IMAGE: DEMATERIALISATION

Digital photographs offer a different experience to their analogue counterparts. Photography as a medium has gone through a process of 'dematerialisation'. Digital files are virtual, rather than physical objects. As Batchen was arguing by 2001:

> [T]he substance of a [digital] image, the matter of its identity, no longer has to do with paper or particles of silver or pictorial appearance or place of origin; instead it comprises a pliable sequence of digital codes and electrical impulses . . . It is their reproduction, consumption, flow and exchange, maintenance and disruption, that already constitute our culture.
>
> (Batchen 2001: 155)

Such photographic images are now as likely to be viewed on screens – via computer monitors, mobile phones, digital photo frames, shop displays, street advertising, plasmas – as they are in print. We live in what Manovich calls 'the society of the screen' (Manovich 2001: 94). This can be seen as changing the viewer or viewers' relationship to the image, effectively disembodying the observer. Manovich contends that images on screens move, while viewers remain immobile (2001: 94–115; see also Chapter 3). Physical relationships with photographs alter as a result. For example, to look closely at a material photograph on paper, Joanna Sassoon notes, involves moving the photograph or moving the body nearer to it. A digital photographic image on a computer screen can be zoomed in and out of via the mouse or keyboard with almost no movement by the viewer (Sassoon 2004: 192). Nevertheless, it can be countered that viewing digital photographs on hand-held devices (mobile phones, iPods, portable digital photo frames in the form of key rings, etc.) often returns the image to a social object to be passed around and discussed (Manovich 2001: 114). Furthermore it is important to note that the simulation of physically connecting with pictures via the 'touch screens' of some digital devices (such as iPhones) now closely simulates the materiality of physical photographs (Edwards 2009: 31–33).

Photographs in digital form are more mobile than ever, being transmitted around the world (often within seconds of being taken) from email to email, website to website, uploaded and downloaded. With

digital technology, electronic mass reproduction of photographs goes way beyond Benjamin's idea of mechanical mass reproduction (Benjamin 1999). In this sense the digitally reproduced image shares some characteristics with the postmodernist thinker Jean Baudrillard's idea of the simulacrum. Extending Benjamin's ideas relating to the era of modernity, in the 1980s Baudrillard argued that we increasingly live in a virtual world of copies – simulacra – for which the real original has been lost. The simulacrum is a copy of a copy of a copy . . . *ad infinitum* (Baudrillard 1984: 253–281). Like the simulacrum, the digital photograph has no definitive original version, yet is capable of going anywhere. Digital photographs are simultaneously everywhere and nowhere.

With digital cameras and camera phones more photographs are being taken than ever before. These images are captured with the instantaneity that has been part of photography for most of its existence – but there are also more photographs being instantly deleted than ever before too (see Rubinstein and Sluis 2008: 13). The erasing of a digital file can happen as quickly as its creation: it is much faster, more final and far less physically demanding than the material destruction of a fixed negative or printed photograph. Mitchell has contended that digital files require no negative or print to exist and can, in principle, be endlessly replicated (Mitchell 1992: 6), although Manovich has pointed out that duplication often leads to a loss of digital information via compression (for example by turning a file into a JPEG) (Manovich 2001: 54). Transmission online also means that smaller memory size images are used, resulting in images with an absence of fine detail (see Chapter 6). Digital cameras, memory cards and memory sticks can, of course, also be lost. However, the ability to endlessly back-up digital images combined with the ease in which erasure can occur, mean it could be argued that the loss of a digital file no longer involves the potential trauma that Barthes identified with the physical destruction of the printed photograph, or of the unique negative.

FROM FIXITY TO TRANSIENCE: THE RE-CONCEPTION OF PHOTOGRAPHY

The idea of fixed photography as conceived between 1790 and 1839 and based on one-off negatives and mass-reproducible printed photographs went almost unchallenged until around 1990. However, as nature has become increasingly re-conceived in the late 20th and early 21st century, a re-conception of photography has also begun to taken place. In an era where digital technologies increasingly mean that nothing exists in a singular, fixed form, and bodies are artificially altered (Batchen 2001: 141–142; see also Chapter 9), the definitions of nature and culture

Raymond Williams recognized in the 1980s have shifted again as nature becomes ever more a product of culture.

In 2009, nearly two decades after he predicted 'the coming revolution in photography', Ritchin argued that it was not just photography that was undergoing a revolution, but the whole of culture and nature that was entering a 'digital age' (Ritchin 2009). Human life had fundamentally changed – the real world becoming only a reference point for digital simulations. To Ritchin, examining the changes happening to photography is just one way of measuring the 'transition from analogue to digital' (2009: 11). Digital photography is a medium in transition as part of an increasingly transient culture with a revised idea of nature (see also Sassoon 2004: 188). Everything is on 'shuffle', constantly being reordered and reassembled, from the mp3 files on an iPod to the pixels of a photograph (Ritchin 2009: 15–51). Caterina Fake, co-founder of photo-sharing website Flickr, regards 'the nature of photography' in the 21st century as 'in motion' (quoted in Rubinstein and Sluis 2008: 22). Christian Metz argued in the 1980s that the photographic print was what separated photography from other media (such as cinema) (Metz 2003: 138–140; see also Chapter 3), but with digital technology photography comes closer to such media – it is a medium on the move (Rubinstein and Sluis 2008: 14). The nature and culture of photography are increasingly unfixed.

The form of the medium that has begun to emerge from this era of re-conception could be termed 'transient photography'. Transient photography is made possible by digital technology. It is the kind of photography most people now make, use and view most of the time: 250 billion digital photographs were created in 2007 (Ritchin 2009: 11). Rather than fixed, physical objects such as negatives, prints and frames, transient photography centres on virtual, changeable elements such as digital files that are produced, reproduced, transmitted digitally and not printed, but viewed on screens (see also Cobley and Haeffner 2009: 125; Rubinstein and Sluis 2008: 13).

This suggests a return to the shifting, screen-based image of the *camera obscura*. To Sassoon, photographs that exist in purely digital form can even be seen as representing a truer version of the medium (Sassoon 2004: 186). It could be argued that a digital image viewed on a screen is a purer form of photography (as 'writing or drawing with light') than an image fixed on a surface. Indeed, from such a perspective, printing a photograph onto a piece of paper seems increasingly like a deviation from the photographic process.

To summarise (taking an approach from Szarkowski) the essential characteristics of transient photography are that it is:

- in transition: always easily open to manipulation
- in transit: transmittable, mobile, and viewed on screens
- in a transient state: ephemeral, inherently erasable and can be destroyed with little physical effort.

I will return to the implications of this continuing movement from fixed to transient photography at various points in this book.

This chapter does not ask 'what is photography?', because photography is never fully defined. Instead we have examined key issues that relate to how the medium is perceived. Changing (and sometimes opposing) ideas of nature and culture are at the very core of the identity of photography.

But the medium itself is only half the story. Photography is used to mediate; it is a form of communication. 'In the end', Kevin Robins has argued, 'images are significant in terms of what we do with them and how they carry meanings for us' (Robins 1995: 48). In the next chapter we will examine the meanings of photographs.

THE MEANINGS OF
PHOTOGRAPHS

'The illiterates of the future', wrote the photographer Laszlo Moholy-Nagy in the early decades of the 20th century, 'will be ignorant of the use of camera and pen alike' (Moholy-Nagy 2003: 95). This now famous statement was echoed by the German writer Walter Benjamin in his 1931 essay 'A Short History of Photography', where he promoted the need to understand how photographs communicate meanings in a society of mass reproduction: a society that by the 1930s was increasingly producing, distributing and consuming photographs (Benjamin 1980: 215). In the 21st century – where more photographs are produced, distributed and consumed than at any time in history – the need to be 'photo-literate' is greater than ever.

In the study of photography it is vital to be aware of the ways in which photographs can be interpreted. Despite appearing to be more about communication outside of verbal language, applying terms and theories to visual media is important in order to analyse how it functions (see Eagleton 2004: 74–79). The main texts on analysing photographs – those that help make up what is often referred to as 'photography theory' – sometimes contain useful words and concepts that may at first be unfamiliar and difficult to understand. This chapter explains and debates many of the key terms and theories used to analyse photographs. It is divided into two parts. The first part has five sections and focuses on photographs themselves, while the second part has four sections and takes into account the viewers of photographs. The first two sections introduce and apply semiotics as a way of interpreting the potential meanings of photographs. The third, fourth and fifth sections examine the importance of words, contexts and discourses in fixing these meanings (what is meant

by 'discourses' is defined within the fifth section). The sixth section, beginning the part of the chapter focusing on the role of the viewer, provides a brief and accessible introduction to some of the ideas from psychoanalysis that have often been used in the interpretation of photographs. These ideas are applied in the seventh and eighth sections in order to debate the position of the audience: an examination of the process by which viewers may be invited to identify with a particular visual and cultural point-of-view offered by photographs is followed by a section questioning whether such a direct process of identification is possible – and offering alternatives (with an emphasis on gender and the gaze). The final section of this chapter discusses a well-known argument for the importance of personal interpretations of photographs.

UNDERSTANDING SEMIOTICS: SIGNS, SIGNIFIERS AND SIGNIFIEDS

Although it is far from the only way to interpret images, semiotics is a common technique applied in the critical analysis of photographic meaning. A common starting point for understanding the semiotic theory used by many photography theorists is the semiology promoted by followers of the Swiss linguist Ferdinand de Saussure. Saussure's course in general linguistics analysing how spoken and written language works, which he gave in the first few years of the 20th century, was collated by his colleagues and students and published after his death (de Saussure 1959). Like Charles Sanders Peirce (see Chapter 2), whose work runs in parallel with his, Saussure's ideas centre on 'signs'.

To Saussure, linguistic signs are what make up all human languages; it is with signs that the communication of meaning happens. A linguistic sign is comprised of two inseparable parts: these have commonly been translated as the signifier and the signified (for example, in the translation from the 1916 edition of Saussure's course by Wade Baskin in 1959). Every linguistic sign must have both of these parts to function as a form of communication. The signifier was put forward by Saussure as the 'sound pattern' in the mind yet, after its use by the French writer Roland Barthes, semiologists also extended the idea of the signifier and made it the material part of the sign, for example, the sound of someone saying the word 'dog' or the written word 'dog' (Barthes 1967). The signified is therefore the mental concept that is produced in the mind of the listener or reader who receives the signifier. The sound 'dog', for instance, produces a mental concept in the listener that will be something along the lines of 'a four-legged, hairy animal with a tail, which barks and likes chewing bones'. This is known as the process of signification.

To Saussure, the connection between the signifier (the sound pattern or, for later semiologists, even the written word, for example 'dog') and the signified (the mental concept it produces, for example 'a four-legged, hairy animal', etc.) is an arbitrary convention – there is normally no reason for the sound or word to actually relate to the concept. In German, 'hund' would produce the same mental concept, even though the word is different; in French 'chien' would produce the same concept, and so on. It is only because the speaker and listener of the sound, or the writer and reader of the written word, have learned and share the same language that they know what concept goes with what sound.

It is also important to note that, while to say or write 'dog' (or 'hund' or 'chien', etc.) does not specify a particular type of dog, it does distinguish it from other animals such as a cat or a mouse. Central to Saussure's idea of language is that signs work by being different to other signs; it is through this difference that meaning is made. Saussure called his system 'semiology' (literally, the science of signs), although the term 'semiotics' has since come to be widely used to describe the analysis of signs (see Cobley and Jansz 1999: 8–17).

During the mid-1950s, Barthes (whose ideas are also discussed in the previous chapter) contributed a series of articles to the magazine *Les Lettres Nouvelles*. These short pieces analysed aspects of everyday life at the time such as soap-powder or the latest Citroen car and, in a number of instances, photographs (Barthes 1973). When the articles were gathered together in 1957 as the collection *Mythologies*, Barthes wrote a new section for the second half of the book, 'Myth Today', where he looked back on the articles and began to develop a system to put together what he had been doing. To achieve this he applied and extended Saussure's concept of the sign (1973: 117–124).

While Saussure's concept works at the level of language, Barthes argued that it is also important to take into account the culture in which language produces meanings. In other words, examining the look of soap-powder or the meanings of a car's design are ways of analysing what he called the 'myths' of daily life that form the culture of which the products, however trivial or obvious they might seem, are a part (1973: 11). John Fiske regrets Barthes' use of the term 'myth' because that particular word is often understood to mean things that are regarded as false (Fiske 1990: 88). In fact, Barthes uses the term to refer to the things that are generally believed to be true in certain cultures (such as the belief that the foamier and whiter the soap-powder, the more the clothes are 'purified' by the wash, or the way the smooth, seamless design of the latest model of Citroen car made it appear like a goddess descended from heaven to be experienced by human beings). In 'Myth Today' Barthes applies these ideas to his analysis

of a photograph from the cover of *Paris Match* magazine showing a young black soldier saluting the French flag. The myth suggested by this image, Barthes argues, is that, despite its colonial past, the French nation in the 1950s had become inclusive and open to all (1973: 125–138).

In 1964 Barthes elaborated on these ideas in 'Elements of Semiology', an extended essay published in the journal *Communications* and later as a book in its own right (Barthes 1967; see also Burgin 1982c: 60). Here he added terms from the Dutch linguist Louis Hjelmslev, who also argued that signs needed to be considered in relation to their role in culture (Cobley and Jansz 1999: 39–42). Hjelmslev used the term 'denotation' to describe Saussure's idea of how signs communicate at the level of language, while he used 'connotation' to refer to the cultural meanings that arise from the specifics of when, where and how that communication takes place.

A number of writers have commented that applying semiotics (which they assume is semiology, a science focused on linguistics, as opposed to the major tradition of semiotics derived from Peirce) to analyse the non-verbal, visual language of photographs is not entirely appropriate (e.g. Frosh 2003: 19–22; Mitchell 1986: 9; Welch and Long 2009: 4–10). In fact, as we will see at the end of this chapter, towards the end of his life Barthes himself moved away from formal semiological analysis, adopting a much more personal approach to his analysis of photographs in books such as *Camera Lucida* (Barthes 2000; see also Chapter 2). However, in the 1960s Barthes went to some lengths in various writings specifically on photographs to adapt semiology for the purposes of visual interpretation. In 'The Photographic Message', an essay on press photographs (published a few years before 'Elements of Semiology'), Barthes refers to what he calls the 'codes' of connotation that such photographs draw upon and which are understood culturally (Barthes 1977a). These include codes of pose and gesture, technical effects (such as focus and blur) and the meanings of objects in pictures. Many other codes are specific to different photographic genres such as portraiture, where codes of facial expression, for example, join with those of pose to connote meaning (see Chapter 6).

A BAG OF PASTA AND A CUP OF TEA: RHETORIC OF THE IMAGE

When first published, 'Elements of Semiology' was accompanied by a shorter piece called 'Rhetoric of the Image', later reprinted in the anthology *Image/Music/Text* (Barthes 1977b). In 'Rhetoric of the Image' Barthes applies denotation and connotation to analyse an advertisement for pasta products made by the company Panzani (see Campany 2003a: 40). The photograph used in the advert shows a string bag containing

peppers, onions and two packets of pasta, while a tin of tomato sauce, a sachet of Parmesan cheese and a mushroom are spilling out onto a surface. All of this is shown against a bright red background. The picture is accompanied by two lines of text layered over the image in the lower right-hand corner.

Barthes' analysis of the photograph starts with its connotation. This is because, as he explains, the viewer will understand the cultural meaning of the image before they realise they are thinking about the details of what they are looking at. Indeed, Barthes' analysis relies on slowing down the process of interpreting each sign – something that usually takes place almost instantly – in order to study in detail precisely how meaning is understood. The denotation here is the 'literal' content of the image; in other words, the things within the picture that will be recognised instantly by the viewer. This is the visual equivalent to the idea of the verbal sign, except instead of the sound of a spoken word or the letters of a written word producing a 'mental concept' we could argue here that it is the shape, colour and texture of what is seen in the photograph that produces the recognition in the viewer that they are looking at a string bag, vegetables, pasta, a red background, and so on.

Barthes proposes that the string bag full of food connotes what he calls a 'return from the market' (1977b: 34). This connotation suggests a considered process of selection. Had it been a manufactured paper bag (or one of the plastic bags that were replacing them during the early 1960s) then the connotation would be quite different: a stressful, hurried trip to the high street perhaps.

The string bag is stretching into the image from the top left corner as if being emptied by the unseen hand of the consumer having arrived home. The organic quality of the food confers its connotation of naturalness onto the other objects in the bag, the factory-made products in their plastic and tin containers. As well as this, Barthes notes further connotation, such as the associations of quality and high culture deriving from the photograph's overall compositional resemblance to 17th-century Dutch still life paintings (of which bountiful food was a common subject) and the colours of the advert, which are predominantly red, white and green – the colours of the Italian flag – connoting a generalised idea of Italy, which Barthes terms 'Italianicity'. Putting all these connotations together: to the readers of the French magazine in which the advert first appeared, the photograph was intended to connote that the mass-produced products shown will provide their consumer with a natural, high-quality, authentic Italian meal.

In 'Rhetoric of the Image' Barthes argues that connotation is dependent on ideology (1977b: 49–50). The term 'ideology' was originally used by

Karl Marx to mean the beliefs of those in power that are imposed upon the masses from above. However, Barthes is applying the then-current use of the term by the French Marxist Louis Althusser, who adapted Marx's version, arguing instead that ideology is a shared set of beliefs, learned and reinforced by the masses themselves (Sturken and Cartwright 2001: 50–56). Ideological beliefs work because they seem completely normal and therefore go unnoticed and undisputed. A full understanding of the connotation of the pasta advert, for instance, depends on its position in a culture where ideologies of naturalness, authenticity and the experience of other cultures are unquestionably considered desirable. Further to this, the advert reinforces the ideological belief that these desires can be fulfilled through the consuming of the product advertised. 'Rhetoric' is a persuasive argument and so, to Barthes, the way that photographs persuade their viewers to believe in what they show is due to what he terms the 'rhetoric of the image'.

To Barthes, photography is the ideal medium to make ideological beliefs appear normal because, despite their use of codes to communicate, the photograph seems to be what he called in 'The Photographic Message' 'a message without a code' (Barthes 1977a: 17).

Unlike verbal signs, with photographs the connection between the signifier and the signified is not arbitrary, but results from a direct link with the specific things in the real world that the image depicts. Following the work of Charles Kay Ogden and Ivor Armstrong Richards, the thing in the real world to which signs refer is commonly called the 'referent' (Ogden and Richards 1923). The effect of what Peirce called the 'indexicality of photography' makes photographs appear to become the referent, even though they are two different things (see Chapter 2). As Barthes put it years later, 'the referent adheres' to the photograph (Barthes 2000: 6). Barthes' claim that the photograph is 'a message without a code' should not be taken to mean that he thinks photographs are unmediated reality, only that their construction is 'concealed elusively' (1977a: 21). So the power of the photograph, to Barthes, is that it reproduces ideology while apparently showing what is merely obvious and natural. Photographs connote, while seeming only to denote. Therefore what is actually culturally specific is made to appear 'only natural' (1977b: 51).

Barthes acknowledges that he uses an advertising photograph to demonstrate his ideas because such images are carefully put together to connote particular meanings in order to sell a product – and indeed contemporary adverts can be analysed using the same terms and ideas (see below and the next chapter for more on photography and advertising). However, his use of connotation can be applied to any photograph, not just those produced to sell things to a consumer.

Take for example a photograph made in the mid-1990s, by British photographer Martin Parr, of beige coloured tea in a blue and white willow pattern cup and saucer standing on a red and white plastic, gingham patterned tablecloth (see Figure 3.1). As with the 'Italianicity' connoted by the colours in the pasta advert, the red, white and blue denoted in the Parr photograph can be read as connoting 'Britishness'. This is reinforced by the colour of the tea itself, which clearly contains milk and connotes a customary British way of tea drinking. Further to this, the denotation of the Chinese-style willow pattern connotes an idea of 'Eastern-ness', although the pattern was actually designed in Britain based on Chinese motifs. Overall the image could be read ideologically as a reminder that much of what is considered to be traditional British culture (like tea) is very often adapted from other countries (see also Pepler 1998: 39–42).

This interpretation of what is denoted and connoted in the Parr photograph does not exhaust its meaning. Even though the denotation of any photograph remains the same, the connoted meaning can change. In 'Rhetoric of the Image' Barthes makes the argument that all images are 'polysemous' (sometimes referred to as 'polysemic'): they have more than one potential meaning (1977b: 37–41). The polysemy of photographs is an essential point to remember when considering how they are interpreted. However, it must not be taken to imply that any given photograph might mean anything at all.

Figure 3.1 Martin Parr *England* from the series *Ooh La La* (1998) © Martin Parr / Magnum Photos.

John A Walker has discussed his experience of asking students at an art college to interpret a photograph. He was concerned to discover that many students subscribed to what he calls 'the ideology of individualism': the argument that 'individuals are unique therefore everyone is different, therefore everyone interprets images differently, therefore one cannot speak about *the* meaning of an image; there are as many meanings as there are human beings' (Walker 1997: 52). Therefore, as Walker says, if an image has billions of meanings it may as well be meaningless. However, a photograph's meanings are not entirely unique to each individual. Not only does the content of the photograph limit the meaning (Parr's image of the tea, for example, is very likely to communicate something about tea and Britishness, but very unlikely to have anything to do with, say, pasta and Italianicity; see Slater 1997a: 93) but also, as we shall examine in the following sections, the words that accompany a photograph, the contexts in which a photograph is seen, and the wider discourses of which the photograph is a part, are three further ways by which meanings may be guided and fixed. (The position of the viewer in relation to the photograph, including the idea of personal interpretation, is analysed further in the second part of this chapter.)

FIXING MEANINGS: WORDS

This section, and the next two sections, will use another photograph by Parr as a case study to investigate how the meanings of an image can be fixed and can change. Later on I will reveal when Parr made the photograph and where it has since appeared, but to begin with we will only examine it in terms of both the denotation and connotation of its content.

The photograph (see Figure 3.2) shows six people in the back garden of a house. Two men wearing suits and ties are standing amid the hollyhocks, one holding a plate and fork, the other a glass of wine. The first man's lips are pursed and his eyes are downcast, the out-of-focus grey wedge of a neighbouring house's guttering runs vertically from the top centre of the picture to just above his head. The man with the glass has cocked his head to one. Behind him the leg of a woman in a flowery skirt sitting in a folding chair is visible and between the two men a third man with grey hair and a moustache sits holding a glass of wine. The right of the picture is dominated by a white-haired woman in a flowery dress and matching green necklace, an empty plate (like the man's, made out of china not paper), with knife and fork (metal not plastic) neatly placed together, rests in her lap. Slightly out of focus and illuminated by flash, she looks to the right of the photograph into which some more white hair, as

Figure 3.2 Martin Parr *Conservative 'Midsummer Madness' Party* (1988) ©
Martin Parr / Magnum Photos.

well as a slither of the side of a head and a hand intrude: just enough visual
information to surmise that there is another person partly out of shot.

In her book *Visual Methodologies*, Gillian Rose lists what Gillian Dyer
has referred to as the 'signs of humans' that viewers interpret. These
include the representation of bodies, manner and activities, combined
with props and settings (see Rose 2007: 81–82). Rose notes that to
interpret the codes of these human signs requires 'extensive knowledge of
images of culturally specific social difference and social relations' (2007:
82). Applying this kind of semiotic analysis to the bodies, manner,
activities, props and settings in the Parr photograph, the overall conno-
tation of the image could be interpreted as that of a polite but socially
tense occasion. The gestural codes of conversation we see in the photo-
graph are combined with facial expressions connoting boredom or even
conflict. Every visible mouth is firmly shut. No one looks too pleased to
be there. The suits and ties (one with an insignia), red wine, china plates
and metal cutlery also connote that these people may well be middle-class
and are probably very aspirational.

Liz Kotz has argued that 'the fusion of words and photographic
images' is one of the basic elements of visual culture: almost every time

photographs appear they are joined with language 'as caption, headline, surrounding text, intertitle, or spoken voiceover or dialogue' (Kotz 2006: 513). Burgin has acknowledged the important effect written text has on photographic meaning (Burgin 1986a), while writers including Richard Chalfen and Elizabeth Edwards have noted the vital impact that the spoken words that can surround photographs have on how we interpret them (Chalfen 1987: 119–130; Edwards 2009: 37–42). (See Chapter 5 for more analysis of 'spoken words' in relation to photographs.)

In 'Rhetoric of the Image' Barthes suggests that written text works with photographs in two ways: anchorage and relay (1977b: 37–41). Text as *anchorage* tends to function as a written equivalent to what appears in the image. It tells the viewer with some precision what they are looking at, fixing the meaning of the photograph the way an anchor moors a boat in place. Barthes says that this form of text is most commonly found with press photographs and advertising. Today, the caption of a press photograph still tends to confirm the 'who, what, why, where and when' of the image, but – as I will go on to argue below – the use of text in advertising has changed considerably since Barthes wrote his essay in the 1960s.

The text at the bottom of the Panzani pasta products advert reads (in French) 'Pasta. Sauce. Parmesan' and 'Italian Luxury'. This anchors the viewer's reading of the image by directing their attention to the manufactured products within the photograph – telling us for sure that it is not selling us the bag or the vegetables – and confirming the reading of the advert as connoting an idea of high-quality, authentic Italian food (even if the text within the image on the labels of the Panzani products tells us the food is manufactured in France – such is the persuasion of rhetoric!).

Relay is where the picture and text work in tandem to create a meaning that could not be made by each element separately; it is the result of a relaying of messages between both elements (1977b: 41). In order to analyse this I will return to the Parr photograph of the people in the garden. The title of this picture is *Conservative 'Midsummer Madness' Party*. Most of this title could be regarded as anchorage. If we believe what it says – and of course titles can be inaccurate – it tells us who these people are (Conservative supporters), what time of year the picture was taken (in the middle of summer), and what they are doing (having a party). All of this is quite matter-of-fact and functions like the caption of a press photograph in anchoring the basic facts of the photograph. However, the word 'madness', while part of the name of the event also seems to jar with the image. The ideas connoted by a 'madness' themed party suggest a wild, energetic and fun occasion. As I have suggested above, the picture seems to connote the very opposite to this. The word 'madness' therefore could be seen to work in relay here: the contradiction between the usual

connotations of the word 'madness' and the connotations of the image work together only to heighten the impression of tense conformism that the photograph conveys.

Barthes argues in 'Rhetoric of the Image' that relay is used less commonly than anchorage in relation to photographs (1977b: 40–41). However, in the decades since he made this statement, the use of text as relay has become standard practice in advertising, giving the viewer the impression of involving them more directly in the process of making meaning. For example, in the 1990s Conservative 'Midsummer Madness' Party was used as part of a campaign to sell Pepe jeans. The image was presented as if it was stapled to a notice board accompanied by a piece of paper with the Pepe jeans logo and the phrase 'The world is full of people you hope you'll never meet'. In this advert the text works as relay with Parr's image, playing on the subjects' expressions, gestures and formal clothes, in order to contrast them with the more relaxed, casual lifestyle of the intended consumer of Pepe jeans. In the following section the importance of context to a photograph's meanings is analysed.

FIXING MEANINGS: CONTEXTS

The act of making a photograph automatically de-contextualises what is in front of the camera and places what is photographed into new contexts. Elizabeth Edwards and Allan Sekula are two writers who have insightfully traced this process and how it affects a photograph's meanings (Edwards 1992; Sekula 1982). When a camera lens is pointed at something and the shutter opens and closes, a fragment of the world and a period of time (usually lasting for a fraction of a second) are recorded onto a digital sensor or film. A view and a moment, Edwards has noted, are therefore detached from their original context and displaced spatially and tem-porally (1992: 6–7). While the photograph's view does not change and the moment in the photograph does not move, the meanings of a photograph can change and move around it. A photograph, Sekula argues, presents 'the possibility of meaning' (1982: 91). These meanings are contingent on words (as we have examined above), but can also depend on other images that accompany the photograph. Just as a photograph is rarely seen without words, so too is it unusual to find a photograph in isolation.

Benjamin, writing the essay 'A Short History of Photography' from a Marxist position in the Germany of the 1930s, wanted photography to be used politically to make viewers conscious of what was going on in the country at the time, such as the poor conditions of workers in factories owned by businesses including the steel manufacturer Krupp and the electrical company AEG (Benjamin 1980). Although Benjamin sees a

photograph as a 'reflection of reality' (a phrase quoted from the play-wright Bertolt Brecht), a single photograph alone would be unlikely to show what was going on in the factories (see Slater 1997a: 93–94). In one of the most widely cited statements on photography, Benjamin continues to quote Brecht who argues that, 'A photograph of the Krupp works or the AEG reveals almost nothing about these institutions' (Benjamin 1980: 213). The solution, according to Benjamin, is to 'build something up', to add other elements to the single photograph. It is clear that Benjamin saw that one of way of doing this could be through the addition of text ('Will not captions become the essential component of pictures?' he asks later in the essay (1980: 215)). But another way that he suggests is via the addition of more photographs.

This idea of putting images together, based on the cinematic principal of 'montage', pioneered for the purposes of Communist propaganda in the 1920s by the Russian filmmaker Sergei Eisenstein (see Joyce 1999), creates what Barthes called the 'third meaning', often also referred to as the 'third effect' (Walker 1997). At its most basic, to montage is to assemble together two or more images, while 'photomontage' involves the combining of separate photographs into a single image (see Ades 1986; Bull 1999a; Evans and Gohl 1986). The German photo-magazines of the 1930s, which applied montage techniques, significantly influenced the use of photographs in magazines across the world as well as the 'photobooks' that became increasingly popular during the 20th century (see Chapter 6).

An entire page is dedicated to *Conservative 'Midsummer Madness' Party* in Parr's 1989 book *The Cost of Living* (the picture's first published appearance), where he turned his camera onto the British people who were successful under Thatcherism in the 1980s (Parr 1989). Printed on the opposite page, alongside the photograph's title, is a second photograph, labelled *Coffee Morning*, where another group of people at another social gathering are involved in a similarly tight-lipped conversation. Throughout the book a feeling of discomfort is created by Parr's catching of uneasy gestures and expressions and his use of a 'snapshot aesthetic' as heads are cut off, focus is lost and horizons tilted (see Chapters 5 and 6). There is an overall connotation of parody to Parr's pictures in *The Cost of Living* as his subjects are, literally, framed by the camera (which led to accusations by reviewers of stereotyping and exploitation); however, the use of individual images builds up a bigger picture that reveals – from Parr's perspective – an important aspect of British culture in the late 1980s (see Bull 1995).

A photograph's immediate context among other photographs – whether it be on a magazine, book or website page, in a photo album or in an exhibition – has a significant effect on our interpretation of it. Such

placements are all forms of montage and have the potential to create meanings across images (see also Chapter 5 on photo albums and social networking websites and Chapters 6 and 7 on photobooks). However, the influence of immediate context must be considered in relation to the wider discourses of which a photograph can become a part, as the next section examines.

FIXING MEANINGS: DISCOURSES

Discourses are notoriously tricky to define. Since the 1970s the idea of 'discourse' has complemented, absorbed and/or replaced the theory of ideology analysed earlier in this chapter (Briggs and Cobley 1998: 278–280). Its use in the analysis of photographs generally originates from the writings of French philosopher Michel Foucault. Rose has summarised Foucault's definition of discourse as 'groups of statements which structure the way a thing is thought, and the way we act on the basis of that thinking' (2007: 142). All of the statements around a particular photograph or photographic practice – its discursive context – produce how it is thought about.

To illustrate this idea, it is useful to examine in detail how Parr's *Conservative 'Midsummer Madness' Party* has travelled through a number of discourses, the production of its meaning changing – sometimes subtly, sometimes significantly – in the process.

Positioned on the pages of *The Cost of Living*, *Conservative 'Midsummer Madness' Party* is part of the documentary discourse – where 'things as they are' are shown. Writers such as John Tagg would be likely to argue that the positioning of the photographs in *The Cost of Living* within the discourse of documentary produces the idea that they depict the 'reality' of middle-class consumerism in 1980s Britain (see Rose 2007: 175; Tagg 1988b). (Although Parr's work is part of a development in the discourse of documentary where the photographer presents a more personal, subjective viewpoint on their topic (see Chapter 6).)

The following year the same photograph reappeared on the front of the catalogue for the Museum of Modern Art, New York (MoMA) exhibition of *British Photography from the Thatcher Years* (Kismaric 1990). In this discourse the photograph was still strongly connected to the middle-classes and the political situation in Britain (despite the retrospective sound of the show's title, Margaret Thatcher remained Prime Minister at the time). However, the discussion surrounding the photograph in the catalogue firmly situates both it, Parr's work in general, and that of his co-exhibitors (including John Davies, Paul Graham, Chris Killip and Graham Smith) as having revived British photography from what Susan Kismaric,

MoMA curator and author of the catalogue essay, perceives as the doldrums it had been in during the previous decades (1990: 6–10).

Kismaric positions Parr's work as pioneering colour documentary photography in Britain, but the discourse of art that surrounds the placement of the photograph in one of the world's most important galleries also begins to add much greater emphasis to the idea that the image is an example of personal expression by Parr. Even the white borders that surround the picture on the cover of *British Photography in the Thatcher Years* reinforce the removal of the photograph from its relevance to the outside world and a specific place and period of time, with the emphasis instead on isolating the image as a work of art. (In Chapter 7 I elaborate on the idea of art and personal expression.)

Parr became a full member of the Magnum photography agency in 1994. Magnum was set up in the 1940s to protect the rights of photographers in respect of how their work was used and to promote the generally humanitarian attitude of the photographers towards the subjects they photographed (see Chapter 6). While Magnum photographers had been selling their work to advertisers for decades, by the mid-1990s the organisation became far more active in promoting its photographs for commercial purposes. When *Conservative 'Midsummer Madness' Party* was used in the advertising campaign for Pepe jeans discussed above, permission was gained from the people in the photograph and payments were made to them. However, at the time Colin Jacobson expressed a concern that in the discourse of advertising the image was being used in a way that not only went against the principles upon which Magnum was established, but also reinforced the stereotypes Parr's work had been accused of exploiting in his books and exhibitions (Jacobson 2008). While Parr acknowledges the exploitation of prejudices as integral to his projects, within the commercial discourse of advertising the end result was that the garden party photograph was primarily selling jeans rather than commenting on British culture (Parr and Brittain 1999; Parr 2008).

In 2002 a retrospective exhibition of Parr's work began to tour the world. The accompanying book by the show's curator, Val Williams, placed Parr's photographs into the discourse of biography, considering them in relation to his middle-class upbringing (Williams 2002). In Parr's youth, the book tells us, he would visit his grandparents and go to Harry Ramsden's fish and chip shop – a far cry from the bird watching holidays he had with his parents. Williams relates the story of how it was in the chip shop that Parr made his first photo-essay and where he learnt that people were distracted when eating and therefore open to being photographed:

Throughout his photographic career Parr has returned to the portrayal of the British eating in public, creating a comedy of manners and social exposure. From the finger food at the Conservative party fête, to the consumption of fast food on the move, from an elderly couple staring past each other in a drab tea shop, to a crowd of raucous girls in a New Brighton chip shop, Parr has produced photographs that form a direct link to that first photo-essay at Harry Ramsden's.

(Williams 2002: 25)

Within Williams' retrospective the meaning of the garden party photograph changes again to an image that resonates with Parr's own life. It relates to the discourse of authorship, where biographical details are regarded as the primary factors in defining the meanings of a work, helping to establish food, and eating in public, as recurring themes in Parr's work as an 'author'. In Chapter 7 challenges to this idea of authorship are debated.

Conservative 'Midsummer Madness' Party is also on the Magnum website (image reference LON28888) where, like many more pictures by Parr and other Magnum photographers, it can be bought for use in publications (although the website notes that this particular image 'must not be used for any merchandising', perhaps because it has already been associated with the Pepe jeans brand). The photograph can be located on the website, not just by looking up the name 'Martin Parr', but also through searching for the following keywords:

Conversation, Drinking Glass, Eating, Exterior, Man – 45 to 60 Years, Middle Class, Party, Plate, Private Garden, Right Wing, Seated, Clothes (Suit), White People, Wine, Woman – 45 to 60 Years

As such it is part of the discourse of the 'image bank', a database of photographs that allow the picture to illustrate an extensive range of themes in countless other discourses (see Chapter 4). The Magnum website can be accessed via links from sites such as Parr's own website, placing the photograph in its digital form within a wider virtual context.

While the material qualities and physical context of photographs play a vital role in determining meanings (see Chapter 2), viewing digital photographic images in the interconnected virtual space of the web creates a 'hyper-context' for photographs online, resulting in their positioning within potentially limitless discourses (see Sassoon 2004). Fred Ritchin regards the digital photograph not as a window on the world (a definition that fits the documentary discourse) or a mirror of the photographer (the discourses of art, biography and authorship), but as a

'mosaic' – a fragmented image, parts of which can be hyperlinked, 'mapped' or 'tagged' and clicked on to provide other points-of-view on the picture. The web's numerous discursive perspectives suit photography well, he argues: emphasising the interpretation of photographs as being collaborative and 'multi-vocal' (Ritchin 2009: 69–77).

Clearly, what a photograph means does not derive entirely from its content (although it is essential that content is analysed). By their very nature photographs are mobile signs whose meanings change across space and time and through virtual spaces too. Words, contexts and discourses all play vital roles in determining the consensus of how a photograph will be interpreted at any given moment and in any given place. The meanings of photographs are never permanently fixed.

PHOTOGRAPHY AND PSYCHOANALYSIS: THE UNCONSCIOUS, FETISHISM AND THE UNCANNY

We have so far examined the use of semiotics, words, contexts and discourses to determine the meanings of photographs. What Walker has called the 'mental context' – in other words the mind of the viewer as interpreter of photographs – should also be taken into account (Walker 1997: 60). This is not easy: 'After all,' Walker notes, 'what goes on inside other people's heads?' But, as he explains, people share common experiences, desires and anxieties, all of which have an effect on how they will view a photograph. Photographs trigger emotions (joy, fear, anger, etc.) – although semiotics has addressed these ideas, the simplified version of it applied in photography theory is unable to acknowledge such states (see for example Watney 1999).

Since the 1970s many writers on photography have employed psychoanalysis – and in particular those ideas about the mind deriving initially from the writings of Sigmund Freud that began to be published in the late 19th century – as a way of analysing the experiences, desires and anxieties that we commonly share, and which affect how we interpret photographs and how they are made (Roberts 1998; see for example Burgin 1986a). Freud's theories also form an important part of the concept of individuality that fully emerged in the era of modernity (see Chapter 2).

The central idea in Freudian psychoanalysis is the 'unconscious'. Freud argues that everyone's mind contains the conscious, the preconscious and the unconscious. The conscious part of the mind is the one we use most of the time to deliberately control our thoughts, actions and speech. The preconscious is where the thoughts of which we can become aware at any given moment are stored. But in life there are also certain thoughts that

the conscious mind cannot handle. Specifically there are desires and anxieties that we may have, which – often for reasons of cultural conditioning – we do not, or feel we should not, consciously think about, act upon or discuss. Freud argued that these desires and anxieties are often hidden away in our minds; not expressed consciously, nor stored in the preconscious, but repressed into the unconscious (Freud 1991a: 327–343; Freud 1991b).

But repressed anxieties do not stay in the unconscious. They return, travelling from the unconscious into consciousness. The preconscious acts as a kind of guardian between the unconscious and the conscious parts of the mind and therefore the repressed thoughts find various ways to sneak through into consciousness via, for instance, slips of the tongue: where a speaker involuntarily says what they are unconsciously thinking, even though it was not the correct thing to say (Freud 1991a: 37–108). Although such slips may often appear illogical, Freud argued that they can be interpreted in order to make sense of them.

Freud also emphasised dreams as a place where the unconscious is allowed to take over from the conscious mind (beginning with his pioneering book *The Interpretation of Dreams*, first published in 1900 (Freud 1991c)). Unconscious desires and anxieties transform events, objects, places and people that the dreamer has experienced in real life, via a process of distortion which Freud called 'the dream-work' (Freud 1991a: 109–279; Freud 1991d). These transformations include displacement: the exchange of one thing or person by another (often resulting in things or people being out-of-place); and condensation: where two or more objects, places or people are combined (Freud sometimes used Francis Galton's 'composite' portrait photographs as an analogy for the latter, for example Freud 1991d: 95; see also Chapter 6). In both condensation and displacement there is an unconscious association between the things displaced or condensed that the dreamer will not have been consciously aware of and which relates to the dreamer's repressed anxieties and desires.

Freud argued that many anxieties and desires come from our experiences as a child. I will briefly focus on two of those experiences in this section: the related moments of the 'Oedipus complex' and the 'castration complex'. Like most of Freud's writings, these experiences tend to be related from a male perspective – a limitation which he acknowledged (Freud 1991e) and which has led to criticisms and adaptations by many authors ever since (see McClintock 1994 and Gamman and Makinen 1994 for a detailed examination of attempts to adapt Freudian psychoanalysis to a female perspective).

As a child, Freud suggests, a person initially identifies with its mother, who is a loving, nurturing influence on them. However, the child then

becomes jealous of the father over the love of the mother – put crudely, it wants its mother all to itself. Unconsciously, Freud argues, the child fantasises about killing its father. This Freud calls the 'Oedipus complex', based on the Greek myth of Oedipus who as a child was taken away from his parents and who later in life unknowingly kills his father and marries his mother, blinding himself as punishment when he realises what he has done (see Freud 1991a: 362–382).

The Oedipus complex is resolved later in the child's life through what Freud calls the 'castration complex'. At first, Freud argues, the male child assumes that everyone has a penis. After all, he has one, so why shouldn't everyone else? The child does not understand gender difference. Freud says that at some point the child sees its mother's genitals and realises that she does not have a penis. Assuming, still, that everyone is born with one, the child imagines that its mother's penis must have been cut off. This is what Freud calls 'lack': the woman lacks what the man has. The child also becomes concerned for its own penis – which it has grown rather attached to – fearing that it might be removed as well. So the woman's body becomes the site of both desire and anxiety. The boy also believes that it is the father who has cut off the mother's penis. From this stage on the child identifies instead with its father as a powerful figure: the possession of the penis comes to represent the authority of the father, symbolised by the idea of the 'phallus' (see Freud 1991f: 334–361).

One of the ways in which the child copes with the trauma of this perceived castration is to disavow it. Freud says that unconsciously the child – and later on in its life, the adult – replaces the 'absent penis' with another object when the female body is looked at with desire for any length of time. This object might be a shoe, or some other item of clothing which, as Freud developed his ideas he decided could be an object seen just before the moment the child recognised its mother's 'lack' of a penis, symbolically freezing the instant prior to the trauma (Freud 1991f: 297–299). This disavowal effectively proclaims, 'I know very well that the woman does not have a penis, nevertheless I choose to believe that she does.'

The term Freud uses for this is 'fetishism'. While the word 'fetish' has many meanings (in anthropology or Marxism, for example), in the context of Freudian psychoanalysis it refers to an object that becomes excessively valued because it stands in for something else. Photographs, too, generally stand in for something else that is absent: a person, a place, a moment in time (Berger 1980; see also Burgin 1982a: 189–191). In an essay applying the idea of the fetish to cinema and photography, the theoretician Christian Metz argued that cinematic images go by fast and are therefore too ephemeral to be fetish objects; whereas photographs can usually be held in

the hand or kept in a pocket, wallet or purse – the length of time for which the still image is looked at can be controlled by the viewer. As such, Metz contends, photographs are far more easily capable of becoming fetish objects themselves (Metz 2003). From this perspective they represent another disavowal based on desire: 'I know very well that the photograph is not the thing itself, nevertheless I choose to believe it is.'

Freud's ideas and those of his followers became the basis of Surrealism, a movement founded by André Breton in Paris in the 1920s after some key writings on psychoanalysis were translated into French. The main revolutionary, idea of Surrealism was to discard all culturally acceptable rules and access the unconscious mind through methods such as automatic writing where conscious control could be abandoned (see Alexandrian 1970; Breton 2003; Mundy 2001). Among other techniques, Surrealist artists soon came to use equivalent photographic processes such as solarisation where the light and dark areas of a print exposed to light during printing are displaced in unpredictable ways (see Bate 2004b; Breton 2003; Caws 1986; Grundberg 1990; Krauss 1985a, 1986b; Walker 2002).

Other Surrealist photographic techniques of transformation included photomontages and multiple and long exposures, often used to mimic the dream-work's effect of condensation, processes that Rosalind Krauss has linked to the idea of doubling (Krauss 1985b: 28–31). This concept is vital to Freud's concept of the 'uncanny'. In his 1919 essay 'The "Uncanny"', Freud attempts to analyse why certain things disturb us – things that are not quite right and have a disquieting strangeness (Bate 2004b: 39–45; Freud 1990). He suggests a number of common examples of this, such as things that reoccur in doubles or many times where there should only be one. This includes the *doppelgänger* or 'double', where an exact duplicate of a person suggests a loss of certainty about identity; as well as the apparently inexplicable repetitions such as when an image, word or number keep appearing as if by chance (1990: 356–361). Further instances of the uncanny include an uncertainty about things that appear to be alive when they should not be and, conversely, things that seem to be dead when they should be alive.

As Krauss's examples of montages and multiple exposures in her analysis of doubling suggest, photography is a particularly apt medium for the uncanny. Further to this, in semiotic terms: every photograph is indexically also a double, through its duplication of what it depicts (Krauss 1985b: 31), and most photographs simultaneously bring to life things that have passed and cause what was living to be stilled. Such ideas also led to the use of photography in spiritualism during the mid- to late 19th century and again after the trauma of the First World War, where eerily

accurate body doubles of the dead were summoned up by medium-photographers and exposed in the darkness of their studios to create spirit photographs for those wishing to see their loved ones again (see Gunning 1995; West 2000: 148–153).

Photography and psychoanalysis both relate closely to anxiety and desire. As such, they are vitally linked in the study of photographic meanings.

PLEASURES OF LOOKING AT PHOTOGRAPHS: THE GAZE

In 1975 film theorist Laura Mulvey published her essay 'Visual Pleasure and Narrative Cinema' (Mulvey 2009). This essay has come to be endlessly referred to, quoted from and challenged in both film and photography theory. Its influence on photography theory remains vital and so it is important to summarise the relevant key ideas from the essay in order to both build upon and question them. In her essay Mulvey initially draws on ideas from psychoanalysis to identify two pleasures of looking: scopophilia and narcissistic identification (2009: 16–19). Scopophilia is pleasure gained from looking and is a common desire among, in Freud's words, 'most normal people'; however, at its extreme, he argued, scopophilia can become voyeurism, where the viewer remains unseen and seeks to control what they see (Freud 1991e: 300). Narcissistic identification is an opposing pleasure, although still based on looking. The psychoanalyst Jacques Lacan developed ideas from Freud to formulate his concept of the 'mirror phase' (sometimes referred to as the 'mirror stage'). Lacan argues that initially a child cannot separate itself from other bodies, such as that of its mother, or even from objects, regarding its body as fragmented and out of control. A separation occurs when, sometime between the ages of 6 and 18 months, a child sees its reflection in a mirror and realises for the first time that it is looking at its own face and body (Lacan 2003). Not only this, but the child it sees reflected is a more perfect version of its as yet uncoordinated self: it is like itself but better. The wholeness and pleasure that was symbolised by the attachment to the mother is now represented by the wholeness and pleasure of the ideal body image. Before, the child's body and its identity were amorphous and fluid; afterwards, they are fixed. 'This is who I am,' the child recognises, in an instant that determines its identity.

Importantly, this recognition is also a misrecognition (Mulvey 2009: 18). What the child sees is not itself, but an image: an idealised 'self' that it identifies with and tries to live up to, while those who it does not identify with are defined as different and 'Other' (I expand on the ideas of

'self' and 'Other' in Chapters 4 and 6). According to Lacan, this process of identification continues unconsciously in adult life.

Mulvey uses the two visual pleasures of scopophilia and identification in her analysis of the content of mainstream, narrative cinema. Her purpose in doing so is to demonstrate that such films reflect and reinforce culturally and historically specific roles. She focuses on gender, arguing that narrative cinema represents a sexual divide in looking that is split into active/male and passive/female. According to Mulvey's essay, women in such films are coded as passive exhibitionists, objects 'to-be-looked-at', while it is the male characters that actively and powerfully drive the narrative forward and that viewers are invited to identify with (2009: 19).

However, from the perspective of psychoanalysis, the women displayed to the male viewer are shaped by unconscious anxieties and desires: they are simultaneously pleasurable and threatening due to their lingering reminder of castration anxiety. Mulvey notes that in Freud's writings the male unconscious has two avenues of escape from this anxiety: 'the complete disavowal of castration by the substitution of a fetish object, or turning the represented figure into a fetish so that it becomes reassuring rather than dangerous' (2009: 22). Both of these avenues appear to recur regularly in the films Mulvey examines, which include *RearWindow* (1954) and *Vertigo* (1958), both directed by Alfred Hitchcock.

It is important to note that Mulvey highlights the apparatus of visual pleasure in narrative cinema and the power relations of gendered looking not to support them, but from a feminist perspective in order to suggest that both mainstream cinema and sexual inequality should be changed and 'a new language of desire' created (2009: 16).

In 'Looking at Photographs', written just a few years after Mulvey's essay and reprinted in the book *Thinking Photography* (see Chapter 2), Victor Burgin adapted many of her ideas to the analysis of photographs (Burgin 1982d). He lists and adapts to photography the three 'looks' that Mulvey says exist in cinema. These are:

- The look of the camera as it records the 'pro-photographic' event ('pro-filmic' in Mulvey's essay)
- The look of the viewer as they look at the resulting photograph
- The looks of the people in the photograph, either at other people or objects.

To these Burgin adds a fourth look:

- The look the people in the photograph may direct to the camera (and therefore to the viewer).

This final 'look' does not appear in Mulvey's essay as it is rarely found in mainstream narrative cinema (one exception being where the narrative is broken and the audience is addressed by one of the characters). However, the look to the camera is very common in photography; indeed, it is standard practice for portraiture and snapshots (see Chapters 5 and 6). For still photographs we often hold poses – 'freezing' for the camera, usually in mimicry of poses seen in other pictures (see Barthes 2000: 10; Holschbach 2008: 174; Owens 1992a).

In 'Looking at Photographs', Burgin applies ideas from psychoanalysis to his semiotic interpretation of a photograph, treating it as a 'photo-work', as though it were a dream to be examined in order to discover repressed anxieties and desires (see also Burgin 1982a). Burgin discusses the four looks in relation to a staged photojournalistic image made by James Jarché in North Africa during 1941. The photograph shows the English General Archibald Wavell watching what the caption identifies as 'his gardener' at work. As the viewer of this picture, we are sharing the look of Jarché's camera as it recorded the scene many years ago. The two people in the photograph, the white General Wavell and the unnamed black gardener, do not look at each other. Instead, Burgin argues, our look connects with that of Wavell, who assumes a pose that Burgin interprets as resembling that which we might adopt if gazing at our reflection in a full-length mirror (1982d: 148).

The four looks relating to the Jarché photograph could therefore be summarised as:

- The look of the camera recording the General and his gardener in 1941
- The look of the viewer at the photograph (in 1941, 1982, 2010, etc.)
- The gardener looking down
- The General looking at the camera/viewer.

In Burgin's account, anyone looking at the photograph is invited to identify with Wavell as a surrogate self (as if in the identity-defining moment of Lacan's mirror phase), despite their own cultural background. While the black gardener, as passive Other, is about to cut across the picture, threatening our identification – a point underlined by Burgin through his psychoanalytic interpretation of the lawnmower that the gardener pushes as a 'scythe', symbolic of imminent castration. It could be contended that Burgin's interpretation reveals his own unconscious, the meanings he is projecting into the image. (For an alternative inter-pretation of the same image from a historical approach, see Ian Jeffrey's review of *Thinking Photography* (Jeffrey 1999a).)

Burgin sees Jarché's picture as just one example of how photographs supply an ideological point-of-view to their audience through the viewpoint of the camera and the looks within the image. Photographs are seductive, he argues, they make us 'an offer you can't refuse'. Drawing upon the cinematic theory of 'suture' (which demonstrates how cinema viewers become immersed in a film), he suggests that viewers of photographs usually fail to acknowledge the camera and instead, in an echo of Lacan's mirror phase, misrecognise the camera's point-of-view as being their own; with the 'good composition' of the photograph maintaining the viewer's gaze within the frame as if the content of the photograph is their own field of vision (1982d: 150). Thus, to Burgin, 'It is the position of point-of-view, occupied in fact by the camera that is bestowed upon the spectator' (1982d: 146; see also Solomon-Godeau 1991b: 180–181).

Building on ideas from Barthes and Mulvey, Burgin argues that along with this visual point-of-view comes an ideological viewpoint on the world that is made to appear completely natural to the viewer. Photographic images provide the viewer with a particular ideology at the same moment that they communicate their contents to us. We might think we are just looking at photographs, Burgin argues, but they are shaping our selves too (see Chapter 4 for this idea in relation to advertising photography).

VIEWERS OF PHOTOGRAPHS: OTHER LOOKS

Mulvey's ideas in 'Visual Pleasure and Narrative Cinema' – and by extension their transferral to photography in Burgin's 'Looking at Photographs' – have been widely criticised (see Rose 2007: 122–136). These criticisms tend to focus on the argument that the cultural background of the viewer is in fact very relevant to their response to the image. Mulvey seems to assume a male, heterosexual viewer, leaving open the question of how viewers of different genders or sexualities relate to the same imagery (for essays that address these aspects of spectatorship, including Mulvey's own afterthoughts on her essay, see Bright 1998; Mulvey 2009b; Stacey 1999; see also Blessing 1997). The focus on gender and sexuality that comes from Freudian psychoanalysis also fails to acknowledge other factors that shape viewers' identification with images, such as race (see for example Mercer 1999). In this section some alternatives to the ideas about looking in 'Visual Pleasure and Narrative Cinema' and 'Looking at Photographs' will be debated.

Burgin himself complicated the model of the male/active and female/passive gaze in 'Perverse Space', an essay published in the early 1990s

about a photograph by fashion and portrait photographer Helmut Newton called *Self Portrait with Wife June and Models, Vogue Studio, Paris, 1981* (see Figure 3.3) (Burgin 1991b; see also Burgin 1991c for an earlier version of the essay). He uses his reading of the photograph to suggest that the crucial and complex ideas Mulvey discussed in 1975 in relation to film had become oversimplified when applied to the analysis of 'the male gaze' as active and the female body as passive in the static photograph (see also Rose 2007: 121–122).

Unusually, Newton – known for his depictions of semi-naked women wearing high-heeled shoes as objects of the fetishising look (see also Chapter 9) – appears in the photograph that Burgin analyses. Newton has moved across the studio to stand on a backdrop to take a picture and is reflected in the studio mirror that would normally be used by the models to see how they looked for the camera. One of the models Newton was

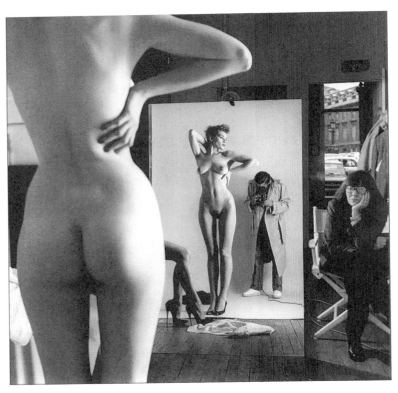

Figure 3.3 Helmut Newton *Self Portrait with Wife June and Models, Vogue Studio, Paris* (1981) © Helmut Newton Estate / Maconochie Photography.

photographing stands between him and the mirror. She adopts what Burgin refers to as a 'pin-up' pose, one arm lifted above her head to raise her breasts (in mimicry of millions of other poses held before it). As with all Newton's nudes, her heels remain on. The fragmented legs and (inevitably) high-heeled feet of another model, this time seated, enter the picture from the left. To Burgin, Newton – exposed to the viewer, while clad in a long coat and taking a photograph – is simultaneously revealed as both exhibitionist and voyeur: 'a flasher making an exposure' (Burgin 1991b: 128). This, Burgin argues, fits with Freud's belief that every active perversion is accompanied by its passive counterpart (see Freud 1991f: 303).

There is something else irregular about this photograph in relation to Newton's usual work. As the title anchors for us, his wife June is seated on the right side of the picture, beyond the studio backdrop and watching the scene: an actively looking, clothed woman in a Newton image. The space and codes of the fashion photograph have become perverse as the photographer occupies the place of the model and is revealed both to the gaze of the viewer and to his own wife. Burgin's interpretation of the photograph begins to break down the idea of the active/male, passive/ female divide, suggesting that more complicated forms of spectatorship are possible.

In *Visual Methodologies*, Rose points out the importance of the ways in which viewers make meaning of photographs. She takes the example of a 1948 picture by Robert Doisneau taken looking through a shop window onto the street. Outside, a woman discusses a painting that is in the window (and which we only see the back of) with a man who is surreptitiously looking away at a different painting in the window depicting a naked woman. In the 1980s, Mary Ann Doane and Griselda Pollock used this image to argue that it visualised sexual inequality in looking: what the man wants is clearly shown, while what the woman desires goes unseen. The sexual imbalance is weighted against the woman (Doane 1982: 84–87; Pollock 1988; Rose 2007: 14–27). Yet Rose found that showing the picture to students in the 1980s and 1990s resulted in a much wider range of readings influenced by cultural changes: from broad agreement with Doane and Pollock's feminist interpretation in the 1980s to debates during the 1990s about what the woman was looking at. In the early to mid-1990s – as the male body became more prominent in advertising and, as Rose puts it, 'girl power' led to young women saying 'what they want, what they really, really want' – the subject of the painting that the woman in the photograph could be looking at was often interpreted by the students as 'a gorgeous semi-naked man'. While in the late 1990s, the result of what Rose refers to as a culture of 'lesbian chic' influenced

students to suggest that the image could show 'a gorgeous woman' (Rose 2007: 24–25). As this example indicates, the positioning of the spectator of a photograph is not as fixed by composition and content as Burgin's 'Looking at Photographs' might argue.

A good example of a further attempt to change photographic power relations in terms of the gendered gaze is *What She Wants*, the 1994 touring exhibition and book assembled by Naomi Salaman (Salaman 1994b) (its title based on Freud's admission that he was unsure what women desired (Smyth 1994: 51)). The book and show brought together a range of then-recent photographs made by women of men, generally revealing the men naked and objectified before the lens, their faces often hidden so that they could not 'look back'. *What She Wants* represented important work in redressing the gender balance in terms of who was looking and who was (in Mulvey's phrase) 'to-be-looked-at'. Also wary of how 'the male gaze' had sometimes been reduced by many of those who made use of Mulvey's essay to a simplified and inflexible idea, Salaman organised *What She Wants* not as an attempt to define a singular female gaze, but to present a number of possible female gazes (Salaman 1993: 59).

However, these experimental reversals of who was in front of and behind the camera represented only one step towards a visual conception of the 'new language of desire' that Mulvey called for in the 1970s. The power relations of actively looking and being passively looked at almost always remained present in the images, regardless of the gender of who was on either side of the camera's lens. Solomon-Godeau has argued against the idea that women will inevitably 'in some fashion reflect or inscribe their gender in the photographs they take' (Solomon-Godeau 1991c: 257). Instead, the masculinisation of the photographer and feminisation of the photographed continues. Grace Lau has discussed how she has felt this exchange of roles take place not just while photographing men, but also while experiencing the perverse power of control over their images as she cropped and manipulated them in the darkroom (Lau 1993: 46).

Images by the artist Jemima Stehli have taken further the ideas suggested by such projects as *What She Wants*. In *Self Portrait with Karen* (2000), Stehli recreates Newton's picture made in the *Vogue* studio – this time in her own studio, with Stehli as the reflected photographer photographing a female model (see Figure 3.4). In this image Stehli herself condenses the look of both Newton and June (see Slyce 2002). In other recreations of Newton images Stehli places herself before the camera naked except for Newtonesque high-heels, the cable release in her hand seeming to connote that she is both the subject and the object of the gaze (see Santacatterina 2002).

Figure 3.4 Jemima Stehli *Self Portrait with Karen* (2000) © Jemima Stehli.

Men looking at women also play a key part in Stehli's work. For her performative series *Strip* (1999 / 2000) Stehli invited male curators and art critics, including Matthew Collings and Adrian Searle, to sit on a chair placed on the studio backdrop while holding the cable release. Stehli then stood before the men and started to take her clothes off. The men could choose when to release the shutter as Stehli gradually exposed more of her body to them and the camera until she was naked (apart, of course, from her heels). One interpretation of the photographs, presented as a 'strip' of images when shown on gallery walls, is that Stehli has set up the situation so that it is the men themselves that are central to the images – often grinning and nervous – as they look at her body. In a reversal of the apparatus of the gaze itself, the scopophilic look of the men is revealed in her images.

CAMERA LUCIDA: *STUDIUM* AND *PUNCTUM*

In the final section of this chapter, I will examine an example of a highly personal interpretation of photographs. During the late 1970s Barthes

began writing his book *Camera Lucida* (Barthes 2000), which centres on his attempt to find a single photograph of his recently deceased mother that sums her up to him: 'just an image', Barthes says, but also 'a just image' – one that does her justice (Barthes 2000: 70; see also Chapter 2).

During the process of his search, Barthes looks at many photographs and discusses what he calls their '*studium*'. As David Bate has noted, this term is rather briefly defined in the book (Bate 2007: 254), but the *studium* can be taken broadly to refer to the general experience that a viewer will derive from a photograph. For example, in most viewers a photograph of a starving child in a war zone will arouse feelings of pity, thoughts of injustice, and a desire to help (as such the *studium* reiterates the semiotic idea of communication via a shared language).

Yet the book also represents an important move away from semiological analysis to a more personal interpretation of photographs. It is clearly what Barthes calls the '*punctum*' that really interests him, and it is this idea that runs through his analysis of the photographs he considers. According to Barthes, a *punctum* is what 'pricks' or 'punctures' the viewer of a photograph: it is an aspect of the image that affects them in a particular and personal way (and is unlikely to have even been considered significant by the photographer). As Welch and Long characterise it, the *studium* is 'what everyone sees', while a *punctum* is 'what only I can feel' (Welch and Long 2009: 13).

The *studium* of a studio portrait of a smartly dressed family taken by James van der Zee in Harlem during the 1920s could be widely interpreted as what Barthes calls 'respectability, family life, conformism, Sunday best' and, with some further cultural knowledge, a representation of a black American family displaying a desire for social advancement at a time before the civil rights movement (Barthes 2000: 43). But, to Barthes, what really gets to him about the photograph is the necklace worn by one of the women. After thinking about the picture for a while he remembers that it reminds him of a similar necklace worn by a member of his own family who lived alone, and which was shut away in a box after she died (2000: 53). Time and mortality are often central to the *punctum* (see Chapter 2).

Although Barthes finally finds a photograph of his mother that sums her up to him, he does not reproduce the image in his book. The picture, we are told, shows Barthes' mother as a child, photographed in a conservatory (the *camera lucida* – Latin for 'light chamber' – that may provide the book with its title, see Iverson 1994: 451; for an alternative possibility see Batchen 2008a: 78–84). This photograph, with the *punctum* of a 'just' image of his mother, is personal to Barthes; it would not have the same meaning to the book's readers (Barthes 2000: 73). Instead, Batchen has

argued, the excluding of the image ingeniously allows each reader to project an image that has personal meaning to them in its place (Batchen 2008b: 136–137). Controversially perhaps, Welch and Long contend that it is not a political approach to photography, but the more personal approach adopted by Barthes in *Camera Lucida* that 'has gained the most critical currency' in photography theory 'as it has taken shape since the 1980s' (Welch and Long 2009: 14–15).

This chapter has set out to make accessible – and debate – the key concepts that have been used in 'photography theory' to interpret the meanings of photographs: the sign; denotation and connotation; the fixing of meanings by words, context, and discourse; psychoanalysis; the gaze; the role of the viewer; and the ideas of the *studium* and *punctum*. As noted in the last chapter, the mass digital reproduction of images in the 21st century has extended far beyond anything Walter Benjamin could have imagined when he wrote 'A Short History of Photography' in the 1930s. We now see more photographic images in quick succession than at any other time. More than ever the need to use such concepts to be photo-literate is essential if we wish to understand the meanings of photographs.

PHOTOGRAPHY FOR SALE

Isn't it simple, isn't it quick?
Such a small box, it must be a trick
How do you work it, what is the test?
You press the button, we do the rest
 W Fulton and W S Mullaly, 'You Press The Button, We Do The Rest' (1891)

Photography is primarily a commercial medium. Photographic imagery is used to sell things to us; and, photographs, as well as the apparatus of photography, are on sale as commodities. It is impossible to calculate the amount of photographs in existence, whether in the form of negatives, printed images or digital files. Nevertheless, the vast majority of photographs in the world are either snapshots (see Chapter 5) or are made and used for the purposes of advertising. Despite its ubiquity, advertising photography has been analysed critically far less than photographs made, for example, as documents or as art (see Chapters 6 and 7) (Frosh 2003: 9–11; Slater 1997b: 172). Anandi Ramamurthy has suggested that this is because advertising photographs are not seen as creative in their own right, but rather as parasitic on groundbreaking work in documentary and art photography (Ramamurthy 2009: 217); yet it is worth noting that art photographs and images that document are saleable commodities as well (Badger 2007: 203–220). Writers such as Don Slater have also argued for the importance of going beyond analysing the meanings of photographs in order to consider how photography itself is marketed to consumers, in both the physical form of cameras and film and, more recently, in a virtual form (Slater 1999).

This chapter is divided into two halves, with three sections in each half. The first half analyses advertising photography. This begins with a section debating the ways advertising photographs invite viewers to identify with what they depict – and how such images promote a myth of individuality, while simultaneously selling the same product to as many consumers as possible. How ideas of nature and the environment are communicated in photographs that sell products and that appear on product packaging are also analysed in this section. In the second section the disappearance of the product itself from advertising images is traced through the increasing use of stock photographs that sell 'atmospheres' and feelings rather than physical objects. The third section of the first half of the chapter analyses attempts to subvert photographic advertising via the creation and distribution of oppositional images. The second half of the chapter examines the selling of photographs and the selling of photography as a medium for mass consumption: first, in terms of the selling of photographs via portrait studios, art galleries, auction rooms and the press; second, through the business of mass-marketing the physical apparatus of photographic equipment; and third, by the selling of photography in its digital form.

PHOTOGRAPHY FOR SELLING: ADVERTISING AND IDENTIFICATION

'You Press The Button, We Do The Rest' appeared as the first advertising slogan for Kodak in 1888. It is an excellent, early example of an advertisement connecting the consumer (*You* Press The Button) with the company (*We* Do The Rest). The consumer is directly addressed and told how simple they are going to find the product is to use, while the company will handle, in Nancy Martha West's phrase, 'all the mess and mystery of the darkroom' (West 2000: 8). The image that accompanied the slogan – a drawing in this instance – shows a hand holding a simple box camera, the thumb pressing down on the button that will open and close the shutter (see Figure 4.1). However, the drawing also suggests a hand outstretched ready to be shaken as a greeting, a sign connoting friendship or perhaps the sealing of a deal, further linking the consumer to the company's product. Later in this chapter (and in Chapter 5) I will return to Kodak in more detail. For now it is important to understand that this approach to selling at the end of the 19th century helped to establish a form of advertising imagery that directly addressed the potential customer.

Chapter 3 included an examination of the relationship that photographs have with their viewers; the point-of-view of the camera's lens often blending apparently seamlessly with the viewers' own gazes as they look at an image. This makes photography an ideal tool for selling. In her

Figure 4.1
Kodak advertisement (1888).

highly influential 1978 study, *Decoding Advertisements*, Judith Williamson argues that viewers are invited to identify with the scenes depicted in the advertising imagery that is an inescapable element of contemporary life (Williamson 2002). In her book, Williamson combines semiology and the variant of psychoanalytic studies current in the 1970s in order to examine what she describes as 'advertising-work' (see Chapter 3 for more on semiotics and psychoanalysis). The term 'advertising-work' is based on Freud's 'dream-work', which he uses to describe the transformations that real life undergoes in dreams as the dreamer's unconscious makes associations between events, objects, places and people (see Chapter 3). Williamson argues that photographic advertisements are often created to suggest similar associations between visual signs (such as a sexualised image of a woman being linked with the product on offer) (Williamson 2002: 20–39). These associations are anchored by, or work in relay with, verbal signs; a point demonstrated by Victor Burgin, too (Burgin 1986a).

Williamson also draws on Jacques Lacan's concept of the 'mirror phase'. As we saw in Chapter 3, Lacan had claimed in the 1930s that every young child begins to recognise what it sees as its ideal 'self' through identifying with images, and that a similar identification continues throughout adult life (Lacan 2003). Like the image identified with in the mirror phase, the ideal people depicted in photographic advertisements represent a wholeness that the child has desired to reclaim since it stopped believing it was physically attached to its mother (Williamson 2002: 40–70). The rhetoric of the photographic image is powerful enough to convince us, in the instant that we glimpse the advertisement, that what we are seeing is real and to disavow the knowledge that we are looking at models in a highly constructed scene (and therefore disavow that the dream we see is unattainable).

Advertising images generally offer a chance to 'belong' with the people depicted, who tend to be shown inhabiting an idyllic place and time (occasionally set in a mythical past, but more often in the immediate future) that can be accessed by the consumer if they possess the product (Williamson 2002: 152–179). In an example that I will return to over the next few sections, a 2008 advertising campaign for Waitrose supermarkets used a photograph showing a group of people (of various ages and from a range of cultural backgrounds) strolling enthusiastically towards the camera/viewer through a grassy field on a sunny day, some of them carrying wicker baskets and picnic hampers (see Figure 4.2). The phrase 'Everyone deserves quality food. Everyone deserves Waitrose' that appears within the image works in relay with the photograph to convey the message that the consumer (as part of 'everyone') belongs with the people in this desirable scene and deserves the products made by the company (Waitrose).

It is vital that the people in the advertising image are shown to be different and individual. Although the idea of the campaign is to encourage as many consumers as possible to shop at the same supermarket, like a lot of advertisements it uses the myth of individuality to do this. A connection can be made here with arguments formulated by the German critics Theodor Adorno and Max Horkheimer in the 1940s. Adorno and Horkheimer criticised Western popular culture for being homogenised, contending that most products (such as pop songs) were essentially the same, but that in order to be sold they were marketed as if they were unique (Adorno and Horkheimer 1999). This creates the illusion of choice: by choosing to shop at Waitrose, for example, rather than another supermarket, an individual decision is apparently being made. Adorno and Horkheimer called this idea 'pseudo-individuality'. The same myth is propagated within much contemporary advertising where consumers are shown as individuals, all using the product differently, to connote the idea that each consumer of the product will be unique (Sturken and Cartwright 2001: 205).

At the same time as selling a product, Williamson maintains, advertising images offer the viewer identification with a particular set of shared beliefs (in crude Marxist terms, an ideology; see Chapter 3), such as the belief that consuming products will improve our lives or, in more recent advertising, that buying a product will make us 'ecologically sound' (see below and Myers 1999). Williamson argues that advertising images 'suggest we recreate ourselves in accordance with an ideology based on property' (2002: 179). Louis Althusser coined the term 'interpellation' to describe the process by which viewers are led towards certain ideological beliefs through imagery (Althusser 2003). This is particularly explicit

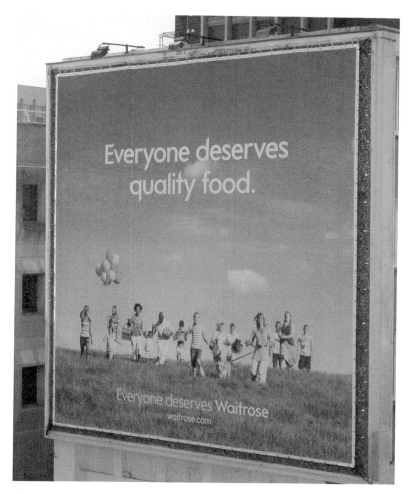

Figure 4.2 Waitrose advertisement, Brighton (2007). Photograph of advertisement taken by Terence Dudley.

when, as discussed above, the text in advertisements uses the word 'you' to appear to personally address the viewer. In this context, the use of words such as 'you' and 'we' connote the idea of a direct relationship between the consumer and the producer.

Simultaneously, advertisements conceal the actual labour involved in the production of what is being sold. Karl Marx referred to this as 'commodity fetishism' (Marx 1990: 163–177). Essentially, this is where the reality of a product – its physical production and its actual use – is

replaced by a fantasy where the product exists as a sign to be bought and sold. The product is given new meanings that idealise it and conceal its origins (much like Freud's concept of the fetish object as something that stands in for something else; see Chapter 3) and the product gains an 'exchange value' that is disconnected from its actual use. Williamson's book was written during the 1970s when advertising was more blatant in its selling of luxury and concealment of production. As Marita Sturken and Lisa Cartwright have pointed out, the text (or 'copy') in 21st-century advertising often adopts a more informal tone as though it were having a chat with the consumer. This sometimes involves apparently revealing the process by which the product is made in a way that might be seen to contradict the idea of commodity fetishism (Sturken and Cartwright 2001: 204).

Such a technique can now extend to the photographs used in the packaging of products themselves. For example, the cardboard sleeve surrounding a cheese and onion pasty 'handmade' by a British manufacturer in the early 21st century includes a black and white photograph of a young woman pictured while apparently in conversation with someone off-camera (in the manner of a television news interview). An arrow drawn onto the photograph points to the woman and, at the other end of the arrow, text in a font that connotes handwriting tells us 'This is Jessica who grates our cheese!' On the reverse of the packaging the photograph of 'Jessica' is reproduced on a smaller scale and further text provides more information, including telling us 'what a "grate" job' Jessica does. This casual, punning approach is intended to humanise and individualise the process by which the pasty is made, connoting that it has been created by hand with individual care rather than mass-produced in a factory. The apparent revealing of the means of production seems to contradict Marx's idea that production remains hidden. However, such photographs still sell an idealised myth about the production of the food. Like much contemporary packaging and advertising, this is a myth used to promote the idea that the product has been created 'naturally'.

The grass field and the blue sky in the Waitrose advertisement discussed above are essential. Contemporary advertising almost invariably uses imagery that suggests the commodities being sold are connected to nature. This is not new: many of the photographic advertisements that Williamson analyses in the 1970s use the idea of nature as a symbol, and a key aspect of Roland Barthes' analysis of the pasta products advertisement in the essay 'Rhetoric of the Image' centres around how the natural connotations of the vegetables in the string bag are conferred on the manufactured products in their plastic packaging and tins (Barthes 1977b: 35; see also Chapter 3). Again, this is not just true of advertising, but of

product packaging too. Playing upon the perceived indexicality of photographs (see Chapter 2), a carton of supermarket orange juice features a photograph of an orange cut in half on two of its sides. As the pourer holds the carton it is almost as if they are squeezing the juice out of the orange represented on the packaging for the first time, despite the fact that the juice has been transported as concentrate.

Williamson argues that 'nature' becomes more important in societies when it is seen as increasingly distant from human culture, resulting in advertising imagery that sells products as a way of getting 'back to nature' (2002: 122–137). What has changed since the 1970s is not simply a greater use of nature as a symbol; the additional ideas of 'the environment' as something to be protected and the purchase of products as a way of contributing to this have also been increasingly sold to consumers (Myers 1990). Since the late 1980s the natural environment has gone beyond being seen as something to get back to, and become something in peril that must be saved. The representation of nature in advertising photographs therefore performs a strongly ideological function, reinforcing the notion that we should all live in a 'natural' way to achieve this preservation of nature. That this message about nature is connoted through advertisements seems ironic when it is remembered just how culturally constructed and 'unnatural' the photographs are that sell the idea to us.

FROM SELLING PRODUCTS TO CREATING ATMOSPHERES: ADVERTISING PHOTOGRAPHY AND IMAGE BANKS

No food products are visible in the Waitrose advertisement. The picnic baskets and hampers carried by the people in the image are the closest that the photograph comes to showing the produce sold by the supermarket. Instead, an overall feeling is created of heading into the countryside for a summer picnic. This is in stark contrast to the way that advertising photography worked in the 1920s, the decade when photography replaced drawings as the primary means of depicting products for sale. By the end of the 1920s almost 80 per cent of newspaper and magazine advertising employed photographs (Johnston 1997: 1). Patricia Johnston has traced the development of advertising photography from the first plain and frontal images that simply showed what the product looked like, to the dynamic angles pioneered by modernist photographers such as Edward Steichen, and then to the more sophisticated techniques that came to be applied later (1997: 7–131; see also Chapter 7).

At first, advertising images that only pictured the product were accompanied by lengthy text that was required to explain what the

product was and how it worked. Johnston refers to this as the 'reason why' approach: the photograph in the advertisement shows the product and the text tells the potential customer what it does and why they should buy it. By the 1930s and 1940s, advertisers began to commission photographs of the products in use, requiring less verbal information (1997: 60–66). These images evoke what Johnston calls 'atmospheres' around the products. Influenced by psychoanalysis, advertisers created images that stimulated in viewers the desire to share the experience represented; or provoked anxiety about a problem to which the product offered the solution (1997: 97; see also Chapter 3). As Christina Kotchemidova puts it, 'portraying consumer happiness became the paramount directive of advertising' (Kotchemidova 2005: 5). Because of the indexicality of the photograph, these images suggested what Johnston refers to as 'real fantasies' (1997: 72–104).

Advertising photography now tends to focus on creating such atmospheres, often with little or no explicit reference to the items being sold. The Waitrose advertisement, for instance, only directly refers to 'food' in the text, which works in relay with the image of the people, drawing attention to their baskets and hampers to suggest a picnic (rather than highlighting other elements within the image, such as the clothes the people wear). This advertisement is intended to create an 'atmosphere' or 'feeling' associated with the brand, rather than to sell any specific product. Similarly, the photographs used in a series of 2008 advertisements for a bank simply showed images, including two elderly women laughing hysterically, a boy popping a wheelie on his bike, and a young girl wearing wellington boots jumping up and down in a muddy puddle, each accompanied by the caption 'This is what saving feels like' – evoking an atmosphere of joy in connection with the brand. There is no evidence of money or of a bank in any of these pictures, which like so many advertisements attempt to establish a 'feel good' atmosphere around the brand.

While many advertisements involve specially commissioned photographs, a great deal of photographic imagery selling products through atmospheres uses pictures already in existence. According to Paul Frosh, around 70 per cent of the photographs that are put to use as part of everyday advertising – including images encountered in magazines, on packaging, or on the walls of fast-food restaurants and convenience stores – are stock photographs (Frosh 2003: 2). These images are so familiar that they usually remain overlooked and are engaged with almost unconsciously. To Frosh this gives the images a powerful ideological advantage, allowing the ideas they promote to be accepted without question.

The kinds of photographs found in image banks are usually timeless and generic to the point of cliché, showing subjects clearly and simply. Frosh

argues that this deliberately provides the images with a 'profitable polysemy': they retain an ambiguity about their meanings – enabling the same photograph, denoting the same thing, to be used again and again in a vast range of contexts, with differing connotations (2003: 17; see also Chapter 3). These stock images are owned by just a few companies, including Corbis and Getty Images, who also possess the rights to many famous photographs (see below).

David Machin points out that the databases of these companies' websites can be searched using keywords, including such abstract terms as 'freedom' (Machin 2004; see also Ramamurthy 2009: 213–216). However, Machin notes, in 2004 the kinds of images that such terms called up tended to be idealised and overwhelmingly positive. 'Freedom', for example, a key concept in philosophical thought and a basic right that continues to be fought for, generated many images when entered into the Getty database. However, almost all of these photographs showed people in open spaces running and jumping (in a similar style to the Waitrose photograph) (2004: 331–334). Machin argues that feelings and moods have replaced any historically or culturally specific images and that the vast majority of commercial photographic imagery that surrounds us is non-specific and idealised. This abstracted, harmonised view of the world resembles the marketing categories of image banks and has no explicit indication of politics, social issues or conflict.

In complete contrast to the replacement of products by abstract atmospheres, the photographs appearing on eBay of items for sale focus entirely on the products themselves. Roger Hargreaves has noted the central role that photographs occupy on the website, arguing that 'the shop window for eBay is essentially photographic' (Hargreaves 2004: 67). These pixelated images can be seen as a raw, basic form of photography, using the indexical power of the medium at its most fundamental to simply point things out to the viewer (Berger 1980; see also Chapter 2). The eBay images also represent a return to the pure product approach of early advertising photography.

PHOTOGRAPHY AGAINST SELLING: SUBVERTISING AND STENCILS

In 1978 Williamson described how advertisements were a ubiquitous and inevitable part of everyone's lives: 'even if you do not read a newspaper or watch television, the images posted over our urban surroundings are inescapable' (2002: 11). In the 21st century, those that do not read newspapers or watch television will not only encounter even more advertisements in the urban environment (not just posted, but also on

digital screens with constantly changing images), but are also likely to experience a constant flow of advertising images online via banner ads and pop-ups connected to search engines, social networking and websites. In the 1960s French Situationist theorist Guy Debord argued that contemporary society was dominated by spectacular images of entertainment and capitalist products that distracted people from the real world, transforming them into numbed consumers (Debord 2003; see also Chapter 6). As Ramamurthy notes, these ideas have since been elaborated upon by postmodern writers such as Jean Baudrillard and Umberto Eco, who both argued that images have come to replace any experience with the real world whatsoever (2009: 208; see also Chapter 2). As with image banks, in advertising photographs any sign of conflict is hidden. This can be interpreted from a Marxist-orientated point-of-view as promoting a 'false consciousness' where images are passively consumed, identities learned and confirmed – and the ideology of capitalist consumption perpetuated.

However, Stuart Hall has argued that images are not always consumed so passively. Instead, in an essay analysing television (that has since been widely applied to other media), he identifies three ways by which the meanings encoded in images by their producers are decoded differently by the audience (Hall 1999). The first of these is the *dominant* or *preferred* reading, where the viewer passively receives the intended meanings of the image in their entirety. The second, and arguably most common reading, is *negotiated* – where the viewer accepts some of the intended meanings, but questions others and adapts them to their own experience. The third reading is *oppositional*, where the viewer entirely rejects the intended meanings of the image, seeing them as disconnected from their understanding of the world (1999: 513–517).

Sturken and Cartwright argue that increased access to the media (especially via the web) has resulted in oppositional readings having much greater potential to become oppositional practices, where images are taken from advertising and subversively reinterpreted (2001: 58–67). Debord referred to this technique as 'detournement' (2003: 704–705; see also Chapter 7), although in relation to the subversion of advertising images it is now commonly known as 'subvertising'. Some of the most well-known examples of subvertising have been made by the group Adbusters, who produced a series of parodies of famous advertisements on their website. These parodies oppose the intended meanings of the original advertisements and replace them with images and texts that aim to reveal what their makers see as the reality of the lifestyle that is being sold along with the product.

For example, two spoof Calvin Klein advertisements play on the scent *Obsession* and its slogan to comment on the desires and anxieties associated

with gender. The words 'Obsession for Women' appear with a black and white photograph of a woman holding her stomach as she bends over a toilet bowl, connoting the eating disorders that may be encouraged by the promotion of the female body size that appears in much advertising. The same moodily lit black and white style – based on the campaigns for Calvin Klein by photographers such as Bruce Weber and Herb Ritts (see Chapter 9) – is used in Adbusters' 'Obsession for Men' parody. This depicts a muscular man peering down into his Calvin Klein boxer shorts, suggesting the root of much male anxiety and desire.

Bypassing the mass media altogether, some oppositional readings have been articulated on the streets themselves. Practitioners such as Banksy use the indexicality of the photographic image in their illegal photography-based stencil graffiti, justifying their actions as opposition to the bombardment of advertising:

> The people who truly deface our neighbourhoods are the companies that scrawl giant slogans across buildings and buses trying to make us feel inadequate unless we buy their stuff. They expect to be able to shout their message in your face from every available surface but you're never allowed to shout back. Well, they started the fight and the wall is the weapon of choice to hit them back.

> (Banksy 2006: 8)

In another instance, a billboard apparently left temporarily blank between advertisements was filmed as Banksy wrote on it a simple phrase: 'The joy of not being sold anything' (see Figure 4.3). However, Banksy's

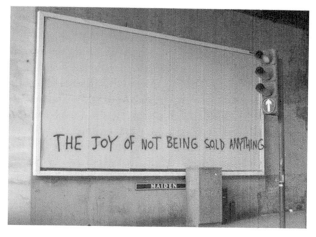

Figure 4.3
Graffiti by
Banksy,
London (2008).

own work has become a commodity itself and is often either prised off walls and sold as art or exhibited by Banksy himself in galleries in the form of prints, fetching increasingly high prices. Photographs do not just sell commodities – they are commodities. The second half of this chapter focuses on the commodification of photographs themselves.

SELLING PHOTOGRAPHS: MARKETING THE MEDIA

West has argued that snapshot photographs represent the ultimate commodity: possessing the 'aura' of the unique while also being infinitely reproducible (West 2000: 5–8). But in the first decade of photography's existence it was daguerreotypes, the one-off images pioneered by Nicéphore Niépce and Louis Daguerre (see Chapter 2), that were commercially successful. Made on polished metal plates and placed in velvet-lined cases of leather, metal, glass or wood, the images held the public's fascination with their ability to record people in tiny detail (see Trachtenberg 1992). As a result, daguerreotype studios and travelling daguerreotype photographers with mobile studios become some of the first entrepreneurs to make money from selling photographs (at least one of them advertising his profession as 'daguerreotyping on wheels'). As Geoffrey Batchen has noted, many portraits were made into affordable photo-jewellery such as lockets and rings, purchased and worn by middle-class customers (Batchen 2004: 32–35).

By the 1850s portrait studios were flourishing, particularly in France, America and Japan, while the patent for making daguerreotypes in Britain was bought from Daguerre and controlled by the photographer Richard Beard, who has been hailed by Patricia Holland as 'photography's first millionaire' (Holland 2009: 130–131; see also Rosenblum 1997: 38–83; Tagg 1988a). These studios allowed people the chance to appear in and own photographs without the need to possess their own photographic equipment; although the images made were very contrived, using props and backgrounds, and were stiffly posed due to the long exposures required. Portrait photographs became much cheaper during the 1850s and 1860s with the invention of *carte de visite* photography by the portrait studio entrepreneur Adolph-Eugéne Disderi. This technique involved a camera with multiple lenses and a revolving plate holder that enabled six or eight images to be made on a single glass plate. The speed of the *carte de visite* process and amount of images produced (originally intended to be pasted on the reverse of visiting cards) meant the price of having portraits made dropped dramatically. Portrait studios also began to sell photographs of famous people that had sat for portraits – with images of members of the royal family becoming particularly popular in Britain (see Chapter 9).

Batchen sees the *carte de visite* as the first significant example of photographs being mass reproduced and manufactured in production lines (Batchen 2009: 88–90). However, by the 1870s the trend for *carte de visite* portraits subsided. After the invention of roll film and the introduction of cheaper cameras (see below), studios became less fashionable with the middle-classes in Europe and America, although some studios in Britain continued to be regularly used to commemorate special occasions by immigrants (see Harding 2005) and the upper-class (for example, in the pioneering 'performative' colour portraits of society women as goddesses made by British photographer Madame Yevonde in the 1930s; see Gibson and Roberts 1990). In countries such as India and Africa portrait studios have continued to thrive, manufacturing carefully co-ordinated markers of social occasions, aspiration and achievement (see Behrend 2003; Pinney 1997; and Chapter 5).

The stereograph craze in the mid-1850s is another important moment in the marketing of photographs (see Chapter 2). The commercial popularity of stereography led to the opening up of a market for photographs in other genres beside portraiture, notably rural landscapes and street scenes where the impression of deep space could be exploited, although pornographic images were also popular (Holmes 1980; Jeffrey 1999b: 39–47; Marien 2006: 81–84; Richard 1998; Williams 1995; see also Chapter 3).

Photographic artists such as Julia-Margaret Cameron and Roger Fenton capitalised on the new market for photography in the 1850s and 1860s by holding exhibitions of their work and selling portfolios of prints (see Taylor 2004). A number of galleries were set up in the 20th century with the selling of photographs as their primary purpose – most famously those spaces associated with Alfred Stieglitz, who used exhibitions along with lavishly produced magazines to promote a connoisseurship around art photographs (Sekula 1982; see also Chapter 7). But these attempts usually met with limited results until the latter third of the century. Instead, the market for art photography only began to fully emerge in the 1970s. Lindsay Stewart of Christie's auction house sees this as the result of various coinciding developments: an increase in the amount of museums collecting photographs (see also Chapter 7); an expansion of successful photography galleries, which provide prestige to the images they show; dealers finding a new source of sales in photographs leading to the first specialist photography auctions (see also Solomon-Godeau 1991d); and the expansion in photographic practice resulting from the proliferation of photography degree courses (of which there were over 60 in Britain alone by 2009) (Stewart 2005).

One of the main reasons why photographs have proven difficult to sell as valuable commodities is their inherent potential for mass reproduction, which reduces the rarity that is essential to market value (Benjamin 1999; Berger 1980: 291; see Chapter 2 for more on mass reproduction). Gerry Badger has outlined the two strategies used by the market to overcome this issue and ensure that art photographs are rare (Badger 2007: 205). First, older photographs – by collectible photographers – are of far greater value if they are 'vintage' prints, meaning they were printed (generally by the photographer themselves) within five years of being taken. So-called 'printed laters' command far lower prices. Second, contemporary art photographs are printed in limited editions to prevent the market being flooded (see also Badger 2003: 59–81). In these ways the unique 'aura' that Walter Benjamin saw in the 1930s as not applying to photographs is arguably restored (see Chapter 2). Although Stewart points out that art photographs have seldom been printed in large numbers at any point in the medium's existence, and therefore some limited editions of art photographs actually result in a greater amount of prints existing than would otherwise be the case (2005). Running parallel to this, many photographic books – particularly monographs that were themselves printed in small runs – have also become increasingly collectible (see Parr and Badger 2004; 2006).

In the early 21st century record prices for the sale of art photographs at auction continued to be regularly broken. At an auction in 2006, Edward Steichen's photograph *The Pond – Moonlight* (1904) sold to a private collector for $2,928,000. An example of a 'vintage' print, Steichen's Pictorialist photograph involves much painterly retouching by the photographer, meaning that each of the three copies of the print known to exist are different and therefore unique (the other two remain within museum collections) (see Chapter 7 for more on Steichen and Pictorialist photography). In the early 21st century the highest price paid for a photograph at auction was $3,346,456 for *99 Cent II Diptych* (2001), a limited edition print by contemporary art photographer Andreas Gursky. The global market is a key theme in Gursky's work (see Chapter 7) and so it seems particularly appropriate that the sale of one of his images is an ideal example of the market for art photographs.

It is not just prints of photographs that are subject to this market. Batchen has discussed how Bill Gates, the founder of Microsoft and owner of Corbis (see above), bought the electronic reproduction rights to thousands of photographs. These form part of the billions of images owned by Corbis (which, as well as the far more generic examples discussed in the section above, include Nick Ut's photograph from the Vietnam war of a running child whose clothes have been burnt away by napalm and

Dorothea Lange's picture taken during the American economic depression of the 1920s of a mother with her starving children) (Batchen 2001: 147–154; see Chapter 6 for more about the Ut and Lange photographs). Corbis owns the electronic reproduction rights to many of art photographer Ansel Adams' images. However, as Batchen points out, this does not mean that the corporation has rights to existing prints of these images (a vintage print of one – *Moonrise, Hernandez, New Mexico* (1948) – sold at auction in 2006 for $609,600). Instead, it is the digital reproduction of Adams' photographs that is controlled. Gates clearly considers the viewing of photographs in electronic form as more important than the possession of original prints. Batchen notes that Gates has described the large digital screens installed in at least one of his houses that are linked to the Corbis database and upon which he and his guests can call up any of the Corbis-owned images in an instant (2001: 154).

Most photographs that are sold and bought are not great art. The vast majority are of subjects required within the daily economy of the mass media: including photographs of celebrity weddings (which can fetch the highest prices of any photographs; see Wombell 2008); paparazzi photographs of the same celebrities looking bad (see Chapter 9); sports photography (Wombell 2000); and whatever photojournalism is required by the news in an increasingly fast turnover in newspapers and online. This has resulted in what Ramamurthy refers to as 'the journalism of the spectacle' (2009: 213). Whether great art or not, the market for photographs remains a big deal.

SELLING PHOTOGRAPHY: MASS-MARKETING THE MEDIUM

Eighteen-thirty-nine is the year photography went on sale. Photographs were marketed as soon as the existence of the medium was announced. But 1888 is when photography started to be mass-marketed with the introduction of the Kodak camera. Up until the late 19th century, Slater has argued, camera equipment was expensive, difficult to use and photographs were required to be processed by hand. Photography was the specialised craft of wealthy amateurs (such as Victorian families who presented their images in elaborately constructed albums; see Chapter 5), professionals (such as Disderi) and artists (such as Cameron and Fenton). To extend the market beyond these groups and make it available to the masses, a form of photography was needed that was much cheaper and which involved no specialist knowledge (Slater 1991: 50–51).

In the 1880s, the American George Eastman founded Kodak on his invention of roll film made of paper and then flexible celluloid, which

meant that 100 images could be exposed on a single strip. The film was sold ready-loaded in easy to use 'box' cameras and was advanced in the camera from one spool to another. Once the film was finished the whole camera was sent to one of Eastman's factories and processed for the customer. The prints were then returned along with the camera – reloaded with a new roll of film ready for more pictures to be made (see Marien 2006: 167–170). As Slater notes, Kodak's customers never saw the film throughout the entire procedure, cheapness and ease of use coming at the expense of access to the apparatus and a limiting of technical possibilities (1991: 53). In 1900 this idea of simplicity was further reinforced by the introduction of the Kodak Brownie camera, advertised as being basic enough to be 'Operated by Any School Boy or Girl' (West 2000: 75–108).

The company that aimed at a global market was given a globally marketable name by Eastman: Kodak is an invented word coined to be short, memorable and pronounceable in any language around the world. Ian Jeffrey has noted that what might be photographed with these new cameras was initially unclear, suggesting that at first it tended to be used to photograph chance encounters while travelling (Jeffrey 1999b: 63–66). Advertising, for Kodak, soon came to emphasise the importance of recording for posterity significant instants, centring on the family and holidays, that could not be otherwise be retrieved – an idea that led to the phrase 'the Kodak moment' (see Johnston 1997: 98–102; Paster 1992; Sutton 2005, West 2000: 157). Chapter 5 returns to these issues to analyse the effect on snapshot photography of Kodak's emphasis on such subject matter.

The image of the 'Kodak Girl' was used in many Kodak advertisements from the 1890s onwards. The Kodak Girl was always young, usually wearing a striped dress adapted to the fashionable style of the time and often photographing a relaxed, leisurely scene. This was partly to promote the effortlessness with which photographs could be made and to associate Kodak with pleasurable times (Kotchemidova 2005: 5). But these advertisements were also cleverly designed to hold particular appeal to the independent 'new woman' of the early 20th century (Holland 2009: 142–145; Taylor 1994: 136–145; West 2000: 56, 113–135). The real revolution in photography, Slater argues, was a marketing revolution – and Eastman was its figurehead (1991: 52).

All this marketing worked: Eastman had sold over 100,000 cameras by 1896 (Slater 1997b: 180). Even within two years of its first appearance, the Kodak camera, along with its promotional slogan – which Eastman devised in discussion with an advertising company (Johnston 1997: 98) – was immortalised in a popular song written by W Fulton and W S Mullaly.

The lyrics of 'You Press The Button, We Do The Rest' express amazement at the ease by which the new cameras could be used and the speed in which pictures could be made, with further verses wryly commenting on other new 19th-century inventions such as the elevator. The Kodak camera was part of an ongoing series of innovations in modern Western society that made technologies accessible, fast and saleable. Slater has argued that the mass-marketing of photography represents a model of capitalism that is part of a much larger project of selling consumer goods linked to the family and leisure (1991: 57–59). Daguerre, for example, was an entrepreneur who, prior to his involvement with Niépce, had created the Diorama in Paris as an entertainment for paying audiences (see Slater 1997a: 107). The Diorama was a pre-cinematic spectacle where large panoramic landscape images, which Daguerre created with the aid of a *camera obscura* (see Chapter 2), were illuminated by dramatically changing lighting to create the illusion of time and movement (see Marien 2006: 11–12; Rosenblum 1997: 17).

Dave Kenyon has argued that, while Kodak cameras made photography accessible to the British lower middle-classes in the late 19th century and early 20th century, it was not until after the Second World War, with the integration of production line mechanisation from Japan, that photography became fully available to the working-classes in Britain (Kenyon 1992: 12–18). By 1980, nearly a century after the formation of Kodak, two-thirds of households in Britain possessed at least one camera (well over half of which were manufactured by Kodak), and 80 million films (producing on average 24 or 36 negatives each) were being bought each year in the UK alone (Slater 1997b: 176).

In his writings on photography from the same era, Slater used statistics from marketing reports to confirm that the main mass markets for photography were 'snapshooters' – people who used photography to record family occasions such as holidays and birthdays (see Chapter 5) – and amateurs, for whom photography was a serious hobby (1997b; see also Bourdieu 1990). For the snapshooter market, cameras were 'vehicles for films'; the buying, developing and processing of film accounting for around two-thirds of the £400 million spent on photography every year. Amateurs spent more money on the equipment – cameras, lenses, tripods, etc. – that accounts for much of the rest of the overall expenditure (1997b: 175–181).

Slater's social and economic approach was criticised by Simon Watney for not fully accounting for the specifics of photography as a medium that is shaped by desires and anxieties and which performs an ideological function (see Chapter 3). After all, Watney argues, photography 'is not simply "another" commodity, to be analysed like margarine or petroleum'

(Watney 1999: 158). What all these snapshots actually represent to those that make and look at them needs to be debated. This issue is addressed in Chapter 5.

SELLING DIGITAL PHOTOGRAPHY: FIXED AND TRANSIENT COMMODITIES

A report by the consumer retail organisation Mintel from 2006 revealed that since 2001 digital camera sales had increased by 530 per cent, resulting in a market where digital cameras made up 85 per cent of the overall share, with even single-use cameras (10 per cent of the market) overtaking film models (the remaining 5 per cent) (Mintel 2006). Rubinstein and Sluis argue that the two main barriers to an even wider engagement with photography were the delay in viewing the photographs after they were taken and the cost of film (Rubinstein and Sluis 2008: 12; see also Barthes 2000: 9; Bourdieu 1990: 78). With its capacity for instant viewing and the provision to delete unwanted pictures, digital photography removed both of these barriers (see also Chapter 2).

Yet, by the middle of the first decade of the 21st century, even digital cameras were under threat. Mintel reported that the increased quality of mobile phone camera images meant that many consumers were bypassing the purchase of a separate digital camera entirely. Camera phones (see Figure 4.4) are a vast market, with 656 million handsets sold by 2008 and sales predicted to reach one billion by 2010 (Marien 2006: 510; Sutton 2005: 46). The screen is as essential to the design of camera phones as it is to dedicated digital cameras. A 2007 Samsung advertisement shows a camera phone apparently emerging from a pristine, metallic heaven: a smooth and immaculately conceived object to be fetishised like the new Citroen car analysed by Barthes in his essay in *Mythologies* (1973: 95–97; see Chapter 3).

The screen on such mobile devices takes over most of the body of the device itself. Such an emphasis is hardly surprising. Screens have become as connected to the experience of viewing photographs as looking at printed pictures on paper. Indeed, handheld digital devices are often passed around so that images can be viewed in the same way that paper photographs have been for years (see Chapter 5). As Damian Sutton has noted, the camera phone's portability and ease of use continues and expands the ideas of the first Kodak cameras (Sutton 2005: 45). But, if transient digital photographs stored on re-usable memory cards have replaced the images fixed on the millions of single-use films that previously went through millions of cameras every year, what is there left to sell?

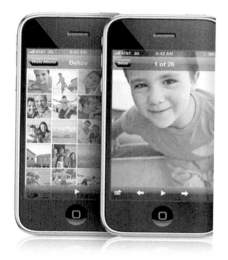

Figure 4.4
iPhone™ promotional image (2009). iPhone is a trademark of Apple Inc.

Of course the market has found new ways to vend commodities to consumers. Digital cameras and the software needed to engage with digital images require ever more frequent upgrades. As well as this, the continuing fetishistic desire that Christian Metz argued fosters the need for photographs to exist in a fixed, solid form so that they can be touched and held (Metz 2003; see also Chapter 2) has led to the success of companies such as PhotoBox. On the PhotoBox website, digital files can be uploaded from a camera or phone and then, having paid in virtual currency via PayPal, the customer receives their prints in the post in an old-fashioned envelope (or on the pages of a book, or wrapped around a mug, or made into a jigsaw, and so on). Other apparatus, such as digital photo frames, where photographs are uploaded onto screens from a memory card – the order of the images, length of viewing time and style of transition from one picture to the next programmed in – as well as the equivalent in the form of key rings etc., allow for the display of multiple digital images which often change rapidly, creating a far faster and more transient viewing experience to that of a fixed print on paper fading over many years (see Chapter 2 and Chapter 5). Photographs and the apparatus of photography are embedded in the culture of capitalism; in whatever forms it takes, photography is always for sale.

The kinds of 'mobile photographs' I have discussed so far are only viewed by a few people. Passing around camera phones and other handheld electronic devices to look at images on screens; a digital photo frame on a domestic shelf: these activities access a relatively limited

audience. But of course digital photographs are mobile in the sense of being in transit from computer to computer and screen to screen all the time and all over the world via the Internet, with a theoretically unlimited audience. Increasingly – and at any given moment – digital snapshots are uploaded from most parts of the world to photo-sharing websites such as Flickr, as well as less photo specific, but still heavily photo-based social networking sites, including the tellingly named *Facebook*. These images can be viewed online anywhere there is a connection or signal. But what is the subject matter of these transient snaps? Has it changed from the kind of imagery that dominated popular photography in the era of fixed photography? (See Chapter 2 for more about the distinctions between fixed and transient photography.) The next chapter suggests answers to these questions through a detailed analysis of snapshots.

SNAPSHOTS

> Family photos depict smiling faces. Births, weddings, holidays, children's
> birthday parties: people take pictures of the happy moments in their lives.
> Someone looking through our photo albums would conclude that we had led
> a joyous, leisurely existence, free of tragedy. No one ever takes a photograph
> of something they want to forget.
>
> *One Hour Photo* (Mark Romanek, 2002)

The above lines are spoken by Seymour Parrish, the narrator and central
character of the 2002 film *One Hour Photo*. Parrish works in the photo-
graphic department of a large out of town store, processing and printing
customers' films. As his narration suggests, Parrish is well aware of the
highly selective version of family life provided by the snapshots he sees all
day. Nevertheless he disavows what he knows, becoming obsessed with
the photographs he develops of a family that he convinces himself is
perfect: imagining himself within their images as an escape from his own
less than ideal family background. More generally, *One Hour Photo* serves
as a commentary on the constructed character of snapshots and the desire
to believe in the content of what is by far the most popular form of
photography. Snapshots are the photographs most people make and
appear in most of the time. They are sophisticated images and the majority
of us receive an education in how to pose for and take snapshots from the
moment we are born. It is only because this detailed knowledge becomes
second nature at an early age that we forget our indoctrination into the
culture of snapshot photography, making snaps seem simple and even
'naïve'. They are neither.

This chapter begins with an analysis of the term 'snapshot' and a debate about the relative lack of study of this ubiquitous form of imagery. The second section examines in detail what is meant by snapshot photography. Taking its cue from the modernist approach of authors such as John Szarkowski with the book *The Photographer's Eye* (2007; see Chapter 2), the essential nature of the snapshot photograph is defined. From a more postmodern approach, the next section examines the cultural context of snapshots, the outside influences upon them that shape their look and their purpose. This is followed by a section examining the work carried out in the area of 'phototherapy', a practice that both analyses and goes beyond the content of the family album. In the penultimate section, the changes to the nature of the snapshot that happened with digital technology are debated. This leads to the concluding section, which considers the implications of the increasing distribution of the snapshot as part of the culture of online social networking: a process that has seen the private snapshot go public.

PRIVATE SNAPSHOTS: THE SILENT MAJORITY OF PHOTOGRAPHY

The origin of the word 'snapshot' is generally agreed to derive from a 19th-century hunting term for a gunshot fired quickly and haphazardly. Although writers disagree over details, it is usually accepted that Sir John Herschel first applied the term to photography in an 1860 article (see Green 1975: 3; Greenough 2007: 284n; King 1986: 4; Kotchemidova 2005: 7; West 2000: 217n) (Herschel also coined the word 'photography'; see Chapter 2). Parrish's narration in *One Hour Photo* reiterates the idea of a snapshot as being a photograph taken with a lack of deliberate aim. Yet the anthropologist Richard Chalfen, in his book *Snapshot Versions of Life*, argues that it is clear from watching people in the process of creating snapshots, as well as from examining the resulting pictures, that such photographs 'are made with considerable *deliberation*' (Chalfen 1987: 72).

The process of making snapshots evolved across the late 19th and early 20th century. Julia Hirsch has traced the development of family photographs – the subject matter of much snapshot photography, as I discuss below – from formal portraits made in commercial studios with poses held as if sitting for an oil painting, to the same kinds of formal images being made by families themselves in and outside homes, particularly as a way of displaying possessions (Hirsch 1981: 15–79). The special occasion for these pictures was usually the taking of the photograph itself, one of the factors that led to less relaxed attitudes and

fixed, serious expressions in these images as the sitters concentrated on maintaining their posture.

Kodak's marketing of its cheap and easy to use cameras in the years between the late 1880s and the introduction of the Brownie in 1900 transformed the making of snapshots into a much more widespread and apparently casual activity, an idea encapsulated in the company's 1888 slogan 'You Press The Button, We Do The Rest' (see Chapter 4). One hundred years later, according to the Wolfman Report (an annual survey of the photographic industry), over 16 billion snapshots were processed in the US alone during the (pre-digital camera) financial year 1989–1990 (see Paster 1992: 139).

Writing in 1986, Graham King described the result of this century of picture taking as an 'ocean of snapshots' (King 1986: xi). Yet, as King and a number of other authors noted in the 1980s, snapshots were hardly paid attention to within the critical study of photographs over those 100 years. Analysis of snaps tended to consider them from the perspective of art photography, such as Szarkowski's book and exhibition *The Photographer's Eye* (see Chapter 2 and Chapter 7), which was pioneering in its inclusion of anonymous snapshots, but examined them only through the application of modernist aesthetics (Szarkowski 2007; see also Malcolm 1997). As Chalfen notes, Szarkowski tends to just incorporate those snapshots that are inconsistent exceptions to the kinds that are usually made (Chalfen 1987: 152), a practice that continues in most of the books of snapshot photography published in the 1990s and 2000s (see Batchen 2008b: 130–131).

Douglas R. Nickel has argued that 'what we call the history of photography' began to be written in the 1930s by art historians such as Beaumont Newhall from the perspective of modernism (see Chapter 7 for more on art photography and the writing of its history) (Nickel 2000: 229). From this viewpoint, snapshots have often been regarded as 'vernacular' photography: a phrase that, as Elizabeth Hutchinson has noted, was originally used to refer to a specialised language belonging to a particular group of people (Hutchinson 2000: 229–230). However, from a position outside of the history of art, it is snapshots that represent the majority of photographs and art photography itself that is 'vernacular' in its specialisation of language and its ownership by a specific group (see also Edwards 2009: 47). Art photography is only a drop in the ocean of photography as a whole. It is snapshots that flooded the world from the late 19th century onwards, although their absence from histories of the medium meant that snaps came to represent the 'silent majority' of photography. As Geoffrey Batchen put it, the effect has been that photography 'is consistently left out of its own history' (Batchen 2008b: 125).

Since the 1990s writers such as Batchen have regularly put forward the view that it is not snapshots that somehow fall short of being included in histories of photography, but rather histories of photography written from the perspective of art that fall short of what is required in order to analyse the greater body of photography (e.g. Batchen 2003: 28–29; see also Starl 1993: 7). Batchen argues that histories of the snapshot cannot be written by homing-in on individual pictures (or representing them as 'art'), but must consider snapshot photography as a mass. As Patricia Holland has also contended, snapshots need to be studied on their own terms (Holland 2009: 124). Although the cultural context and social function of snapshot production is vital (and is examined below), it is important to first debate the essential 'nature' of snapshots in terms of their look and subject matter (Chalfen 1987: 166; Cobley and Haeffner 2009; Zuromskis 2009: 53). Graham King, Dave Kenyon and Richard Chalfen are three writers who have contributed significantly to such an examination.

THE NATURE OF SNAPSHOTS: THE SNAPSHOOTER'S EYE

In 'The Quintessential Snapshot', the third chapter of his book *Say 'Cheese!'*, King describes the general qualities of snapshots in a similar way to which Szarkowski approaches a definition of modernist art photographs in *The Photographer's Eye* (King 1986: 48–60). Yet King's aim is not to suggest that snapshots are art photographs. Instead he wishes to 'isolate and describe' those characteristics that define the look – or as King puts it, the 'visual surface' – of snapshot photography itself (1986: 48–49). King lists 12 characteristics common to images made not by 'photographers', but by snapshooters. Many of these refer to what might be considered 'mistakes', and some of them require a brief explanation here. The recurring characteristics of snapshots, according to King (and using his own terms), are:

- Tilted horizon
- Unconventional cropping
- Eccentric framing
- The distant subject
- Blurring
- Double exposure
- Enter the light (where a light source has overexposed part of the image)
- The 'Siamese' frame (where the film has not wound on fully and two images are conjoined)

- The close encounter (where the view is obstructed by an object such as a finger over the lens)
- The shadow (of the photographer entering the frame)
- Banality (the subject and how it has been photographed is 'uninteresting')
- Ambiguity (the purpose of the photograph is unclear).

Although King's list is eccentric in its terminology, it successfully encompasses many of the main visual characteristics that have come to be (sometimes pejoratively) associated with snapshot photography.

With *Inside Amateur Photography*, Kenyon emphasises the general subject matter, rather than the look, of snapshots, presenting an extensive categorisation in five parts of what most people tend to photograph (although the subjects discussed are inevitably generalised and informed by a Western viewpoint) (1992: 23–63):

- Family (parents with babies, new bikes and cars, pets, etc.)
- Christmas (which could be substituted by other religious and secular festivals)
- Holidays (hotel window views, tourist sites, seaside images, etc.)
- Weddings (signing the register, the exit from the church, cutting the cake, etc.)
- Environmental (images of landscapes, trees, animals).

Kenyon also uses these categories of what appears in snapshots to discuss what such photographs usually miss out, including 'everyday drudgery, the unpleasant or threatening experience, illness, discord' (Kenyon 1992: 24). The absence of these subjects has been referred to by Judith Williamson in psychoanalytic terms as a form of repression (Williamson 1988a: 122–124; see also Chapter 3 and below). Kenyon provides funerals as a specific example of subject matter avoided by the Western snapshooter, in this case the recording of a ritual prompted by death (Kenyon 1992: 56–57; see also Ruby 1995; Townsend 1998: 128–136).

In his study of snapshots Chalfen considers answers to the question 'When in the course of a lifetime is a white middle-class member of American society asked to appear as an on-camera participant in snapshot communication?' (Chalfen 1987: 70–99). He lists the following general stages of a (rather stereotypical) life when snaps are produced:

- Beginnings (Chalfen notes that the birth of a baby is often the impetus to buy a camera and to take snapshots)

- From Infancy to Toddlerhood (the 'firsts' of everything: first birthday, Christmas, etc.)
- Childhood and Adolescence (from the first day at school to the graduation photograph)
- Early Adulthood (including relationships, which may well eventually include marriage, leading to . . .)
- Married Life (many of the snaps taken at this time, Chalfen points out, are made on holiday)
- Parenthood (returning the subject of the snapshot back to its beginnings, as the child and their own 'firsts' become the central subject)
- The Later Years (snapshots become infrequent, but there may be a desire to record the 'lasts': the final significant events in a life)
- Images Of Life's End (death is a subject that, like Kenyon, Chalfen argues is seldom documented).

Chalfen notes that snapshots are only used to record positive changes, which he sees as transitional events from one stage of life to the next. What is photographed in a snapshot is therefore extremely discriminatory: for example, work colleagues who might be seen almost every day for years may never be photographed (1987: 90). The achievements and possessions gained as a result of work will often appear in snapshots, while the many hours, months and years of work that enabled them to be attained will almost certainly go unseen (1987: 88–89; see also Stanley 1991).

Chalfen also makes a remarkable calculation. Based on the average life expectancy of a middle-class American in 1987 of 75 years, it is likely that a person will accumulate around 3000 snapshots by the end of their life. If the average shutter speed is 1/100th of a second, then these photographs represent a total of 30 seconds of that person's life (1987: 96–97). With reference to Henri Cartier-Bresson's idea of 'the decisive moment' (see Chapters 2 and 6), Chalfen calls this 'the decisive half-minute'.

Seventy-five years represented by 30 seconds of what are – as we shall go on to further examine – highly constructed photographs: there cannot be a better illustration of how selective snapshot versions of life are. As Chalfen puts it,

> In contrast to popularised and accepted views that photographic images serve us as objective, authentic, 'true-to-life' visual accounts of what 'is there', we must understand that pictures can never show everything . . . Snapshots do *not* offer us a documentary account of exactly what the world looked like; collections of snapshots do *not* provide viewers with a magical

mirror of the past and present 'true' situations. It is more the case that snapshooters and family album makers selectively expose parts of their world to their cameras; or, said differently, snapshooters selectively use their cameras at specific times, in specific places, during specific events, for specific reasons.

(Chalfen 1987: 98)

In the next section the specific reasons why these specific times, places and events are photographed will be analysed.

THE KODAK CULTURE OF SNAPSHOTS: TOURISM, FAMILY AND MEMORY

Chapter 4 examined the ways in which the cameras and films made by George Eastman's company, Kodak, came to dominate photography as it became a popular medium in the late 19th and early 20th century. Nickel has claimed that 'Eastman created not just a product, but a culture' (quoted in Kotchemidova 2005: 10). Chalfen calls this 'Kodak Culture' and argues that it came to dictate the popular idea of what makes a good picture: defining who and what to photograph, as well as when and where to photograph them (1987: 4–48). Kodak Culture is therefore the culture of snapshots that developed from the dominance of Kodak's marketing during the period in which photography became widespread. It is important to acknowledge that, although global, Kodak Culture is at its most influential in the Western world. Writers such as Christopher Pinney have shown that what constitutes a 'good' snapshot varies, often subtly, across the world (see for example Pinney 1997).

Don Slater warns that the influential marketing of Kodak should not be regarded as an 'evil plot', but does argue that the mass-marketing of photography restricted most snapshooters to photographing 'conventional situations' (Slater 1991: 57). Phillip Stokes points to logistical factors that have also shaped the look of snapshots. He notes that the paucity of photographs of people at work may be explained as much by a lack of time and opportunity to make such images as by the socialisation of snapshooters into Kodak Culture (Stokes 1992: 200–201). Nevertheless, the influence of Kodak is vital to the culture of snapshots. In this section we will analyse this culture and how it has circumscribed the look and subject matter of snapshots as defined in the previous section – with particular emphasis on the key areas of tourism, family and memory.

Holland notes that Kodak's marketing of popular photography in the late 19th and early 20th century through its advertising campaigns initially

directed the consumer 'outwards'. Kodak advocated the use of snapshots as a way of documenting the leisurely travel that was becoming increasingly accessible via the expansion of the railway network and the technology of the bicycle (and, soon after, the automobile) (Holland 2009: 144). Nancy Martha West has argued that Kodak used the independent, freely roaming and photographing figure of the 'Kodak Girl' in many of their advertising images of the time to represent this idea (West 2000: 53–60; see also Chapter 4). In her book *Kodak and the Lens of Nostalgia*, West details how the associations Kodak made between travel, holidays and photography shrewdly connected with changes in Western culture that led to the determining of the structure of the working week, the weekend, and the legal requirement for paid holidays. These changes resulted in increased leisure time for the working-classes as well as the previously privileged middle-classes, allowing greater opportunities for travel and leading to the expansion of tourism (West 2000: 36–73). West notes how Kodak pressurised consumers to preserve their leisure time photographically. One early advertisement showed a Kodak Girl with her camera – positioned between illustrations of a train steaming through a rural landscape and a boat sailing off the coast – accompanied by the claim 'A vacation without a Kodak is a vacation wasted'.

Tourist photography is a highly cultural construction. Following on from the studies of tourism made in the 1960s and 1970s by Daniel Boorstin and Dean MacCannell at a time when the industry was rapidly expanding in the West, Chalfen discusses the way that tourists are directed towards particular sites in which to take photographs that, as John Urry has noted, often emulate the kinds of images used to promote the holiday in the first place (Chalfen 1987: 104; Urry 1990: 140). Some 'pseudo-events' (Boorstin's phrase) even came to be fabricated just for tourists to watch and take pictures of, such as Kodak-sponsored hula dances in Hawaii in the 1950s (see Chalfen 1987: 100–118,; see also Bourdieu 1990: 35–39; Osborne 2000: 70–121; Sontag 1979: 65; Taylor 1994; Urry 1990: 138–140). Kenyon notes that by the 1980s and 1990s many coach outings for tourists incorporated stops at attractions primarily so that holidaymakers could take photographs of themselves in front of the sites (1992: 52–54). The tourist snapshots that result from this kind of sightseeing tend to depict, as Holland puts it, 'a familiar face . . . in an unfamiliar place' (2004: 146).

Tourist snapshots in particular are photographs made to show to others, confirming that their participants really have been on holiday and had a good experience (Kenyon 1992: 46–47; Urry 1990: 140). Between the 1950s and the 1980s tourist photographs were often made public (albeit to a limited audience) via the domestic slideshow, where colour

slides were projected onto a wall or a screen at home (Parr and Badger 2007: 205). Indeed, this era of the snapshot can be thought of as 'the golden age of domestic slide projection', although Slater's reference to 'the dreaded slideshow' in a 1995 essay suggests that this period had well and truly passed by the final decade of the 20th century (Bull 2004a: 57; Slater 1995: 141; see also Starl 1993: 12).

Nevertheless, as Elizabeth Edwards and Janice Hart have argued, the snapshot photograph in use remains a social object (Edwards and Hart 2004; Edwards 2005; see also Chalfen 1987: 70). When viewed as slides snapshots are commented on, while in their physical form (on album pages or individually) snapshots are passed around, talked about, laughed at. These are activities that continue and, as I will suggest below, have arguably expanded with the digital photographic image through its display on the screens of handheld electronic devices as well as via online social networking (see also Chapter 2).

While, as Holland notes, the public audience for such social activities includes friends, it is families that arguably remain central to snapshot culture as both the primary audience and subject matter of snaps (2009: 119–121). After an initial emphasis on travel, Kodak Culture soon turned 'inwards' to concentrate on the family (Holland 2009: 144). West meticulously traces how Kodak advertising between the 1880s and early 1930s systematically demonstrated to the public not only what family events they should photograph, but also played a significant role in shaping the idea of the family itself (West 2000: xii; see also Hirsch 1999; Slater 1991: 49–59). Williamson has argued that photography developed historically in parallel with the formation of the modern family (Williamson 1988a: 125–126). The institution of the family, she contends, is crucial in maintaining the state – although snapshots may seem far removed from politics, the idealised images in family snaps represent the fulfilment of desires that help to prevent a descent into 'social chaos' (1988a: 115–116).

Snapshots therefore play a part in the naturalisation and replication of the ideology of the family and as such are rarely radical (see Chapter 3 for an analysis of ideology). Pierre Bourdieu, in a pioneering sociological study of snapshots made in the 1960s, saw the key role of the snap as being the social integration of the family via the recording of celebratory moments, especially markers of family success and enlargement (Bourdieu 1990; see also Kenyon 1992: 92–93). This helps to explain the wilful omission of subjects such as funerals (as we saw in the previous section), which Kenyon regards as marking the 'reduction and impoverishment' of the family group (1992: 56).

Kodak's marketing images used in magazines, newspaper advertisements, handbooks and promotional pamphlets were initially playful –

emphasising the fun of making photographs while insinuating the brand into everyday life (West 2000: 19–35). Although the snapshots used in Kodak's promotional material were clearly staged, West notes that the indexicality of the photographs helped to convince the viewer of their authenticity, creating what, as noted in Chapter 4, Patricia Johnston has called 'real fantasies' (Johnston 1997: 72–104; West 2000: 204–205). The photographic Kodak advertisements of 'families' photographed by Edward Steichen in the 1930s, for example, were deliberately designed to be mimicked by their consumers (Johnston 1997: 98–104; see also Chapter 4). Many of these adverts demonstrate both the act of taking a photograph and the image that will result from it. Beyond directly promotional material such imagery extends to the packaging of films and cameras, the envelopes photographic prints arrived in, and even the example images found in photo frames (see Holland 2009: 150–151; Kotchemidova 2005; Williamson 1988a: 119; Zuromskis 2009: 57).

Christina Kotchemidova argues that this imagery resulted in a consensus of when to photograph the family, and this helped to overcome the initial anxiety that many had of being 'shot' by the camera. As photographing became accepted as something to do at special occasions – rather than a special occasion in itself – the fixed poses and serious expressions of the 19th century gave way to more casual images of family members already relaxed and engaged in festivities (Kotchemidova 2005: 8). The phrase 'say prunes', originally used in the Victorian era (when a closed, small mouth was considered polite and attractive), came to be

Figure 5.1 Joachim Schmid *Archiv # 440* (1993) © Joachim Schmid.

replaced by 'say cheese!' – the resulting open-mouthed smile creating what Kodak advocated as exuberant and 'lifelike' snaps (2005: 2–3). Handbooks and magazines and the images found on the packaging of photographic products – either made by Kodak or influenced by the company – continue to educate snapshooters in how to carefully construct 'spontaneous' photographs of happy families (Holland 2009: 150–151; Williamson 1988a: 119). Kotchemidova suggests that through such images the public has fully absorbed ideas about how to make snapshots, as well as what facial expressions and poses to adopt themselves when photographed in order to create the impression of contentment and social integration: 'No matter how bored we are at a social gathering, we always smile for the camera' (2000: 22). Zuromskis argues that the making of snapshots is far more collaborative than other forms of photography, such as documentary (see Chapter 6). Rather than the power relations that can be dictated by who is behind and in front of the camera (see Chapter 3), Zuromskis sees snaps as a form of photography where all of those involved participate in a 'photographic fiction' (Zuromskis 2009: 60). Such a fiction, still determined in its overall look by promotional imagery, came to be widely referred to in the 20th century as a 'Kodak Moment' (West 2000: 157).

The shift towards recording the family at important instants occurred over the first few decades of the 20th century and changed the emphasis in the role of the snapshooter from photographing for fun to having the duty to record irretrievable events. Making these moments look pleasurable became a serious business. As West puts it, 'Playtime was now over' (2000: 135). Advertising began to pressurise families to record loved ones during times that would otherwise be lost forever, with Kodak often using the phrase 'Let Kodak Keep The Story' in its 1920s magazine advertisements. The stories that these adverts demonstrated must be kept included, for example, what Chalfen refers to as important 'firsts' in infancy (such as learning to walk). Sarah Kennel has discussed how it became a 'moral responsibility' for families to preserve these passing moments, pointing to Kodak advertisements such as one from 1936 where a father shows snaps of his children to another man who (the caption tells us) 'felt ashamed' that he had not taken similar pictures of his own children (Kennel 2007: 94–96). In some, rarer, cases the duty could even be to record potential 'lasts'. A 1926 American advertisement by the Master Photo Finishers of America (that is clearly influenced by Kodak's strategy) shows a young man and woman with a child – and two elderly people likely to be their relatives and in-laws – catching turkeys for Thanksgiving. The slightly awkwardly phrased text accompanying the picture advises the consumer to:

'Save the Day with Snap Shots' – the day of the year which brings most families together, is a splendid opportunity to take snap-shots [*sic*] of the entire family, both singly and as a group. Next year might be too late. Have your camera and a few extra film [*sic*] ready.

The duty thus falls upon the snapshooter to not just 'save' moments, but to 'immortalise' the people who they photograph.

James E Paster observes that the early emphasis on the technology of the camera to catch an instant came to be overtaken by a focus on preserving life forever: 'Kodak, and the photographic industry as a whole, wields a profoundly compelling sales tool, one that is intertwined with concepts of life, death and ritual' (Paster 1992: 139). Although Paster does not make the connection directly, his argument corresponds with Roland Barthes' claim in his book *Camera Lucida* that photographs by amateurs come closest to the 'essence' of photography, which he perceives as being the photograph's apparent ability to prove '*that-has-been*' (Barthes 2000: 98; see Chapters 2 and 3). However, Barthes' explicit associations between the photograph and physical mortality – which he elaborates upon throughout *Camera Lucida* – remain only implicit in Kodak Culture (see Batchen 2003: 21). As we have seen, death itself is rarely dealt with in snapshots. West notes that a proposed 1932 campaign by Kodak that employed images and captions directly addressing the deaths of family members – including a Thanksgiving scene with elderly relatives – was pulled before it had even reached any publications (2000: 200–207).

Instead, as we have seen, the snapshooter is educated by Kodak Culture to preserve life only through 'happy memories' (West 2000: 143). West sees this memorialising as an attempt to seize control of time and find stability in an idealised past while in the midst of constant change: a form of reminiscence that became increasingly important in the era of fast-paced transformation that arrived with modernity in the 19th century (2000: 154–155; see also Chapter 2). Batchen makes a similar point, but argues that photographs are not a good way to fight against the loss of memory in fast-changing cultures as they only preserve the visual sense, leaving out other sensual experiences such as touch, taste, smell, sound and temperature (Batchen 2004: 94–98; see also Chapter 2). To Batchen, photographs are hollowed-out versions of memory, replacing a full sensory experience with a picture (see also Batchen 2003: 25). The real role of the snapshot, he argues, is less about memorialising the past (which after all, as we have seen, is only very partially represented in a snap) and more about creating a positive image for the future. From this perspective, the snapshot might be thought of not as a memory preserved but as a plan for nostalgia (West 2000: 155).

PHOTOTHERAPY: THE FAMILY ALBUM AND BEYOND

An important part of this planning lies in the editing and arrangement of snapshots. Batchen writes that photo albums present the opportunity to order and control the meanings of snaps, as well as add to their sensory experience with text and, in some cases, objects (for example, tickets for an event recorded in the images) (2004: 48–60; see also Chalfen 1987: 142). Marina Warner emphasises the playful nature of Victorian photo albums that often placed the photographs within hand-painted, fantasy scenes in order to create narratives of escapism (and perhaps to compensate for the lack of spontaneity afforded by static 19th-century photographs such as *cartes de visite*) (Warner 1999). Philip Stokes suggests that the inventiveness that went into assembling these albums came to be replaced over time by a more strictly systematic and chronological approach as a result of Kodak's influence, with the family being confirmed as the key subject matter (Stokes 1992). Martha Langford argues that the family album remains a performance, presenting a constructed version of the identity of its participants both to the participants themselves and to others – a process in which the addition of written explanation and narrative occupies a key role (Langford 2001). Edwards has emphasised the importance of orality to family albums, noting that they are used to narrate stories, often from a range of interweaving viewpoints (Edwards 2009: 38–39).

However, the partial tales told in snapshot albums and the selective fictions created in snapshots result in a wide gap between photographs and lived experience. This is a point made clear in some of the books and exhibitions constructed by Joachim Schmid, where he gathers together thousands of 'found' photographs taken by anonymous snapshooters (see Figure 5.1), revealing both the repetitive nature of the snapshot styles and subjects as well as indicating – by implication – what goes unrepresented (for more about found photography and Schmid see Berger 2009; Bull 1997; MacDonald and Weber 2007). A number of different but related practices under the heading of 'PhotoTherapy' or 'Phototherapy' have actively sought to address and narrow this gap by suggesting other stories that can be told using snapshots (see Chalfen 1987: 156–160).

Since the mid-1970s, psychologists, councillors and therapists, such as Linda Berman and Judy Weiser, have used photographs with their clients. Weiser devised the term 'PhotoTherapy' in 1975 for this process, although others had also begun to employ the same phrase (which, as Weiser uses it, has no gap between the two words 'Photo' and 'Therapy' to imply equality of both elements) (Weiser 1999: xiii). The basic idea of PhotoTherapy shared by these practitioners involved the Freudian psychoanalytic

technique of asking the clients themselves to talk – in this instance by asking them to discuss snapshots (see Chapter 3 for an examination of Freudian psychoanalysis). These snapshots could be pictures taken of the client, taken by the client, or simply pictures selected by the client. The theory is that both the photographs themselves and the ideas that the client projects into the images while discussing them allow access to their repressed unconscious anxieties and desires, aiding the therapeutic process (Berman 1993: 6–9; Weiser 1999: 1–8). Annette Kuhn has applied this process to her own unconscious, using her family's photographs to provoke her memories and creating a reading of snapshots informed by both psychoanalysis and Marxism as a way to connect the personal life of private snapshots with wider political events in public life (Kuhn 2002).

Kuhn's approach was also influenced by the work of Jo Spence and Rosy Martin, who pioneered the related technique usually referred to as 'phototherapy'. A key event for the establishment of this version of the practice was Spence's exhibition *Beyond the Family Album*, shown at the Hayward Gallery, London in 1979 (see Spence 1986: 82–97). Despite its gallery context, *Beyond the Family Album* was not intended to suggest that snapshots could be art photography, but instead created a forum to present and analyse snapshots publicly. The show largely consisted of snapshots taken of Spence from her birth in 1939 – all of which fitted the standard categories of happy snaps defined earlier in this chapter. However, as Julia Hirsch notes, the captions and texts accompanying the snapshots did not reinforce the positive messages of the images, but instead went 'beyond' the album to fill in what the photographs did not record: negative memories and anxieties centring particularly on issues of class and gender (Hirsch 1997: 133–135).

Spence did not just analyse snapshots, she created new ones too (a technique that is also sometimes used by psychotherapists, including Berman). This was a practice that she continued in the 1980s and 1990s. As well as making snapshots of everyday life such as daily work (as opposed to special occasions), this form of phototherapy also involved what Spence and Martin called 'the theatre of the self' (Spence and Martin 1995: 180). For this latter practice, Spence, in collaboration with Martin and others, used makeshift studios and a few props and outfits to restage moments from the subjects' past that had gone unrecorded in snapshots made at the time. For these photographs the participants would play younger versions of themselves or other roles, such as that of their parents, in order to come to terms with anxieties and desires, as well as issues such as health and mortality (see Spence 1986, 1995). This kind of phototherapy aimed to create richness in images of the family, as opposed to the poverty of instants recorded in the conventional photo album.

Yet, as Hirsch has pointed out, Spence also recognised the need to stage idealised photographs and create positive memories (Hirsch 1997: 135). As with Seymour Parrish in *One Hour Photo*, even those who are fully aware of the lies that snapshots can tell still need to believe them occasionally. *Beyond the Family Album* ends with a panel of conventional snaps mimicking the pages of albums, accompanied by the explanation: 'These pictures are here for no better reason than they remind me of happy times and of people I love.'

DIGITAL SNAPSHOTS: SCREENS AND PERFORMANCE

David Campany has argued that the scenes in the processing lab that appear in *One Hour Photo* were 'made at the last point where a contemporary film could linger legitimately over celluloid negatives, sprocket holes, gurgling chemicals, and all the rest of the production process, without seeming nostalgic' (Campany 2008b: 55). The film also includes many moments where characters become absorbed in what they are viewing on screens (while using a computer, playing on a games console, watching television and so on) as well as a scene where a customer discussing her camera with Parrish tells him she has been advised to 'go digital'.

Of course most snapshooters have now 'gone digital' and use digital cameras to make their images (see Chapter 4 for statistics relating to this). In 1986 King presciently asked of the then nascent digital photograph: 'Will these novel and intangible images further change the essential nature of the snapshot?' (King 1986: 13). Paul Cobley and Nick Haeffner have argued that this is exactly what has happened – and that the fast-moving, changing character of the photographic apparatus therefore needs to be studied and commented on (Cobley and Haeffner 2009: 142–143). The wider implications of digital technology for the identity of photography as a whole are debated in Chapter 2. The rest of this chapter looks at the impact of digital technology on snapshots and (in the final section) their distribution.

While contemporary art photography is often referred to as 'performative' (Green and Lowry 2003: 47–60; see also Chapter 2), snapshots are arguably the most constructed of all photographs. Hirsch suggests that snaps have always been events performed for the camera (Hirsch 1981: 72). In 1992, Kenyon argued that instant Polaroid film made participants in snaps more aware of how the resulting picture looked by allowing for an 'instant check' on the snapshot to ensure that their performance was satisfactory. If it was not, then adjustments in angle, pose

and expression could be made for a second image (Kenyon 1992: 94). In 2008 Polaroid (temporarily) ceased production of instant film (see Buse 2008). It seemed that it was no longer required. The screens on digital cameras mean that the staging of performances for snaps may be instantly checked, deleted and remade until the snapshot has been fine-tuned to all the participants' satisfaction (and at no financial cost) (see Cobley and Haeffner 2009: 142).

This fine-tuning continues after the event, as digital snaps can be adjusted both in-camera and on a computer (Cobley and Haeffner 2009: 144). Digital technology allows snapshooters greater control of the images they make. Applications such as Photogene for the iPhone can be used to manipulate images via the device itself. Tourist snapshots can be made even before going to the location by using Photoshop to place the tourist-to-be in front of an image of their destination; while 'scene completion' software now allows users to search other uploaded snaps to fill in gaps obscured in their own picture (by the back of a head, perhaps) (Ritchin 2009: 53–59). Unwanted ex-lovers can also be digitally removed from our lives by Photoshopping them out of the picture (Ritchin 2009: 22). As Holland argues, digital images are not only more disposable, but also more open to alteration than their film and paper counterparts: '"Doing the rest" is now as easy as "pressing the button"' (2009: 120; see also Chapter 2).

Many of the digital cameras used for these snaps are not just cameras but mobile devices such as camera phones. As examined in the previous chapter, the market for camera phones is huge, with an estimated one billion sales by 2010 (Sutton 2005: 46; Marien 2006: 510). There are parallels between the initial impact of Kodak and the effects of mobile devices on snapshot photography. Damian Sutton as well as Daniel Rubinstein and Katrina Sluis have identified analogies between the increase in accessibility that arrived with miniature and novelty cameras in the late 19th century and the even greater integration of the snapshot into everyday life via the miniaturisation and mobility of devices incorporating digital cameras (Rubinstein and Sluis 2008: 21; Sutton 2005). This has prompted Sutton to refer to the idealised snapshots made on such devices as 'Nokia Moments', with Nokia as the pioneering equivalent to Kodak in the development and marketing of camera phone technology (Sutton 2005).

Digital snapshots are not just 'mobile' due to their likelihood of being made on highly portable devices; they are also far more mobile than printed images in terms of their distribution online. This is an aspect of the shift from the early Web 1.0 – a 'top down' structure with a select few dictating the content – to Web 2.0 – where the content is 'bottom up', or

'crowd sourced' from a vast range of participants (Gauntlett 2008: 1–2; Ritchin 2009: 125). This gives the impression that each participant is engaging creatively with the media through both text-based and visual communication, often with an emphasis on playful participation. Images made on camera phones, for example, can be uploaded instantly to websites as digital files, or picture messaged from one phone to another. It is this that Sutton refers to as 'the mobile photograph'.

In 1995 Slater addressed the new issues arising from digital photography, prophetically noting that the flow of photographic images in digital form was becoming the most significant issue relating to the new version of the medium (Slater 1995: 131–132). Digital snaps can be uploaded to sites such as PhotoBox where they are printed and sent to customers often within 24 hours, or printed out by being sent wirelessly to other portable printers. But, as discussed in Chapter 4, the printing of photographs is only one way of experiencing them: digital photo frames for example allow images to be edited, ordered and viewed in domestic spaces, while handheld devices such as iPods, iPhones and camera phones include increasingly large screens and are often used to display images, as they can be passed around like individual printed snaps or photo albums (Rubinstein and Sluis 2008: 13–14). However, it is via the online dissemination of photographs that private snapshots have gone public.

ONLINE SOCIAL NETWORKING: SNAPSHOTS GO PUBLIC

In the mid-1990s, Slater pointed out that family albums were highly valued, noting that most people were likely to say that their photo albums would be the first thing rescued from a house fire after relatives and pets. However, Slater argues, surveys revealed that the making of snapshots often took precedence over the act of looking at the resulting photographs, which instead languished unseen in albums, boxes and envelopes (1995: 137–141). The reason for this, Slater suggests, is that while the process of making snapshots was incorporated into systematised leisure activities (holidays, family celebrations, etc.), very few structured activities existed for viewing them (1995: 138–140).

While digital photography had been in existence for some time by 1995 (see Chapter 2), it remained largely the preserve of professionals and hobbyists, who used the new technology as an old-fashioned 'darkroom' where a print was still the end result (Rubinstein and Sluis 2008: 11–12). But around the turn of the millennium the digital snapshot found a role as part of new mainstream structured leisure activities. This was due to the revolution in home computers and high-speed Internet

access, leading to the widespread use of emails, blogs and websites as forms of communication. Digital photographs became the preserve of most people, with snapshots rarely printed but instead viewed on screens. The ease with which digital images could be transmitted online led to a dramatic change in the circulation of photographs.

As Rubinstein and Sluis argue, this revolution coincided with the development of camera phones, resulting in a convergence between 'Kodak Culture' and 'Nokia Moments' (2008: 10). Sutton has identified the significance of moblogs (blogs consisting of regularly uploaded mobile phone images) (Sutton 2005). More generally, photo-sharing sites such as *Fotolog* (which featured 90 million pictures by 2006 (Long 2006)) and *Flickr* (19 million pictures by 2008, increasing annually by around 30 per cent (Rabia 2008)) became places where all kinds of photographic images were made visible to their millions of members. But it was with the emergence of online social networking websites such as *Facebook* in the early part of the 21st century that the snapshot became more public than at any time in its history (see Figure 5.2).

Facebook has its origins in a website developed at Harvard University in 2004 based on yearbooks where students present an image and information about themselves for fellow students to see. By 2007 the website had expanded to a global scale with 50 million users worldwide:

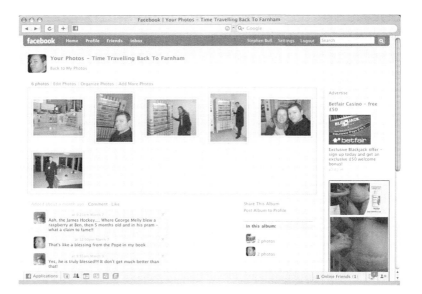

Figure 5.2 *Facebook* page (2009) © Facebook.

its primary functions centring on self-presentation, communication, game playing, and the publicising of events and issues (Hodges 2008: 8–10). Such a phenomenon fits with an era of individuality and isolation in the West, as it reconnects people in an increasingly disconnected culture. Snapshots are central to *Facebook*, with users regularly uploading images of themselves and their relatives and friends (Hodges 2008: 8). Through photo-sharing and online social networking millions of snapshots are now made public, not as art – which was usually the only way such images were previously publicly seen – but still in their role as snaps (Cobley and Haeffner 2009: 125–126; Rubinstein and Sluis 2008; see also Langford 2008). From this perspective, snapshots could now be seen as the 'loud majority' of photography.

How these snapshots are ordered and viewed needs to be considered. Lev Manovich has argued that storing digital photographs results in a collection that can be viewed, navigated and searched (Manovich 2001: 219). Rubinstein and Sluis contend that the millions of online snapshots on social networking sites create an expanded 'social life' for the snapshot (2008: 17–18). But authors such as Langford have noted that the meanings of snapshots are only clear to their participants (Langford 2001), and it might therefore be asked whether the potential for millions to see snapshots online actually results in a public interest in viewing other people's snaps. However, the navigation of snapshots on websites via devices such as tagging – where the subject matter of images is labelled by users and becomes searchable within a 'database' – allows people to find and be alerted to images that are potentially relevant to them.

Through such navigation, the experience of snapshots online becomes far less linear than viewing the chronologically ordered snaps in most post-Victorian photo albums (Rubinstein and Sluis 2008: 19–20). The tags and comments that can be added to online snapshots mimic the pointing out of subjects and verbal commentary by viewers that accompanies looking at albums and was also a vital element of traditional domestic slideshows. Indeed it could be argued that with online social networking Slater's 'dreaded slideshow' has returned on a global scale. The reappearance of digital snapshots in different users' online 'photo albums' and the varied comments that can accompany them from a multitude of viewpoints creates an endless re-contextualisation of images, whose meanings are never fixed – fully exposing the polysemy of photographs (Ritchin 2009: 147–157; Rubinstein and Sluis 2008: 18–21; see Chapter 3 for a definition of polysemy).

Every December the American magazine *Time* announces its 'Person of the Year'. This accolade has been given to such luminaries as Winston Churchill, Martin Luthor King Junior, and Barack Obama. In 2006 *Time*

gave the title to 'You'. The cover of the 25 December issue of the magazine featured a computer, the screen of its monitor replaced by mirrored paper to reflect the reader. Richard Stengel, the magazine's editor, justified this choice by arguing inside that through online technologies the public were interacting with – and therefore 'creating' – the mass media as never before (Stengel 2006: 4). Slater contends that in the late 20th century the idea of the 'chooser', who decides their own pathway through the media they use, was replacing that of the consumer. However, he argues that these decisions can only be made within a structure that is not created by the choosers themselves. Instead, digital images join the previously existing flow of systematised leisure, with users selecting from pre-programmed choices and with certain pathways encouraged (Slater 1995: 141–143).

In terms of snapshots, online social networking sites take their structures from older traditions: for example, just as with Kodak Culture, the recording and viewing of leisure activities rather than work is actively promoted on *Facebook*. Most uploaded snaps still fit the traditional categories defined in the first section of this chapter. Any potential for true interactivity and empowerment through disseminating a more diverse range of photographs via online social networking does not take place because these images do not fit within the structure of such sites (see Cobley and Haeffner 2009). The online systems by which 21st-century snapshots are widely distributed empower the user to conform.

Private viewing is arguably a central characteristic of snapshot photography. Once a snap becomes public, the meaning of the picture – which was previously specific to its participants – can change dramatically with its new context. For example, in 2007 images of Oxford students celebrating their exams over-enthusiastically in the street were used as evidence towards their expulsion after the photographs were posted on a *Facebook* page. The same year, a British parliamentary aide was forced to resign from his job when images of him 'blacking up' the face of a colleague appeared online (Doorne 2008: 110–111; see also Sutton 2005: 46–47). Images from social networking sites are also widely used to illustrate news stories in papers and online; for example, if someone who was previously unknown to the public becomes newsworthy, images of them from their online albums often become widely reproduced.

With their move from the domestic space to wider contexts, snapshots have gone from the silent majority to the loud majority of photography. However, in that process the meanings of the images have altered. Snapshots can now function as a form of voluntary surveillance, where the private photograph becomes a public document.

THE PHOTOGRAPH
AS DOCUMENT

In 1844 William Henry Fox Talbot enthusiastically promoted the useful-
ness of the photograph as document. Inside his book *The Pencil of Nature*
he accompanied a picture of his own *Articles of China* (ornate vases, bowls,
figurines, and cups and saucers lined up in rows on shelves) with the
statement that the photograph would provide legal evidence of his
possession of these objects should they be stolen (Sekula 1989: 344–345).
The descriptive simplicity of Talbot's image, each object ordered and
presented frontally to the camera then recorded in some detail by the
resulting photograph, makes it the perfect example of a photographic
document (this desire to catalogue also recalls the legacy of photog-
raphy's Enlightenment-era origins; see Chapter 2 and Roberts 2004b).
Throughout its uses in this context, photography is seen to provide
evidence of what was in front of the camera lens. Central to this are the
terms 'objectivity' and 'subjectivity'. With photographic objectivity it is
'the objects' in front of the camera that are regarded as producing the
photograph. With photographic subjectivity it is the photographer behind
the camera – known as 'the subject' (not to be confused with the picture's
subject *matter*) – who is regarded as the producer of the photograph. I
return to these ideas and apply them to images throughout the chapter. As
we shall see, the distinction between the terms is often open to question.

 This chapter examines the various applications of photographs as
documents. The first two sections begin with an introduction to ideas of
photographic evidence and how photography has been used to record and
survey the human face and body in legal, medical, educational and anthro-
pological discourses. The next two sections trace the way documentary

photography moved from being regarded as an objective device for revealing 'things as they are' in a primarily photojournalistic context to a form of subjective expression in the context of photobooks and gallery exhibitions. In the final two sections I debate the role of photography in war and terrorist incidents in revealing and concealing evidence; including an examination of the ways that such events are now more likely to be seen by the public through photographic documents made not by professionals but by amateurs.

PHOTOGRAPHS AS EVIDENCE: PORTRAITS AND SURVEILLANCE

Portrait photographs have generally been widely regarded as providing evidence about their subject's outward appearance; sometimes portraits are also thought of as revealing something about their subject's inner personality (Barthes 2000: 10–12; Clarke 1992; Ewing 2006; Rosenblum 1997: 74–78). The portrait photographs that appear on the profile pages of social networking websites such as *Facebook* form part of an online image and text database of information by and about that individual (see Chapter 5). In turn, this is embedded within a much larger database of information about other individuals. In the 21st century, concerns have been raised about the availability and use of such personal details, especially when they can be widely disseminated (or lost) (see Davies 2000). In the UK, the planned National Identity Scheme, wherein all British citizens were due to have their passport information recorded on a national database by 2012 with the option of an identity card complete with photograph, became the centre of much controversy. Whereas the range of profile pictures on social networking sites have no official guidelines for them and vary widely in their style, the look of such government-controlled photographs is strictly regulated and demands that the front of the subject's head and face are fully revealed to the camera.

The increasing opportunity to have a photographic portrait made in the mid-19th century (see Chapter 4) led to what John Tagg refers to as a 'democracy' of the image (Tagg 1988a). Like the profile pictures found on *Facebook*, most photographic studio portraits in the mid-19th century exhibit a range of styles, often resembling portrait paintings in their asymmetry and elaborate posing (see Pinney 1997: 74–75). Even police photographs of the 19th century, such as the image of the captured Lewis Payne discussed by Roland Barthes in *Camera Lucida* and reproduced in John Szarkowski's *The Photographer's Eye* (Barthes 2000; Szarkowski 2007; see also Chapter 2), can look like a flattering portrait to a contemporary

audience. But by the end of that century a much more familiar and uniform approach had come to dominate the look of the photographic portrait: a frontal view of the head and shoulders, much like that of the passport photograph (Tagg 1988c). David Green and Allan Sekula have both argued that this was due to the effects of developing ideas about physiognomy and phrenology, which together influenced the emerging science of eugenics (Green 1986; Sekula 1989). All of these theories, which continue the Western world's earlier Enlightenment beliefs in progress, order and classification (see Chapter 2), contentiously suggested that facial appearance and the structure of the head were visible indications of personality and intelligence.

Because photography was seen as the ideal tool for providing evidence due to its perceived indexicality (see Chapter 2), it was used to observe and record the face and head. In the 1850s and 1860s the British eugenicist Francis Galton obtained portrait photographs of criminals from the archive of Millbank Prison. He meticulously re-photographed these pictures, exposing a number of them onto a single glass plate negative to create a 'composite' image. As Green notes, any individual details were lost in the mass of superimposed faces, while any recurring traits were emphasised (1986: 17). The resulting images, Galton argued, provided faithful evidence of the physical appearance of 'the criminal type'.

Galton's images are often examined in comparison to those made by the 19th-century Paris police photographer Alphonse Bertillon, who devised a precise system of photographing criminals (Hamilton 2001). This involved photographing the full face and profile of each individual subject from a precise distance, accompanied by the measuring and recording of information about the subject's physical features (Sekula 1989). Vitally, these details were then filed within cabinets enabling data to be quickly found and through which comparisons of subject could be made. As Sekula puts it, Galton 'sought to embed the archive in the photograph' through his combining of archival photographs in his composites, while Bertillon 'sought to embed the photograph in the archive' through his placing of the photograph within an archival system (1989: 373). Arguing from a postmodern critical approach, Green and Sekula emphasise the meaning of these photographs in the social context of the developing evolutionary theory in the West in the 19th century (Galton was the cousin of its chief proponent, Charles Darwin). The physiognomic 'evidence' provided by these photographs was used to legitimate the hereditary 'superiority' of certain groups of people, such as the emerging middle-classes, and even the potential elimination of their 'inferiors'.

The legacy of this systematisation of photography as evidence was – and is – huge. By the 1890s the UK was the first of many other countries

to take up France's Bertillon-style technique of full-face and profile images for photographing criminals (a technique that is still in place). Since 2005 these kinds of images have been made available to the public on the UK police force's *Most Wanted* web pages. To Peter Hamilton this style of photographic evidence continues and extends far beyond legal institutions, remaining 'the dominant metaphor for identity in the 21st century' (Hamilton 2001: 106). Sekula argued towards the end of the 20th century that the ideas evidenced in Galton's work continued to be central to debates about genetics (1989: 376). Sekula also noted that the emergence and development of institutions such as the police run parallel with the emergence and development of photography.

This is an argument expanded by Tagg, who has demonstrated that it is not just legal, but also medical and educational institutions that refined the use of photography as evidence in remarkably similar ways. Dr Hugh Diamond's 1850s photographs of inmates of the Surrey County Asylum, the pictures of children admitted to Dr Barnardo's 'Home for Destitute Lads' from the 1870s onwards, the anonymous images of convicts from Wandsworth Prison Records from the same era (at this point still showing the influence of painted portraits prior to their full 'Bertillonage' systematisation): all of these institutional and archival documents that were becoming elements of an increasingly ordered society during the 19th century connected their textual information with the same style of photographing their subjects (isolated, in a narrow space, brightly and evenly lit, sharply focused) (Tagg 1988c).

Tagg uses ideas from the French thinker Michel Foucault about how power and control permeates every part of society in order to analyse the way these images were used to survey and discipline the workforce of an increasingly industrialised society (whose members were required to be 'produced' as healthy, educated and law-abiding citizens) without the need for physical coercion (Tagg 1988c: 85–87; see also Chapter 3 and Green 1997). Foucault employed the Panopticon as a metaphor to describe such a society. The Panopticon was an 'ideal prison' (designed in the 19th century by the reformer Jeremy Bentham, who also first proposed the police force) where each prisoner was isolated in a narrow, brightly lit cell. Every cell was in a view of a tall central guard tower that had slatted windows so that the guards could see out, but the prisoners could not see in (Foucault 1977: 195–228). The Panopticon's potential for constant and unseen surveillance means that it is often employed as a metaphor for the society of surveillance in which many argue we now live.

The most visible means of this surveillance are closed circuit television (CCTV) cameras, which are prevalent in many cities: for example, in 2002 there was estimated to be one CCTV camera for every 14 people in

London (McCahill and Norris 2002: 20). Stills from these cameras are frequently reproduced in newspapers as evidence when criminal activity is reported. Although, as Sarah Kember notes, this can create frustration as the crime has not been prevented, only recorded, and vital details are often not visible (an early and particularly disturbing example being the stills of two-year-old James Bulger being led from a shopping centre by the two older boys who then murdered him) (Kember 1995). Kember has argued that the very look of CCTV stills – low definition, aerial views – has come to connote 'guilt' (1995: 125). (In the same way, pixelated images from social networking sites of the victims or perpetrators of crimes are often reproduced in newspaper articles, with similar connotations (see Chapter 5).)

The aerial view has been a part of photographic evidence since Nadar (Gaspard-Félix Tournachon) took pictures of Paris from a hot air balloon in the 1850s (Martin 1983; Rosenblum 1997: 245–247). In the 21st century, *Google Earth* provides another apparent 'democracy of the image', not for everyone to have a portrait made so that they can be looked at, but for everyone to look upon the entire world in great detail via a patchwork of satellite photographs (see Mitchell 1992: 57) and details at ground level via the controversially revealing *Street View* application. Or almost the entire world: some governments have requested that certain areas of their country remain pixelated from view (Ritchin 2009: 123). This precise mapping of the world recalls the Enlightenment-era origins of photography discussed in Chapter 2.

CLASSIFICATION BY OBSERVATION: ANTHROPOLOGY AND COLONIALISM

The same Enlightenment-era beliefs in progress, order and classification that led to the development of eugenics and evolutionary theory in the Western world also inspired the creation of encyclopaedias. The original vast *Encyclopaedia*, published between 1751 and 1772, comprised 17 volumes of text and a further 12 volumes of illustrations which, as Hamilton argues, indicates the importance of images as a method of conveying information (Hamilton 2001: 58–59). Encyclopaedias were a way to bring together knowledge based on observation and recording: once things were observed and recorded they could be put into some kind of order and classified. In the 1830s, just as photography was becoming public, Auguste Comte developed the philosophy of positivism, the central idea of which is that facts about the world can be gained through unbiased observation (see Robins 1995: 33–34; Slater 1997a: 96–99; see also Chapter 2). Positivism exerted a huge influence on the development

of sciences, including the social science of anthropology (the study of humankind).

With its links to science and nature and its perceived indexicality (see Chapter 2), photography, coupled with positivism, began to be used as an observational and recording tool for anthropology as the West explored and documented 'the rest of the world' (Hamilton 2001: 85). This exploration included colonising countries such as Africa and India as the British Empire – and the empires of other European countries – expanded (Edwards 1997). In Britain the Royal Anthropological Institute, another institution that emerged at around the same time as photography, began to establish guidelines about how to create photographic evidence of the people, places and objects that were being observed. While there were some variations in technique, the conventions encouraged are remarkably similar to those that Tagg identifies within medical, educational and legal institutions. Elizabeth Edwards, a writer at the forefront of studies on photography and anthropology, notes how people were photographed one by one, isolated in bright and evenly lit shallow spaces (Edwards 1997: 56).

The two pioneers of this kind of anthropological photographic classification were J H Lamprey and T H Huxley. As well as full face and profile images, their guidelines advocated the full-length study of the body, which they recommended should be naked (a style that has been linked to the type of illustrations found in encyclopaedias; see Spencer 1992). In the late 1860s, Lamprey devised a system where subjects were photographed in front of a portable frame of silk threads forming a grid of two-inch squares, allowing for the comparison of measurements across subjects, while at around the same time Huxley recommended the use of measuring rods against which subjects were positioned (Edwards 1997; Hamilton 2001). Placed within a system of images, these photographs could be made to function as individual types representing the whole, allowing for comparisons across races. As Hamilton notes, what was considered 'superior' (the look and shape of the Western European face and body) was compared with what was considered 'inferior' (the look and shape of any other type of face and body) in order to legitimate colonialism and social Darwinist evolutionary theory (2001: 84–93).

Edwards applies the idea of the exotic 'Other' to this issue: where what is different (or Other) is an object of both anxiety and desire, used to justify the 'normality' of what is not Other (an idea that has also been analysed in detail by Edward Said) (Edwards 1997; see also Said 1991 and Chapter 3). Photography plays a key role in providing 'evidence' of this in what are of course highly staged, performative photographs: for example, the nakedness of the subjects could be read as connoting an uncivilised

'savage' compared to the civilised clothed Westerner (Edwards 1992, 2001). Christopher Pinney has argued that it is not just the strict guidelines for making anthropological photographs that authenticates them as evidence (their meanings fixed by their positioning within the image and text system of the archive), but also the perceived technological superiority of the camera apparatus itself (Pinney 1992). The era of anthropological and colonial certainty, from approximately the mid-19th century to the early 20th century, coincides with an era of photographic certainty. Pinney argues that uncertainty about photographs of anthropological origin emerged when they were removed from their meaning-fixing position within archives and became the object of much critical analysis during the final decades of the 20th century – coinciding with an era of postmodern questioning of the reality of the photograph (Charity et al 1995; Edwards 1992; Pinney 1992). Edwards has consistently emphasised that while anthropological photographs are still images meant to record facts, meanings move around them and shift over time: they are active, unfixed images, not passive bearers of fixed, anthropological evidence (Edwards 1992: 3–17; Edwards 2001; see also Chapter 2). As Edwards and Pinney's arguments make clear, the perception of anthropological photographs as evidence has altered as the belief in the reliability of photographic documents in general has changed.

OBJECTIVE FICTIONS: DOCUMENTARY PHOTOGRAPHY AND PHOTOJOURNALISM

Although the term 'documentary' was occasionally used before the 1920s (see Winston 1995: 8–10), it was not yet in wide circulation when photographers such as Jacob Riis and Lewis Hine were making the images that are regarded as some of the most well-known precursors to documentary photography. Riis, a pioneer of flash photography, and Hine, a sociologist who took up the camera to record child and immigrant labour, illuminated the poor conditions of workers in America in the late 19th century and early 20th century respectively (Marien 2006: 202–208). The books they published of their photographs were an attempt at social reform and led to some improvements in the situations they recorded. It is this kind of social documentation that first came to be closely linked with the term 'documentary'. As the previous sections in this chapter have suggested – and as Martha Rosler, Abigail Solomon-Godeau and Ian Walker have all pointed out – the word 'document' was believed to be applicable to most photographs up until the early 20th century. When Eugéne Atget (another perceived precursor of documentary photography, who meticulously photographed Paris for over 30 years until his death in

1927) described his pictures as 'simply documents I make', he was articulating a view of photographs as being 'objective' that was dominant at the time (Nesbit 1992: 1; Walker 2002: 21–22). It was only after some practitioners began to successfully establish photography as an art form that there was a need to define which images were based on 'objective' reality (documentary) and which were instead the creations of an artist's 'subjective' sensibility (art) (Rosler 2003; Sekula 1982; Solomon-Godeau 1991b; Walker 2002: 21–23; see also Chapter 7).

The concept of documentary is therefore historically specific. The word and its associated ideas largely derive from the filmmaker John Grierson, who in 1926 described a film by Robert Flaherty as having 'documentary value' (see Solomon-Godeau 1991b: 299–300n; Wells 1999: 213). Like Grierson, Flaherty made films about the lives of real people, including *Man of Aran* (1934) based on a family struggling to survive the harsh conditions on the west coast of Ireland. Flaherty also used a high degree of fiction, construction and staging; for example, the family members in *Man of Aran* were not actually related and many scenes were performed specifically for the camera (see Wells 1999: 217–219; Winston 1995: 19–23). Nevertheless, the idea of objectively recording people living very different lives to those of the film's viewers, and especially lives that are difficult and which might raise the moral concern of the audience, became embedded in the idea of documentary film and was carried over to the term's use in photography (later being retrospectively conferred onto the work of Riis and Hine in seminal histories of photography, such as Newhall 1964; see also Bull 2003). Yet both Rosler and Solomon-Godeau have argued, from a point-of-view clearly informed by Marxism, that this kind of 'concerned' documentary labours under the idea that social reform will make a fundamental difference to society by raising consciousness of issues, without taking into account that a capitalist system requires the exploitation of workers and a hierarchy of wealth to function (Rosler 2003: 262; Solomon-Godeau 1991b: 179).

What is arguably the definitive concerned documentary photography project took place in 1930s America during an era when the US capitalist system seemed on the verge of collapse. At a time of droughts and economic depression, the government-led Farm Security Adminstration (FSA) commissioned a team of photographers including Walker Evans and Dorothea Lange to record the plight of the starving farmers, many of which had left their farms to search for work. Evans' images of farming families and the austere conditions in which they lived (such as the corner of a barely furnished farmhouse kitchen taken in Hale County, Alabama during 1936 (see also Chapter 7)) and Lange's famous photograph of a

worried but stoic woman still looking after her children (a picture usually known as the *Migrant Mother*, see Lange 1996; Price and Wells 2009: 38–49), have come to represent not just the FSA but concerned documentary photography in general. It is important to note that at the time, however, the names of the photographers were irrelevant to the audience, reinforcing the idea of objectivity. Only later, as discussed below, did the photographers' subjective viewpoints become recognised as significant.

Many of the FSA photographs were published in widely read newspapers and magazines to raise awareness of what was happening. Mary Panzer has traced the development of photography in newspapers and magazines where, from the first reproduction of an actual photograph in 1880 to the boom in photo magazines from the 1920s to the 1960s, photographs were prioritised and appeared along with text, applying the principle of montage (see Chapter 3) to tell 'objective' stories about 'things as they are' (Panzer 2006: 8–33). In Europe *VU*, *Münchner Illustriete Presse* and *Berliner Illustriete Zeitung,* in Britain *Picture Post* and *The Sunday Times Magazine* and in America *Life* (along with many other photo magazines across the world) helped to establish and consolidate the principles of photojournalism during this period (Hall 1979; Hopkinson 1970; Panzer 2006; Rosenblum 1997: 462–479).

Initially, newspapers and photo magazines would commission photographers to work for them, and it is important to remember the impact of editorial control over photographers' commissioned work and the wider ideological context in which these magazines were produced (*Picture Post*, for instance, was primarily created by its editor Stefan Lorant as a form of pro-British propaganda in the run up to the Second World War). However, clashes between editorial policy and the use of photographs led to many photographers resigning from their roles as staff photographers and seeking greater independence (Capa 1989; Rosenblum 1997: 485).

During the middle years of the 20th century, freelance photographers such as Robert Capa and Henri Cartier-Bresson strived for such a freedom, travelling the world and getting close to the action using new smaller and faster cameras such as the Leica (Rosenblum 1997: 480–191). Capa's pictures from the D-Day Landings and Spanish Civil War show his close proximity to the fighting, especially in images such as that of a falling Spanish loyalist soldier (published in magazines including *VU* and *Life*) who was apparently shot dead in front of him. Cartier-Bresson defined the act of street documentary and coined the term 'the decisive moment', where an action, gesture or expression is caught in a perfectly composed photograph (see Chapter 2); his approach, like other street photographers

of the mid-20th century, was also influenced by the Surrealist idea of 'chance encounters' in the city street (Durden 1999; Scott 2007: 162–194; Walker 2002: 168–187; see also Chapter 3).

Sometimes these 'chance encounters' have proven to be less than random. Images by photographers such as the similarly Surrealism-influenced Bill Brandt, the street photographer Robert Doisneau and the extraordinary tabloid photojournalist Weegee (Arthur Fellig) have been revealed to be set-ups with fictionalised elements (Barth 2000: 26–28; Thomas 2006: 126–128). There has also been much debate about whether Capa's famous photograph actually depicts the soldier being shot (see for example Brothers 1997: 178–185; Koetzle 2002: 18–27; Sontag 2004: 29–30; Taylor 1998: 58–59). Many of the supposedly 'objective' images made within the discourse of documentary are in fact highly constructed fictions. The peak of such fictional photojournalism may have been reached in the 21st century with a new breed of freelance reportage photographers who work within virtual worlds such as *Second Life*, photographing entirely digital people and places in entirely digital images (see Ritchin 2009: 144).

The American philosopher and semiotician John Deely has made the distinction between things, objects and signs (Deely 1994) – distinctions that are useful for the analysis of objectivity and subjectivity in photography. 'Things', in Deely's terms, exist in nature without the need to be experienced by humans, whereas 'objects' – to be objects – are things that are, as he refers to it, 'dosed' with human experience. When these objects are used in processes of signification (when they are photographed, for example) they become signs (see Chapter 3). To Deely, then, 'objectivity' must be redefined: it is not – as it is commonly understood – some kind of unbiased point-of-view, but is instead already a viewpoint on the world determined by human experience of objects. Deely's distinctions suggest that the idea of presenting 'things as they are' – without human intervention – via photographs is impossible. We can never apprehend 'things' because, as soon as we do so, they become 'objects' of our experience. Equally, 'subjectivity' is also called into question by Deely's ideas. Because he argues that the interpretation of all objects is affected by human experience in general, a subjective view of the world can consist only in what is an individual variation of a more general objectivity. According to Deely's argument, the differences between objectivity and subjectivity become almost irrelevant. In the next section, ideas of subjectivity are further debated in relation to documentary photography.

SUBJECTIVE FACTS: DOCUMENTARY PHOTOGRAPHY IN THE PHOTOBOOK AND GALLERY

Walker has argued that, whereas American documentary photography such as the FSA was seen as state-sponsored and objective, from the 1930s onwards an increasing idea of the subjective expression of individual convictions through photographs was combined with the observation of reality that had developed in European documentary photography (Walker 2002: 22). Emblematic of this freedom from editorial control and the increasing emphasis on supposedly subjective, individual viewpoints on topics was the formation in 1947 of Magnum, a co-operative photo agency where all members retain control of how their images are used (Capa and Cartier-Bresson were two of the agency's founders, and pioneers of the photo essay such as W Eugene Smith soon joined) (see also Chapter 3). However, as Deely's ideas suggest, this idea of individual viewpoints in documentary photographs suggests a potential problem. Grierson himself defined documentary as 'the creative treatment of actuality' – but Brian Winston has wondered just what is left of 'actuality' after it has been treated creatively (1995: 11). In answer to this, Walker proposes that the documentary photograph combines construction with indexicality: positioning the documentary photograph as a kind of subjective fact (Walker 2002: 8–29). Catherine Belsey has defined the term 'expressive realism' as one which describes works in any medium that 'tell truths – about the period that produced them, about the world in general or about human nature – and that in doing so . . . express the particular perceptions, the individual insights of their authors' (Belsey 1980: 2). Victor Burgin has argued that this idea of expressive realism underpins a great deal of visual practice in the Western world, 'and it is nowhere stronger than when it is legitimating documentary photography' (Burgin 1986b: 157).

Documentary photographers came to increasingly acknowledge and exploit this idea of presenting subjective facts in their photographs (Westerbeck 1998), and the single-authored book (or 'photobook') became one of the key vehicles for their opinions. When Robert Frank toured America in the 1950s making photographs along the way for his book *The Americans*, originally published in 1958/9, he deliberately set out to discover and present his own point-of-view on the country (see Ferguson 2001: 9–11; Mitchell 2005; Weski 2003: 24–25). With its subtle, rhythmic ordering of images and recurring motifs, Frank's book was a cynical and celebratory 'poem' in photographs – and hugely influential on future generations of photographers who were to convey their subjective viewpoints in projects on specific subjects (Parr and Badger 2004: 232–239).

In the 1970s and 1980s, under the influence of Americans William Eggleston and Stephen Shore, colour became used increasingly in documentary (see Butler 1999). Black and white photography – so long the format of 'serious' photography associated with photojournalism, rather than garish, fanciful advertising (see Chapter 4) or frivolous snapshots (see Chapter 5) – began to look nostalgic in a culture of colourful consumerism. By the 1980s, a British wave of subjective colour documentary photographers including Anna Fox, Paul Graham and Paul Reas were depicting their personal viewpoints on contemporary themes in monographs of their work (Williams and Bright 2007: 137–139). Martin Parr, the most well-known photographer to emerge from this era, was able to fully acknowledge that his witty, bright photographs recording everyday life in a style that became known as the 'snapshot aesthetic' (mimicking some of the visual characteristics of snapshot photography defined in Chapter 5), were created with a full awareness that photography is an inherently prejudiced and exploitative medium (Parr 1999; Williams 2002).

By the last decades of the 20th century, photographers such as Nobuyoshi Araki, Nan Goldin and Richard Billingham were essentially producing diaries in a loosely documentary form. Throughout the years since the 1970s, Japanese photographer Araki and the American Goldin have recorded their own lives as well as those of their friends and lovers in intimate, explicit and sometimes painful detail (Cotton 2004: 136–165). Some of British artist Billingham's photographs of his family were originally taken as the basis for paintings. The photographs themselves were then expanded into book form in the 1990s and have been regularly exhibited in galleries ever since, with Billingham being nominated for the Turner Prize in 2001 (see Billingham and MacDonald 2007). The showing of work such as Billingham's in exhibitions is an indication of the shift in context for documentary photography that happened in the late 20th and early 21st century – as documentary photography left the pages of newspapers and magazines to find a place, not just in photobooks, but on the gallery wall.

The 1955 exhibition *The Family of Man* at the Museum of Modern Art, New York (MoMA) represents a transitional moment when the kinds of photographs found in a documentary context of newspapers and magazines moved to being exhibited in an art gallery (Steichen 1955). Like many of the photography exhibitions curated by Edward Steichen during his time at MoMA, the look of the show retained some aspects of a photojournalistic context: prints of varying sizes (some very large) were hung from the ceiling as well as on freestanding walls and arranged so that visitors 'walked through the exhibition as if strolling inside the pages of a magazine' (Panzer 2006: 20).

In Steichen's shows at MoMA the overall theme of the exhibits generally superseded the ideas of individual photographers. Indeed, Christopher Phillips has likened Steichen's role to that of a picture editor (Phillips 1989: 24–25). The concept of *The Family of Man* was to present a 'humanist' view of the world (an approach familiar from much magazine photojournalism under the auspices of editors such as Lorant), where documentary photographs from around the planet were combined to suggest that all human beings are essentially the same and equal. *The Family of Man* in the form of both its touring exhibition and accompanying book was hugely successful but has been widely criticised, most famously by Roland Barthes who argued that the presentation of human life as 'one big family' ignored all the historical, cultural and economic differences that separate human beings across the world (Barthes 1973: 107–110). Other writers such as Miles Orvell and John Roberts have countered that the show's incorporation of images from Communist Russia and of contemporary American black culture into 'the family of man' at all during a time of widespread Cold War paranoia and racial segregation in 1950s America was an achievement in itself (Orvell 2003: 115–120; Roberts 1998: 122–127).

Even before they were used for *The Family of Man*, Evans' photographs had already been removed from their FSA context and exhibited in 1938 as evidence of his skill as a practitioner in the first solo exhibition by a photographer at MoMA (and in the accompanying book *American Photographs*). Evans was later to distance his work from the 'documents' that he argued were the kinds of images made by police photographers, claiming instead to work in a 'documentary style'; a phrase which has been interpreted as meaning the taking of a more subjective, individual and artistic approach to documentary photography (Bush and Sladen 2006: 11; Dexter 2003: 16; Weski 2003: 23). This is an example of the way that the interpretation of photographs can shift depending on discursive context: in this case the images came to be presented as subjective expression rather than objective documentary (see Chapter 3 and Sekula 1982: 108–109). In 1967, John Szarkowski's MoMA exhibition *New Documents* presented three street documentary photographers (Diane Arbus, Lee Friedlander and Garry Winogrand) in precisely the role Belsey defines as 'expressive realists' (Panzer 2006: 22; Rosler 2003: 269–270). As Steve Edwards has put it, their photographs were now seen as 'documentary turned inwards' (Edwards 2006: 58).

By the 1970s, what Walker has referred to as 'honourable' documentary photography was commonplace in galleries: a form of image-making where practitioners show concern for their subjects while simultaneously expressing their own gifts as photographers (Walker 1995b:

244). Rosler called this 'victim' photography. The subjects were not only victims of their situations, but also of the camera itself, which presented them in aesthetically pleasing documents, while showing a general condition of humankind that apparently could not be changed (Rosler 2003: 261–264) and where pity, in Sekula's words, 'supplants political understanding' (quoted in Campany 2003a: 30). Susan Sontag argued that photographs represent a power relation between the person photographing and the person photographed, with the photographer as the one in power and the photographed as their 'victim'; an idea she saw as reinforced by the potentially violent language of photography (load, aim, shoot, etc.) (Sontag 1979: 14; see also Chapter 5 for the origins of these terms in photography).

As a response, and following Rosler's lead, Solomon-Godeau called for a reconstruction of documentary photography into a form that was critical both of social realities and of the claim to factuality of documentary photography itself (Solomon-Godeau 1991b: 183). Work made for galleries and books using sequences of images and texts were identified by Solomon-Godeau as examples of this. Rosler's own *The Bowery in Two Inadequate Descriptive Systems* (1975), made in pointed contrast to the work of the 'new documentary' photographers, presented images of an area of New York known at the time for street drinking, but minus any of the 'victims' themselves, alongside text panels of American slang terms for being drunk (Slyce 2001). Larry Sultan and Mike Mandel's 1977 book *Evidence* re-presented anonymous photographs made to record scientific, engineering, industrial and medical experiments in an art book context and minus captions in order to humorously reveal how the aesthetics of 'art photography' could be discovered in anonymous documentation (Sultan and Mandel 2003; see also Chapter 7).

The arguments for the necessity of such reconstruction and parody of documentary were strong. However, Walker has suggested that by the early 1980s the genre of documentary photography had been 'problematised almost to the point of paralysis' (1995b: 244). As an apparent response to this seizing up of the genre, the late 20th and early 21st century saw two different tendencies reinvigorate documentary photography in the context of art: images which used various degrees of construction (by artists such as Jeff Wall) and, at the other extreme, images which – returning to the early styles of photographic evidence such as Talbot's *Articles of China* – stripped documentary photography back down to an apparently basic level of describing 'the real' from straight-on, often distanced viewpoints (by artists such as Andreas Gursky). Both of these tendencies are analysed in the next chapter, which focuses on photography as art.

SHOCK AND AWE: WAR AND ITS AFTERMATH

British photographer Roger Fenton's photographs, made using a large format camera during the Crimean War in the 1850s, are often regarded as some of the first examples of war photography (see Rosenblum 1997: 178–191). The images Fenton made were generally either posed portraits of soldiers at rest or landscapes showing the aftermath of battles, most famously *The Valley of the Shadow of Death* (1855) where cannonballs strewn across the scene are the only visible suggestion of the preceding conflict (their possible interpretation as skulls suggested by the image's title and its reference to a line from Alfred, Lord Tennyson's poem *The Charge of the Light Brigade*, published the previous year). A decade later, Matthew Brady and his team of photographers also recorded the aftermath of battles, this time during the American Civil War. Their photographic documentation included picturing the dead bodies of those lying on the battlefield, as well as the devastation to cities and towns caused by the war – such as a series of pictures showing the skeletal remains of buildings in Richmond, Virginia.

While printing technology in the 1850s and 1860s was not yet advanced enough to allow actual photographs to be reproduced in newspapers (see Panzer 2006: 12), illustrations drawn from Fenton and Brady's pictures did appear – their basis on photographs conferring a kind of indexicality to the images (see Albert and Feyel 1998). The discursive context of the newspaper reportage also provided the images with an alleged neutral and factual objectivity, which the distance of space and time that photographers such as Fenton and Brady maintained from the events of war emphasised. However, as with Flaherty's filmmaking, these photographs involved elements of fiction as well: Fenton added many more cannonballs to the valley he photographed, while Brady and his team were not averse to moving bodies (Sontag 2004: 43–51).

By the time of the Vietnam War in the 1960s and 1970s – and following in the tradition of practitioners such as Capa – photographers, including Larry Burrows and Don McCullin, got as close to the conflict as possible while it happened (sometimes at the expense of their own lives). The photographs they made reached a vast audience via their reproduction as photojournalism in widely read publications such as *Life* and *The Sunday Times Magazine*. Many of what Umberto Eco has called the 'epoch-making' images of war and conflict (the ones that go beyond individual incidents and speak of a whole era) have often been regarded as 'shocking' in their content (Eco 1987; see also Barthes 1999). In the imagery of the Vietnam War these include Eddie Adams' image of a suspected Vietcong terrorist being executed, shot in the street by Saigon police chief Nguyen Ngoc

Loan (the picture capturing the moment the bullet is in his head) and Huynh Cong 'Nick' Ut's picture of a naked girl fleeing the napalm attack that has burnt off her clothes and is still burning her skin.

John Taylor has argued that these kinds of photographs are images of a simultaneously repulsive and attractive 'body horror', revealing bodies that are what Julia Kristeva calls 'abject' – where borders have been penetrated, threatening the imaginary limits of the body that the psychoanalyst Jacques Lacan argued are established in childhood during the mirror phase – and reminding the viewer of their own mortality (Kristeva 1984; Taylor 1998: 2; see also Chapter 3). The mass repro-duction of such images of a 'dirty' war helped to create active resistance against America's involvement in Vietnam. Taylor argues that, although such images disturb us, in a civilised society they need to be seen in order to provide knowledge of the atrocities of war (Taylor 1998: 193–196; Taylor 1999). This is a point agreed on by Susan Sontag in 2004 (2004: 102–106), consciously reversing her earlier belief that the repetition of such images eventually numbed their audience (1979: 19–21).

The Vietnam War also marked a turning point in the photojournal-istic coverage of conflict. Although still images were widely reproduced, the war was also transmitted on television throughout the world. Photography in newspapers and magazines, which had dominated reportage since the 1920s, was no longer the fastest means of visual communication (Campany 2003c: 127; Sontag 2004: 52). Governments learnt lessons from Vietnam. Later conflicts such as the 1981 Falklands War were kept 'clean' through the barring of coverage by all but a few photographers (McCullin, for example, was refused access; see Brothers 1997: 201–217). In more recent wars, photojournalists have been granted access through being 'embedded' within a regiment, leading to empathy with the soldiers and, arguably, less critical reflection on what they are photographing (Panzer 2006: 25; Ritchin 2009: 88). The Western mass media has also displayed a tendency to self-censor horrific images of death and suffering. Yet, as both Rosler, Sontag and Taylor have all pointed out, in an echo of a colonial past, the exceptions to this are the 'foreign bodies' of Others in distant countries (Sontag 2004: 63–65; Taylor 1998: 129–156). Such censorship became most apparent with the early 1990s Gulf War wherein, as Taylor puts it, 'the body vanished' from coverage to be replaced by images of glowing dots on screens representing missiles and targets, prompting Fred Ritchin to note the absence of any close-up photographs in the style of Capa or McCullin from the conflict (Ritchin 1991: 11; Taylor 1998: 157–192). This situation led Jean Baudrillard to controversially declare that 'the Gulf War did not take place'; although his point was that, due to the lack of images

the public saw of it, the war may as well not have happened (Taylor 1998: 175–176; Walker 1995: 246).

In these instances, what photography can do, Walker has argued, is document 'what comes after. . . it can still speak in considered retrospect' (Walker 1995: 240). As an example of this, Walker suggests the series *Aftermath* (or *Fait*): a photobook and exhibition of aerial views of the ravaged desert in Kuwait made six months after the end of the 1991 Gulf War by the French artist Sophie Ristelhueber. Walker notes that the images also appeared in magazines to publicise the book and show, but the work lost its impact in this edited and reduced form (1995: 241). This is a good indication of the contexts for which much documentary photography is now created in the first place: books and galleries rather than magazines (see also Panzer 2006: 33). Walker regards Ristelhueber's images as being 'weirdly beautiful', while also allowing the viewer to contemplate without sensationalism the terrible effects of the conflict (1995: 240).

Many other photographers, including Paul Seawright and Simon Norfolk, have adopted similar approaches since the early 1990s, influenced in part by the movement of documentary photography away from catching the action close-up in a 'decisive moment' (which has partially been replaced by the digital grabbing of stills from recording of events that have already happened, see Chapter 2) and instead towards influences from other genres such as landscape (see also Williams 1994; and Chapter 7). For example, Seawright's series *Hidden* – commissioned by the Imperial War Museum, London and made in June 2002 in Afghanistan following America's retaliation to the 9/11 attacks – avoids any spectacle; instead his images meditatively suggest what goes unseen by documenting the aftermath of the events, often with only their titles (such as *Minefield*) to anchor their significance (Bull 2004b; Chandler 2003). One of the photographs, *Valley*, which shows spent missile shells in a desert landscape (see Figure 6.1), has been widely interpreted as a conscious echo of Fenton's *The Valley of the Shadow of Death* from a century and a half before (see above) (Badger 2007: 26–27; Bull 2004b; Cotton 2004: 171; Durden 2003). This is contemporary art documentary photography's take on war: big, aesthetically pleasing photographs made after the bombs have been dropped and the bodies removed. Indeed, this kind of 'aftermath' approach can be seen to represent a partial return to the very earliest forms of war photography.

David Campany has labelled this type of documentary 'late photography', referring both to the arrival of the photographers after the action (resulting in photographs that are, in Campany's words, 'not so much the trace of an event as the *trace of* a trace of an event') as well as to the style

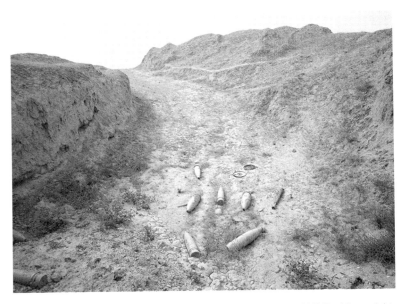

Figure 6.1 Paul Seawright *Valley* from the series *Hidden* (2002) © Paul Seawright. Courtesy Kerlin Gallery.

as being a late development in a genre of photography that, in the 21st century, appears to have been fully superseded by television and the Internet as the fastest way of communicating events (Campany 2003c: 124–127). Campany suggests that Joel Meyerowitz's images of Ground Zero taken in the days immediately following 9/11 on a large-format camera run the risk of being too 'safe' and beautiful, rather than addressing the politics of their horrifying subject matter directly (Campany 2003c: 132). Liam Kennedy has argued for these awesome images as important for 'national reflection and testimony' and noted Meyerowitz's awareness of their links to early documentary work and resemblance to Brady's images of American cities in ruins (Kennedy 2003). Mark Reinhardt has also debated the dangers of aestheticising violence, pain and death into photographs of 'beautiful suffering' (Reinhardt 2008), while Walker contends that, ultimately, a balance is required between aesthetically pleasing images of contemplation and images that evidence body horror. In contrast to Ristelhueber's aftermath images, photojournalist Kenneth Jarecke's disturbing picture of the charred remains of a dead Iraqi soldier from the 1991 Gulf War was one of the very few to appear in British newspapers at the time (perhaps because Jarecke's image shows the body of an Other), but was absolutely

vital in showing that 'the Gulf War did happen' and that people were killed (Taylor 1998: 181–183; Walker 1995: 247–248).

Just occasionally an image combines aesthetic contemplation with horrific evidence. Immediately after 9/11, Associated Press photographer Richard Drew's harrowing image of a man who leapt to his death from the stricken North Tower of the World Trade Centre was widely reproduced in newspapers and magazines. The man is perfectly vertical. After attempts to verify the true identity of 'the falling man', Drew's image has come to symbolically represent all of those who died in the attacks (Junod 2003).

EVIDENCE BY PARTICIPANTS: AMATEUR DOCUMENTS AND CITIZEN JOURNALISM

The repressed body dramatically reappeared in early 21st-century war photography, although this was often not through pictures made by professional photographers but by amateurs who, as well as being close to the conflict, were also integral to the events depicted. Dozens of images made by US soldiers including Lynddie England, Charles Graner and Sabrina Harman on digital cameras documenting their own humiliating torture of Iraqi prisoners in Abu Ghraib emerged in 2004 when a CD was leaked and the images were posted online and shown on news programmes around the world. Startling and disturbing in their content, these photographs were made by the victimisers of their victims (see Eisenman 2007). The soldiers adopt snapshot poses that, as Catherine Zuromskis has argued, are 'unsettlingly familiar': the soldiers have said that the poses came naturally to them, revealing the way we are all trained how to marshal ourselves for snapshots (Zuromskis 2009: 53; see also Chapter 5). As David Bate has noted, such kinds of 'trophy' photographs are far from new (Bate 2004b: 39), but in this case the images were made public, distributed fast via the very media – television and the Internet – that Campany argues have led to a slowing down of some forms of documentary photography. Indeed, while Campany sees photography's place in contemporary culture as being 'less central' due to other image technologies (Campany 2003a: 41), it could also be argued that photography is increasingly central to contemporary culture as part of these technologies. It is the digital pictures from Abu Ghraib, rather than the more 'triumphant' photojournalistic images by professionals of photo opportunities (such as the face of the statue of Saddam Hussein being covered by an American flag before the effigy was toppled), that have become – in Eco's term – the epoch-making photographs from the Iraq War.

As well as being recorded by professional photojournalists, the 7 July 2005 terrorist attacks on London were also documented by some of the

victims on their mobile phone cameras (which Panzer has described as 'a new means to reveal things as they are', Panzer 2006: 33). Alexander Chadwick took a series of pictures as he and hundreds of others walked to safety having evacuated a train on the underground (see Figure 6.2). Chadwick sent an image showing people moving towards a light at the end of a tube tunnel to the BBC website. As Ritchin has noted, the first images of the attacks appeared online. They also quickly provoked comments from the public: indicating how the immediacy of digital documentation can vastly expand not just the viewpoints seen on events, but also viewers' interpretations of the images (Ritchin 2009: 147–159). Within a few hours Chadwick's photograph appeared on *Flickr* as well as the BBC website. He was contacted via *Flickr* by the *New York Times* newspaper, which used the image on its front page the following day.

Chadwick's picture and the many thousands of other mobile phone pictures that were sent to the BBC website and *Flickr* by the end of the day of the bombings are examples of 'citizen journalism' where newsworthy events are documented by the public as well as professional journalists. Citizen journalism (including citizen photojournalism) makes amateurs the producers, not just the consumers of media (see Cobley and Haeffner 2009). Rubinstein and Sluis make the distinction that citizen

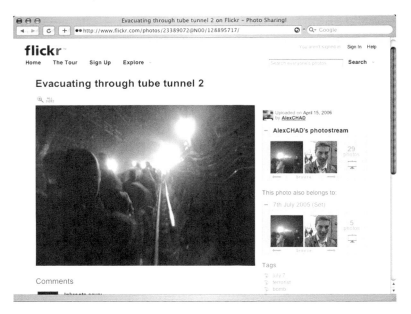

Figure 6.2 Alexander Chadwick *Evacuating Through Tube Tunnel 2* (2005). Picture by Alexander Chadwick / AP / PA Photos © AP / PA Photos.

photojournalism is from the subjective perspective of the participant, rather than what they call 'the position of the detached observer' occupied by the professional photojournalist (Rubinstein and Sluis 2008: 11). Angus Carlyle and André Gunthert have both suggested that, rather than digital images being seen as untrustworthy due to their malleability, the low-quality pixilation of photographs such as Chadwick's connotes authenticity (Carlyle 2005; Gunthert 2008; see also Berger 2009: 35; Brothers 1997: 179) – although there is no reason why an image with poor technical quality should actually be more factual than a technically good image. Carlyle suggests that this belief may only be temporary as the increasingly high technical quality of camera phones makes their pictures indistinguishable from those made on other digital cameras. However, Sontag has argued that it is not just the technical quality, but also the lack of 'good' aesthetics that leads to such pictures (and those from Abu Ghraib) being seen as having a greater authenticity than those of professionals:

> For the photography of atrocity, people want the weight of witnessing without the taint of artistry, which is equated with insincerity or mere contrivance. Pictures of hellish events seem more authentic when they don't have the look that comes from being 'properly' lighted and composed . . .
>
> (Sontag 2004: 23–24)

Ritchin argues that a distrust of a mass media based on staged 'photo opportunities' has made amateur photographs all the more convincing (Ritchin 2009: 125–130). It could therefore be said that the connotations of a lack of construction in such images connote to viewers that the photographs are 'too bad to be false'.

Panzer has argued for the importance of a combination of citizen photojournalism and professional images in contemporary documentary photography (2006: 374–375). Taylor claims that the mass media tends to fit documentary photographs into predetermined narratives of attack, victims, enemies, and retaliation, the meanings of each picture being directed according to the story required at any given moment (Taylor 1998, 2001). The making and distributing of images by amateurs bypassing the mass media can be a way of avoiding these narratives. The 2002 book, website and touring exhibition *Here Is New York: A Democracy of Photographs* mixed pictures taken by professionals and amateurs of the terrorist attacks on 9/11 and its after effects (George and Peress 2002; see also Panzer 2006: 33; Sontag 2004: 24–26). *Here Is New York* presents a plurality of points-of-view on the events, including a sparing few images of 'body horror'. Ritchin has referred to this as 'an intelligent predecessor'

to the online collaborative and multi-vocal websites that proliferated by the end of the first decade of the 21st century (see Ritchin 2009: 83–85). However, it is important to remember that all of the viewpoints in *Here Is New York* are from a Western perspective. The main title of the show reinforces the idea of the photographs as documents of 'things as they are', while the subtitle not only suggests the lack of distinction made between the professional and amateur images, but also the democratic myth (in Barthes' use of the term, see Chapter 3) that is a fundamental aspect of American society.

The photograph as document remains central to 21st-century culture. While the meanings of such photographs vary according to institutional context, the perceived indexicality of their content remains vital throughout. Debates about the potential differences between objective and subjective approaches continue. Most commentators on documentary photography see it as being in a constant state of flux as its aesthetics change and it moves from the newspaper and magazine page to the book, the gallery wall to the website (for example Rosler in the 1980s (2003), Walker in the 1990s (1995a) and Panzer in the 2000s (2006)). These changes have never yet heralded the death of documentary photography, but instead are symptoms of its continual and necessary rebirth.

PHOTOGRAPHS AS ART

The perennial question 'Is photography art?' may seem to have been answered for good by the early 21st century. In Britain, for example, major retrospective exhibitions of photography appeared for the first time at the art galleries Tate Modern (*Cruel and Tender*, 2003, *Street and Studio*, 2008) and Tate Britain (*How We Are*, 2007) and in 2005, after more than 180 years, London's National Gallery staged its first show by a photographer (see Chevalier and Wiggins 2005; Dexter and Weski 2003; Eskildsen 2008; Williams and Bright 2007). The photobook was fully acknowledged as a form of art practice (Parr and Badger 2004, 2006) and an abundance of overviews bringing together examples of photography as contemporary art were published (for example Bright 2005; Carver 2002; Cotton 2004; Demos 2006).

However, as established in the previous three chapters, the vast majority of photographs, made by almost everyone and appearing almost everywhere, are not considered to be art. It is therefore important to debate the practices and conditions through which certain photographs become perceived as works of art. This chapter begins with a section analysing the attempts by Pictorialists to establish their photographs as art by mimicking the look and subject of another media: painting. The second section examines how modernist practitioners switched to promoting the inherent qualities of photography itself for the same purposes. The implications of the placement of photographs within the context and discourse of galleries such as the Museum of Modern Art, New York are considered in the next section. In the following sections the influential role of photographs in the art movement Conceptualism and as part of

postmodern practices are assessed. Both of these led to galleries being far more open to contemporary art photography and the final section debates key aspects of such work in the late 20th and early 21st century, including the return to a form of Pictorialism and the critical language often used to analyse photography as art.

PICTORIALISM: PHOTOGRAPHY AS PAINTING

The perceived indexicality of photography has been central to its use in advertising, as snapshots, and as evidence (see Chapters 4, 5 and 6 respectively). However, since the public declaration of photography in 1839, many writers and practitioners have sought to establish the medium as art. In 1861 the British critic Jabez Hughes noted that photography was generally used as a document, asking 'may it not aspire to delineate beauty too?' (quoted in Newhall 1964: 59). Hughes' use of the term 'beauty' suggests the types of paintings then prevalent in the official 'Academy' exhibitions: attractive landscapes, idealised nudes, dramatically staged fictional, religious and historical tableaux, and flattering portraits.

By the mid-19th century photography had begun to enter the art gallery: the first exhibition entirely dedicated to photography took place in December 1852 at the Society of Arts, London (Taylor 2004). In January 1853, within the same exhibition, the founding of the Photographic Society – soon to be the Royal Photographic Society (RPS) – was announced. Its objective was the promotion of 'the Art and Science of Photography' (see Roberts 2004a).

In his book *Art and Photography*, written in the 1960s, Aaron Scharf traces the complicated relationship between painting and photography ('art' generally means painting in Scharf's book) (Scharf 1983). He notes that by 1859 the showing of photographs was finally permitted in Paris's annual Exhibition of Fine Arts. However, in a review of the 1859 exhibition, Charles Baudelaire attacked the way the 'modern public' had mistaken photography to be an art because it accurately recorded 'nature' – and were consequently rushing to have their portraits made (see Chapter 4). Art, Baudelaire argued, should not be about reproducing nature and harsh realities, but must instead be about beauty and the imagination of the artist (Baudelaire 1980; see also Galassi 1981: 27–28). Photography, with its mechanical basis, should remain the servant of art and 'the secretary or record-keeper of whomsoever needs absolute material accuracy' (Baudelaire 1980: 88).

Baudelaire's criticism hits upon many of the reasons why photographs have often been unfavourably compared to paintings as art. Susan Bright

has discussed these reasons (Bright 2005: 8), which in summary are due to photography's

- mechanically produced origins
- potential for mass reproduction
- links with commerce
- apparent lack of the need for 'artistic' skill.

In the 1850s and 1860s, those who had the time and finances to experiment with photography were able to counter some of these challenges with the groundbreaking work they made. Examples of these practitioners include Julia-Margaret Cameron (see Marien 2006: 96–97), Lady Clementina Hawarden (see Dodier 1999) and Henry Peach Robinson. Like his fellow RPS member Oscar Rejlander (see Chapter 2), Robinson composed photographs from a number of separate images. In 1869 he published *Pictorial Effect in Photography*, where he demonstrated how photographers could take their inspiration from Academy painting (Edwards 2006: 44; Scharf 1983: 238). For instance Robinson's *The Lady of Shalott* (1861) (see Figure 7.1) is a meticulously constructed photograph based on a mythological scene described in Alfred, Lord Tennyson's poem of the same title, which concerns a woman cursed to view the world only through its reflection in a mirror (a theme that relates to the mediation of the world via photographs). Not only does the fictional

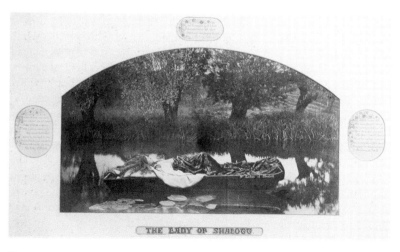

Figure 7.1 Henry Peach Robinson *The Lady of Shalott* (1861) © Royal Photographic Society collection at the National Media Museum / SSPL.

subject matter also connect with that of Academy painting at the time, but the arch-shaped presentation of prints of *The Lady of Shalott* that Robinson made associated it directly with John Everett Millais' similarly composed and framed pre-Raphaelite painting *Ophelia*, made ten years earlier and based on a scene from Shakespeare's *Hamlet* (and now in the Tate collection).

By the end of the 19th century Baudelaire's 'modern public' was beginning to photograph itself with the new, cheaper and easier to use cameras manufactured and marketed by Kodak (see Chapters 4 and 5). The resulting ubiquity of photography meant that those who wished to continue establishing the medium as a specialised and skilled art needed to separate themselves from the masses, leading to the creation of the multinational Linked Ring in 1892 (Mélon 1987; Solomon-Godeau 1991d: 110).

The style of photography these practitioners made has retrospectively come to be known as 'Pictorialism', partly due to the title of Robinson's book. It is the imitation of painting in an attempt to raise photography up to the same status as art that characterises the Pictorialist movement. This was tried through attention to content (subject matter and technique) and context (where the work was seen). As with Robinson's work, the subject matter of Pictorialism derives from the genres of traditional Academy painting of the time. Tableaux (images depicting elaborate and dramatically staged narratives) were a common theme of Pictorialist photography, each one meticulously constructed, with models' positions held as if they were posing for a painter (Henry 2006: 133–138). The Pictorialists also made use of techniques such as gum-bichromate, a way of printing a photograph so that the image could be manipulated with a brush while wet as though it were paint on a canvas (Scharf 1983: 238). As Abigail Solomon-Godeau has argued, such processes deny the mechanical nature, lack of 'artistic' skill and repetitive mass reproducibility of photography: factors that Bright identifies as preventing photography being seen as art. They offer the possibility for each print to be unique and show evidence of skilful alteration, potentially providing the photograph with what Benjamin referred to as the 'aura' of a one-off work of art (Solomon-Godeau 1991d: 106–108; see also Chapter 2 and Chapter 4). The Pictorialists hung their pictures in the Academy-style, with photographs filling the walls. This connection with the Academies of Paris, the centre of the Western art world in the late 19th and early 20th century, also helped to establish the images as art by association.

The most dramatic and arguably the most representative example of Pictorialist photography was made by Edward Steichen, a member of the Linked Ring responsible for many well-known images such as the

landscape *The Pond — Moonlight* of 1904 (see Chapter 4). Two years earlier, Steichen made a picture of himself that has so much painterly working of its gum-bichromate surface that it could easily be mistaken for a painting. Steichen appears in the photograph with brush and palette in hand, the artists' materials of the time. A brush and palette equalled easel painting and easel painting equalled art. Steichen's signature and the date of the photograph also appear within the image itself — something almost unheard of in the use of photographs as objective documents (see Chapter 6), but very familiar from subjective and expressive paintings. Finally, the title of the picture, *Self Portrait With Brush and Palette, Paris,* not only anchors what we see in the image, but also adds the information that the photograph was taken in Paris (although for all we know it could have been taken anywhere) — again connoting art by association. The clear suggestion made by this hazy print is that Steichen is an artist because he looks like a painter and the photograph is art because it looks like a painting.

MODERNISM: 'STRAIGHT' PHOTOGRAPHY

The American photographer Alfred Stieglitz was initially a member of the Linked Ring and a Pictorialist. In 1892 he made the photograph *Car Horses* showing the animals in a snow-covered scene. The steam rising from their bodies creates a misty Pictorialist effect. However, the horses are not in a rural setting, but are at rest after pulling a coach along a busy New York street. The urban setting hints at the inclusion of more up-to-date subject matter in Stieglitz's work, which continued with *The Hand of Man* in 1902. In *The Hand of Man* steam rises not from the bodies of horses, but from the funnel of a train as it travels towards the camera. The title anchors the reading of the photograph as being about a cultural product rather than nature: the train that has been created by human technology. This deliberately separates it from the traditional Academy subjects of Pictorialism (see Sekula 1982: 97). Although the detail of the image is still hazily Pictorial, it shows a moment caught — rather than the scenes set up and posed for the camera that were associated with Pictorialism (Henry 2006: 138). In *The Hand of Man* we see both the modern world arriving and the beginnings of a modern way of photographing it.

Chapter 2 includes a detailed analysis of the idea of modernism, which can be broadly described as the representation of the experience of the modern world from the mid-19th to the mid-20th century. However, not every representation made during this period should be regarded as modernist; it is only the practitioners at the forefront of new developments that are considered the *avant-garde* — those that go in advance of

others, contrasted with those that follow on once what is new and shocking has become tradition (see Greenberg 2003b; Wood 2002).

The image that is often discussed in histories of photography as one of the avant-garde modernist photographs of the early 20th century is Stieglitz's *The Steerage* (1907) (see for example Marien 2006: 182–183; Newhall 1964: 111–112; Orvell 2003: 88). This photograph is sharply focused and has no retouching. It shows the passengers huddled together in the cheap steerage section of a ship heading towards Europe. Stieglitz was travelling on the same ship, but in the expensive section. During the journey he discovered the scene at the steerage. It is useful here to quote at length Stieglitz's description, written 35 years later, of what happened next:

> As I came to the end of the deck I stood alone, looking down. There were men and women and children on the lower deck of the steerage. There was a narrow stairway leading up to the upper deck of the steerage, a small deck to the right at the bow of the steamer.
>
> To the left was an inclining funnel and from the upper steerage deck was fastened a gangway bridge which was glistening in its freshly painted state. It was rather long, white, and during the trip remained untouched by anyone.
>
> On the upper deck, looking over the railing, there was a young man with a straw hat. The shape of the hat was round. . . I saw shapes related to each other. I saw a picture of shapes and underlying that of the feeling I had about life . . .
>
> I had but one plate holder with one unexposed plate. Would I get what I saw, what I felt? Finally, I released the shutter. My heart thumping, I had never heard my heart thump before. Had I gotten my picture? I knew if I had, another milestone in photography would have been reached, related to the milestone of my *Car Horses* made in 1892, and my *Hand of Man* made in 1902, which had opened up a whole new era of photography, of seeing. In a sense it would go beyond them. For here would be a picture based on related shapes and on the deepest human feeling, a step in my own evolution, a spontaneous discovery.
>
> (quoted in Sekula 1982: 98–99)

In this perhaps unreliable reminiscence we can locate many of the characteristics of modernism. Stieglitz sees the image as a breakthrough in the progression not just of his own photographs, but also of the medium in general ('another milestone in photography'). He also presents himself as a gifted individual, able to capture precisely the right moment on the one unexposed photographic plate he has left. The reason he regards the

image as particularly significant and original is that he starts seeing the subject matter as abstract forms and tones ('I saw a picture of shapes').

To understand the importance of this, Stieglitz's analysis of his image must also be seen in the context of painting, but a very different kind of painting to that which inspired the Pictorialists (Orvell 2003: 86–91). Not just the year that Stieglitz photographed *The Steerage*, 1907 is also the year that Pablo Picasso painted *Les Demoiselles d'Avignon* where the subject matter (of women in a brothel) is similarly flattened out and broken down into abstract shapes. In the 1920s and 1930s Alfred H Barr, the first curator of the Museum of Modern Art, New York, helped to establish the idea that modern art history was a series of progressive movements (most of them often referred to as 'isms'), each leading onto the next. *Les Demoiselles d'Avignon* is regarded in such histories of art as the first modern painting of the 20th century and the work that inspired Cubism and its successive movements including Futurism and Surrealism (Green 1989: 366–368; Hughes 1991: 21–26). With its turn away from figurative painting (where the subject matter is 'realistic' and instantly recognisable) towards the breaking down of perspective via the use of multiple viewpoints, Cubism is presented in such histories as starting a process of increasing abstraction in painting. This avant-garde art was an inspiration on the new wave of photographers in the early 20th century. Stieglitz started a break from Pictorialism and a progression towards more abstract photographs by using the inherent qualities of the technology of the camera itself: tightly cropping images in-camera, and creating sharply focused pictures with no painterly post-production (Solomon-Godeau 1991d). In opposition to the manipulations of Pictorialism, the images resulting from this technique became known as 'straight' photographs (Newhall 1964: 111).

Stieglitz was the first person to exhibit Picasso's work in America. He opened the New York based 291 gallery in 1905, where he promoted photography as an art by showing it alongside painting, drawing and sculpture. There was still an element of photography achieving the status of art by association inherent in 291, but this time the art associated with the photographs was modern and avant-garde. The same attitude was taken in the lavish journal *Camera Work* started by Stieglitz two years earlier. In each issue a select few photographs were printed in high-quality reproductions on luxurious paper, in an attempt to make them appear as unique and valuable as modern art paintings (see Frizot 1998e: 327–333).

The final double issue of *Camera Work* in 1917 was dedicated to the photographs of Paul Strand – as if Stieglitz was passing the baton to a photographer whose work represented the next movement on from the images he was producing (Frizot 1998f: 392). Strand depicted the subject

matter of modernity such as car wheels and city streets in a modernist style that emphasised abstract shapes: the black rectangles made by the large windows in New York's Wall Street, the white verticals and horizontals of a picket fence. Sometimes the subject would be virtually unrecognisable (and irrelevant): bowls and fruit, or the shadows of a balcony's railings, forming patterns of shapes and tones.

By the 1920s in Russia and Europe a 'new vision' of the new modern world was being represented through photography. Using recently developed smaller cameras, such as the Leica, photographers could take pictures from anywhere and at any angle as if the camera was attached to them. Russian Constructivist photographer Alexander Rodchenko escaped the confines of what he called 'belly-button' photography (where the camera was held at waist level and looked at through the viewfinder) by photographing his subjects from revolutionary new perspectives (Marien 2006: 239–241). His camera was pointed up and on the diagonal at heroic workers and the new modernist structures that they built, then dynamically and dizzyingly down on street parades or the vast White Sea Canal built at the expense of thousands of lives but depicted as a triumph through photomontage and text for the elaborately designed magazine *USSR in Construction* (see Parr and Badger 2004: 148–151).

The idea of the camera as an extension to the eye was represented in German exhibitions such as *Film and Foto* and the publications *foto-eye* and the dynamically titled *Here Comes the New Photographer!* (all 1929) (see Badger 2007: 57–69; Company 2003a: 36). In Berlin, Laszlo Moholy-Nagy made highly modernist bird's-eye views such as a photograph taken from the top of a radio tower looking down on a building and path that became virtually abstract through their distance from the camera; while his fellow photographers in the 'New Objectivity' movement, Karl Blossfeldt and Albert Renger-Patzsch, used the inherent technical qualities of the camera to zoom in on details of natural and industrial forms (for more on New Objectivity see Badger 2007: 57–69; see also Benjamin 1980).

PHOTOGRAPHY IN THE MODERN ART GALLERY: AUTHORSHIP AND EXPRESSION

These new visions of a new world by Russian and European photographers, along with their American counterparts, helped to develop a visual language specific to modernist avant-garde photography (Nesbit 1987). Influenced by such developments, the Museum of Modern Art, New York (MoMA) collected photography from its opening in 1929. In the 1930s and 1940s, encouraged by Barr and his approach centring on

progressive movements, the museum's photography librarian and then historian Beaumont Newhall started to establish a progressive history of art photography. This began with a huge survey exhibition covering the years from 1839 to 1937 and its accompanying catalogue, which later became his book *The History of Photography* (published in various revisions ever since, such as Newhall 1964, 1982). Douglas R Nickel has noted that the history of photography in the Western world started being written via the perspective of modern art from the 1930s onwards (see Nickel 2000: 229; for alternative versions of photography's histories see Pinney and Peterson 2003). As Christopher Phillips argues in his analysis of MoMA's photography department (officially formed in 1940), Newhall expanded on Stieglitz's belief that certain photographers could create art photographs by opening up the possibility for any photograph to be considered art via its re-contextualisation on the blank walls of the modern art gallery – or to use Brian O'Doherty's now ubiquitous term coined in the 1970s: by being placed inside the 'white cube' (O'Doherty 1999; Phillips 1989; see also Chapter 8).

Despite a move towards blowing up freestanding images and emphasising the social role of photography under Steichen's directorship of the department during the 1950s (with shows such as *The Family of Man*, see Chapter 6), John Szarkowski's appointment in 1962 saw a return to the practice of displaying images in frames and in rows on walls, consolidating and expanding upon Newhall's earlier approach. But it is not just the immediate context – the physical space of a gallery and presentation of photographs – that leads to them being seen as art. Although images in modernist exhibitions might be quietly isolated on white walls, there is a vociferous discussion that surrounds the images, ranging from wall texts to reviews, gallery talks to conferences, and catalogues to collections that affects how the images are considered (this can be referred to as the 'discourse of art', see Chapter 3).

With his 1964 exhibition *The Photographer's Eye* and the introduction and organisation of the book of the same name published two years later, Szarkowski (2007) extrapolated from modernist photography his pronouncements about the specific nature of the medium that are analysed in Chapter 2. Importantly, Szarkowski saw photography as possessing inherent qualities that could be used by the photographer to express their individual vision as an author: a key concept in modernism. Indeed, the title *The Photographer's Eye* echoes the concept of the 'foto-eye', but shifts the emphasis from the apparatus to the role of the photographer in the picture's production. The idea that a photographer was the author of the images they made with a unique, original and recognisable 'voice' – and that themes in their work reflected their life – was applied not just to

modernist photographs of the 20th century such as those by Stieglitz and Strand, but also to photographers from the past: retrospectively establishing a set of practitioners and images to represent the 'canon' of art photography (Phillips 1989).

The best-known example of this retrospective canonisation is Eugéne Atget, who recorded Paris in the late 19th and early 20th century in utilitarian photographs made for the use of architects, artists and historians (see Chapter 6). Atget did not see himself as an artist, but just before he died his photographs were used by Man Ray in a Surrealist magazine and after his death his work was bought and promoted by Berenice Abbott and sold to MoMA. This has led to Atget being endorsed by the museum as a poetic author and influential figure in the history of art photography (his work is seen as connected to Surrealism and as an influence on the work of Walker Evans, for example) (see Krauss 1986c; Nesbit 1992; Solomon-Godeau 1991e). More recently a similar process has happened to the brightly coloured postcard images of tourist resorts and *Butlin's* holiday camps made by John Hinde Studios from the 1950s to the 1970s. A team of photographers worked on the photographs, initially under the tutelage of Hinde. However, it is John Hinde who is often now credited as the sole author of all the company's postcard photographs when the images are exhibited – usually extensively enlarged from their intended scale and minus any elements that would acknowledge their origins not as art but as commercial, mass-produced objects designed to be written on the back of and sent in the post (Bull 2002; Lee and McGonagle 1993; Parr 2002; for a brief analysis of postcards see also Stewart 1993: 138).

Douglas Crimp argues that the placement of photographs in the gallery means that their subject matter is superseded by the identity of the photographer as author, even if the original context of the images was that of documentary photography: 'urban poverty becomes Jacob Riis and Lewis Hine . . . World War Two becomes Robert Capa' (Crimp 1989: 7). By the 1940s, Evans' photographs, the subject of the first solo exhibition of photography at MoMA, came to be regarded as the expression of a gifted author on generalised themes rather than about the specific situations documented for organisations such as the Farm Security Administration (Hopkins 2000: 211–212; see Chapter 6 for more on Riis, Hine, Capa and Evans). The potential multiple functions of the images are narrowed down to that of the expression of their respective photographers. Even without the techniques applied by the Pictorialists, the photographs gain the aura that Benjamin saw as absent from the mechanically reproduced image (Kriebel 2007: 24–26; Phillips 1989: 16–17).

In the 1920s and 1930s, Stieglitz made a series of 'straight' photographs of clouds (some dark, some light, many dramatic in their composition,

others much calmer) that he called *Equivalents*. Stieglitz was not really interested in clouds – instead he wanted to find ways to give expression to his emotions and thoughts through imagery that was almost abstract (but never completely, due to the photographs' indexicality). 'Abstract' and 'expression': these two words closely connect the *Equivalents* to the work of the Abstract Expressionists, a group of American painters canonised as a movement in modern art history in the 1940s and 1950s, when the centre of the Western art world shifted from France and Paris to America and New York (see Harrison 1997: 53–61; Hopkins 2000: 5–34; Wood 1996). Artists such as Jackson Pollock expressed their emotions through paintings with little or no figurative content, in Pollock's case by splashing and dripping the paint on canvas stretched out on the floor. The resulting paintings are an index of his gestures, interpreted in the discourse of the gallery as carrying symbolic meaning (Leja 2002). In the first few decades of the 20th century, Stieglitz's photography progressed through increasing abstraction to the point where, in Allan Sekula's phrase, 'shapes = feelings' (Sekula 1982: 100). The imagery of what might be termed 'high modernism' increasingly withdrew from visualising the real world as art separated itself from popular culture (see Greenberg 2003b).

With this combination of authorship and abstract imagery – conveyed via straight photographs that used the technical qualities of the camera – modernist photography reached its peak between the 1920s and early 1960s. Representative of this are photographers including Ansel Adams, Imogen Cunningham, Edward Weston and Minor White, who joined together during this time as the f64 Group (named after the aperture setting that provides the most detail). Inspired by Stieglitz, who told him to aim for 'a maximum of detail with a maximum of simplification' (quoted by Weston in Newhall 1990: 4), Weston made sharp, refined photographs, the subject matter of which is essentially abstract. Weston's female nudes, for example, are photographed to appear like the rolling dunes of the desert, while his dunes are composed to look like curving female bodies: 'nude' and 'dune' become not just verbal but visual anagrams in his photographs as one transforms into the other again and again (see McGrath 2003 for an astute analysis of Weston's images of the female body in relation to psychoanalysis and the gaze; see also Weston 2003). Influenced by Stieglitz's *Equivalents*, White saw art photographs as 'mirrors' of the photographer rather than 'windows on the world' (Marien 2006: 338–339). These were oppositions on which Szarkowski based his exhibition *Mirrors and Windows* at MoMA in 1977.

But, as Solomon-Godeau has observed, by the time *Mirror and Windows* appeared modernism was no longer the avant-garde in art (Solomon-

Godeau 1991d: 103). Just as Abstract Expressionism marked the beginning of the end for modernist painting's movement towards complete abstraction, so too did the work of photographers such as White mark the end of modernist photography's progression. However, this does not mean that such photography has disappeared: Andreas Huyssen has argued that modernism remains, no longer moving forward, through its dissemination in mass culture (Huyssen 1986: 196–197). For example, Ansel Adams' landscape images continue to appear as posters and calendars on the walls of offices and as screensavers on the desktops of computer monitors, while modernist photography thrives in amateur camera clubs as a kind of 'après-garde' (see Bourdieu 1990: 103–128; Bull 1999b; Schwartz 1986).

CONCEPTUAL ART: ARTISTS USING PHOTOGRAPHY

In his 2003 book *Art and Photography*, David Campany picks up where Scharf's book of the same title published 35 years earlier left off. Campany renounces the idea that photography had become art, arguing instead that since the 1960s 'art has become increasingly photographic' (Campany 2003a: 14; Scharf 1983). To make this point Campany charts the complex links between photographs and art from the 1960s when 'artists using photography' become more involved with popular culture and the social world beyond the gallery.

Pop Art can be seen as a turning point – not just in the history of 20th-century art, but also in photography's role in relation to art. After the entirely non-figurative and self-contained work of the Abstract Expressionists reached a peak in the 1950s, artists such as Andy Warhol re-engaged with the popular culture of the time through their use of recognisable mass-produced images and objects. Warhol's multiple screen-prints from newspaper photographs and publicity pictures of celebrities can be seen as a representation of the ideas about the effects of mass reproduction that Benjamin debated 30 years earlier (Hamburg Kunsthalle and The Andy Warhol Museum, Pittsburgh, PA: 1999; see also Chapters 2 and 9). Starting in 1963, the artist Ed Ruscha produced a series of books including *Twentysix Gasoline Stations* and *Every Building on Sunset Strip, Los Angeles* where the subjects coolly described in each title were systematically recorded in detached, banal photographs (see Badger 2007: 208–209).

In their direct employment of photographs within the context of art, Ruscha's books are a precursor to the role of photography in Conceptual Art, a movement that was prominent from the mid-1960s to the mid-1970s (de Salvo 2005; Green and Lowry 2003: 48–49; Kotz 2006: 516; Wood 2002). Conceptualism, as it is sometimes referred to, was all about

ideas as art: resulting in the complete 'dematerialisation' of the physical art object to be replaced by events, actions and the creation of impermanent items – the art itself often happening outside of the gallery space and sometimes with little or no audience (Harrison 2002).

The ephemeral nature of such works and their physical distance from gallery-goers meant that photography and film were often used to record them. Initially photographs were taken in a snapshot or utilitarian style, with artists employing photography as a 'non-medium' with a lack of expression to record their work, sometimes borrowing the language of popular photography (Ruscha described his pictures as 'nothing more than snapshots') and formal documentation (Campany 2003a: 23–27; Kotz 2006; Roberts 1997). The identity of the actual photographer usually remained unknown and irrelevant. Adrian Piper walking through the streets in 1970 with a 'Wet Paint' sign around her neck was documented in a series of snaps recording both her action and the reactions of passers-by; forensically functional photographs of Keith Arnatt's *Self-Burial* the previous year evidence the artist's performance as he disappears into the ground standing up (mimicking the disappearance of the object itself in avant-garde art). In Arnatt's sequence a finger even seems to have strayed in front of the lens at the edge of each image. During the early years of Conceptual Art it was clear that the actions, not the photographs, were the art. In this kind of work photography occupies the role Baudelaire allocated for it in the 1850s: the servant of art.

However, photography and aesthetics began to occupy a more central role in Conceptual Art. John Roberts argues that some artists such as Hamish Fulton and Richard Long, both of whose work engaged with the natural environment, made photographs as 'a kind of conceptual-pictorialism' (Roberts 1997: 38). John Baldessari's *Throwing Three Balls in the Air to Get an Equilateral Triangle* (1972–3) was an action that not only relied on the timing of the photograph to record the failed attempts and actual moment the desired shape was formed, but also resulted in starkly striking colour images of the orange balls against a blue sky. Photographs eventually became the work of art itself, with artists such as Arnatt moving on to making close-up colour images from a rubbish tip where the detritus wittily takes on the aesthetic qualities of Turner watercolours (Grafik 2007). Gilbert and George's performances and actions in the 1960s and 1970s were replaced by the large grids of photographs that they are now most associated with, and in which the artists, still wearing their trademark tailored suits, react to the subject matter of the images that surround them (Livingstone 2007).

Works by Fulton, Long, Arnatt, and Gilbert and George were purchased for the Tate collection during the 1970s and 1980s. In a 1982

interview Alan Bowness, then the director of the Tate Gallery, London (yet to become Tate Britain), explained that the Tate collected photographs by artists, but not photographs by photographers (Bowness 1999). The role of collecting British photographers' work, Bowness contended, was the responsibility of the Victoria and Albert Museum, an institution that had been buying photographs since the 1850s. Nevertheless, his statement was regarded by many as symptomatic of an attitude that photography itself could not be art on its own terms. Arnatt wrote a short article in response called 'Sausages and Food' where he argued that, just as sausages are one type of food, so too are photographs one type of art and it was absurd to make any distinctions between photographs made by photographers and photographs made by artists (Arnatt 2003). Although it could be countered that, while all sausages are made for food, the overwhelming majority of photographs are not made for art; the very ubiquity of photography as a medium remains a key problem when positioning it as an art form.

Many Conceptual artists also reflected on photography itself (Green 1999). In *Camera Recording Its Own Condition (7 Apertures, 10 Speeds, 2 Mirrors)* (1971), John Hilliard systematically adjusted the settings of a camera as he pointed it at a mirror. The relative visibility of the camera as it fades in and out of the resulting grid of 70 images relies on the 'correctness' of each exposure made. In another work, *Causes of Death* (1974), Hilliard demonstrated how text and image work together by showing the same photograph of an apparently dead man cropped in four different ways to include either a pile of rocks, a riverbank, a bridge, or a fire alongside the body. The different words accompanying each cropped version of the image – 'crushed', 'drowned', 'fell' and 'burned' respectively – suggest a different fatal end. Taking each photograph individually the accompanying word could function as anchorage, but seen together the four words work as relay, their meanings adding different information and contradicting each other without ever defining one definitive 'cause of death' (see Chapter 3 for more about text as anchorage and relay). Works such as this, where text is integral to the photograph and to its meaning, became known as 'photo-texts' (Kotz 2006; Scott 1999: 46–74). Among Victor Burgin's experiments was *Photo Path* (1970), where Burgin placed photographs of a gallery floor over the top of the floor itself. Joseph Kosuth's *One and Three Chairs* (1965), in which he exhibited a photograph of a chair, the actual chair, and a dictionary definition of 'chair', was part of a series of what the artist termed 'photo-investigations' into the relationships between images, objects and texts. John Roberts regards Conceptual Art as demolishing modern art (Roberts 1997: 10–11). Similarly, it could be argued that Conceptual Art's

reflection on the character of photographs played a part in dismantling modernist photography.

As suggested by Kosuth's idea of the 'photo-investigation', Conceptual Art is also where phrases such as 'investigate', 'explore' and 'question' become a central part of art discourse (Bull 2003; Campany 2003a: 23). With Conceptual Art this attitude was applied not just to reflections on the medium itself, but also to the social world. Eleanor Antin's *Carving: A Traditional Sculpture* (1971), for example, documents her changing body shape in 140 full-length pseudo-scientific photographs made over 36 days as she dieted. The final image in the sequence is intended to match what was culturally defined at the time as the 'ideal' female body-size. Such work, bringing in ideas from feminism, represents an engagement with issues relating to the world beyond art: cultural context instead of aesthetic content. It is this attitude, incorporating issues not just from feminism but also from semiotics and psychoanalysis, that led to the emergence of what Liz Kotz refers to as 'photo-based artist-critics' including Burgin and Martha Rosler (Kotz 2006: 525). Burgin's visual practice (including *Photo-Path*) and his writing in books such as *Thinking Photography* (Burgin 1982e; see Chapter 2), and Rosler's essays and work (for example, her series of photographs and texts *The Bowery in Two Inadequate Systems* (1975); see Chapter 6) must be understood in this context.

By the mid- to late 1970s artists using photography were engaging with mass culture and addressing social issues. As such, Conceptual Art paved the way for those artists whose practice came to be termed 'postmodern'.

POSTMODERNISM: THE ARTIST AS PHOTOGRAPHER AND 'THE DEATH OF THE AUTHOR'

It is possible to identify major cultural changes happening from the 1960s onwards where ideas associated with modernity such as progression and fixed individual identity are turned on their head. For example, instead of progressive new ideas, in postmodernity old ideas are constantly revived and the concept of a fluid, fragmented self that is performed replaces that of a single unified identity. Postmodernism, as the representation of postmodernity, constantly recycles recognisable (or figurative) imagery from mass culture rather than the abstract expressions of an artist's mind (see Harrison and Wood 2003: 1013–1017; Harvey 1990; Heartney 2001; Hopkins 2000: 197–231; Huyssen 1986; Jameson 1991).

Postmodernism in art photography was primarily defined through the writings of critics such as Rosalind Krauss, Douglas Crimp and Abigail Solomon-Godeau, who made connections between the techniques and

work of artists beginning to exhibit during the late 1970s and early 1980s. Following the legacy of Pop Art's return to the figurative and art's reengagement with society through Conceptualism, Krauss introduced the semiotic term 'indexicality' to the analysis of visual art to argue that many of the new artists were making work that had direct links to the real world via the use of photographs and other media (Krauss 1986a; see also Chapter 2). In 1977, the same year as Szarkowski's *Mirrors and Windows*, Crimp curated an exhibition also in New York called *Pictures*, which brought together some of these emerging artists. In an essay of the same title, Crimp argued that the new practitioners were using a range of media with little regard to progressively developing the specific nature of any of them (Crimp 1984), whereas 'medium specificity' was a key element of modernism and promoted in Szarkowski's writings on modernist photography (see Grundberg 1998). Crimp was one of the first writers to see this work as a break with modernism and labelled it 'postmodernist' (1984: 186–187). Solomon-Godeau identified a return in the early 1980s to what she refers to as 'pseudo-expressionist' painting during an era of burgeoning capitalism – and so promoted the postmodernists as an alternative to this, both in their techniques and in what she interpreted as their critique of capitalist ideology (Solomon-Godeau 1991f, 1991g).

Many of these writers were inspired by the Situationist Guy Debord's idea of the 'society of the spectacle' developed a decade earlier. Debord argued that contemporary society was dominated by spectacular images of entertainment and capitalist products (on billboards, magazine pages, and cinema and television screens). These distracted people from the real world, transforming them into numbed consumers (Campany 2003a: 33–34; Debord 2003; Solomon-Godeau 1991h: xxxiv). One reaction to this was to use Debord's technique of 'detournement', where mass-reproduced images that are part of the spectacle (and which might otherwise be hardly looked at) are appropriated in order for their meanings to be playfully and subversively redirected by artists (Bowen 2006: 536–540; Henry 2006: 138; see also Chapter 4): a move that Solomon-Godeau characterises as shifting photographic practice 'from production to reproduction' (Solomon-Godeau 1991d: 103). An engagement with culture and social issues, the use of a range of media, and the appropriation of existing popular imagery from what Campany calls 'the domains in which values, opinions and identities are formed' was detected by postmodernist critics in the work of artists including Cindy Sherman, Barbara Kruger, Richard Prince and Sherrie Levine (Campany 2003a: 35–36; see also Dennis 2009).

In a partial continuation of the Conceptualist use of the camera to record performances, Sherman's series of *Untitled Film Stills* (1977–1980)

where she acts out characters from a range of cinematic genres from earlier decades (familiar to audiences from watching old films on television) were seen as a critique of female stereotypes in the media (Owens 1984: 223–234), a feminist celebration of the different roles a woman can have (Williamson 1988b) and even as an act of art criticism itself (Krauss 1990: 27). Kruger's addition of words to 1940s and 1950s image bank photographs in photo-text pieces such as *You Are Not Yourself* (1981) were interpreted as subverting the address to the consumer found in advertising (Owens 1992b: 191–200; see Chapter 4). Prince's series where cowboys were directly cropped from Marlboro cigarette advertisements were regarded as exposing the macho myths of Ronald Reagan-era America (Bright 1989; Solomon-Godeau 1991g: 140). In an even bolder act of appropriation, Levine simply re-photographed pictures by canonised modernist photographers, such as Evans' image of a farmhouse interior taken in Hale County, Alabama in 1936 (a photograph discussed in Chapter 6), leading Solomon-Godeau to argue that 'with a dazzling economy of means Levine's pictures upset the foundation stones (authorship, originality, subjective expression) on which the . . . work of art are presumed to rest' (Solomon-Godeau 1991g: 128). In her 1981 essay 'The Originality of the Avant-Garde' (Krauss 1986d), Krauss not only suggested that the avant-garde idea of art moving forward through the creation of new work was at an end, but also that originality in modernism itself was being simultaneously exposed as a myth.

The practice of these artists also seems to visualise ideas put forward in Roland Barthes' 'Death of the Author', a founding essay of postmodern theory written in 1968 (Barthes 1977c). Although Barthes focuses on writing in this essay, his ideas can be applied to work made in any media. However, Barthes uses the word 'text' instead of 'work'. A work, he argues in another essay, is seen as something fixed in meaning and created by a single author, while a 'text' is never fixed in its meaning – its content relating to other texts through 'intertextuality' (Barthes 1977d). For example, a photograph analysed as a text (by examining the elements within it through techniques such as semiotics) can be seen as intertextually connected to other texts such as films, paintings, other photographs, etc.

This goes against the idea of authorship associated with modernism – where a work is isolated as original and unique, with all its influences deriving from the life of its creator. Barthes contends that the authority of the text's meaning does not lie with its creator (the 'author-God') and their life. Instead, a text is 'a tissue of quotations' from the cultural context in which it is created, where 'a variety of writings, none of them original blend and clash' (Barthes 1977c: 146). The single meaning of a piece of

work cannot therefore be discovered and fixed by examining the biographical details of the person that made it. Rather, the meanings of the text remain polysemous and depend on its interpretation by the viewer (see also Chapter 3).

'The death of the Author', Barthes argues, leads to 'the birth of the reader' (Barthes 1977c: 148; see also Wolff 1993: 117–136). Although, as Carol Mavor has argued, Barthes' use of a capital 'A' for the 'dead' Author suggests that the author's own interpretation has not disappeared, but is no longer the primary authority on the work's meaning: it is instead one voice among many others (Mavor 2006). Prince seemed to sum up the adoption of this idea by postmodern artists that appropriated photographs with his remark, 'I think the audience has always been the author of an artist's work. What's different now is that the artist can become the author of someone else's work' (quoted in Heartney 2001: 38; see also Hopkins 2000: 82; Solomon-Godeau 1991d: 117).

At first, most of the postmodern artists using photography were regarded as appropriating imagery in direct opposition to such issues as the practices of modern art history and the culture of capitalism. However, these oppositional ideas were often actually those of the critics themselves, rather than the artists. As Kelly Dennis has put it, 'Postmodernist art critics in some cases displaced their own function as critics onto the medium' (Dennis 2009: 121). Dennis contends that the postmodern critics took a 'modernist' approach to postmodern art photography, seeing the form itself as being essentially critical in its nature, rather than still part of capitalist culture.

Owens, for instance, argued that the work of postmodern artists called attention to the traditional discourses of the gallery and art market (Owens 1992c). But the postmodern critics soon found that the artists whose work they championed were not immune to such discourses. For example, Levine began to relate her work to that of 1980s 'pseudo-expressionist' painters such as Julian Schnabel, and her appropriated photographs were exhibited in galleries alongside the 'original' photographs, re-establishing authorship to their photographers and positioning Levine within the very canon of art history that Solomon-Godeau saw her as demolishing (Hopkins 2000: 82; Solomon-Godeau 1991g: 132–135). Images by Kruger and Sherman have been used in the discourses of advertising and fashion (see Chapters 4 and 8), while in 2006 Prince's *Untitled (Cowboy)* (1989) – one of his photographs enlarged from a Marlboro advertisement – sold for $1,248,000 at auction. This price would not have been fetched by the original advert had it been up for sale instead. Reports of the death of the author turn out to have been greatly exaggerated.

Even oppositional art becomes marketable eventually. Solomon-Godeau acknowledged this – while pointing out that in the 1980s artists using photography seemed more willing than ever to quickly surrender their work to the expanding marketplace (Solomon-Godeau 1991g: 136–140). By the 1990s even the most sensational and subversive work arrived with a price tag.

CONTEMPORARY ART PHOTOGRAPHY: THE PHOTOGRAPHER AS ARTIST

After its employment by Conceptualists in the 1960s and 1970s and by postmodernists in the 1980s, photography became 'the medium of choice' for a wide range of artists from the late 20th and early 21st century (Bright 2005; Campany 2003a: 15). The focus of the Western art world shifted to Britain with exhibitions such as *Sensation* at the Royal Academy, London in 1997 (which included photographs by Richard Billingham; see Chapter 6). Work by the so-called 'Young British Artists' was often conceptual in its approach and used snapshot-style photographs to record ephemeral actions. Gillian Wearing's *Signs That Say What You Want Them To Say And Not Signs That Say What Someone Else Wants You To Say* (1992–3) – where members of the public were stopped in the street and given a blank piece of card on which to write a statement that Wearing then photographed them holding – recalls work by artists such as Piper in its engagement with everyday life and apparently casual use of photography (see Lowry 1999).

During the 1990s the genres of portraiture, landscape and documentary returned to the gallery in images by a 'German School' of photography including Andreas Gursky and Thomas Ruff. These images stressed photography's apparent ability to convey 'the real': depicting the world in a precise and descriptive form. Both Gursky and Ruff (as well as their contemporaries Candida Höfer and Thomas Struth) had been taught at the Dusseldorf Academy of Arts by the Conceptual Art-influenced Bernd and Hilla Becher.

The Bechers own influences derive from the work of August Sander who in the 1920s and 1930s attempted to sum up German society at the time by photographing individuals from a range of backgrounds to represent whole types of people. Generally, Sander's images were taken straight on to their subjects in a style recalling anthropological techniques of photography, although he was also influenced by New Objectivity (Schreier 1996; see also Chapter 6). In 1957 the Bechers began photographing industrial architecture such as water towers and blast furnaces in an even more uniform style in order to create typologies (often

presented in grids) of what they referred to in the first book and exhibition of their work as 'anonymous sculptures' (see Company 2003a: 71; Lange 2003). The Bechers exhibited in the show *New Topographics: Man Altered Landscapes* in 1975 along with Robert Adams, Lewis Baltz and Stephen Shore; a show which, although generally regarded as highly influential, was seen by some as still essentially modernist in style (Bright 1989).

The former students of the Bechers continued their teachers' coolly detached systematic approach to photographing subjects. Ruff made a series of portraits where the head and shoulders of each sitter were framed as if for a passport photograph. Presented on a large scale on gallery walls, a great deal of physical detail can be discerned in the images, but nothing of the subjects' personalities appears to be expressed, going against the conventional idea of portraiture (Cotton 2004: 105–106; see also Chapter 6). Big photographs dealing with big issues, such as identity and globalisation, became a key trope of photographic art in the late 20th century. Photographs did not have to be big to be art, but it helped. As with Adams and Baltz, Gursky took the architecture of the industrialised landscape as a subject in his huge pictures, usually made from a distant, elevated position and depicting subjects such as busy stock exchanges, vast hotel atriums, crammed shop floors and seemingly infinite rubbish dumps. His work has been interpreted as a 'contemporary sublime' (Ohlin 2002). In a tradition popularised in the 18th century, sublime landscape paintings depicted nature as something exhilarating but immeasurable, fearful and beyond human control (Andrews 1999: 128–148; Kant 2005; Taylor 1994: 17–19). With Gursky's photographs, often digitally altered to exaggerate their subjects' vastness, it is not nature but the culture of global capitalism that overwhelms (Galassi 2001).

Charlotte Cotton has labelled this kind of work, made for the gallery and with a 'neutrality and totality of vision', as 'deadpan' (Cotton 2004: 80–113). The influence of the Bechers and their students, Ian Jeffrey has argued, created an influential 'formula' for art photography that by the end of the 20th century could either be accepted in its entirety, taken and adjusted as an influence, or rejected entirely (Jeffrey 2006; see Bull 2002b; Bush 2002).

As if returning to the era of Pictorialism and the composites of Rejlander and Robinson, photographs suggesting a high degree of construction and craftsmanship also found a place within contemporary art galleries in the 1990s and 2000s. What is, arguably, a rejection of the deadpan style is found in the elaborately staged tableaux that are characteristic of contemporary art photography. Gregory Crewdson's meticulously directed scenes apparently documenting odd events in

suburban America are clearly cinematic in their influence and ambition (see Campany 2008a: 140–141; Cotton 2004: 48–79; Durden 1999; Henry 2006: 138–141; Kismaric and Respini 2004: 22–25). Painting is also a key inspiration. Jeff Wall often borrows his subject matter and composition from well-known paintings and prints covering a wide range of eras (in pictures such as *A Sudden Gust of Wind (After Hokusai)* (1991), based on a 19th-century print by the Japanese artist), while his 'near-documentary' images restage events he has observed in real life (de Duve 2002). One of the artists who Wall references intertextually in his practice is Eduoard Manet; and like that 19th-century 'painter of modern life' (Clark 1999), Wall often constructs his pictures of contemporary everyday existence from a number of separate images (*A Sudden Gust of Wind (After Hokusai)*, for example, is digitally composed from 100 photographs).

In another return to Pictorialism, it is common for contemporary art photography to borrow directly from pre-modern European and British painting. For instance, Tom Hunter, the first photographer to have a solo exhibition at London's National Gallery, made images showing people in contemporary clothes and situations (see Figure 7.2), but took his composition and lighting from painters working centuries before, such as the 17th-century Dutch artist Jan Vermeer (see also Chapter 2) and Millais

Figure 7.2 Tom Hunter *The Way Home* (2000) © Tom Hunter.

(recreating the same painting of Ophelia that inspired Robinson in the 1850s, see Figures 7.1 and 7.2) (Wiggins 2005: 40–73).

The language used to discuss contemporary art photography takes its key phrases from Conceptual Art and postmodernism. As Karen Raney has argued, the idea of an artist making work as 'research' has overtaken the concept of 'expression', and many practitioners no longer regard themselves as connected to particular media (Raney 2003: 3–6). Consequently, contemporary art photographs are critically discussed as 'seeking' to 'investigate', 'explore', 'question', 'challenge' and/or 'interrogate' their subject and their medium – the aim of much conceptually based photography in the 1960s and 1970s – and to 'blur boundaries' in the way that postmodernist work needed to do during the 1980s in the wake of modernism's emphasis on medium-specificity (Bull 2003).

But these older terms are often inappropriately used when referring to art photography now. While they help to establish the photographs as art within a gallery discourse informed by 20th-century art movements, such a lexicon usually ignores the return to aesthetics in contemporary art photographs. Michelle Nicol has pointed out that the use of the word 'beauty' became almost politically incorrect when art was critically analysed in the 1980s and 1990s (Nicol 1998). However, via such influences as the tableaux and fashion photography (see Chapter 9), aesthetically pleasing composition and lighting have returned as almost subversive elements in the context of contemporary photographic art, just as they seemed to be when Jabez Hughes called for photographers to aspire to beauty in 1861 (see also James 2007; Raney 2003: 31–33). Yet many of those who discuss art photography (sometimes including the photographers themselves) still seem obliged to ignore this and only use terms from the discourses of Conceptualism and postmodernism – even when the photographs do not visually articulate any questions and the time has passed when there are any boundaries left to be blurred.

Pronouncements that photography has been accepted as art have been made for many decades. For example, this chapter adapts its title from 'Photography as Art', a section in Gisele Freund's book *Photography and Society*, written in the 1970s, where she makes the same claim (Freund 1982: 192–200). However, by the early 21st century more writers than ever were presenting more evidence than ever that photographs were considered an art form (Bright 2005: 8). The market for photographs was expanding rapidly, with pictures selling for millions of dollars (see Chapter 4) and galleries, such as the Tate, that had previously shunned the idea of collecting photography by photographers, starting to acquire and exhibit them with alacrity (Dexter and Morris 2003). While this reflects the necessity for the salesrooms to find new commodities to sell, it has

also affected how art photographs are made and looked at. The market for art photographs sped up dramatically in the early 21st century as, every few months, yet another photograph broke the record for the highest price paid at auction. Yet simultaneously there was also a slowing down in art photography. An art photograph in a prestigious gallery might be acquiring value by the second due to its location, but Karen Henry argues that its placement in the context of the white cube also removes it from the fast-moving 'society of the spectacle', allowing viewers to stop and be absorbed in the contemplation of richly constructed images (Henry 2006: 154).

To Campany, large photographs in galleries 'assume the scale and modes of attention formerly ascribed to painting' (Campany 2003a: 40). This is a point expanded upon by Michael Fried in his book *Why Photography Matters as Art as Never Before* (Fried 2008). Fried argues that since the 1970s art photographs have not just got increasingly bigger, but have been made specifically for the gallery wall. As a result of the images' size and location, the viewer of contemporary art photography is absorbed in the pictures for a length of time associated with pre-modern tableaux painting.

After attempts ever since the 19th century to establish photography as art, it was in the final decades of the 20th century that art became 'increasingly photographic' through the varying uses of photography by the newest art movements. However, it seems that in the early 21st century it is through the adoption of a far older set of practices, in terms of both content and context, that certain photographs have become accepted as art.

PHOTOGRAPHS IN FASHION

The face of Kate Moss is reflected in a mirror. The mirror is propped up on a chest of drawers at which the model stands, her back to us. She is dressed only in a vest top and briefs and occupies a room suggesting a casual lifestyle: magazines are piled up in one corner; rather than a curtain, a diaphanous sheet hangs in front of a window; two pieces of broken glass lie on the floor. The snapshot style of the photograph (see Figure 8.1) seems to confirm the idea that we are looking at a spontaneous moment in the life of Moss; a connotation anchored by the title that has often accompanied the image, *Kate's Flat, 1993*. Just over a decade later in a very different photograph (yet one with parallels to its predecessor), the actress Julianne Moore is staring intently at the reflections in large shards of a broken mirror that are dramatically spread across a carpeted floor. She is on her knees, bent over the glass, dressed in a clean white blouse, tight grey skirt and white high-heeled shoes. Moore's face is made-up with dark eye shadow and neat, but pronounced eyebrows. A silver drop earring and rings on fingers are revealed as Moore holds back her long, immaculately coiffed hair that is backlit from a bright, white window. The light also illuminates the marbled steps behind her.

These two images represent contrasting eras of fashion photography. The picture of Moss, a version of which was published in British *Vogue* in 1993, is characteristic of a style identified with the early 1990s where the fashion in fashion photography was for 'realism' in terms of both a naturalness and a social realism that seemed to show the actual lifestyle of the models. The image of Moore, published in a 2004 *W* magazine, is part of a very different trend in early 21st-century fashion photography

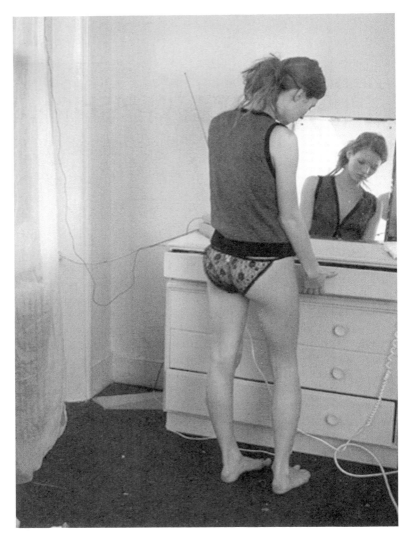

Figure 8.1 Corinne Day *Kate's Flat* from *Vogue* (1993) © Corinne Day / Maconochie Photography.

towards constructed scenes and performances for the camera (often by famous people who are not primarily known as models). As we will see in this chapter, fashion – and fashion photography – is often a reaction against previous eras, yet each era also has precedents and revives elements of earlier styles. Paul Jobling in his book *Fashion Spreads* has referred to this

as fashion's 'temporal paradox' (Jobling 1999: 80). Fashion, by definition and in order to exist commercially, must always be 'new'; yet it is also constantly recycling, drawing on the past for ideas. Fashion photographs, Jobling argues, are evidence of this in their blending of elements from many previous images and times (1999: 79–80). Jobling draws on Roland Barthes' influential study of what he called 'the fashion system' (Barthes 1983). Writing in the 1960s, Barthes argued that fashion plays on 'the limits of our memory' in order to conceal the fact that the same styles return (1983: 299–300). This chapter therefore takes a historical approach, examining the links and the breaks between five eras of fashion photography: the shift from elitist imagery to accessibility from the 1920s to the 1960s; the fantasies of the 1970s and the 1980s; the early 1990s era of realism; the impact of digital manipulation leading up to the turn of the millennium; and the performativity and emphasis on an art context in the first part of the 21st century.

THE 1920s TO THE 1960s: ELITISM TO ACCESSIBILITY

Despite fashion photography's presence online and in galleries in the 21st century, magazines have been and remain the main vehicles for getting the majority of fashion photographs to consumers quickly (Bright 2005: 134–135; Bright 2007: 12–23; Jobling 1999: 17–62). The usual elements of fashion magazines considered for photographic analysis are the editorial series of pictures and texts whereby a single range or mix of garments and accessories are publicised. However, some writers on fashion photography such as Susan Bright, Martin Harrison and Jobling, have also emphasised the importance of advertising images within the magazines (Bright 2007: 21–23; Harrison 1991; Jobling 1999).

Photography started to be incorporated into fashion magazines from the 1880s onwards. But due to still developing techniques in film and reproduction, the frozen poses of drawn and painted illustrations remained the main form in which fashion images were made up until the 1920s and 1930s (Craik 1994: 93–98; Jobling 1999: 19–20). As with every genre, fashion photography took a while to develop its own visual language, even after photographs became the predominant medium for the fashion images appearing in magazines such as *Vogue* and *Harper's Bazaar*. As late as the 1940s and 1950s most fashion photographs retained the fixed figures and basic backgrounds of the illustrations that preceded them decades before. As Hilary Radner has pointed out, even an innovative photographer such as Edward Steichen produced staid and static images that simply catalogued the clothes and jewellery that the

model displayed as they stood stiffly, contained by the frame of the photograph (Radner 2000: 132–133) (see Johnston 1997 and Chapters 6 and 7 of this book for more on Steichen's work in the areas of commercial and art photography). There were exceptions to this style: Harrison, Radner, and Susan Kismaric and Eva Respini all note that sports photographer Martin Munkacsi's early 1930s fashion images of women running begin to show models in active poses, breaking out of the confines of both the frame and the studio itself as Munkacsi took his camera outside and into the world (Harrison 1991: 36; Kismaric and Respini 2004: 13; Radner 2000: 131–132).

But between the 1920s and the 1940s the main innovations came within the studio itself, even while the stiff poses continued. The influence of modernist techniques of composition, cropping and abstraction (see Chapter 7) radically altered fashion photography from the 1920s onwards, resulting in an increasing fragmentation of the model and their clothes through the use of close-ups and abstract composition (see Kismaric and Respini 2004: 12–13). This modernist sensibility is also evident in *Vogue* 'house' photographer Horst P Horst's famous 1939 black and white image of a woman wearing a tightly-laced Mainbocher corset, where the dramatic diagonal composition and tonal range of the photograph clearly transcend the need to provide details of the garment (Jobling 1999: 20–21). Ian Jeffrey has argued that the unreal atmosphere of Horst's image also reveals the influence of Surrealism (Jeffrey 2000: 214). Images by Man Ray such as *Noir et Blanche* (1924) (made for *Vogue*, see Bate 2004a: 172–202) and the elaborate and theatrical studio constructions of another *Vogue* house photographer, Cecil Beaton (Beaton 1951: 69–75), provide excellent examples of 'Surrealist' fashion photography (although Beaton's photographs always had elements of the bizarre in their style, rather than any obvious employment of the psychoanalytic ideas on which Surrealism was based; see Chapter 3).

Despite these experiments, the fashion photograph continued to be a representation made by an elite photographer of elite clothes worn by elite models. Beaton's models were part of the wealthy establishment, as was Beaton himself, and even Irving Penn's daring abstracted images of the 1950s, where models where depicted in sparse, bold arrangements (as on his cover for *Vogue* in April 1950), still showed fashion models as 'aloof' and inaccessible (Craik 1994: 98; Jobling 1999: 22). The photographs from this era connote a look that is unattainable by most people: the upper-class establishment as a closed shop. Kismaric and Respini have argued that 'Encoded in such hierarchical values is an implied system of power, morality, good behaviour, stability and propriety . . .' (2004: 13). While the readers of the magazine might aspire to this life, it is one that

few of them could live up to. Social positions were as fixed as the poses of the models and the standardised position of the camera.

In Britain, magazines started or revitalised in the early 1960s such as *Man About Town* (later just *Town*), *Queen* and the supplements for the newspapers *The Sunday Times* and *The Observer* featured the work of photographers including Don McCullin, David Bailey and Terence Donovan, all of whom documented life in working-class areas such as the East End of London (Harrison 1998: 52–57; see also Chapter 6). Fashion shoots by Bailey and Donovan appeared in the same magazines as the documentary work, and the two genres began to cross over as fashion models were placed in environments that referenced a 'documentary tradition' (Williams 1998: 106–108).

These shoots were also influenced by Italian neo-realist cinema's use of non-professional actors and real locations, as well as the move outside the studio and into the streets made by American photographers such as Richard Avedon and William Klein (the latter's 1960 shoot in Rome saw models stepping through scooters and pedestrians as they traversed a zebra crossing). The high point of this trend was reached in 1962 when Bailey travelled to America with model Jean Shrimpton for a series of fashion pictures taken on the streets of New York for *Vogue* using the documentary format of a 35mm camera (Harrison 1991: 213–214).

If fashion photography until the 1950s was about elitism, the theme of the 1960s was accessibility. Jennifer Craik sees the 1960s as a revolutionary time when fashion as an industry opened up to all (Craik 1994: 105). As fashion became widely available on the high street, the readers of the magazines from all classes had increasing access to the kinds of clothes depicted in fashion photographs (Radner 2000: 136–137). Harrison argues that the erosion of some social barriers around the turn of the decade also provided access to fashion for photographers from a wider range of social strata (1991: 200–202). Bailey, along with Donovan and fashion photographer Brian Duffy, came to be linked together for all time as the 'Modelmakers' who shaped the look of a newly dynamic London after they were written about in a 1964 *Sunday Times* magazine article by Francis Wyndham (Craik 1994: 106–107; Williams 1998: 106–107). Each one of the 'Modelmakers' came from a working-class background in the East End of London to find fame and success as a photographer within a few short years.

This accessibility was not just for the readers and photographers, but also for the models that they 'made'. Neither Shrimpton nor Twiggy (originally Lesley Hornby) were from the same social background as the elegant models of the previous decades, but both models became talismanic of the era: symbolically plucked from their everyday lives into

the 'world' of fashion. The girls that populated the fashion photographs of the mid-1960s tended to be very thin and, although these models often came to be referred to as 'waifs', they appeared to be healthy and were often portrayed in active and dynamic poses (Williams 1998: 104). Models had increased access to the making of images too: Bailey and Shrimpton collaborated on shoots for a number of years, a working relationship echoed in John Cowan's images made with model Jill Kennington. Across an increasingly astonishing series of pictorials in the 1960s, Kennington was photographed by Cowan running, jumping, climbing walls and even parachuting out of a plane (Garner 1999) (see Figure 8.2).

Radner sees the dynamism of such images of women 'on the move' as both reflecting and circulating the new idea of the 'single girl' independently forging a career for herself (Radner 2000: 128–129). The 20th century, Radner argues, was an era where individuality and economic freedom were increasingly emphasised, and feminism logically continued this idea with the promotion of female independence (see also Chapter 4 for more on individuality and consumerism in photographic advertising). However, the independent women in the photographs are not as free as they could appear, Radner suggests. While the models might be shown as active and actively breaking the frame of the image, the fashion photograph is ultimately put in motion to sell clothes: the freedom attained is a freedom to consume within the wider frame of capitalism (2000: 140–142).

Figure 8.2
John Cowan *Flying High*
from *Queen* (1966)
© John Cowan Images.
Courtesy Philippe Garner

Kennington also appeared as a model in the 1966 film *Blow Up*, starring David Hemmings as a fashion photographer. *Blow Up* was filmed in London by the neo-realism influenced Italian director Michelangelo Antonioni after months of research into the culture of what *Time* magazine referred to as 'Swinging London' (*Time*, 15 April 1966; see also Campany 2008a: 115–118; Mellor 2007). However, despite the use of Cowan's studio and McCullin's photographs in the film – and the basing of Hemmings' character on a composite of the 'Modelmakers' – much of the portrayal of fashion photography in *Blow Up* is highly fictionalised, perhaps reflecting a fantasy about 1960s London and the lifestyles and behaviour of fashion photographers (Williams 1998: 103). By the time the film was released Bailey had already abandoned his documentary style and was making photographs in the studio against plain white backgrounds (Harrison 1991: 214). In the late 1960s and early 1970s fashion photography moved away from 'documentary' influences and instead returned once more to highly staged images and elaborate fantasies.

THE 1970s AND THE 1980s: FANTASY

Whereas fashion photography moved into the exterior world beyond the studio in the 1950s and 1960s, Harrison argues that the 1970s and 1980s represent an exploration of the 'interior world': the mind of the photographer (1991: 232–271). One turning point for this, according to Harrison, is the decision made by fashion photographer Helmut Newton, following a near-death experience in 1971, to stop following the dictates of magazine editors and begin to, in Harrison's words, 'deal with his personal obsessions' in his photographs (1991: 238).

The pictures made by Newton for *Vogue* in the 1970s and 1980s, along with those of his contemporary Guy Bourdin, create fantasy worlds where women (and occasionally men) act out flights of the imagination in highly staged environments. In Newton's images women are dressed and undressed in fetishised clothing (stockings, corsets, always very high-heeled shoes) and engage in sexually suggestive acts (see Chapter 3 for an examination of fetishism and its representation in Newton's work). In Bourdin's brightly coloured photographs the fetishism goes further and sometimes slides into potentially violent imagery, with models often appearing only as fragmented body parts. For Bourdin's long-running campaign for Charles Jourdan shoes it is often just the legs and feet of the women that appear, as if dismembered from the body.

It was this kind of imagery that came in for criticism during the 1970s and 1980s by feminist writers such as Rosetta Brooks (Brooks 1997:

205–217). The question of whose fantasies we are seeing is central to this debate. Brooks argued that the fetishistic reveries of power and violence in Newton and Bourdin's photographs represent a male fantasy of control over women. Newton's models, Brooks suggests, are portrayed as unreal automatons – stereotypes rather than real women – and objects manipulated for the male gaze (1997: 209–211) (see Chapters 3 and 6 for more on 'the gaze'). Bourdin's use of the mass-produced double-page spread in his editorial work is seen to suggest power and control. One such spread, printed in a 1978 *Vogue*, positions the legs of a female model either side of the page so that the reader 'opens and closes' them as they flick through the magazine (1997: 213–214). Overall, Brooks argues, the photographs of Newton and Bourdin go beyond the pleasant dreams promoted by most commercial photography and instead bring to the viewer's attention 'the power relations and the sexual violence which are implicit in all fashion photography' (1997: 205), while inviting them to join in with scenarios that reflect and circulate wider fantasies of male fetishism and domination.

Conversely, in the next two decades – following a far more positive assessment of their work in Harrison's 1991 history of fashion photography *Appearances: Fashion Photography Since 1945* – both Bourdin's and Newton's images were increasingly re-contextualised and reappraised within the settings of books and exhibitions: both reflecting and amplifying their influence on later fashion photography (see Cotton 2004; Gingeras 2006; Harrison 1991: 232–250). By 1998, Val Williams was arguing that Newton's early 1970s pictures 'were able to deconstruct the new and questionable orthodoxy of the liberated woman' (1998: 104–105), while in 1994 Craik regarded Newton and Bourdin as 'pushing the limits of fashion photography to produce images that shocked by questioning the foundations of fashion. . .' (1994: 109). Craik also connected Newton and Bourdin's work with their contemporaries Deborah Turbeville and Sarah Moon, both of whom she regards as having challenged the male dominance of fashion photography. Craik argues that Turbeville and Moon 'questioned the conventions of photography and the artifice of modelling through caricatures of poses and gestures' (1994: 109). These images, then, came to be regarded by some writers not as perpetuating stereotypes, but as critiquing them through parody.

In her 1990 book *Gender Trouble*, Judith Butler builds on Jacques Lacan's theory of the mirror stage which argues that identities begin to be fixed when a child recognises itself in a mirror image (Butler 1990) (see Chapter 3 for a more detailed analysis of Lacan's theory). From this point onwards, according to Lacan, the child enters into the verbal and visual

language of human culture. It is in this culture that male and female roles are replicated. The important point here for Butler is that, although seen as connected to biological differences, gender roles are not 'natural' and fixed, but 'cultural' and fluid. In other words, gender roles can be changed. Butler argues that these changes are usually prevented by the cultural repetition of traditional gender stereotypes 'performed' through images and texts, but that it is also possible to transgress these by 'acting against the grain' (see Jobling 1999: 171–173).

Taking his cue from Butler, Jobling argues that in the fashion spreads of the 1980s the performance of such roles starts to be subverted, as fantasies of power supplement those of sexuality. He sees the trend during the decade for images by photographers such as Herb Ritts of muscular and hard female bodies, often wearing clothes that appear almost like armour, as being symbolic. To Jobling these images of active, healthy bodies not only represent a defence against the potential inactivity imposed by high unemployment in the 1980s and protection against 'new' diseases such as HIV and AIDS, but also (in the photographs of female models) create an image of the 'phallic woman' who symbolically possesses the power of the phallus culturally associated with men (see Chapter 3).

Male models were rarely prominent in fashion photographs up until the 1980s. During the previous decades, when men did appear in such pictures, they were usually either half out of or to one side of the frame, or half-hidden and some distance from the camera (as in the 1960s photographs by Donovan for *Town* magazine). With the launch of fashion magazines such as *Arena* in the 1980s, men came to the forefront as objects within fashion photographs in ways that they had only occasionally been before (Craik 1994: 111–112; Williams 1998: 104). To Jobling the image of the 'New Man', an idea established in the mid-1980s, ostensibly so that fashion and cosmetics could be marketed to men, further complicated the binary opposition of the idea of the male gaze directed at the female object that Laura Mulvey had identified as still dominant 10 years before (Mulvey 2009a; see also Chapter 3). Lacan, Jobling argues, sees the gaze as capable of transcending gender. Images by Ritts and Bruce Weber in the 1980s where men are central to the photographs – often appearing in entirely male environments – provide evidence that a culture where men look and women are to-be-looked-at was being transgressed. A number of new viewpoints (men looking at men, women at men, women at women) were becoming more prominent (1999: 165–167).

The statuesque, often semi-naked men that appear in Ritts and Weber's fashion photography are, however, equally phallic. As Richard Dyer has argued, the male muscular physique connotes the potential for activity

even when the man is made 'passive' by the objectifying gaze of the camera (Dyer 1982: 67; Jobling 1999: 143–158). Indeed, the fact that men start to appear regularly in fashion photographs only at a time when bodies can be shown as active and powerful could be interpreted as actually reinforcing stereotypical gender roles. It is revealing to note that the male body returns to the margins of the images and the female body is central once more as 'real' and vulnerable bodies become the focus of fashion photography in the early 1990s, when it engaged again with reality rather than fantasy.

INTO THE 1990s: ABJECT REALISM

By the early 1980s a number of smaller, more independent fashion and lifestyle magazines had become the place for innovative fashion photography. Inspired by the do-it-yourself attitude of cheaply produced punk fanzines, British magazines such as *i-D* and *The Face* launched with a more dynamic approach to the photography of fashion that took its inspiration from what was happening in the outside world, rather than fashion houses (Kismaric and Respini 2004: 20). This was exemplified in the very first issue of *i-D* by Steve Johnston's pioneering of the 'straight-up': simple and straightforward full-length photographs of people the photographer chanced upon in the street (Smedley 2000: 146–147; Williams 1998: 111–112). Revealing each person's style from their haircut to their shoes, the straight-ups were accompanied by brief information supplied by the subjects about where their clothes were from and the music they were currently listening to. The connotation of these images was that they showed 'real' fashion coming 'from the streets' (Rocamora and O'Neill 2008).

At the height of punk's spreading influence, Dick Hebdige wrote his book *Subculture: The Meaning of Style* (1979). One of Hebdige's main arguments in the book is that all subcultures begin as a threat to the dominant culture (subverting it through alternative clothes, music and behaviour), but are soon incorporated into the mainstream in two ways: through the signs of the subculture being made into commodities, and by the rebellious behaviour becoming merged with established ideologies (Hebdige 1979: 90–99; see also Chapter 3 for a definition of ideology). For example, while punk clothes were originally one-off creations made by individuals, they soon become mass-produced and sold on every high street. Simultaneously, any ideological threat the punk subculture may have presented to family life (for instance) was defused by the representation of punks as a comedic spectacle or, conversely, being shown as just the same as anyone else.

However, in a postmodern culture of retrospection and revivalism (see Chapter 7), repressed subcultures can return. While this is often only a stylistic re-emergence, if that style is perceived to have substance then the threatening meanings that initially accompanied the subculture can also return. In this section I will suggest that this happened with some of the subcultures revived within the new style of fashion photography in the early 1990s.

The first notable example of this new style came with a series of snapshot-style photographs made by Kate Moss's friend Corinne Day for a 1990 issue of *The Face* that show Moss playing semi-naked on a beach (see Chapter 5 for an analysis of the style of snapshots). As Elliot Smedley has argued, the free-spirited connotations of the look and content of the pictures, anchored by the series' title *The Third Summer of Love*, make references not just to the original 1967 'summer of love' centred around the subculture of hippies, but also its 1988 counterpart based on acid house music, raves and drug culture (Smedley 2000: 148–150). The effects of the latter subculture, which had undergone both of Hebdige's forms of incorporation by 1990, blended during the early part of the decade with 'grunge' – a partial revival of the 1970s punk subculture, this time focused on dressing down and the unsentimental music of American rock bands such as Nirvana and Hole (the respective lead singers of these groups, Kurt Cobain and Courtney Love, were to become the emblematic couple of grunge by the mid-1990s) (Arnold 2001: 52).

Day's images of Moss in her flat, including the one described at the start of this chapter, were published in a feature titled *Under-Exposure* in British *Vogue* in June 1993 – and were in stark contrast to the vibrant images of the 'supermodels' that were emerging at the same time. The pictures of Moss have come to exemplify the more direct, personal approach of the 'grunge aesthetic' in fashion photography – an approach adopted by other London-based photographers such as Wolfgang Tillmans and Juergen Teller, who were also working for *i-D*, *The Face* and *Dazed and Confused* (Shinkle 2008; Williams 1998: 114–115). As in the 1960s pictures by Bailey, Donovan and Duffy, a 'documentary' influence is evident in some of this work, with its employment of real locations and capturing of apparently spontaneous moments. Smedley has suggested that the application of this kind of documentary technique enabled photographers to address the issues that photojournalism was by then unable to do through the sheer familiarity of emotive images in that genre (2000: 154–155). However, it could be argued that the adoption of a documentary style actually resulted from a lack of visibility for documentary photography. As traditional photojournalism began to disappear from the majority of magazines and newspaper supplements during the

1990s (see Chapter 6), many photographers found an outlet for addressing social issues via the types of features that had increased: fashion and lifestyle sections.

Other examples of fashion photography addressing social issues related to the body include fashion and portrait photographer Rankin's 1995 series *Hungry?*, which features an image of a model devouring a large bar of chocolate while her ill-fitting top is held tight around her skinny torso by bulldog clips (Rankin also photographed women of varying body-sizes, who were not professional models, for the beauty product company Dove's 'Campaign for Real Beauty'); Nick Knight's 1998 *Fashion-Able* shoot for *Dazed and Confused* magazine with disabled models (see also Evans 1998: 335–353); Martin Parr's use of 'everyday' people as models in commonplace settings (see Rhodes 2008); and the 2007 anti-'size zero' pictorial made by Steven Klein for the fashion magazine *Pop* with the 210lb singer Beth Ditto, entitled *Size Hero* – an idea reprised two years later as a cover feature for the first issue of *Love* by the photographers Mert Alas and Marcus Piggott. But these examples remain notable precisely because of their rarity; culturally idealised and manipulated images of the body are still dominant.

The grunge aesthetic of the early 1990s then, with its use of the visual codes of snapshot and documentary photography (see Chapter 5 and Chapter 6), suggests that it shows real people and real-life situations. However, most commentators on this form of fashion photography are careful to place the word 'real' in quotes to warn that what we see is not reality, regardless of how the pictures appear (see for example Cotton 2000; Williams 1998). The idea of 'realism' – as distinct from reality – is useful here. Linda Nochlin has traced the roots of realism in visual culture to the movement in French 19th-century painting away from historical, religious and mythical scenes and towards contemporary subjects, typified by the work of Gustave Courbet (Nochlin 1971; see also Chapter 6). Nochlin argues that the realist approach Courbet pioneered was characterised by the picturing of everyday subject matter, the capturing of spontaneous moments (influenced in fact by the arrival of photography), and a desire to address important social issues, often by depicting the hitherto unrepresented poor and working-class (1971: 13–56). Like realist painting, grunge fashion photography was characterised by a concern with the everyday and the capturing of spontaneity, and, in some cases, it also touched upon social issues. The coupling of these characteristics with the connotations suggested by the style of the photographs that they depict reality, led to the interpretation of images by Day, Tillmans, Teller and many others as 'realist' fashion photography.

To Kismaric and Respini, the casual, snapshot look of these images created the impression of everyday contemporary lifestyles being recorded: 'fashion as it is lived' (Kismaric and Respini 2004: 26). But the lifestyles suggested by the photographs seemed far from healthy. While the models that feature in the photographs share their thinness with the 1960s 'waifs', they do not possess their dynamism. There is no leaping up and jumping about in these images, only leaning on walls and slumping on sofas. When what Kismaric and Respini sum up as 'images of very thin models with greasy hair and sallow skin lounging in rooms littered with cigarette butts, dirty carpets, and beer-stained couches' moved from the pages of smaller, subcultural and experimental fashion magazines to the widely-read, mainstream and conservative British *Vogue* with the 1993 pictures of Moss in her flat, a negative media backlash began (Cotton 2000: 6–7; Kismaric and Respini 2004: 20). The images of Moss, together with similar shoots throughout the mid-1990s, were seen as evidence of a culture of addiction and emaciation (Smedley 2000: 150–151).

After the death from a drug overdose at the age of 21 of fashion photographer Davide Sorrenti in 1997, American president Bill Clinton famously accused fashion photography as glamourising drug use and glorifying anorexia to sell clothes (Arnold 2001: 48). To Hanne Loreck, Clinton was persuaded by the realism of the grunge fashion photograph and 'fell into the trap of failing to recognise the difference between reality and representation' (Loreck 2002: 271). Jobling also criticises the widespread negative reaction by American and British newspapers – to what they termed 'heroin chic' – for being taken in by the convincing rhetoric of the photograph (1999: 114–115; see also Chapter 3).

Jobling and Arnold have argued that these images do not just relate to social aspects of issues relating to the body, such as eating disorders and drug use (two key concerns of the late 20th and early 21st century), but to psychological aspects of these issues too. Jobling applies Julia Kristeva's theory of 'abjection' to his analysis of the photographs. As I examine in Chapter 6, Kristeva contends that an abject body is one that is revealed to be mortal flesh and blood and whose boundaries are broken (for example, by exposing those things that enter and leave the body) (Kristeva 1984). This – by extension – disrupts the idea of fixed identity. Jobling interprets the early 1990s fashion photographs of thin, possibly anorexic or bulimic bodies as evidence of eating disorders that in their focus on the consumption and expulsion of food reveal the body as abject, where it has no fixed boundaries and identity remains unstable (1999: 130–131; see also Shinkle 2008: 221–224).

Rebecca Arnold, in her essay 'Heroin Chic' (Arnold 1999; see also Arnold 2001), argues that the origins of the image of the abject,

vulnerable female body apparently ravaged by drugs go back much further in the history of visual culture. In Eugene Delacroix's 19th-century paintings of an imagined Orient, drugs are linked with the image of woman as exotic 'Other', whose drugged body is depicted as out of control and excessively sexual. Edward Degas' *The Absinthe Drinker* (1876) shows a woman sedated into inaction, perhaps even insanity, by alcohol addiction (Arnold, 2001: 48–49). To Arnold the image of the out-of-control, sexualised, addicted Other becomes an object of both anxiety and desire to the middle-class viewer who fears such a loss of control but is fascinated by the escape from their own lives the abject body seems to represent (1999: 284–285).

Not only did grunge fashion photography offer such an escape after the requirement to be invulnerable in the 1980s, but to Arnold the images also represent a Western world in economic recession and losing financial control during the early 1990s (2001: 51). The imagery of the female body as out-of-control Other extends beyond the 1990s too. For example, Arnold's description of Courtney Love's style as hinting at 'madness, loss of control . . . dangerous and sexual, publicly flaunting her flaws instead of presenting a contained and acceptable face of prettiness and seduction' (1999: 289) could equally be applied to a 2003 shoot for *i-D* by David LaChapelle (titled on the cover *Crazy In Love*) where the singer poses in an artfully dishevelled room, wearing torn fishnet stockings and with mascara running down her face.

However, the LaChapelle shoot with Love – despite its attempts at appearing off-the-cuff – is a highly contrived recycling of the abject realism of 1990s grunge fashion photography. The once controversial approach had become an acceptable mainstream style well before the decade was over. Smedley has contended that by the middle of the 1990s Teller was meticulously constructing his grunge-style fashion photographs to resemble spontaneous moments (2000: 153–154), while Kismaric and Respini argue that 'the new "spontaneous" photographs were as fabricated as any other fashion images from a previous age, and inevitably became as mannered and self-conscious as the studio portraits they were replacing' (2004: 26). In 2006, Corinne Day even recreated some of her 1990s shots with different models at the request of British *Vogue*'s fashion editor (Bright 2007: 23).

Yet even Day's photographs of Moss from 1993 are dubious in their authenticity to what was before the camera. In 2007 a selection of Day's images from the shoot were exhibited (alongside the issue of *Vogue* in which they were published) at the National Portrait Gallery, London as part of the exhibition *Face of Fashion*. Day's original photograph of Moss in her flat standing at the chest of drawers – also reproduced in the catalogue

(Bright 2007) – reveals that the pieces of broken glass and the propped-up mirror were removed from the image when it was reproduced in *Vogue* on the first page of the published series. It may be that the broken glass was thought simply too suggestive of abject existence for *Vogue* to accept in 1993 (although the reason for the loss of the mirror is more ambiguous). Whatever the motives, the elements were almost certainly modified digitally: an early and subtle example of the computer manipulation of fashion photography. By the middle of the decade, however, the use of digital alteration in fashion photography became far more overt.

POST-PHOTOGRAPHIC / PRE-MILLENNIAL FASHION PHOTOGRAPHY: ANXIETY AND DESIRE

As I have examined in Chapter 2, the 1990s saw a great deal of debate about the effects of new digital technology on photography. William Mitchell's phrase 'post-photographic' came to be adopted as shorthand for the idea that photography as it had been known was over (Mitchell 1992). The possibilities of what could now be done with the digitally manipulated image worried many writers (see Lister 2009: 316–320), but excited many others. In the introduction to *The Impossible Image: Fashion Photography In The Digital Age*, a compilation of digitally manipulated fashion photographs mostly made between 1995 and 1999, Robin Derrick enthusiastically traces the move from realist fashion photography ('sleazy models in run-down apartments shot in gritty real-life situations') to digital fantasies where 'pictures can be seamlessly altered, blended and mixed together' (Derrick 2000: 2).

Examples of digital fictions reproduced in *The Impossible Image* include: Andrea Giacobbe's *Simplex Concordia*, made for *The Face* in 1996, where a semi-naked man and woman pose robotically in artificially lit environments (at one point their heads are seamlessly swapped in an image where both models appear to be breastfeeding plastic babies); Nick Knight's *Laura de Palma* created for *Visionaire* the same year, showing a smooth-skinned woman with flesh stiletto heels emerging from her feet; Lee Jenkins' 1998 *Dazed and Confused* images *Spot the Difference*, where models' noses disappear and mouths are reshaped into terrifyingly exaggerated smiles; and Inez van Lamsveerde and Vinoodh Matadin's gallery work *The Forest, Andy* (1995) in which male and female and adult and child bodies are combined.

These bizarre images, with mutated and mutilated bodies that appear to be simultaneously male and female, young and old, and alive and dead, are interpreted by Jobling as representative of anxieties about cataclysmic events common to the turning of centuries. As he says, 'events such as

death, disease and war are thrown into sharper relief when time seems to be running out and the imminent future seems uncertain' (Jobling 2002: 4). Such fears about the end of civilisation are even more pronounced when it is millennia that are on the turn. The fashion photographs described above might be viewed as dystopian: predicting a world where everything has warped out of control. However, Jobling argues that such images can also be seen as revolutionary utopian visions of an improved future. To Jobling, pre-millennial images such those by Giacobbe and Lamsveerde and Matadin, where male and female bodies are unstable, suggest that gender and sexual identity are not natural and fixed but are – as Butler argues – mere performances that can be transcended (Jobling 1999: 177–179, 2002 18–19).

Building on Barthes' idea in *The Fashion System* that everything in the fashion photograph becomes part of the fashion garment (1983: 303), Karen de Perthuis has argued that in fashion photography the body has always been altered and distorted as if it were an item of clothing (de Perthuis 2005: 412; see also de Perthuis 2008). Horst's photograph from the 1930s of the model in the Mainbocher corset – discussed earlier in this chapter – is a good example of this: not only does the corset cinch the model's waist, but on close examination the photograph itself has clearly been retouched with ink to take off a few extra inches (Koetzle 2002: 42). To de Perthuis, the body as timeless unchanging nature becomes fused with clothing as fashionable changeable culture in fashion photographs – blatantly so in pre-millennial digital images such as Knight's stiletto-footed model (2005: 416–417).

Just as fashionable clothes change, so too do fashionable bodies. The body as a cultural object, de Perthuis argues, is shown in these fashion photographs as malleable and open to alteration. This is so even when no clothes are depicted, such as in Knight's *It's a Jungle Out There*, depicting a naked model whose legs stretch into cloven furred hooves, while tusks sprout from her back and shoulder (2005: 407–408). The image was made for the invite to view Alexander McQueen's Autumn/Winter 1997–98 collection, which included clothes where horns emerged from shoulders and horn-shaped rings were worn by the catwalk models. According to de Perthuis, the suggestion made by these images (and the clothes themselves) that actual bodies can be adapted reverses the argument often made that fashion images incite viewers to mimic what they see. In fact, she contends, in an era where body modification is increasingly common in real life, the influence works in the opposite direction as fashion photography continually 'ups the ante' in reaction to actual altered bodies (2005: 412).

Such alteration has progressed from the piercings, tattoos and scarification that permeated the Western world from the punk era onwards to

the reshaping of flesh that characterises the pre- and post-millennial period (see Chapter 2; see also Ince 2000). A 2007 fashion page from *The Independent on Sunday* magazine shows Izzi von Kohler, the manager of clubwear store Cyberdog. Dressed in skimpy Day-Glo clothes, pink boots and with horn-like sculpted neon hair, von Kohler's most striking feature is her pointed ears, which were created by a body modification artist. 'I decided I wanted to be a bit magical, not a real person', von Kohler tells her interviewer (*The Independent on Sunday* magazine, 30 December 2007). The histories of the cosmetic manipulation of the body and the digital manipulation of the photograph run in parallel. Von Kohler's look is reminiscent of digitally altered fashion photography, but she could also have stepped straight out of (or could walk straight into) a computer-generated environment such as *Second Life*, where virtual clothes and bodies are meticulously shaped and redesigned (Dibbell 2007).

After the move from the studio to the real world in fashion photography between the 1920s and early 1990s, the digitally manipulated fashion images of the mid- to late 1990s (such as those by van Lamsveerde and Matadin) marked a further step on by depicting models within virtual worlds and digitally created environments. However, while this trend for staging and construction developed in the early 21st century, the cyclical trait of fashion photography also meant that by the new millennium digital manipulation was becoming subtle again as commercial, glamourous images overtook fashion photography once more (Cotton 2000: 7).

THE 2000s: PERFORMANCE ART

> Perhaps though, fashion photography's greatest affinity is with performance art. A performance is directed by the photographer: it is created out of three principal elements, an actor (model), dress and gesture, and crystallised by the camera.
>
> (Harrison 1991: 21)

In *Appearances*, Harrison describes fashion photography through the metaphor of Performance Art. This is a genre closely related to that of Conceptual Art (see Chapter 7) that normally involves an artist or other participants carrying out predetermined actions in a specific space, usually recorded by a still or moving image camera (see Hopkins 2000: 187–195). While Harrison's statement is intended to encompass fashion photography up until 1991 (when *Appearances* was published), the comparison between Performance Art and Conceptual Art seems even more appropriate to the imagery that has been made since the start of the 21st century. Although the snapshot aesthetic of the early 1990s was still used

for some shoots (albeit in a far more contrived and constructed form), by the 2000s what Bright calls 'bags under the eyes' realism was unacceptable once again in fashion photography (Bright 2007: 23). Kismaric and Respini argue that this is replaced by a tendency for elaborately staged, perfected performances where the photographer and model collaborate as though they are film director and actor (2004: 22–25).

By the beginning of the new decade, Mario Sorrenti (the brother of Davide Sorrenti) had moved from the realist style, in which he had photographed Kate Moss sprawled naked on a sofa for a celebrated Calvin Klein campaign in 1992, to a cinematic technique. He was now creating sets for flawlessly dressed and digitally perfected models – as well as famous actors, singers and so on – to perform within. In 2004 Sorrenti worked with actress Julianne Moore on a shoot for *W* magazine titled *The Actress* (in which the second image described at the start of this chapter appears). In an interview published three years later, Sorrenti and Moore discussed how the photographer took his inspiration from Italian director Pier Pasolini's 1968 film *Theorem*, even basing the immaculately constructed studio set on one of the scenes from the film (Moore and Sorrenti 2007: 25–28). Moore then spent two days in the studio acting out various dramatic scenarios determined by Sorrenti. Digital technology was used to view the images as this took place but, 10 years after such technology had been a novel focus of attention, the use of digital techniques was to Moore 'just another way of working' (2007: 27).

Some of the images from the magazine shoot appeared in the exhibition *Face of Fashion* at The National Portrait Gallery, London (see above). By the early 21st century, such crossovers between art and fashion had been happening for nearly 100 years (the career of Man Ray representing a key example, with images such as *Noir et Blanche*) and Harrison's *Appearances* had made a significant impact with its modernist-style history of selected fashion photographers, canonising them as great innovators (see Chapter 7 for more on modernism and canonisation). Nevertheless, as Bright has pointed out, the crossing-over of fashion and art increased significantly from the 1990s onwards, Fashion photographers enjoyed the implied status and gravitas of their images being reproduced in an art context (such as *Fashioning Fictions* at the Museum of Modern Art, New York in 2004); while photographers used to a gallery setting for their work benefited from the cutting-edge credibility of having their photographs in fashion contexts (such as *W* magazine, which regularly features the work of art photographers including Philip-Lorca diCorcia and Martin Parr) (Bright 2005: 133–135; 2007: 15–17).

This joining of art and fashion photography was enabled, in part, by a

stylistic similarity. Harrison sees the use of constructed images in 1980s postmodern photography (see Chapter 7) as opening up the possibility for connections with the highly-staged pictures that have remained central to the genre of fashion photography throughout much of its history (1991: 247). Cindy Sherman is exemplary here: her fashion pictorials for *Harper's Bazaar* magazine as well as Commes des Garcons and Calvin Klein advertisements flow seamlessly to and from her art practice (see Loreck 2002). Meanwhile, the gritty art documentary work of Nan Goldin and Larry Clark is often cited as an influence upon early 1990s realism (see for example Cotton 2000: 85; Williams 1998: 100). When the contriving of 'performative' images and tableaux emerged as central to art photography practice in the 2000s (see Chapter 7), much art photography became indistinguishable in style from fashion, while fashion photography fitted increasingly neatly into the kind of work found in art galleries.

Whereas the fashion magazine format encourages a quick glimpse at the photographs printed on its pages, the move from page to art gallery wall persuades the viewer to look for longer and take stock of what the image represents (Bright 2007: 12). As I argued in Chapter 3, such a slowing down of time allows the meanings of photographs to be studied. Often this analysis, together with the benefit of some retrospection, enables the viewer to see more clearly just what it is these photographs say about both fashion itself and wider cultural issues.

It is rare to find a piece of writing on fashion photography that does not quote (or misquote) Susan Sontag's pronouncement within a short article about Richard Avedon in a 1978 issue of *Vogue* that 'The greatest fashion photography is more than the photography of fashion' (Sontag 1978: 177). As we have seen, what that 'more than' might be changes according to context – reflecting and circulating ideas that were around in the time and place the images were made (as well as according to the discursive context in which they are viewed, see Chapter 3). From elitist portrayals of an established class to images of social mobility; from sexual fantasy to aspirational glamour; from anxieties about the body to pre-millennial manipulations; from the magazine page to the art gallery wall: fashion photography has, as Hadley Freeman put it in a review of *Face of Fashion*, 'encapsulated the obsessions of its time' (*The Guardian Weekend*, 20 January 2007).

Freeman adds that the most noticeable obsession of the early 21st century has been celebrity. In the next chapter I analyse the role of photography in relation to our celebrity-obsessed age.

PHOTOGRAPHY
AND CELEBRITY

We are living in a celebrity-obsessed age. Photography plays a central role in the culture of celebrity. It could be argued that the desire to accurately see what well-known people looked like was one of the main reasons for photography coming into existence (see Chapter 2). Equally, the idea of celebrity would not exist to such an extent without photography. Over the last century and a half, photographs have played an ever-more significant part in the creation of fame in the first place; indeed, this has become so much the case that, in the 21st century, a form of celebrity can be gained purely through images themselves. However, while photographs have created almost god-like images of perfect celebrities, they are also increasingly used to suggest that those with fame are only human: an idea that, as I will argue below, makes celebrity more accessible.

This chapter examines five different eras and issues relating to photography and celebrity. The first section focuses on the picturing of people who had achieved fame by the time photography became widespread in the 19th century. In these cases, the photographs of the famous only put faces to the names of people who were already well-known. The second section examines how photographic mass repro-duction in what I am calling 'The Golden Age of Celebrity' was used to create idealised images of celebrities from the 1920s to the 1970s. The less flattering photographs made by paparazzi photographers since the late 1950s are analysed in the next section, along with the application of photography in fan culture to enable fans to associate themselves with the famous. The fourth section examines why celebrity magazines that have

regularly used photography to visualise bodily 'flaws' of celebrities since the 1990s are so popular. In the final section we will analyse the way that celebrity can now be gained purely through appearing in enough images, especially when these are mass reproduced online in what might be regarded as 'The Age of Mass Celebrity'.

THE FACE OF CELEBRITY: PHOTOGRAPHING THE FAMOUS

As I argued in Chapter 2, after the industrial revolution in 18th-century Europe a whole new class of wealthy and successful people wanted to make themselves seen. Indeed, in the decades prior to the existence of photography it was a mark of status to have an accurate, if flattering, portrait painted of yourself to display the success you had attained (Crary 1992: 11). This was accompanied by a desire to see others too, to 'put faces to the names' of those who were well-known, in order to measure your own status against that of your peers (Hargreaves 2001; Tagg 1988a).

When photography publicly emerged in the 1830s and 1840s it was immediately put to work recording the famous people of the age. Portrait studios sprang up in cities all over Europe, America and Japan (see Chapter 4). One of the most well-known photographers to run such a studio was the French photographer Nadar. What David Bailey was to London in the 1960s (or Rankin in the 1990s), Nadar was to Paris in the 1860s. Everyone who was anyone came to Nadar's studio on the Boulevard de Capucine to have their portrait made. He photographed the celebrities of the era: poets like Théophile Gaultier, the artist Gustave Doré, and the actress Sarah Bernhardt (in some ways the Madonna of her time). To be photographed by Nadar, whose signature was scrawled ostentatiously onto his pictures and was also lit up by gas lamps in huge red letters on the outside wall of his studio, was a sign that you had made it. Performers such as Bernhardt must have felt right at home: Nadar was based in the middle of Paris's theatre district and his studio, as Jean Sagne, has pointed out, was set up like a theatre with props and backdrops (Sagne 1998: 103). This benefited both participants. The theatres provided Nadar with a visual style and brought many of his subjects to him, while his photography promoted the theatres and their stars (Hargreaves 2001: 45–46).

Studios such as Nadar's would have window displays of the latest pictures of the celebrities that had visited them. As Roger Hargreaves describes it, people would walk along and look at the new photographs in the same way we might now idly flip through a celebrity magazine (2001: 43). Copies of the pictures could be bought so that people were able to

take the images away with them, a way of fetishistically possessing a little part of your hero. Photography seems to provide intimacy with the people depicted in the images and so, as writers such as Leo Braudy and Sean Redmond have argued, photography can be a means to get 'closer' to stars who, in the mid-19th century, were only read about or seen on a distant stage (Braudy 1997: 491–498; Redmond 2006; see also Chapter 3 on the photograph as fetish object). In the 19th century these images were often placed on the pages of early domestic photo albums, where celebrities would join family members (Batchen 2009: 91), in an era before the structure of the album became less playful and more systematised (see Chapter 5). The celebrities began to charge for their poses, Bernhardt asking for $10,000 from American studio photographer Napoléon Sarony for the privilege (Hargreaves 2001: 40). But the studios did not lose out financially, so great was the public's desire to purchase such pictures (Wombell 2008).

By the mid-1850s publishers began to bring out books of celebrity photographs, often in instalments. The word 'celebrity' predates the 20th century and is present in many of the books' titles such as Maull and Pollybank's *Photographic Portraits of Living Celebrities* (1855), which included images of famous people of the time including the writer Charles Dickens and the explorer David Livingstone. These were people who were celebrated for their achievements. The name of the book also emphasises that the pictures are of 'living celebrities'. If these were new and up-to-the-minute photographs, then the celebrities had to be alive: the fast-moving modern commercial world meant that there was a constant need for new pictures – and new celebrities to fulfil that need.

The title of a 'photo-mosaic', composed of many portraits, from an 1887 book indicates the extent of the increasingly all-encompassing category of celebrity. *Celebrities in the Church, Science, Literature and Art: Photographic Groups of Eminent Personages* combines 103 images made by various photographers into a single group photograph, as if those portrayed had somehow gathered together in the same spot. Amongst the 'eminent personages' are two celebrities of the 19th century who used photography to promote themselves: the poet Alfred, Lord Tennyson and the playwright Oscar Wilde. I will briefly focus on these examples here.

Tennyson, Poet Laureate of the Victorian era and author of such popular works as *The Lady of Shalott* (1833) (see Chapter 7) and *The Charge of the Light Brigade* (1854) (see Chapter 6) went to many photographic studios to have his portrait made (and sat for Julia-Margaret Cameron). The photographs were widely seen and, in part, cemented his fame. Yet the reclusive author also found that strangers, recognising him from the photographs, would stop him in the street and ask for autographs or follow him to

his home, an invasion of privacy that Tennyson complained about bitterly (Hargreaves 2001: 19). There is something very familiar about this situation. Like so many celebrities of our own times, Tennyson enjoyed the benefits of photography to help his career – and yet found those same photographs made him unable to live a normal life. Tennyson, however, had already achieved much before he was photographed; which is not often the case with the stars of today. I will return to this point later in the chapter.

Oscar Wilde, writer, wit and flamboyant dresser, went to America in 1882 to undertake a lecture tour. Having gone through customs (and saying, as legend records, 'I have nothing to declare but my genius'), the first thing Wilde did on arrival was to visit the New York photographic studio of Sarony (Rojek 2001: 128). In the photographs made during that session it is clear that Wilde is trying out set poses, eyes fixed on the camera, his left hand pensively holding the side of his face, index finger crooked. In some images he wears a large fur-trimmed and lined coat, in others a velvet suit and knickerbockers are revealed. He holds a book, as if he were about to open it and give us one of the readings from his tour. Essentially, Wilde was playing live across the United States and these photographs were publicity shots to promote both the tour and Wilde himself. This is an early example of the conscious use of photography, by a person just beginning to find fame, to shape their own public image and achieve even greater celebrity. It worked – and it was an idea that would catch on in a big way during the next century.

THE GOLDEN AGE OF CELEBRITY: FAME AND MASS REPRODUCTION

By the emerging age of mass reproduced images that Walter Benjamin wrote about in his 1936 essay 'The Work of Art in the Age of Mechanical Reproduction', photography and celebrity were working as a team (Benjamin 1999). Elsewhere in this book I have discussed Benjamin's essay in relation to modernism and art photography (see Chapters 2 and 7 respectively). There are two important connected points that Benjamin makes in his essay that are relevant to this chapter:

• In the 20th century, mechanical reproduction allowed a potentially infinite amount of versions to be made from an original
• This meant that things which had previously occupied one single place were able to be in many places simultaneously.

As Benjamin argues in his essay, and as Hargreaves' work on the 19th century also suggests, mass reproduction and fame have always gone

hand-in-hand (Hargreaves 2001; see also Lai 2006: 218). By the mid-20th century photographs, films, television broadcasts and sound recordings of actors, singers, political figures and sports people became a central part of Western culture. As Patricia Holland notes, their images also moved from photographs bought from studios (such as *cartes de visite*) to the mass media (Holland 2009: 147).

This same era of near-global mass reproduction – roughly from the 1920s up to the 1970s – marks what could be called 'The Golden Age of Celebrity'. Idealised images of celebrities were refined at the start of this era in Hollywood through carefully stage-managed publicity shots; such as Edward Steichen's images of Greta Garbo taken in 1928 to promote her latest films – where the photographer made sure that Garbo used her hands to sweep her unkempt hair back from her face to make the star look her best (Muir 2005: 76). Mass reproduction became essential to celebrity. Elvis Presley's fame derived only in part from audiences seeing him live. It was mostly through sound recordings, television appearances, film roles and publicity photographs that his star status was achieved. One hundred years earlier, fame simply could not happen on anything like the same scale.

The culture of mass reproduction is what Andy Warhol represented in his screen-prints from the 1960s where he multiplied celebrities over and over, including his now ubiquitous images of Marilyn Monroe made using a cropped publicity photograph by Greg Korman for the film *Niagara* (1953) (Livingstone 1989: 72). Warhol's *Triple Elvis* (1962) and *Double Elvis* (1964) also suggest the repetition of the celebrity image. Again, the photograph Warhol based his screen-prints on was a publicity picture for a film, *Flaming Star* (1960). The repetition of Elvis's picture connotes the way the singer's fame was achieved. In *Double Elvis* one image is darker, more solid, as if he is the 'real' Elvis and the other one is the reproduction.

The publicly available photographs of celebrities such as Elvis and Marilyn were carefully managed during this Golden Age to create images of perfection. Pictures of Elvis made to publicise his films with MGM studios in the early 1960s often show him surrounded by girls, from whom he keeps a respectful distance, while photographs of Marilyn were meticulously cropped and retouched to emphasise her beauty and to make her the centre of attention (Muir 2005: 161–166). For example, a doctored picture originally published in 1956 in the London *Evening Standard* newspaper shows her at a press conference. Although the picture has clearly been snapped quickly through a crowd, Marilyn is aware that it is being taken and is consciously posing for the camera. The picture editor for the newspaper selected the already flattering image and, as Robin Muir has demonstrated (Muir 2005: 109), a square drawn on the

photograph indicated how it was to be cropped for reproduction in the paper to make Marilyn the focus of the image (see Figure 9.1). Anyone in the crowd that might interfere with our attention being directed to Monroe is blacked out with thick ink (including her then-husband, the playwright Arthur Miller).

These examples indicate how photographs were staged and manipulated during this era to create images of celebrities as being what the sociologist Chris Rojek calls 'ascendant' – godlike people who exist in a realm somehow above the rest of us (Rojek 2001: 74–78). Most publicity photographs in The Golden Age of Celebrity built up such an image of deified perfection. During this time any pictures that might tarnish the flawless sheen of celebrities were generally kept hidden. They remained private images that the public did not see, due to what Rojek calls the 'cultural impresarios': managers who closely controlled what photographs were selected for mass reproduction (2001: 129–137).

Figure 9.1 Unknown Photographer *Marilyn Monroe at Press Conference for 'The Prince and the Showgirl', London* from *The Evening Standard* (1956) © Getty Images.

Elvis's rebranding into a clean-cut performer from his previous rebellious style by his manager Colonel Tom Parker was already in progress by the time a series of photographs were made of him in a Munich nightclub-cum-strip joint. In these images Elvis is shown eagerly kissing and grappling with various showgirls from the club. The pictures were taken by the in-house photographer, who was asked by Parker not to make them public. He stayed good to his promise and they remained hidden until long after Presley's death in 1977 (Muir 2005: 166–172). Similarly, the colour transparencies and contact sheets from Marilyn Monroe's last shoot with Bert Stern, which she slashed with a blade and mutilated with a pen to indicate the images she did not want seen, were not printed as part of the *Vogue* article that the shoot was for and which was published soon after she died in 1962. Although some of these photographs appeared in a less well-known magazine with a much smaller circulation, it was not until Stern's book *The Last Sitting* published 20 years later that the majority of the pictures censored by Monroe were made known to the greater public (Stern 1982).

All this seems remarkable compared to today, when images of famous people getting up to no good are being made public on a regular basis. In 2005, murky stills taken from a covertly filmed video of the fashion model Kate Moss snorting cocaine appeared on the cover and inside the *Daily Mirror* newspaper under the headline 'Cocaine Kate' (see Chapter 9 for an analysis of images of Moss and Chapter 2 for more about stills 'grabbed' from the moving image). Within hours of appearing in newspapers the photographs were available to download from the web, a process that is now often reversed with such photographs making the web first and being reproduced in print soon after. As Sandy Nairne has suggested, 'we may have already passed the moment when unexpected images can remain a secret or photographs can be lost from view' (Nairne 2005: 7). So what has changed in society's attitudes to famous people since The Golden Age of Celebrity? And what part does photography play in this?

THE CELEBRITY CLOSE-UP: PAPARAZZI PHOTOGRAPHY AND FAN CULTURE

The big bang for the contemporary era of celebrity photography happened in Rome in 1958. Over the course of one night on 14 August, a number of Italian photographers caught various Italian and American actors and actresses (such as Ava Gardner) and some politicians in compromising positions with each other. Their victims attacked some of the photographers – and other photographers photographed the retaliations. One picture from the night, taken by Elio Scorci, shows the

photographer Tazio Secchiaroli being assaulted by the actor and former boxer Walter Chiari, who was out on the town with the married actress Anita Ekberg. This, and other photographs taken on the night, appeared in various magazines soon after (see Squiers 1999: 278–288).

Two years later, the Italian director Federico Fellini made the film *La Dolce Vita* that shows various photographers on scooters in Rome chasing celebrities, including an actress played by Ekberg herself. One of the photographers (based on Secchiaroli) is named Paparazzo, a word linked by some writers to the Sicilian term for an oversized mosquito (see for example Squiers 1999: 278). Fellini's character is almost certainly where the phrase 'paparazzi' (the plural form of paparazzo) came from – suggesting a group of annoyingly buzzing pests (see Bate 2005; Becker 2003: 300; Freund 1982: 181). From this point on, the photographing of the famous became as much about catching them off-guard as it did about making them look good. In fact, the photographing became an event in itself, with photographers provoking celebrities to react for the cameras. In 1960, photographers tried to gain access to a showbiz party. Ekberg emerged from the gathering carrying a bow and arrow and started firing at the paparazzi: her reaction became the picture, printed in *Life* magazine in October in a piece called 'Swings and Arrows of Outraged Ekberg' (Squiers 1999: 285–286).

In the 1970s and 1980s the paparazzi style was refined by photographers including New York-based Ron Galella, who surprised such celebrities as Cher, Woody Allen and Jack Nicholson on the city sidewalks. Arguably the first American paparazzo, Galella often provoked extreme reactions and suffered many injuries in his pursuit of pictures, leading him to sometimes don a football helmet (see Howe 2005: 159). By this time Garbo had retired from public life; despite this – or, more likely, because of it – she became the target of many paparazzi photographers in her exile. Ted Leyson, a freelance photographer, obsessively stalked Garbo in her final years during the 1980s when she would walk the streets of New York. The last picture he took of the reclusive Garbo, just days before she died, shows her through the unfocused door frame of a car, her long grey hair partially covering a face which displays a look that is both weary and wary.

Karin E Becker has defined the main characteristics of paparazzi photographs (Becker 2003: 299–300). These can be summarised as follows:

• They are badly composed, and/or out-of-focus
• They often include intrusive foreground objects
• Strange facial expressions and poses are caught by the camera.

All of these aspects of paparazzi photographs, Becker argues, suggest that these are un-staged pictures, connoting what the celebrity is 'really like' (Becker 2003: 299–300; see also Lai 2006). Each characteristic Becker describes is present in Leyson's photograph of Garbo: much of it is out of focus, the window frame of the car door intrudes on the image, and Garbo's odd expression has been frozen by the camera. In other words, the style and content of Leyson's picture suggests that what it shows us is the 'real' Garbo.

The paparazzi techniques of goading and spying on celebrities continued into the early 21st century. For example, when Prince Harry, third in line to the British throne, became involved in a scuffle with paparazzi while leaving a nightclub in 2004, the resulting images of an angry prince being restrained from hitting a photographer appeared in many papers – including the *Evening Standard* which used the headline 'Harry Snaps' (*Evening Standard*, 20 October 2004). Many paparazzi shots are now often set up: stars eager to remain in the public eye contact photographers in order to ensure that they are pictured on the street, or collaborate with them on a constructed image (see Bate 2005; Howe 2005).

The artist Alison Jackson has parodied paparazzi images by creating photographs and film using actors made up to resemble celebrities (Jackson 2003). Grainy photographs such as those apparently showing Prince Charles introducing Camilla to Diana, David and Victoria Beckham playing football with Tony and Cherie Blair, and Robbie Williams guzzling pills while slumped on a toilet, display all the characteristics of paparazzi pictures, especially those shot using telephoto lenses. Their composition is often skewed, out-of-focus foreground objects obscure our view, and strange poses and expressions are captured. Despite our knowledge that the pictures have been set up, the look of the images and their subject matter deliberately tap into a mass desire to imagine what famous people get up to in private. As John A Walker has said, even though they are essentially false images, Jackson's photographs have a truth to them in that 'they make visible the imaginings and wishes of the public' (Walker 2003: 154).

Whether staged or not, paparazzi photographs are pictures that, through the connotations of their photographic codes, suggest they show the 'real' celebrity caught off-guard. They are rarely flattering, but – if mass reproduced in print and online – they guarantee that the celebrity stays famous.

In the 1950s and early 1960s Warhol was a fan of celebrities, sending off for autographed pictures from adverts placed in the celebrity magazines of the time (Butin 1999: 252–253). As we have seen, some of these same mass

reproduced images later found a place in his work. By the 1970s he too was a celebrity, making flattering screen-print portraits based on Polaroids that he took of contemporary stars such as Mick Jagger and Liza Minnelli. As Herbertus Butin has argued, such commissions helped Warhol to become part of celebrity culture – and therefore able to gain access to the famous in order to persuade them to appear in his magazine *Interview* (1999: 253). In *Andy Warhol's Exposures*, his book of photographs taken in celebrity hangouts such as the New York disco Studio 54, Warhol writes that his idea of a good photograph is 'of a famous person doing something unfamous. It's being in the right place at the wrong time' (Warhol 1979: 19): a phrase that seems to sum up the idea of paparazzi photography neatly. But Warhol also loved to be photographed with the famous people who he was now meeting in real life, including John Lennon, Salvador Dalí, and even paparazzo Ron Galella himself, who by the late 1970s had become famous too through his encounters with celebrities (Makos 1988). It is clear from these photographs that, despite his own fame, Warhol was still a fan.

Warhol's celebrity worship has parallels with the wider fan culture. Scott Thorne and Gordon C Bruner have defined the qualities of a 'fan' (Thorne and Bruner 2006). In summary, according to Thorne and Bruner, a fan possesses:

- Internal involvement with the object of their interest, adjusting their lifestyle to become more involved
- A desire for external involvement, by demonstrating their interest to others
- A wish to acquire objects related to their interest
- A desire to interact with other fans.

When it comes to fans of celebrities, the desire to become internally involved is often manifested through meeting famous people; the complexities involved in such an aim mean that a long-term investment is required. When the fan meets the celebrity they may well acquire an autograph, perhaps signed on a publicity photograph (adding to the indexicality of the image, see Chapter 2). Many fans will also take a photograph of the celebrity themselves. These pictures are then displayed externally – in the 21st century via fan websites and blogs.

From the 1960s onwards, one such fan, Gary Lee Boas, photographed any and every celebrity he could spot in New York as they entered and left theatres, television studios and restaurants; his collection eventually totalled more than 60,000 photographs, and by the 1990s he had turned professional and begun to sell his pictures. As Carlo McCormick points out, in the 1960s and 1970s Boas tapped into a particular period when

celebrities were more accessible. Since the murder of John Lennon by an obsessed fan in 1980 marked the end of The Golden Age of Celebrity it has been much harder to get so close to the famous (McCormick 1999: 14). McCormick notes that Boas differs from paparazzi photographers by his interest in his subject. Paparazzi do not ask for autographs: they keep their distance, while Boas attempts to connect with celebrities via the lens.

Other fan photographs represent an even greater attempt to bridge the distance between fan and celebrity; an element of fan culture that Braudy has argued extends back to a pre-photographic era (see Braudy 1997: 380–389). Fans often have themselves pictured meeting their idols. The celebrities that consent to these photographs invariably adopt a friendly pose, usually putting their arm around the fan and smiling at the camera as if for a family album snapshot (see Chapter 5). Although this pose is only adopted for a matter of seconds, the camera freezes the moment of connoted closeness and 'fame by association' for all time. These kinds of photographs – where the unknown public meet the famous – have become increasingly common now that most people carry a camera phone around with them most of the time. As a result, many magazines include sections that publish readers' pictures of themselves with the famous.

Paparazzi photography gives the impression that the celebrity has been snapped momentarily. The style of the photograph connotes both a brief encounter and a distance between the photographer and the photographed. In fact such photography represents a close relationship and a long-term connection between each star and the photographers who help them remain in the public eye. Some 'paparazzi' images may be set up and carefully constructed – yet in their visual style they maintain the connotations of an un-staged image. Conversely, fan photographs strive to forge a connection between the fan and the celebrity photographed. However, even when the fan is depicted apparently on intimate terms with the object of their attention, it is only the photograph that creates the illusion of such a connection being made. The celebrity moves on – and the people in the picture may well never meet again. The 'distance' between the celebrity and the photographer in paparazzi pictures and the 'closeness' between them in fan pictures are both fictions maintained by the connotations of the moment stilled in the photograph.

THE CIRCLE OF SHAME: MORTIFICATION AND THE AGE OF MASS CELEBRITY

Today, in the Western world, we are surrounded by images of celebrities both alive and dead. We are in what could be called 'The Age of Mass

Celebrity'. AA Gill has argued that, since the middle of the 20th century, celebrities have come to be made by the camera. He gives the example of the film actress Brigitte Bardot who, he says, was not a great actress but worked well in front of the camera, and so in the 1950s and 1960s became a star (Gill 2003: 5). However, The Golden Age of Celebrity (during which Bardot emerged) began to decline when paparazzi and fan photography started to break down the image of the famous. The ascendant, godlike celebrity that Rojek writes about – the celebrity who is somehow above the rest of us – has become far less dominant as an image in terms of how the famous are represented. Instead there is now a common desire present in contemporary culture to be famous. This is not fame as a result of having achieved success in a profession, but the achievement of fame as connoting success in itself.

In a number of surveys conducted in the early 21st century an increasing amount of young people have been found to aspire towards fame and recognition, often with very little thought given to what achievements might lead to that fame (see for example Learning and Skills Council 2006). As Angela McRobbie suggests,

> Public recognition and celebrity have replaced more traditional marks of status. A lot of this has to do with media visibility, and the popularity of TV programmes such as *Fame Academy* and *Pop Idol*, which make ordinary people extraordinary and give rise to the idea of a fast track to stardom.
>
> (cited in Hibbert 2005)

This mass desire for celebrity as an achievement in itself is now central in much of Western society, perhaps emerging from the aspirational culture that is the legacy of 1980s Thatcherism and Reaganomics. Appearing in photographs, reproduced in print media such as newspapers and magazines and on screen via the web and television, is a route through which such fame, with its connotation of success, can be gained.

Some celebrity magazines such as *Hello!* and *OK!* still show the famous as living an ideal life removed from the everyday world, making contact with their mortal public via the mass media. *Hello!* and *OK!* (each with an average weekly circulation in 2005 of around 350,000 to 600,000 copies (MediaTel 2005)) raise everyone to godlike status; publishing photographs of perfect people living perfect lives in perfect houses. On close examination the clothes, body language and conspicuous display of possessions in such images are clearly staged; yet the photographs are not intended for such examination. The pages of the magazines are designed to be flicked through casually, like the images briefly glimpsed in the windows of 19th-century portrait studios. The photographs in these celebrity magazines

combine with the text of the accompanying interviews and quotes to connote ideas of success, wealth and happiness: to say, precisely, 'I've done OK!' (Bull 2002c: 36–38). These images are not paparazzi photographs, they are celebrity photography made with the full consent of those in the pictures and designed to flatter and promote. The people celebrated in these magazine photographs are represented in the same positive way whether they are actors, royalty or reality television contestants.

What Rojek calls 'attributed' celebrity is where fame comes not from achievement (such as a successful career as an actor) or being ascribed by birth (such as being born into a royal family), but solely through appearances in the mass media: it is fame entirely from mass reproduction (2001: 17–20) – for instance, through appearing on reality television shows such as *Big Brother*, *Britain's Got Talent* and *The X Factor*. Some reality shows feature people who are already famous, often revealing them to be 'just like us' (a point I return to below), but many feature previously unknown members of the public, some of whom – such as the British celebrity Jade Goody – become famous simply by appearing on television, in print and online (her funeral in 2009 drawing comparisons with that of Diana, Princess of Wales). They need do very little other than to have their images mass reproduced, often through documentary-style 'decisive moments' digitally grabbed after the event from the recordings of the shows (see above and Chapter 2), but also via idealised shots staged in studios before and after their time on the programme. Days after Michelle Bass and Stuart Wilson left the *Big Brother* house in 2003, having publicly met and become a couple during one series, a posed studio photograph of a smiling Michelle and Stuart filled the cover of *OK!* magazine accompanied by the words 'The Pictures The World Has Waited To See', suggesting they had found the global fame that Warhol said everybody would achieve in the original version of his now ubiquitous quote ('In the future everybody will be world famous for fifteen minutes').

Rojek argues that, in mythology and religion, 'ascent' is often accompanied by 'descent' – and that, even in predominantly secular cultures, such beliefs still remain (2001: 78–87). The 'descendant' side of the godlike celebrity is seen in photographs too. Within the pages of *OK!* lurks another magazine, printed on cheaper paper, called *Hot Stars*. This is what could be termed a 'celebrity gossip magazine', where far less flattering photographs of celebrities are published along with gossipy tales about their personal lives (see Feasey 2006). Often, in such magazines, celebrities are not OK. The pictures help to bring the celebrities down to the level of normal people; they are the kinds of photographs – of the famous doing 'unfamous' things – that Warhol would have loved.

Celebrity gossip magazines have also proliferated in recent decades. For every *Hello!* and *OK!* there are at least two or three celebrity gossip magazines such as *Heat* (see Figure 9.2), *Closer*, *Now*, *Star* and *Reveal* (the titles of the magazines are indeed revealing). Similar magazines have been around since the early days of Hollywood, but then they were more illicit and hidden – they ran counter to the mainstream. Celebrity gossip

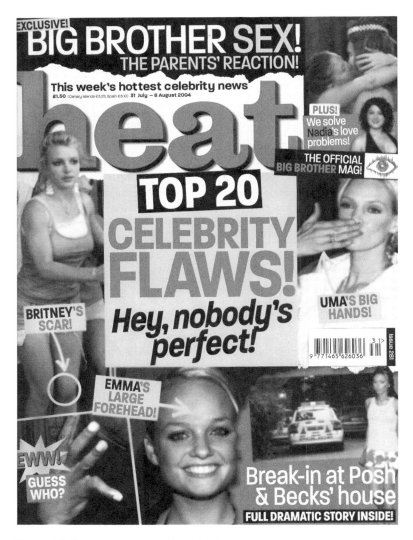

Figure 9.2 Cover of *Heat* magazine (2004).

magazines have become an integral part of the mainstream itself. In the early 21st century *Now*, *Heat* and *Closer* alone achieved a combined weekly circulation of 1.5 million every week (*The Sunday Times Magazine*, 16 October 2005). Celebrity gossip magazines also make full use of paparazzi photographs. They show celebrities caught off-guard, often in badly composed photographs at openings, parties and premieres, as well as out shopping, on the beach, in parks and even through windows (see Lai 2006: 218–219). As already noted, paparazzi photography is an event that often becomes the subject of the photographs themselves. For example, in a 2004 issue of *Heat* magazine a full-page photograph of the actress Cameron Diaz shows her attempting to snatch the camera from one paparazzo and, as a text box with an attached arrow that has been layered onto the image points out, loses a shoe in the scuffle. On the opposite page Diaz is shown fleeing with the camera, while the paparazzo tugs at her jacket. Over the page, Diaz's then-partner, the singer Justin Timberlake, confronts the photographer – whose expression and pose is anchored as connoting 'Bothered!' by another arrowed text box (words are often layered directly onto photographs in celebrity gossip magazines to fix their meaning). While, in 1960, Anita Ekberg aimed arrows at the paparazzi, in the 21st century the arrows have been turned on the celebrities.

But these critical portrayals of the famous are not just about adding arrows and text. The editors of celebrity gossip magazines constantly manipulate their photographs, supplementing the existing effects of the paparazzi picture by the use of cropping, enlargements and colour casts. Very often it is the celebrities' bodies that are the target of this manipulation. Rojek discusses the desire to show the descendant celebrity as being mortal, only human. This is what he calls 'the mortification of celebrity' (2001: 80). Rojek argues that it is often the celebrities' physical appearance that is seen to provide evidence of psychological problems. Until his death in 2009, Michael Jackson's increasingly bizarre appearance was closely examined through photographs in the tabloid press and often regarded as proof of mental instability. When, in 2007, Britney Spears was photographed during and after having had her head shaved, the tabloid newspapers that published the images presented them as evidence that the singer was experiencing problems with her mental health (*Daily Mirror*, 24 February 2007). Amy Winehouse was followed throughout the same year by paparazzi, whose photographs of her were cropped and enlarged for the pages and websites of British newspapers to draw attention to cuts, bloodstains and bruises – connoting the singer's own psychological difficulties (dailymail.co.uk, 24 August 2007). It is more often female

celebrities who are represented in such images, suggesting a continuation of the gendered power relations analysed in Chapter 3 and the abject female body examined in Chapter 8.

The mortification of celebrity is about revealing that the famous are flesh and blood like everyone else. The covers and articles of celebrity gossip magazines such as *Heat* and *Star* often use their arrows to draw attention to parts of photographs that appear to show, for example: cellulite (often the result of the camera catching the body in motion); bad skin (enlarging and toning images already blasted by flash to create and emphasise minor dermatological conditions); and sweat patches (again highlighted by the bright light of the flash). One topic particularly focused on is body size, narrowly cropping photographs of so-called 'skin and bone' celebrities such as the heiress and reality television star Paris Hilton, in order to exaggerate their thinness. An issue of *Heat* compiled many of these images under the title 'Celebrity Flaws'. Yet all of these 'flaws' are bodily; they are about how the celebrity appears physically in the photographs. Each set of pictures highlights the fact that the famous sweat, posess cellulite and have spots: they are mortal. One cover even describes the photographs as 'mortifying pictures'. It is as if the editors have read Rojek and are applying his theory to their practice.

There are two pages in every issue of *Heat* magazine specifically dedicated to drawing the readers' attention to these bodily flaws. This section of the magazine is titled *The Circle of Shame!* (comparable sections exist in most of the other celebrity gossip magazines). Here, circles are printed onto the photographs around 'bad hair' and supposedly odd body parts (such as 'large' thumbs). In 1956, the picture editor of a newspaper privately drew a square around a press photograph of Marilyn Monroe to indicate how an already flattering photograph could be improved to make Monroe the centre of attention: 50 years later, the producers of *Heat* are publicly drawing circles on pictures to point out the 'shame' of having cellulite, spots and sweat patches.

The use of photography in these magazines to show celebrities as mortal may in part be evidence of a need to regurgitate what the public have overindulged in. Celebrities themselves have also played upon the cultural currency of 'keeping it real' and 'just being myself' by staging mock-authentic casual imagery with photographers such as Juergen Teller (Lai 2006; Littler 2005; see also Chapter 8). But beyond this, as I have analysed above, there is another important desire at work in The Age of Mass Celebrity. Where images of the famous are ever present, and especially photographs of the famous at leisure, as the pictures suggest they so often are, the aspiration for fame for its own sake is made greater than ever. The apparent photographic evidence that celebrities have the

same bodies as other people can be seen as empowering to the viewer (Feasey 2006). In The Golden Age of Celebrity from the 1920s to the 1970s, when stage-managed images of perfect celebrities were what most of the public saw most of the time, gaining such fame would have seemed almost impossible: if celebrities are perfect, then we can never be a celebrity. But if celebrities are human beings just like us, with bodies that sweat and faces that have spots, becoming one seems a lot more likely.

More than ever, in the 21st century, there is a desire to bring stars down to earth. And just as in the past photography played a vital role in turning celebrities into gods, so too is it now collaborating in the process of making them mortal.

VIRTUALLY FAMOUS: DIGITAL REPRODUCTION AND ONLINE CELEBRITY

Websites based on celebrity photographs mirror celebrity magazines: some present positive and usually stage-managed photographs of the famous (via, for example, the celebrity's official site or sites made by fans); while others are the equivalent of online gossip. Any image of a celebrity caught doing something 'unfamous' finds its way onto screens around the world almost immediately. Other websites focus entirely on photographs of celebrities in various states of nudity, often scanned from lifestyle magazines such as GQ and FHM. A subgenre of such sites present fake photographs, where the faces of the famous are digitally superimposed onto pornographic images (see Knee 2006).

While most of these instances only add to the fame of the celebrities represented, they have until recently played a relatively small part in the initial creation of that fame – although some performers such as Lily Allen and Lady Gaga have been successfully promoted through well-connected pages on *MySpace* and popular *Facebook* groups. There are, however, an increasing amount of cases where people have gained some form of celebrity primarily because of their appearances in online imagery. These are a form of 'Internet memes': virally self-replicating content that spreads organically from person-to-person via the web.

Someone whose attributed celebrity derived from such online digital reproduction is the Chinese boy Qian Zhijun, whose fame began at the age of 16 when he was photographed (probably by a fellow student) attending a road safety class. The picture of him, glancing wearily at the camera, ended up online and a craze began where his face was Photoshopped onto the bodies of film stars such as Johnny Depp and Jim Carrey. The popularity of the original image is as much down to Zhijun's connection with the viewer – via his apparently knowing look to camera – as it is his

large body size. The *China Daily* newspaper called Zhijun 'the face that launched a thousand clicks' – and the digital reproduction of these images led to Zhijun being recognised in the street (Coonan 2006). He later hired a manager and aimed for a career in the entertainment industry. This is a kind of transient fame: a form of celebrity gained quickly through the infinite mobility of the digitally reproduced image, yet often lost quickly too.

When photography first helped put faces to the names of the famous, their celebrity was the result of achievements that had already been made. As analysed above, Tennyson, for instance, was a very successful and well-known poet before photographs revealed what he looked like to the masses (and increased his fame). By the 20th century, mass reproduced media, including photographs, played a central part in the achievement of celebrity in the first place. During The Golden Age of Celebrity such photographs were carefully constructed to show a positive image of stars who seemed to ascend above mere mortals. But, by the early 21st century, the constant and digitally reproduced presence of descendent images of celebrities continuously demonstrated that they were only human.

There is now a mass desire to gain fame instantly, without the years of work involved in achieving it. It seems that anyone can be attributed a form of celebrity entirely on the basis of being in images appearing on enough screens and in print. The distribution of the photographs that contribute to celebrity is now often outside the control of the owners of the press or cultural impresarios – and is instead in the hands of the public, circulating images online.

Photographs of the famous are everywhere, and anyone can become famous if their own face is reproduced everywhere too. In the 21st century, more than ever before, one of the main roles of photography is to establish, perpetuate, and erode celebrity.

10

CONCLUSION

After Photography?

The last words of Roland Barthes' book *Camera Lucida* offer the reader a choice about photography: to perceive it as creating perfect illusions, or as revealing an unquestionable reality. Such, says Barthes, are 'the two ways of the photograph' (Barthes 2000: 119). This choice between photographic illusion and photographic reality is of course no choice at all. As Barthes himself says, both are intrinsic to the medium.

Along with such debates about photographs combining fact and fiction, Chapter 2 of this book introduced many other examples of similar apparent contradictions integral to photography: its uniting of shifting ideas about nature and culture within its identity; the way photographs appear to bring the past into the present; the embodiment of the photograph as object and its disembodiment as a digital image; the ability of digitally reproduced photographs to be simultaneously everywhere and nowhere; and the need for both modernist and postmodernist approaches to the study of photography (emphasising the content and context of photographs respectively). Following this, Chapter 3 balanced the analysis of the content of photographs with an examination of influences from other factors, such as the surrounding words that often accompany photographs, the effect of a photograph's immediate context, and the significance of its placement within wider discourses. Such discourses include those analysed in Chapters 4 to 9.

The majority of photographs exist either for commercial purposes (selling commodities or being sold as commodities), as analysed in Chapter 4, or are snapshots that, as examined in Chapter 5, have gone

from the mass of private photographs to readily available public images via their move from the album page to the web page.

More specifically, as analysed in Chapter 6, the purpose of certain photographs is documentation – a function that relies upon what is defined in semiotic terms as photographic 'indexicality'. With such debates, ideas of subjectivity and objectivity are central, with objectivity being discursively emphasised where an 'unbiased' image is required. Conversely, a minority of photographs are considered 'art', where subjective, personal expression is emphasised instead. Chapter 7 analysed the methods by which discourses of art have been used to accentuate the subjective aspects of photography. Chapters 8 and 9 focused even more closely on the vital role of photographs in relation to fashion and fame, showing how photography affects, reflects and reinforces shifts in these discourses.

In the future, Fred Ritchin suggests at the end of his book *After Photography*, the 'essential duality' of photography may need to be fully embraced (Ritchin 2009: 177–185). As analysed in Chapter 2, the classical Enlightenment worldview that had been established when photography was first conceived during the late 19th and early 20th centuries is changing – altering the whole understanding of nature on which photography was founded. Ritchin notes that the more recent science of quantum physics sees light not as being made up of continuous waves, but of separate particles. The very reality that photography supposedly evidenced, then, has been called into question. Even gravity might come to be understood differently: perhaps those falling and floating people in some of the photographs discussed in Chapter 2 could actually remain suspended, never reaching the ground.

The re-conception of photography that started in the late 20th century and continues into the 21st century suits this new version of the world. 'Post-photography', which is composed not of fixed analogue photographs, but of transient digital fragments, is an appropriate medium for a 'post-human' culture where fixed ideas about nature are changing. Photography now, in its increasingly transient form, is indexical of the transient culture that is in the process of re-conceiving it.

FURTHER READING

Photography is a huge subject and so only a few general recommendations for further reading will be made in this section. For more specific reading please consult the references made in the main text of the book. Despite the quantity of writing available on photography, detailed and critical analyses of some areas, such as contemporary advertising photography, snapshots, fashion photography and celebrity photography, are still relatively sparse. Readers are encouraged to use the academic journals, magazines and websites listed in the Further Resources section below to supplement their research in these areas.

THE IDENTITY OF PHOTOGRAPHY

Batchen, Geoffrey (1997) *Burning With Desire: The Conception of Photography*
 Boston, MA: Massachusetts Institute of Technology
A meticulously detailed examination of why the idea of photography needed to be conceived between the late 18th and early 19th centuries. Along the way, Batchen contrasts and compares 'modernist' and 'postmodernist' approaches to the analysis of photography, debates the relationship between photography, nature and culture, and formulates a new version of photography history. An essential read for the serious study of photography from a contemporary perspective.

Burgin, Victor (ed.) (1982) *Thinking Photography* London: Macmillan
This is the book that, for better or worse, came to define one of the dominant forms of 'photography theory' for at least the following 20 years. *Thinking Photography* collects together writings on photography from the late 1970s and

early 1980s, influenced by political, psychoanalytic, and semiotic approaches.
Authors include Umberto Eco, Alan Sekula, John Tagg, Simon Watney and Burgin
himself.

Crary, Jonathan (1992) *Techniques of the Observer: On Vision and Modernity in the
 Nineteenth Century* Boston, MA: Massachusetts Institute of Technology
As with Batchen's *Burning With Desire*, Crary's book moved the critical study of
photography forward in the 1990s: in this instance, by emphasising the physical
embodiment of the observer in relation to photographs and viewing devices,
rather than the detached spectator of images.

Edwards, Elizabeth and Hart, Janice (eds) (2004) *Photographs, Objects, Histories: On
 the Materiality of Images* Abingdon: Routledge
A collection of essays by writers who, like Crary, focus on photographs as
material objects, particularly in relation to their uses in institutions and archives.
The final essay, by Joanna Sassoon, starts to address the immateriality of
photographic images in the digital era.

Elkins, James (ed.) (2007) *Photography Theory* London: Routledge
Beginning with an insightful introductory essay by Sabine T Kriebel that traces
the development of the critical study of photography, the centrepiece of this book
is the transcript of a seminar about photography theory that focuses on a heated
debate around indexicality. The transcript is then responded to in a series of short
essays by a vast range of scholars. A fascinating take on where the theory of
photography that began to develop between the 1960s and 1980s had ended up
by the early 21st century.

Green, David (ed.) (2003) *Where is the Photograph?* Brighton: Photoforum /
 Maidstone: Photoworks
Green, David and Lowry, Joanna (eds) (2006) *Stillness and Time: Photography and
 the Moving Image* Brighton: Photoforum / Photoworks
Two collections of excellent and often provocative papers presented at
conferences in 2002 and 2004 by leading writers on contemporary photographic
study, focusing (respectively) on the identity of photography and the relationships
between the still and moving image.

Lister, Martin (ed.) (1995) *The Photographic Image in Digital Culture* London:
 Routledge
These essays insightfully take stock of the debates around digital photography in
the mid-1990s.

Long, J J, Noble, Andrea and Welch, Edward (eds) (2009) *Photography: Theoretical
 Snapshots* Abingdon: Routledge
Over 25 years after *Thinking Photography*, authors including Batchen, Edwards and
Tagg 're-think' photography theory in the 21st century. Reflections on

digitisation, materiality, and snapshots bring the debates of the previous century up to date.

Ritchin, Fred (2009) *After Photography* New York and London: Norton
After the 'coming revolution' that Ritchin predicted in the early 1990s, an invigorating take on the effects of digital photography at the end of the new century's first decade.

Sontag, Susan (1979) *On Photography* London: Penguin
A collection of essays written for *The New York Times Review of Books* during the 1970s, Sontag's book is still a vital and accessible text for anyone interested in the serious study of photography.

Szarkowski, John (2007) *The Photographer's Eye* New York: Museum of Modern Art
Much maligned in the 'postmodern' photography theory of the 1970s and 1980s, Szarkowski's quintessentially modernist and visual approach to defining the nature of photographs (originally published in 1966) is an important exercise in 'focusing boundaries' that should not be casually dismissed.

Trachtenberg, Alan (ed.) (1980) *Classic Essays on Photography* New Haven, CT: Leete's Island Books
An excellent selection of key writings from the 19th century up until the 1970s, including Charles Baudelaire 'The Modern Public and Photography' (1859), André Bazin 'The Ontology of the Photographic Image' (1945) and Walter Benjamin 'A Short History of Photography' (1931).

THE MEANINGS OF PHOTOGRAPHS

Roland Barthes (1977) *Image/Music/Text* London: Fontana
Includes the influential essays 'The Photographic Message' (1961) and 'Rhetoric of the Image' (1964), both of which contributed to the application of semiology to the analysis of photographs – along with a range of other key writings.

Roland Barthes (2000) *Camera Lucida: Reflections on Photography* London: Vintage
Barthes' final book, taking a more personal approach to interpreting the meanings of photographs while simultaneously addressing universal issues, is dense, fascinating, and sometimes ambiguous (making it a constant topic of debate). It remains one of the most influential treatises on photography ever written.

Freud, Sigmund (1991) *The Penguin Freud Library, Volume 1: Introductory Lectures on Psychoanalysis* London: Penguin
Freud, Sigmund (1991) *The Essentials of Psycho-Analysis* London: Penguin
Freudian psychoanalysis has had an understandably substantial influence on many approaches to analysing photographic meaning. The texts of Freud's own

introductory lectures, which were delivered between 1915 and 1917 and designed for an audience with little or no knowledge of his theories, are still an ideal place to start. The *Essentials* volume expands on these lectures, collecting most of the other key writings the student of photography is likely to require.

Krauss, Rosalind (1986) *The Originality of the Avant-garde and Other Modernist Myths* Boston, MA: Massachusetts Institute of Technology
Includes both parts of 'Notes on the Index' (1976/7), where Krauss first applied indexicality to photography in an art context; the continuing effects of which are still being felt (see Elkins 2007, above). Also includes 'The Photographic Conditions of Surrealism' (1981) and 'Photography's Discursive Spaces' (1982).

Mulvey, Laura (2009) *Visual and Other Pleasures* Basingstoke: Palgrave Macmillan
Includes 'Visual Pleasure and Narrative Cinema' (1975), which combines feminism and Freudian psychoanalysis in its study of films – and directly influenced the developing photography theory of the 1970s and 1980s. The book contains Mulvey's own afterthoughts on the essay as well as other useful writings.

Rose, Gillian (2007) *Visual Methodologies: An Introduction to the Interpretation of Visual Materials* London: Sage
Rose lucidly guides the reader through various techniques of visual interpretation, such as the application of semiology, psychoanalysis, methods of discourse analysis and audience studies.

Squiers, Carol (ed.) (1999) *Over Exposed: Essays on Contemporary Photography* New York: The New Press
A well-chosen volume of writings analysing photographs, including Victor Burgin on Helmut Newton's *Self Portrait With Wife June and Models*, Andy Grundberg on photography and Surrealism and Christian Metz's psychoanalytically influenced 'Photography and Fetish'.

PHOTOGRAPHY FOR SALE

Frosh, Paul (2003) *The Image Factory: Consumer Culture, Photography and the Visual Content Industry* Oxford: Berg
Frosh's detailed research draws attention to the often-overlooked stock photographs that we briefly encounter many times every day as advertising – and that subtly promote their ideas while remaining virtually unnoticed.

Johnston, Patricia (1997) *Real Fantasies: Edward Steichen's Advertising Photography* Los Angeles, CA: University of California Press
The development of commercial photography in America during the 1920s and 1930s – and the changing cultural ideals of the nation – are traced through a close

analysis of dozens of Steichen's magazine advertisements, in one of the few books to make a thorough, critical study of advertising photography.

Slater, Don (1995) 'Domestic Photography and Digital Culture' in Martin Lister (ed.) *The Photographic Image in Digital Culture* London: Routledge, pp. 129–146

Slater, Don (1999) 'Marketing Mass Photography' in Jessica Evans and Stuart Hall (eds) *Visual Culture: The Reader* London: Sage, pp. 289–306

In the 1980s Slater wrote a number of vital and detailed essays on the business of popular photography such as 'Marketing Mass Photography', where the camera as a vehicle for selling film is a central theme. In 'Domestic Photography and Digital Culture' Slater examines how the marketing of photography was beginning to transform in the digital age.

West, Nancy Martha (2000) *Kodak and the Lens of Nostalgia* Charlottesville, VA and London: University Press of Virginia

A vital critical analysis of the ways Kodak's marketing strategies shaped how photography came to be consumed and used, argued through a range of compelling visual case studies of advertisements spanning the years 1888 to 1932.

Williamson, Judith (2002) *Decoding Advertisements: Ideology and Meaning in Advertising* London and New York: Marion Boyars

While the visual examples may now appear comically outmoded (the book was originally published in 1978), Williamson's combination of semiology and psychoanalysis to examine the ways advertisements promote ideology is still a key text.

SNAPSHOTS

Bourdieu, Pierre (1990) *Photography: A Middle-Brow Art* Cambridge: Polity Press

In the 1960s, French sociologist Bourdieu (and his associates) surveyed photography's relationship to social class, systematically examining areas such as the taking of snapshots and the aspirations of amateur camera clubs, in a pioneering work that remains vital to this area.

Chalfen, Richard (1987) *Snapshot Versions of Life* Bowling Green, OH: Bowling Green State University Popular Press

Chalfen's anthropological study of the 'Kodak Culture' of snapshot photography is one of the most detailed and perceptive analyses available on the subject. It includes his staggering revelation that the snaps made of someone over the course of their lifetime represent only 30 seconds of that person's life.

Greenough, Sarah and Waggoner, Diane (eds) (2007) *The Art of the American Snapshot: 1888–1978* Washington, DC and Princeton, NJ: National Gallery of Art and Princeton University Press

More than the picture book it first appears, the essays in this collection offer a detailed and brilliantly illustrated examination of the development of snapshot photography in America from the 1880s until the 1970s.

Kenyon, Dave (1992) *Inside Amateur Photography* London: Batsford
Focusing in its longest chapter on an analysis of the types of pictures found in photo albums, Kenyon's book is an important addition to a still relatively under-theorised (yet absolutely central) area of photography.

King, Graham (1986) *Say 'Cheese!' The Snapshot as Art and Social History* London: Collins
Esoteric and diverse in its approach, along with Chalfen and Kenyon, King presents one of the few detailed studies focusing on snapshot photography to be published in book form.

Rubinstein, Daniel and Sluis, Karen (2008) 'A Life More Photographic: Mapping the Networked Image' in *Photographies* 1(1): 9–28
An important essay examining the effects of the move from snapshots existing in print form to digital snapshots transmitted via online networks.

Spence, Jo and Holland, Patricia (eds) (1991) *Family Snaps: The Meanings of Domestic Photography* London: Virago
This strong collection of writing on snapshots, often influenced by techniques of phototherapy, includes essays by Patricia Holland, Annette Kuhn, Rosy Martin, Jo Spence and Val Williams.

THE PHOTOGRAPH AS DOCUMENT

Campany, David (2003) 'Safety in Numbness: Some Remarks on Problems of "Late Photography"' in David Green (ed.) *Where is the Photograph?* Brighton: Photoforum/Maidstone: Photoworks, pp. 123–132
Campany's influential essay debates the shift from documentary photographs that catch the decisive moment to those that show the 'aftermath' of an event, often in aesthetically pleasing images.

Panzer, Mary (2006) *Things As They Are: Photojournalism in Context Since 1955* London: Chris Boot
Panzer's introduction provides an excellent overview of photojournalism in the context of magazines since the 1950s, and includes a useful discussion of the effects on photojournalism of digital technologies such as camera phones.

Reinhardt, Mark, Edwards, Holly and Duganne, Erina (eds) (2008) *Beautiful Suffering: Photography and the Traffic in Pain* Chicago, IL: University of Chicago Press
Five essays reflecting on contemporary war photography and aesthetics in an appropriately well-illustrated book.

Sontag, Susan (2004) *Regarding the Pain of Others* London: Penguin
Reading like a conversation with the author herself, in what is really an extended essay Sontag returns to and revises some of the opinions expressed in *On Photography* via an astute analysis of what it means to look at images of suffering.

Tagg, John (1988) *The Burden of Representation: Essays on Photographies and Histories* London: Macmillan
One of the key texts of 1980s 'postmodernist' photography theory. Tagg applies ideas from Louis Althusser and Michel Foucault to argue for the significance of institutional context in the use of photographs as documents and evidence.

Taylor, John (1998) *Body Horror: Photojournalism, Catastrophe and War* Manchester: Manchester University Press
Taylor's important book perceptively analyses the moral responsibilities in showing disturbing photographs of the dead and injured.

Walker, Ian (1995) 'Desert Stories or Faith in Facts?' in Martin Lister (ed.) *The Photographic Image in Digital Culture* London: Routledge, pp.236–252
While emphasising digitisation, Walker's essay also debates key issues around contemporary documentary photography, including its placement within the context of artists' books and art galleries.

PHOTOGRAPHS AS ART

Barthes, Roland (1977) 'The Death of the Author' in *Image/Music/Text* London: Fontana, pp.142–148
A founding article of postmodernist theory, Barthes' revolutionary 1968 essay argues that the meaning of a work is not to be found in its author, but in its viewer: an idea that turns the modernist approach to art photography on its head, but corresponds with the techniques of appropriation used in postmodern art photography a decade or so later.

Bolton, Richard (ed.) (1989) *The Contest of Meaning: Critical Histories of Photography* Boston, MA: Massachusetts Institute of Technology
Arguably the American equivalent to *Thinking Photography* (see Burgin 1982, above), this anthology of essays forms a critique of the modernist incarnation of art photography still dominant at the time in institutions such as the Museum of Modern Art, New York (analysed here in a key thesis by Christopher Phillips). The book also includes Martha Rosler's important essay 'In, Around, and Afterthoughts (on Documentary Photography)'.

Campany, David (2003) *Art and Photography* London: Phaidon
Picking up chronologically where Aaron Scharf's book of the same title left off, Campany's dense and copiously illustrated volume on how 'art has become

increasingly photographic' since the 1960s also includes a section reprinting key texts, and a perceptive, wide-ranging introductory survey.

Cotton, Charlotte (2004) *The Photograph as Contemporary Art* London: Thames and Hudson
A thematically ordered overview of the subject, which only touches upon individual works and practitioners, but functions perfectly as an excellent introduction to contemporary art photography.

Scharf, Aaron (1983) *Art and Photography* Harmondsworth: Penguin
Art equals painting in Scharf's version of *Art and Photography*, which charts the connections between both areas of visual culture up until the 1960s. A lot has changed since then (see Campany 2003, above), but Scharf's book is still an important work and is particularly strong on the 19th century.

Solomon-Godeau, Abigail (1991) *Photography at the Dock: Essays on Photographic History, Institutions, and Practices* Minneapolis, MN: University of Minnesota Press
Also containing essays on topics such as documentary photography and the representations of gender, Solomon-Godeau's case study of authorship ('Canon Fodder: Authoring Eugéne Atget') and her pieces written during the 1980s on postmodernist art photography's shift from a radical practice of appropriation to a marketable and authored commodity analyse an era where certain photographs (both old and new) were being established as works of art.

PHOTOGRAPHS IN FASHION

Bright, Susan (2007) *Face of Fashion* London: National Portrait Gallery
Ostensibly focusing on the 'fashion portrait', Bright's exhibition catalogue provides an important study of the fashion photograph in an art gallery context.

Craik, Jennifer (1994) 'Soft Focus: Techniques of Fashion Photography' in *The Face of Fashion: Cultural Studies in Fashion* London: Routledge, pp.92–114
Almost the same title as Bright's book, but Craik's *The Face of Fashion* is a more general analysis of fashion culture that includes this useful chapter on fashion photography from its origins in the 19th century up to the 1990s, with an emphasis on gendered looking.

Harrison, Martin (1991) *Appearances: Fashion Photography Since 1945* London: Jonathan Cape
Harrison's meticulously researched book is primarily historical, but has shaped most analytical writing on fashion photography ever since. Amongst other things, it arguably started the critical rehabilitation of Guy Bourdin and Helmut Newton.

Jobling, Paul (1999) *Fashion Spreads: Word and Image in Fashion Photography Since 1980* New York and Oxford: Berg

Taking Barthes' approach in *The Fashion System* (Barthes 1983) as his starting point, Jobling makes a detailed study, centring on gender and sexuality, of photographs and texts from fashion magazines of the 1980s and 1990s.

Shinkle, Eugénie (ed.) (2008) *Fashion as Photograph: Viewing and Reviewing Images of Fashion* London: IB Tauris

An excellent selection of contemporary essays (some adapted from pieces in the journal *Fashion Theory*) and interviews. The book also includes Susan Kismaric and Eva Respini's important text from the 2004 MoMA exhibition catalogue *Fashioning Fiction in Photography Since 1990*.

Williams, Val (1998) *Look at Me: Fashion and Photography in Britain 1960 to the Present* London: The British Council

Following Harrison's work, Williams' insightful and influential essay in this well-illustrated exhibition catalogue focuses on themes in British fashion photography from the 1960s to the 1990s.

PHOTOGRAPHY AND CELEBRITY

Braudy, Leo (1997) *The Frenzy of Renown: Fame and Its History* New York: Vintage

Two and a half thousand years of celebrity, from Alexander the Great to the fleeting fame of the late 20th century, are covered in this 600-page book, which provides an important background to our own celebrity-obsessed era.

Hargreaves, Roger (2001) 'Putting Faces to the Names: Social and Celebrity Portrait Photography' in Peter Hamilton and Roger Hargreaves *The Beautiful and the Damned: The Creation of Identity in Nineteenth Century Photography* Aldershot: Lund Humphries/London: National Portrait Gallery, pp. 16–56

Hargreaves' essay entertainingly and intelligently traces a social history of photography and fame in the 19th century, where those who were already celebrated came before the camera.

Holmes, Su and Redmond, Sean (eds) (2006) *Framing Celebrity: New Directions in Celebrity Culture* Abingdon: Routledge

One of many collections focusing on celebrity to be published in the early 21st century, Holmes and Redmond's book includes a number of essays directly relevant to contemporary celebrity photography.

Muir, Robin (2005) *The World's Most Photographed* London: National Portrait Gallery

Each of the ten chapters in *The World's Most Photographed* is dedicated to the photographs of a specific celebrity: from Queen Victoria to Muhammad Ali via

Greta Garbo, Marilyn Monroe, Elvis Presley, etc. Muir analyses their public and private images in a detailed, accessible and fully illustrated book (that accompanied an exhibition and television series).

Rojek, Chris (2001) *Celebrity* London: Reaktion
Sociologist Rojek applies a number of different ideas to his analysis of celebrity, in a book that gives a useful starting point for thinking about images of celebrities in contemporary culture.

Squiers, Carol (1999) 'Class Struggle: The Invention of Paparazzi Photography and the Death of Diana, Princess of Wales' in Carol Squiers (ed.) *Over Exposed: Essays on Contemporary Photography* New York: The New Press, pp. 269–304
Focusing on the most famous subject of the paparazzi, Squiers' essay also provides one of the more detailed critical studies of paparazzi photography to date.

FURTHER RESOURCES

ACADEMIC JOURNALS

History of Photography
Published four times a year, with each issue concentrating on a specific theme, this journal contains detailed, scholarly texts suitable for advanced research.

www.tandf.co.uk/journals/titles/03087298.asp

Photographies
Published twice a year since 2008 and edited by David Bate, Sarah Kember, Martin Lister and Liz Wells, *Photographies* includes essays that advance the history and theory of photography, updating a 'postmodernist' critical perspective. Highly recommended.

www.tandf.co.uk/journals/rpho

Photography & Culture
Published three times a year since 2008 and edited by Kathy Kubicki, Alison Nordstrom and Val Williams – as its title suggests, *Photography & Culture* examines photography from its cultural and historical context through a variety of approaches. Highly recommended.

www.bergpublishers.com/Journals/PhotographyandCulture

MAGAZINES AND PERIODICALS

Afterimage
Subtitled *The Journal of Media Arts and Cultural Criticism*, this bimonthly magazine publishes critical essays on current debates around photography (and video), as well as book and exhibition reviews.

Aperture
Founded in 1952 by Minor White, American magazine *Aperture* is published four times a year and has gone beyond its modernist remit to include essays and images by key contemporary writers and practitioners.

www.aperture.org/magazine

The British Journal of Photography
The oldest photography magazine in the world (first published in 1854) is a weekly roundup of news, professional work, technical reviews, art photography, and articles.

www.bjp-online.com

Photoworks
Published twice yearly by the organisation of the same name (which commissions and publishes new photographic work), since its debut issue in 2003 *Photoworks* magazine has presented a vital critical commentary on photography, along with work by contemporary photographers and reappraisals of older images.

www.photoworksuk.org/publication/magazine/default.asp

Portfolio
Published twice a year, *Portfolio* is part-magazine, part-exhibition catalogue, with high-quality reproductions of contemporary art photography. Wider areas of the medium are rarely addressed, but this is one of the key places to see art photography now.

www.portfoliocatalogue.com

Source: The Photographic Review
Published since 1992, this quarterly magazine has become established as one of the central forums for debates about photography, as well as being a space where new practice first appears. Along with art photography, *Source* addresses areas such as advertising photography, snapshots and photojournalism through incisive essays and reviews.

www.source.ie

Although no longer published, back issues of the following magazines are well worth investigating:

Camerawork

Published from 1976 to 1985, *Camerawork* pioneered the study of photography as a social practice, informed by evolving political, feminist and semiotic approaches. A selection of essays is included in the anthology Evans, Jessica (ed.) (1997) *The Camerawork Essays: Context and Meaning in Photography* London: Rivers Oram Press.

Creative Camera

Back issues of this magazine, published between 1968 and 2000, contain a wealth of critical writing on photography by key writers. During its existence the magazine also introduced and followed the work of hundreds of pioneering photographers. It became *DPICT* for a final seven issues (2000 to 2001). An excellent anthology also exists: Brittain, David (ed.) (1999) *Creative Camera:Thirty Years of Writing* Manchester: Manchester University Press.

Ten.8

Inspired by *Camerawork*, *Ten.8* ran from 1979 to 1991 with an aim to present new photographs and stimulate debates about photography. The final two issues appeared as 'photo paperbacks', with the last issue themed around 'digital dialogues'. No anthology has yet been published, but some essays from the magazine are reprinted in Wells, Liz (ed.) (2003) *The Photography Reader* London: Routledge.

ONLINE RESOURCES

While there are thousands of websites relating to photography, there is a surprising lack of websites offering a critical approach to the subject. Two of the best are:

Lens Culture: Contemporary Photography Magazine
Lens Culture is an online magazine, primarily focusing on art photography and documentary practice, with intelligently written reviews of new work, as well as audio interviews.

www.lensculture.com

ZoneZero: From Analogue to Digital Photography
Published and directed by Pedro Meyer, since 1995 *ZoneZero* has intelligently charted photography's 'journey' from analogue to digital. The site is regularly updated with new essays and online exhibitions.

www.zonezero.com

For the kinds of photographs most people are taking most of the time, go to www.flickr.com and www.facebook.com.

BIBLIOGRAPHY

Ades, Dawn (1986) *Photomontage* London: Thames and Hudson

Adorno, Theodor and Horkheimer, Max (1999) 'The Culture Industry: Enlightenment as Mass Deception' in Simon During (ed.) *The Cultural Studies Reader* London: Routledge, pp. 31–41

Albert, Pierre and Feyel, Gilles (1998) 'Photography and the Media: Changes in the Illustrated Press' in Michel Frizot (ed.) *The New History of Photography* Cologne: Könemann, pp. 358–369

Alexandrian, Sarane (1970) *Surrealist Art* London: Thames and Hudson

Althusser, Louis (2003) 'From "Ideology and Ideological State Apparatuses"' in Charles Harrison and Paul Wood (eds) *Art in Theory: 1900–2000* London: Blackwell, pp. 953–960

Andrews, Malcolm (1999) *Landscape and Western Art* Oxford: Oxford University Press

Arnatt, Keith (2003) 'Sausages and Food' in David Campany (ed.) *Art and Photography* London: Phaidon, pp. 228–229

Arnold, Rebecca (1999) 'Heroin Chic' in *Fashion Theory* 3(3): 279–295

—— (2001) *Anxiety and Desire: Image and Morality in the 20th Century* London: IB Tauris

Badger, Gerry (2003) *Collecting Photography* London: Mitchell Beazley

—— (2007) *The Genius of Photography: How Photography Has Changed Our Lives* London: Quadrille

Banksy (2006) *Wall and Piece* London: Century

Barth, Miles (2000) 'Weegee's World' in Miles Barth (ed.) *Weegee's World* Boston/New York/London: Bulfinch

Barthes, Roland (1967) *Elements of Semiology* London: Jonathan Cape

—— (1973) *Mythologies* London: Paladin

—— (1977a) 'The Photographic Message' in *Image/Music/Text* London: Fontana, pp.15–31

—— (1977b) 'Rhetoric of the Image' in *Image/Music/Text* London: Fontana, pp.32–51

—— (1977c) 'The Death of the Author' in *Image/Music/Text* London: Fontana, pp.142–148

—— (1977d) 'From Work to Text' in *Image/Music/Text* London: Fontana, pp.155–164

—— (1983) *The Fashion System* Berkeley, CA: University of California Press

—— (1999) 'The Scandal of Horror Photography' in David Brittain (ed.) *Creative Camera: 30 Years of Writing* Manchester: Manchester University Press, pp.32–34

—— (2000) *Camera Lucida: Reflections on Photography* London: Vintage

Batchen, Geoffrey (1997) *Burning With Desire: The Conception of Photography* Boston, MA: Massachusetts Institute of Technology

—— (2001) *Each Wild Idea Writing Photography History* Boston, MA: Massachusetts Institute of Technology

—— (2003) '"Fearful Ghost of Former Bloom": What Photography Is' in David Green (ed.) *Where is the Photograph?* Brighton: Photoforum/Maidstone: Photoworks

—— (2004) *Forget Me Not: Photography and Remembrance* New York: Princeton Architectural Press/Amsterdam: Van Gogh Museum

—— (2008a) '*Camera Lucida*: Another Little History of Photography' in Robin Kelsey and Blake Stimson (eds) *The Meaning of Photography* Massachusetts: Sterling and Francine Clark Art Institute, pp.76–91

—— (2008b) 'Snapshots: Art History and the Ethnographic Turn' in *Photographies* 1(2): 121–142

—— (2009) 'Dreams of Ordinary Life: *Cartes-de-visite* and the Bourgeois Imagination' in J J Long, Andrea Noble and Edward Welch (eds) *Photography: Theoretical Snapshots* Abingdon: Routledge, pp.80–97

Bate, David (2004a) 'After Thought Part II: Neo Realism and Postmodern Realism' in *Source: The Photographic Review* 41: 34–37

—— (2004b) *Photography and Surrealism: Sexuality, Colonialism and Social Dissent* London: IB Tauris

—— (2005) 'We Photograph Them and They Beat Us Up' in *Source: The Photographic Review* 44: 30–35

—— (2007) 'The Emperor's New Clothes' in James Elkins (ed.) *Photography Theory* London: Routledge, pp.253–255

Baudelaire, Charles (1980) 'The Modern Public and Photography' in Alan Trachtenberg (ed.) *Classic Essays on Photography* New Haven, CT: Leete's Island Books, pp.83–89

Baudrillard, Jean (1984) 'The Precession of Simulacra' in Brian Wallis (ed.) *Art After Modernism: Rethinking Representation* Boston, MA: David R Godine, pp.252–281

Bazin, André (1980) 'The Ontology of the Photographic Image' in Alan Trachtenberg (ed.) *Classic Essays on Photography* New Haven, CT: Leete's Island Books, pp.237–244

Beaton, Cecil (1951) *Photobiography* London: Odhams Press

Becker, Karin E (2003) 'Photojournalism and the Tabloid Press' in Liz Wells (ed.) *The Photography Reader* London: Routledge, pp.291–308

Behrend, Heike (2003) 'Imagined Journeys: The Likoni Ferry Photographers of Mombasa, Kenya' in Christopher Pinney and Nicolas Peterson (eds) *Photography's Other Histories* Durham and London: Duke University Press, pp.221–239

Belsey, Catherine (1980) *Critical Practice* London: Routledge

Benjamin, Walter (1980) 'A Short History of Photography' in Alan Trachtenberg (ed.) *Classic Essays on Photography* New Haven, CT: Leete's Island Books, pp.199–216

—— (1982) 'The Author as Producer' in Victor Burgin (ed.) *Thinking Photography* London: Macmillan

—— (1999) 'The Work of Art in the Age of Mechanical Reproduction' in Walter Benjamin *Illuminations* London: Pimlico, pp.211–244

Berger, John (1980) 'Understanding a Photograph' in Alan Trachtenberg (ed.) *Classic Essays on Photography* New Haven, CT: Leete's Island Books, pp.291–294

Berger, Lynn (2009) 'The Authentic Amateur and the Democracy of Collecting Photographs' in *Photography and Culture* 2(1): 31–50

Berman, Linda (1993) *Beyond the Smile: The Therapeutic Use of the Photograph* London: Routledge

Billingham, Richard and MacDonald, Gordon (2007) 'Interview: Richard Billingham' in *Photoworks* 8: 20–25

Blessing, Jennifer (ed.) (1997) *Rrose is a Rrose is a Rrose: Gender Performance in Photography* New York: Guggenheim Museum

Bolton, Richard (ed.) (1989) *The Contest of Meaning: Critical Histories of Photography* Boston, MA: Massachusetts Institute of Technology

Bourdieu, Pierre (ed.) (1990) *Photography: A Middle–Brow Art* Cambridge: Polity Press

Bowen, Dore (2006) 'Imagine There's No Image (It's Easy If You Try): Appropriation in the Age of Digital Reproduction' in Amelia Jones (ed.) *A Companion to Contemporary Art Since 1945* Oxford: Blackwell, pp.534–556

Bowness, Alan (1999) 'The Tate Gallery and Photography' interview by Colin Osman in David Brittain (ed.) *Creative Camera: 30 Years of Writing* Manchester: Manchester University Press, pp.66–72

Braudy, Leo (1997) *The Frenzy of Renown: Fame and Its history* New York: Vintage

Breton, André (2003) 'From "The First Manifesto of Surrealism"' in Charles Harrison and Paul Wood (eds) *Art in Theory: 1900–2000* London: Blackwell, pp.447–453

Briggs, Adam and Cobley, Paul (eds) (1998) *The Media: An Introduction* Harlow: Longman

Bright, Deborah (1989) 'Of Mother Nature and Marlboro Men: An Enquiry into the Cultural Meanings of Landscape Photography' in Richard Bolton (ed.) *The Contest of Meaning: Critical Histories of Photography* Boston, MA: Massachusetts Institute of Technology, pp.125–142

—— (ed.) (1998) *The Passionate Camera: Photography and Bodies of Desire* London: Routledge

Bright, Susan (2005) 'Introduction' in *Art Photography Now* London: Thames and Hudson, pp.6–17

—— (2007) 'Face Value: The Contemporary Fashion Portrait' in *Face of Fashion* London: National Portrait Gallery, pp.12–23

Brittain, David (2007) 'Touch, Feel and Lose' in *Photoworks* 8: 34–37

Brooks, Rosetta (1997) 'Fashion: Double-Page Spread' in Jessica Evans (ed.) *The Camerawork Essays: Context and Meaning in Photography* London: Rivers Oram, pp.205–217

Brothers, Caroline (1997) *War and Photography: A Cultural History* London: Routledge

Brunet, Francois (2008) '"A Better Example is a Photograph": On the Exemplary Values of Photographs in C S Peirce's Reflection on Signs' in Robin Kelsey and Blake Stimson (eds) *The Meaning of Photography* Massachusetts: Sterling and Francine Clark Art Institute, pp.34–49

Bull, Stephen (1995) 'The Tourist as Attraction: *Small World* by Martin Parr' in *Portfolio* 22: 52–53

—— (1997) 'Other People's Photographs' in *Creative Camera* 344: 38–41

—— (1999a) 'Photomontage and the Millennium' in *Creative Camera* 361: 18–21

—— (1999b) 'The Aprés–Garde' in *Creative Camera* 357: 10–13

—— (2002a) 'Review: *Our True Intent Is All For Your Delight*' in *Source: The Photographic Review* 33: 64–66

—— (2002b) 'Back to Reality' in *Art Foto* 1 (supplement with *Art Review* Vol. 53, November): 18–23

—— (2002c) 'Wealthy, Happy and Relaxed' in *Source: The Photographic Review* 32: 37–39

—— (2003) 'Questioning Questions' in *Photoworks* 1: 4–5

—— (2004a) 'Review: The Trachtenburg Family Slideshow Players' in *Source: The Photographic Review* 40: 57

—— (2004b) 'Documentary Photography in the Art Gallery' in *Engage* 14: 14–20

Burgin, Victor (1982a) 'Photography, Phantasy, Function' in Victor Burgin (ed.) *Thinking Photography* London: Macmillan, pp.177–216

——— (1982b) 'Introduction' in Victor Burgin (ed.) *Thinking Photography* London: Macmillan, pp.1–14

——— (1982c) 'Photographic Practice and Art Theory' in Victor Burgin (ed.) *Thinking Photography* London: Macmillan, pp.39–83

——— (1982d) 'Looking at Photographs' in Victor Burgin (ed.) *Thinking Photography* London: Macmillan, pp.142–153

——— (ed.) (1982e) *Thinking Photography* London: Macmillan

——— (1986a) 'Seeing Sense' in *The End of Art Theory: Criticism and Postmodernity* London: Macmillan, pp.51–70

——— (1986b) 'The End of Art Theory' in *The End of Art Theory: Criticism and Postmodernity* London: Macmillan

——— (1991a) 'Realising the Reverie' in *Ten.8* 2(2): 8–15

——— (1991b) 'Perverse Space' in Stephen Bann and William Allen (eds) *Interpreting Contemporary Art* London: Reaktion, pp.124–138

——— (1991c) 'Newton's Gravity' in Carol Squiers (ed.) *The Critical Image: Essays on Contemporary Photography* London: Lawrence and Wishart, pp.165–172

Buse, Peter (2008) 'Surely Fades Away: Polaroid Photography and the Contradictions of Cultural Value' in *Photographies* 1(2): 221–238

Bush, Kate (2002) 'Reality Check: Recent Developments in British Photography and Video' in Frédérique Dolivet (ed.) *Reality Check: Recent Developments in British Photography and Video* London: British Council, Visual Arts, pp.4–11

——— and Sladen, Mark (2006) 'Preface' to Kate Bush and Mark Sladen (eds) *In the Face of History: European Photographers in the 20th Century* London: Black Dog

Butin, Hubertus (1999) 'Oh When Will I be Famous, When Will it Happen?' in Hamburg Kunsthalle and The Andy Warhol Museum, Pittsburgh, PA (eds) *Andy Warhol Photography* Zurich: Edition Stemmle

Butler, Judith (1990) *Gender Trouble* London and New York: Routledge

Butler, Susan (1999) 'From Today Black and White is Dead' in David Brittain (ed.) *Creative Camera: 30 Years of Writing* Manchester: Manchester University Press, pp.121–126

Campany, David (2003a) 'Survey' in David Campany *Art and Photography* London: Phaidon, pp.12–45

——— (2003b) '"Colourless Green Ideas Sleep Furiously": Photography and the Syntax of the Archive' in *Source: The Photographic Review* 36: 14–17

——— (2003c) 'Safety in Numbness: Some Remarks on Problems of "Late Photography"' in David Green (ed.) *Where is the Photograph?* Brighton: Photoforum / Maidstone: Photoworks, pp.123–132

——— (2008a) *Photography and Cinema* London: Reaktion

——— (2008b) 'Re–Viewing *Rear Window*' in *Aperture* 192: 52–55

Carlyle, Angus (2005) 'Once a Certain Notion' in *Photoworks* 5: 6–7

Capa, Robert (1989) 'From *Slightly Out of Focus*' in Mike Weaver (ed.) *The Art of Photography 1839–1989* New Haven, CT and London: Yale University Press, pp. 393–394

Cartier-Bresson, Henri (1952) *The Decisive Moment* New York: Simon and Schuster

Carver, Antonia (ed.) (2002) *Blink: 100 Photographers 010 Writers 010 Curators* London: Phaidon

Caws, Mary Ann (1986) 'Ladies Shot and Painted: Female Embodiment in Surrealist Art' in Susan Rubin Suleiman (ed.) *The Female Body in Western Culture* New York: Harvard University Press, pp. 262–287

Chalfen, Richard (1987) *Snapshot Versions of Life* Bowling Green, OH: Bowling Green State University Popular Press

Chandler, David (2003) 'Paul Seawright *Hidden*' in *Portfolio* 37: 66–67

Chevalier, Tracy and Wiggins, Colin (2005) *Tom Hunter: Living in Hell and Other Stories* London: National Gallery

Clark, Timothy J (1999) *The Painting of Modern Life: Paris in the Art of Manet and His Followers* Princeton, NJ: Princeton University Press

Clarke, Graham (1992) 'Introduction' in Graham Clarke (ed.) *The Portrait in Photography* London: Reaktion, pp. 1–5

Cobley, Paul and Haeffner, Nick (2009) 'Digital Cameras and Domestic Photography: Communication, Agency and Structure' *Visual Communication* 8(2): 123–146

Cobley, Paul and Jansz, Litza (1999) *Introducing Semiotics* Cambridge: Icon

Coonan, Clifford (2006) 'The New Cultural Revolution: How Little Fatty Made it Big' *The Independent*, 16 November

Cotton, Charlotte (2000) *Imperfect Beauty: The Making of Contemporary Fashion Photographs* London: V&A

—— (2004) *The Photograph as Contemporary Art* London: Thames and Hudson

Craik, Jennifer (1994) 'Soft Focus: Techniques of Fashion Photography' in *The Face of Fashion: Cultural Studies in Fashion* London: Routledge, pp. 92–114

Crary, Jonathan (1992) *Techniques of the Observer: On Vision and Modernity in the Nineteenth Century* Boston, MA: Massachusetts Institute of Technology

Crimp, Douglas (1984) 'Pictures' in Brian Wallis (ed.) *Art After Modernism: Rethinking Representation* Boston, MA: David R Godine, pp. 175–187

—— (1989) 'The Museum's Old/The Library's New Subject' in Richard Bolton (ed.) *The Contest of Meaning: Critical Histories of Photography* Boston, MA: Massachusetts Institute of Technology, pp. 3–13

Damisch, Hubert (1980) 'Notes for a Phenomenology of the Photographic Image' in Alan Trachtenberg (ed.) *Classic Essays on Photography* New Haven, CT: Leete's Island Books, pp. 287–290

Davies, Simon (2000) 'Data: The Stuff That Surrounds You' in *DPICT* 1: 30–33

De Duve, Thierry (2002) 'The Mainstream and the Crooked Path' in Thierry de Duve (ed.) *Jeff Wall* London: Phaidon, pp. 26–55

De Perthuis, Karen (2005) 'The Synthetic Ideal: The Fashion Model and Photographic Manipulation' in *Fashion Theory* 9(4): 407–424

—— (2008) 'Beyond Perfection: The Fashion Model in the Age of Digital Manipulation' in Eugénie Shinkle (ed.) *Fashion as Photograph: Viewing and Reviewing Images of Fashion* London: IB Tauris, pp. 168–181

De Salvo, Donna (2005) *Open Systems: Rethinking Art c.1970* London: Tate

De Saussure, Ferdinand (1959) *Course in General Linguistics* New York: The Philosophical Library (1st French edition, 1916; Wade Baskin, trans.)

Debord, Guy (2003) 'Writings from the *Situationist International*' in Charles Harrison and Paul Wood (eds) *Art in Theory: 1900–2000* London: Blackwell, pp. 701–707

Deely, John (1994) *The Human Use of Signs, or, Elements of Anthroposemiosis* Lanham, MD: Rowman and Littlefield

Demos, T J (2006) *Vitamin Ph: New Perspectives on Photography* London: Phaidon

Dennis, Kelly (2009) 'Benjamin, Atget and the 'Readymade' Politics of Postmodern Photography Studies' in J J Long, Andrea Noble and Edward Welch (eds) *Photography: Theoretical Snapshots* Abingdon: Routledge, pp. 112–124

Derrick, Robin (2000) 'The Impossible Image: The Camera Never Lies' in Mark Sanders, Phil Poynter and Robin Derrick (eds) *The Impossible Image: Fashion Photography in the Digital Age* London: Phaidon, pp. 2–3

Dexter, Emma (2003) 'Photography Itself' in Emma Dexter and Thomas Weski (eds) *Cruel and Tender: The Real in the Twentieth Century Photograph* London: Tate, pp. 15–21

—— and Morris, Emma interviewed by Helen James (2003) 'Here Comes the Tate' in *Source: The Photographic Review* 35: 34–39

—— and Weski, Thomas (ed.) (2003) *Cruel and Tender: The Real in the Twentieth Century Photograph* London: Tate

Dibbell, Julian (2007) 'Introduction' to Robbie Cooper *Alter–Ego: Avatars and Their Creators* London: Chris Boot (unpaginated)

Doane, Mary Anne (1982) 'Film and the Masquerade: Theorising the Female Spectator' in *Screen* 23 (3–4): 74–87

Dodier, Virginia (1999) *Lady Hawarden: Studies From Life 1857–1864* New York: Aperture

Doorne, James (2008) 'Facebook in the News' in *Facebook: Your Complete Guide to Social Networking* London: Dennis, pp. 108–114

Durden, Mark (1999) 'Defining the Moment' in David Brittain (ed.) *Creative Camera: 30 Years of Writing* Manchester: Manchester University Press, pp. 290–295

—— (2003) '"The Poetics of Absence": Photography in the "Aftermath" of War' in Paul Seawright (ed.) *Hidden* London: Imperial War Museum

Dyer, Geoff (2006) *The Ongoing Moment* London: Abacus

Dyer, Richard (1982) 'Don't Look Now: The Male Pin–Up' in *Screen* 23 (3–4): 61–73

Eagleton, Terry (2004) *After Theory* London: Penguin

Eco, Umberto (1987) 'A Photograph' in *Travels in Hyper-reality* London: Picador, pp.213–217

Edwards, Elizabeth (1992) 'Introduction' in *Anthropology and Photography 1860–1920* New Haven, CT and London: Yale University Press and The Royal Anthropological Institute, pp.3–17

—— (1997) 'Ordering Others: Photography, Anthropologies and Taxonomies' in Chrissie Iles and Russell Roberts (eds) *In Visible Light: Photography and Classification in Art, Science and the Everyday* Oxford: Museum of Modern Art, pp.54–68

—— (2001) *Raw Histories: Photographs, Anthropology and Museums* Oxford: Berg

—— (2005) 'Embodied Meanings: The Sound and Feel of Photographs' in *Source: The Photographic Review* 42: 40–43

—— (2009) 'Thinking Photography Beyond the Visual?' in J J Long, Andrea Noble and Edward Welch (eds) *Photography: Theoretical Snapshots* Abingdon: Routledge, pp.31–48

—— and Hart, Janice (2004) 'Introduction: Photographs as Objects' in Elizabeth Edwards and Janice Hart (eds) *Photographs, Objects, Histories: On the Materiality of Images* Abingdon: Routledge, pp.1–15

Edwards, Steve (2006) *Photography: A Very Short Introduction* Oxford: Oxford University Press

Eisenman, Stephen F (2007) *The Abu Ghraib Effect* London: Reaktion

Elkins, James (ed.) (2007) *Photography Theory* London: Routledge

Eskildsen, Ute (ed.) (2008) *Street and Studio: An Urban History of Photography* London: Tate

Evans, David and Gohl, Sylvia (1986) *Photomontage: A Political Weapon* London and Bedford: Gordon Fraser

Evans, Jessica (1998) 'Feeble Monsters: Making Up Disabled People' in Adam Briggs and Paul Cobley (eds) *The Media: An Introduction* Harlow: Longman, pp.335–353

Ewing, William A (2006) 'Introduction: About Face' in *Face: The New Photographic Portrait* New York: Thames and Hudson, pp.14–25

Feasey, Rebecca (2006) 'Get a Famous Body: Star Styles and Celebrity Gossip in *Heat* Magazine' in Su Holmes and Sean Redmond (eds) *Framing Celebrity: New Directions in Celebrity Culture* Abingdon: Routledge, pp.177–194

Ferguson, Russell (2001) 'Open City: Possibilities of the Street' in Kerry Brougher and Russell Ferguson *Open City: Street Photographs Since 1950* Oxford: Museum of Modern Art, pp.8–21

Fiske, John (1990) *An Introduction to Communication Studies* London: Routledge

Foucault, Michel (1977) *Discipline and Punish: The Birth of the Prison* London: Penguin

Freud, Sigmund (1990) 'The "Uncanny"' in *The Penguin Freud Library Volume 14: Art and Literature* London: Penguin, pp. 335–376

—— (1991a) *The Penguin Freud Library Volume 1: Introductory Lectures on Psychoanalysis* London: Penguin

—— (1991b) 'The Unconscious' in *The Essentials of Psycho–Analysis* London: Penguin, pp. 142–183

—— (1991c) *The Penguin Freud Library Volume 4: The Interpretation of Dreams* London: Penguin

—— (1991d) 'On Dreams' in *The Essentials of Psycho–Analysis* London: Penguin, pp. 81–125

—— (1991e) 'Femininity' in *The Essentials of Psycho–Analysis* London: Penguin, pp. 413–432

—— (1991f) 'Three Essays on the Theory of Sexuality' in *The Essentials of Psycho–Analysis* London: Penguin, pp. 277–375

Freund, Giséle (1982) *Photography and Society* Boston, MA: David R Godine

Friday, Jonathan (2006) 'Stillness Becoming: Reflections on Bazin, Barthes and Photographic Stillness' in David Green and Joanna Lowry (eds) *Stillness and Time: Photography and the Moving Image* Brighton: Photoforum / Photoworks

Fried, Michael (2008) *Why Photography Matters as Art as Never Before* New Haven, CT / London: Yale University Press

Frizot, Michel (1998a) *The New History of Photography* Cologne: Könemann

—— (1998b) 'Light Machines: On the Threshold of Invention' in Michel Frizot *The New History of Photography* Cologne: Könemann, pp. 15–21

—— (1998c) 'Speed of Photography: Movement and Duration' in Michel Frizot *The New History of Photography* Cologne: Könemann, pp. 243–257

—— (1998d) 'Body of Evidence: The Ethnophotography of Difference' in Michel Frizot *The New History of Photography* Cologne: Könemann, pp. 259–271

—— (1998e) '*Camera Work* Magazine: 1903–1917' in Michel Frizot *The New History of Photography* Cologne: Könemann, pp. 327–333

—— (1998f) 'Another Kind of Photography: New Points of View' in Michel Frizot *The New History of Photography* Cologne: Könemann, pp. 387–397

—— (2007) 'Who's Afraid of Photons?' in James Elkins (ed.) *Photography Theory* London: Routledge, pp. 269–283

Frosh, Paul (2003) *The Image Factory: Consumer Culture, Photography and the Visual Content Industry* Oxford: Berg

Galassi, Peter (1981) *Before Photography: Painting and the Invention of Photography* New York: Museum of Modern Art

—— (2001) 'Gursky's World' in Peter Galassi *Andreas Gursky* New York: Museum of Modern Art, pp. 9–43

Gamman, Lorraine and Makinen, Merja (1994) *Female Fetishism: A New Look* London: Lawrence and Wishart

Garner, Philippe (1999) *John Cowan: Through the Light Barrier* Munich/Paris/London: Schirmer/Mosel

Gauntlett, David (2008) *Media, Gender and Identity: An Introduction* Abingdon: Routledge

George, Alice Rose and Peress, Gilles (eds) (2002) *Here is New York: A Democracy of Photographs* Zurich/Berlin/New York: Scalo

Gernsheim, Helmut and Gernsheim, Alison (1971) *A Concise History of Photography* London: Thames and Hudson

Gibson, Robin and Roberts, Pam (1990) *Madame Yevonde: Colour, Fantasy and Myth* London: National Portrait Gallery

Gill, A A (2003) 'Introduction' in Terry O'Neill *Celebrity: The Photographs of Terry O'Neill* London: Little Brown, pp.4–18

Gingeras, Alison M (2006) *Guy Bourdin* London: Phaidon

Grafik, Clare (2007) 'Keith Arnatt, Context' in David Hurn and Clare Grafik *I'm a Real Photographer: Keith Arnatt, Photographs 1974–2002* London: Chris Boot, pp.126–138

Green, Christopher (1989) 'Alienation and Innovation 1900–1918' in Denise Hooker (ed.) *Art of the Western World* London: Boxtree, pp.358–379

Green, David (1986) 'Veins of Resemblance: Photography and Eugenics' in Patricia Holland, Jo Spence and Simon Watney (eds) *Photography/Politics: Two* London: Comedia, pp.9–21

—— (1997) 'On Foucault: Disciplinary Power and Photography' in Jessica Evans (ed.) *The Camerawork Essays: Context and Meaning in Photography* London: Rivers Oram, pp.119–131

—— (1999) 'Between Object and Image' in David Brittain (ed.) *Creative Camera: 30 Years of Writing* Manchester: Manchester University Press, pp.261–268

—— (ed.) (2003) *Where is the Photograph?* Brighton: Photoforum/Maidstone: Photoworks

—— (2006) 'Marking Time: Photography, Film and Temporalities of the Image' in David Green and Joanna Lowry (eds) *Stillness and Time: Photography and the Moving Image* Brighton: Photoforum/Photoworks, pp.9–21

—— (2007) 'Indexophobia' in James Elkins (ed.) *Photography Theory* London: Routledge, pp.244–248

—— and Lowry, Joanna (2003) 'From Presence to the Performative: Rethinking Photographic Indexicality' in David Green (ed.) *Where is the Photograph?* Brighton: Photoforum/Maidstone: Photoworks, pp.47–60

—— (eds) (2006) *Stillness and Time: Photography and the Moving Image* Brighton: Photoforum/Photoworks

Green, Jonathan (1975) *The Snapshot* New York: Aperture

Greenberg, Clement (2003a) 'Modernist Painting' in Charles Harrison and Paul Wood (eds) *Art in Theory 1900–2000* London: Blackwell, pp.539–549

—— (2003b) 'Avant–garde and Kitsch' in Charles Harrison and Paul Wood (eds) *Art in Theory 1900–2000* London: Blackwell, pp.773–779

Greenough, Sarah (2007) 'Fun Under the Shade of the Mushroom Cloud: 1940–1959' in Sarah Greenough and Diane Waggoner (eds) *The Art of the American Snapshot: 1888–1978* Washington, DC and Princeton, NJ: National Gallery of Art and Princeton University Press, pp.147–225

Grundberg, Andy (1990) 'On the Dissecting Table: The Unnatural Coupling of Surrealism and Photography' in Carol Squiers (ed.) *The Critical Image: Essays on Contemporary Photography* London: Lawrence and Wishart, pp.80–87

—— (1998) 'Art and Photography, Photography and Art: Across the Modernist Membrane' in Elizabeth Janus (ed.) *Veronica's Revenge: Contemporary Perspectives on Photography* Zurich: Scalo

Gunning, Tom (1995) 'Phantom Images and Modern Manifestations: Spirit Photography, Magic Theater, Trick Films, and Photography's Uncanny' in Patrice Petro (ed.) *Fugitive Images: From Photography to Video* Bloomington, IN and Indianapolis, IN: Indiana University Press, pp.42–71

Gunthert, André (2008) 'Digital Imaging Goes to War: The Abu Ghraib Photographs' in *Photographies* 1(1): 103–112

Hall, Stuart (1979) 'The Social Eye of *Picture Post* (Extract)' in Terry Dennett and Jo Spence (eds) *Photography/Politics: One* London: Photography Workshop, pp.27–29

—— (1999) 'Encoding, Decoding' in Simon During (ed.) *The Cultural Studies Reader* London: Routledge, pp.507–517

Hamburg Kunsthalle and The Andy Warhol Museum, Pittsburgh, PA (eds) (1999) *Andy Warhol Photography* Zurich: Edition Stemmle

Hamilton, Peter (1992) 'The Enlightenment and the Birth of Social Science' in Stuart Hall and Bram Gieben (eds) *Formations of Modernity* Cambridge: Polity Press, pp. 17–58

—— (2001) 'Policing the Face' in Peter Hamilton and Roger Hargreaves *The Beautiful and the Damned: The Creation of Identity in Nineteenth Century Photography* Aldershot: Lund Humphries/London: National Portrait Gallery, pp.57–107

Harding, Colin (2005) 'Belle Vue Studios, Bradford' in Robin Lenman (ed.) *The Oxford Companion to the Photograph* Oxford: Oxford University Press, pp.412–413

Hargreaves, Roger (2001) 'Putting Faces to the Names: Social and Celebrity Portrait Photography' in Peter Hamilton and Roger Hargreaves *The Beautiful and the Damned: The Creation of Identity in Nineteenth Century*

Photography Aldershot: Lund Humphries/London: National Portrait Gallery, pp.16–56

—— (2004) 'Sitting on the Dock of eBay' in *Photoworks* 2: 67–69

Harrison, Charles (1997) *Modernism* London: Tate

—— (2002) 'Conceptual Art' in Paul Smith and Carolyn Wilde *A Companion to Art Theory* Oxford: Blackwell, pp.317–326

—— and Wood, Paul (eds) (2003) *Art in Theory: 1900–2000* London: Blackwell

Harrison, Martin (1991) *Appearances: Fashion Photography Since 1945* London: Jonathan Cape

—— (1998) *Young Meteors: British Photojournalism 1957–1965* London: Jonathan Cape

Harvey, David (1990) *The Condition of Postmodernity: An Enquiry Into the Origins of Cultural Change* Oxford: Blackwell

Heartney, Eleanor (2001) *Postmodernism* London: Tate

Hebdige, Dick (1979) *Subculture: The Meaning of Style* London: Methuen

Henry, Karen (2006) 'The Artful Disposition: Theatricality, Cinema and Social Context in Contemporary Photography' in Lori Pauli (ed.) *Acting the Part: Photography as Theatre* London/New York: Merrell, pp. 132–161

Hibbert, Katherine (2005) 'Meet the S.L.E.B.S', *The Sunday Times*, 16 October

Hirsch, Julia (1981) *Family Photographs: Context, Meaning and Effect* New York and Oxford: Oxford University Press

Hirsch, Marianne (1997) *Family Frames: Photography, Narrative and Postmemory* Cambridge, MA and London: Harvard University Press

—— (ed.) (1999) *The Familial Gaze* Hanover, NH: Dartmouth College

Hockney, David (2006) *Secret Knowledge: Rediscovering the Lost Techniques of the Old Masters* London: Thames and Hudson

Hodges, Kate (2008) 'Why *Facebook*?' in *Facebook: Your Complete Guide to Social Networking* London: Dennis, pp.6–12

Holland, Patricia (2009) '"Sweet it is to Scan . . .": Personal Photographs and Popular Photography' in Liz Wells (ed.) *Photography: A Critical Introduction* London: Routledge, pp.117–165

Holmes, Oliver Wendell (1980) 'The Stereoscope and the Stereograph' in Alan Trachtenberg (ed.) *Classic Essays on Photography* New Haven, CT: Leete's Island Books, pp.71–82

Holmes, Su and Redmond, Sean (eds) (2006) *Framing Celebrity: New Directions in Celebrity Culture* Abingdon: Routledge

Holschbach, Susanne (2008) 'The Pose: Its Troubles and Pleasures' in Ute Eskildsen, (ed.) *Street and Studio: An Urban History of Photography* London: Tate, pp.171–177

Hopkins, David (2000) *After Modern Art: 1945–2000* Oxford: Oxford University Press

Hopkinson, Tom (1970) 'Introduction' in Tom Hopkinson (ed.) *Picture Post 1938–50* London: Penguin, pp.8–21

Howe, Peter (2005) *Paparazzi* New York: Artisan

Hughes, Robert (1991) *The Shock of the New:Art and the Century of Change* London: Thames and Hudson

Hutchinson, Elizabeth (2000) 'Vernacular Photographies: Responses to a Questionnaire' in *History of Photography* 24(3): 229–231

Huyssen, Andreas (1986) *After the Great Divide: Modernism, Mass Culture, Postmodernism* Bloomington, IN and Indianapolis, IN: Indiana University Press

Ince, Karen (2000) *Orlan: Millennial Female* Oxford: Berg

Iverson, Margaret (1994) 'What is a Photograph?' in *Art History* 17(3), September: 450–464

—— (2007) 'Following Pieces: On Perfomative Photography' in James Elkins (ed.) *Photography Theory* London: Routledge, pp.91–108

Jacobson, Colin (2008) 'Magnum Farce' available at www.zonezero.com/magazine/articles/jacobson/magnum1.html

James, Sarah (2007) 'What can we do with Photography?' in *Art Monthly* 312: 1–4

Jameson, Fredric (1991) *Postmodernism, or, The Cultural Logic of Late Capitalism* London: Verso

Jauffret, Magali (2006) 'La Chute' in *Photoworks* 7: 24–31

Jay, Martin (1994) *Downcast Eyes:The Denigration of Vision in Twentieth–Century French Thought* Berkeley, CA and Los Angeles, CA: University of California Press

Jeffrey, Ian (1999a) 'Some Sacred Sites: *Thinking Photography* edited by Victor Burgin' in David Brittain (ed.) *Creative Camera: 30 Years of Writing* Manchester: Manchester University Press, pp.88–92

—— (1999b) *Revisions: An Alternative History of Photography* Bradford: National Museum of Photography, Film and Television

—— (2006) 'A Formula for Art' in *Photoworks* 7: 46–51

Jobling, Paul (1999) *Fashion Spreads:Word and Image in Fashion Photography Since 1980* New York and Oxford: Berg

—— (2002) 'On the Turn: Millennial Bodies and the Meaning of Time in Andrea Giacobbe's Fashion Photography' in *Fashion Theory* 6(1): 3–24

Johnston, Patricia (1997) *Real Fantasies: Edward Steichen's Advertising Photography* Berkeley, CA: University of California Press

Joyce, Mark (1999) 'The Soviet Montage Cinema of the 1920s' in Jill Nelmes (ed.) *An Introduction to Film Studies* London: Routledge, pp.417–450

Junod,Tom (2003) 'The Falling Man' in *Esquire* 140(3), available at www.esquire.com/features/ESQ0903-SEP_FALLINGMAN

Kant, Immanuel (2005) *Critique of Judgment* Mineola,TX: Dover Publications

Kember, Sarah (1995) 'Surveillance, Technology and Crime: The James Bulger Case' in Martin Lister (ed.) *The Photographic Image in Digital Culture* London: Routledge, pp.115–126

Kennedy, Liam (2003) 'Framing September 11: Photography After the Fall' in *History of Photography* 27(3): 272–283

Kennel, Sarah (2007) 'Quick, Casual, Modern: 1920–1939' in Sarah Greenough and Diane Waggoner (eds) *The Art of the American Snapshot: 1888–1978* Washington and Princeton: National Gallery of Art and Princeton University Press, pp.73–145

Kenyon, Dave (1992) *Inside Amateur Photography* London: BT Batsford

King, Graham (1986) *Say 'Cheese!': The Snapshot as Art and Social History* London: William Collins

Kismaric, Susan (1990) *British Photography From the Thatcher Years* New York: Museum of Modern Art

—— and Respini, Eva (2004) 'Fashioning Fiction in Photography' in *Fashioning Fiction in Photography Since 1990* New York: Museum of Modern Art, pp.11–31

Knee, Adam (2006) 'Celebrity Skins: The Illicit Textuality of the Celebrity Nude Magazine' in Su Holmes and Sean Redmond (eds) *Framing Celebrity: New Directions in Celebrity Culture* Abingdon: Routledge, pp.161–176

Koetzle, Hans–Michael (2002) *Photo Icons: The Story Behind the Pictures 1928–1991* Cologne: Taschen

Kotchemidova, Christina (2005) 'Why We Say "Cheese": Producing the Smile in Snapshot Photography' in *Critical Studies in Media Communication* 22(1): 2–25

Kotz, Liz (2006) 'Image + Text: Reconsidering Photography in Contemporary Art' in Amelia Jones (ed.) *A Companion to Contemporary Art Since 1945* Oxford: Blackwell, pp.512–533

Krauss, Rosalind (1985a) 'Corpus Delicti' in Rosalind Krauss and Jane Livingston *L'Amour Fou: Photography and Surrealism* New York: Abbeville, pp.54–112

—— (1985b) 'Photography in the Service of Surrealism' in Rosalind Krauss and Jane Livingston *L'Amour Fou: Photography and Surrealism* New York: Abbeville, pp.12–53

—— (1986a) 'Notes on the Index (Part 1)' and 'Notes on the Index (Part 2)' in *The Originality of the Avant–garde and Other Modernist Myths* Boston, MA: Massachusetts Institute of Technology, pp.196–219

—— (1986b) 'The Photographic Conditions of Surrealism' in *The Originality of the Avant-garde and Other Modernist Myths* Boston, MA: Massachusetts Institute of Technology, pp.87–118

—— (1986c) 'Photography's Discursive Spaces' in *The Originality of the Avant-garde and Other Modernist Myths* Boston, MA: Massachusetts Institute of Technology, pp.131–150

—— (1986d) 'The Originality of the Avant-garde' in *The Originality of the Avant–garde and Other Modernist Myths* Boston, MA: Massachusetts, pp.151–170

———— (1990) 'A Note on Photography and the Simulacral' in Carol Squiers (ed.) *The Critical Image: Essays on Contemporary Photography* London: Lawrence and Wishart, pp.15–27

Kriebel, Sabine T (2007) 'Theories of Photography: A Short History' in James Elkins (ed.) *Photography Theory* London: Routledge, pp.3–49

Kristeva, Julia (1984) *The Powers of Horror: An Essay on Abjection* Irvington, NY: Columbia University Press

Kuhn, Annette (1985) *The Power of the Image: Essays on Representations and Sexuality* London: Routledge/Kegan Paul

———— (2002) *Family Secrets: Acts of Memory and Imagination* London: Verso

Lacan, Jacques (2003) 'The Mirror-Phase as Formative of the Function of the I' in Charles Harrison and Paul Wood (eds) *Art in Theory: 1900–2000* London: Blackwell, pp.620–624

Lai, Adrienne (2006) 'Glitter and Grain: Aura and Authenticity in the Celebrity Photographs of Juergen Teller' in Su Holmes and Sean Redmond (eds) *Framing Celebrity: New Directions in Celebrity Culture* Abingdon: Routledge, pp.215–230

Lange, Dorothea (1996) 'The Assignment I'll Never Forget' in Liz Heron and Val Williams (eds) *Illuminations: Women Writing on Photography From the 1850s to the Present* Durham, NC: Duke University Press, pp.151–153

Lange, Susanne (2003) 'August Sander's *People of the 20th Century*: Its Making and Impact' in Emma Dexter and Thomas Weski (ed.) (2003) *Cruel and Tender: The Real in the Twentieth Century Photograph* London: Tate

Langford, Martha (2001) *Suspended Conversations: The Afterlife of Memory in Photographic Albums* Québec: McGill-Queen's University Press

———— (2008) 'Strange Bedfellows: Appropriations of the Vernacular by Photographic Artists' in *Photography and Culture* 1(1): 73–94

Lau, Grace (1993) 'Perversion through the Camera' in *New Formations* 19: 45–46

Learning and Skills Council (2006) 'Kids Seeking Reality TV Fame Instead of Exam Passes' 13 January, available at readingroom.lsc.gov.uk/lsc/2006/externalrelations/press/kids-seeking-reality-tv-fame.pdf

Lee, David and McGonagle, Declan (1993) *Hindesight: John Hinde Photographs and Postcards by John Hinde Ltd. 1935–1971* Dublin: Irish Museum of Modern Art

Lefebvre, Martin (2007) 'The Art of Pointing: On Peirce, Indexicality, and Photographic Images' in James Elkins (ed.) *Photography Theory* London: Routledge, pp.220–244

Leja, Michael (2002) 'Peirce's Visuality and the Semiotics of Art' in Paul Smith and Carolyn Wilde (eds) *A Companion to Art Theory* Oxford: Blackwell, pp.303–316

Lemagny, Jean-Claude and Rouillé, André (eds) (1987) *A History of Photography: Social and Cultural Perspectives* Cambridge: Cambridge University Press

Lister, Martin (1995) 'Introductory Essay' in Martin Lister (ed.) *The Photographic Image in Digital Culture* London: Routledge, pp.1–26

—— (2009) 'Photography in the Age of Electronic Imaging' in Liz Wells (ed.) *Photography: A Critical Introduction* London: Routledge, pp.311–344

Littler, Jo (2005) 'Making Fame Ordinary: Intimacy, Reflexivity and "Keeping it Real"' in *Mediactive* 1(2): 8–25

Livingstone, Marco (1989) 'Do It Yourself: Notes on Warhol's Techniques' in *Andy Warhol: A Retrospective* New York: Museum of Modern Art, pp.63–78

—— (2007) 'From the Heart' in *Gilbert & George* London: Tate, pp.12–25

Long, Andrew (2006) 'Not So Lonely Planet' in *fotolog.book: A Global Snapshot for the Digital Age* London: Thames and Hudson, pp.9–13

Long, J J, Noble, Andrea and Welch, Edward (eds) (2009) *Photography: Theoretical Snapshots* Abingdon: Routledge

Loreck, Hanne (2002) 'De/constructing Fashion/Fashions of Deconstruction: Cindy Sherman's Fashion Photographs' in *Fashion Theory* 6(3): 255–276

Lowry, Joanna (1999) 'Photography, Video and the Everyday' in David Brittain (ed.) *Creative Camera: 30 Years of Writing* Manchester: Manchester University Press, pp.278–283

MacDonald, Gordon and Weber, John (ed.) (2007) *Joachim Schmid: Photoworks 1982–2007* Brighton/London/New York: Photoworks/Stiedl

Machin, David (2004) 'Building the World's Visual Language: The Increasing Global Importance of Image Banks in Corporate Media' in *Visual Communication* 3(3): 316–336

Makos, Christopher (1988) *Warhol Makos* New York: New American Library

Malcolm, Janet (1997) 'Diana and Nikon' in Janet Malcolm *Diana and Nikon: Essays on Photography* New York: Aperture, pp. 54–65

Manovich, Lev (2001) *The Language of New Media* Boston, MA: Massachusetts Institute of Technology

—— (2003) 'The Paradoxes of Photography' in Liz Wells (ed.) *The Photography Reader* London: Routledge, pp.240–249

Marien, Mary Warner (2006) *Photography: A Cultural History* London: Laurence King

Martin, Rupert (ed.) (1983) *The View From Above: 125 Years of Aerial Photography* London: The Photographers' Gallery

Marx, Karl (1990) *Capital Volume 1: A Critique of Political Economy* London: Penguin

Mavor, Carol (2006) 'The *Writerly* Artist: Beautiful, Boring, and Blue' in Amelia Jones (ed.) *A Companion to Contemporary Art Since 1945* Oxford: Blackwell, pp.271–295

McCahill, Michael and Norris, Clive (2002) 'CCTV in Britain' *Urban Eye* Working Paper 3, available at www.urbaneye.net/results/ue_wp3.pdf

McClintock, Anne (1993) 'The Return of Female Fetishism and the Fiction of the Phallus' in *New Formations* 19: 1–21

McCormick, Carlo (1999) 'Introduction' in *Gary Lee Boas Starstruck: Photographs from a Fan* Los Angeles, CA: Dilettante Press, pp.10–14

McGrath, Roberta (2003) 'Re–Reading Edward Weston: Feminism, Photography and Psychoanalysis' in Liz Wells (ed.) *The Photography Reader* London: Routledge, pp.327–337

MediaTel (2005) 'Launches boost women's weeklies' 18 August, available at www.mediatel.co.uk/abcroundup/2005/08/article03.cfm

Mellor, David Alan (2007) '"Fragments of an Unknowable Whole": Michelangelo Antonioni's Incorporation of Contemporary Visualities in London, 1966' in *British Visual Culture* 8(2): 45–61

Mélon, Marc (1987) 'Beyond Reality: Art Photography' in Jean-Claude Lemagny and André Rouillé (eds) *A History of Photography: Social and Cultural Perspectives* Cambridge: Cambridge University Press, pp.82–101

Mercer, Kobena (1999) 'Reading Racial Fetishism: The Photographs of Robert Mapplethorpe' in Jessica Evans and Stuart Hall (eds) *Visual Culture: The Reader* London: Sage, pp.435–447

Metz, Christian (2003) 'Photography and Fetish' in Liz Wells (ed.) *The Photography Reader* London: Routledge, pp.138–145

Mintel (2006) 'British photographers focus on the digital revolution' Press Release, May, available at www.marketresearchworld.net/index.php?option=com_content&task=view&id=776&Itemid=77

Mitchell, William J (1992) *The Reconfigured Eye: Visual Truth in the Post-Photographic Era* Cambridge, MA and London: Massachusetts Institute of Technology Press

—— (1993) 'From Today Photography is Dead' in *Creative Camera* 321: 54–58

Mitchell, W J T (1986) *Iconology: Image, Text, Ideology* Chicago, IL: University of Chicago Press

—— (2005) *What Do Pictures Want? The Lives and Loves of Images* Chicago, IL: University of Chicago Press

Moholy-Nagy, László (2003) 'A New Instrument of Vision' in Liz Wells (ed.) *The Photography Reader* London: Routledge, pp.92–96

Moore, Julianne and Sorrenti, Mario (2007) 'Julianne Moore and Mario Sorrenti In Conversation' in Susan Bright *Face of Fashion* London: National Portrait Gallery, pp.26–29

Muir, Robin (2005) *The World's Most Photographed* London: National Portrait Gallery

Mulvey, Laura (2006) *Death 24x a Second: Stillness and the Moving Image* London: Reaktion

—— (2009a) 'Visual Pleasure and Narrative Cinema' in *Visual and Other Pleasures* Basingstoke: Palgrave Macmillan, pp.14–27

—— (2009b) 'Afterthoughts on "Visual Pleasure and Narrative Cinema" Inspired by King Vidor's *Duel in the Sun* (1946)' in *Visual and Other Pleasures* Basingstoke: Palgrave Macmillan, pp.31–40

Mundy, Jennifer (ed.) (2001) *Surrealism: Desire Unbound* London: Tate

Myers, Karen (1990) 'Selling Green' in Carol Squiers (ed.) *The Critical Image: Essays on Contemporary Photography* London: Lawrence and Wishart, pp.193–201

Nairne, Sandy (2005) 'Foreword' in Robin Muir *The World's Most Photographed* London: National Portrait Gallery, pp.6–7

Nesbit, Molly (1987) 'Photography, Art and Modernity' in Jean-Claude Lemagny and André Rouillé (eds) *A History of Photography: Social and Cultural Perspectives* Cambridge: Cambridge University Press, pp.102–123

—— (1992) *Atget's Seven Albums* New Haven, CT and London: Yale University Press

Newhall, Beaumont (1964) *The History of Photography: From 1839 to the Present Day* (4th edition) New York: Museum of Modern Art

—— (1982) *The History of Photography: From 1839 to the Present Day* (5th edition) New York: Museum of Modern Art

Newhall, Nancy (ed.) (1990) *The Daybooks of Edward Weston* New York: Aperture

Nickel, Douglas R (2000) 'Vernacular Photographies: Responses to a Questionnaire' in *History of Photography* 24(3): 229–231

Nicol, Michelle (1998) 'Beauty and Art: Fashionable Transgressions' in *Creative Camera* 352: 20–27

Nochlin, Linda (1971) *Realism* London: Penguin

O'Doherty, Brian (1999) *Inside the White Cube: The Ideology of the Gallery Space* Berkeley, Los Angeles and London: University of California Press

Ogden, Charles Kay and Richards, Ivor Armstrong (1923) *The Meaning of Meaning: A Study of the Influence of Language Upon Thought and of the Science of Symbolism* London: Routledge and Kegan Paul

Ohlin, Alix (2002) 'Andreas Gursky and the Contemporary Sublime' in *Art Journal* 61(4): 23–35

Orvell, Miles (2003) *American Photography* Oxford: Oxford University Press

Osborne, Peter (2000) *Travelling Light: Photography, Travel and Visual Culture* Manchester: Manchester University Press

Owens, Craig (1984) 'The Allegorical Impulse: Toward a Theory of Postmodernism' in Brian Wallis (ed.) *Art After Modernism: Rethinking Representation* Boston, MA: David R Godine, pp.203–235

—— (1992a) 'Posing' in *Beyond Recognition* Berkeley, CA: University of California Press, pp.201–217

—— (1992b) 'The Medusa Effect, or, the Specular Ruse' in *Beyond Recognition* Berkeley, CA: University of California Press, pp.191–200

—— (1992c) 'From Work to Frame, or, Is There Life After "The Death of the Author"?' in *Beyond Recognition* Berkeley, CA: University of California Press, pp.122–139

Panzer, Mary (2006) 'Introduction' to *Things As They Are: Photojournalism in Context Since 1955* London: Chris Boot, pp.8–33

Parr, Martin (1989) *The Cost of Living* Manchester: Cornerhouse

—— (1999) 'I'm Buggered Without my Prejudices' interview by David Brittain in David Brittain (ed.) *Creative Camera: 30 Years of Writing* Manchester: Manchester University Press, pp.236–240

—— (2002) 'Introduction by Martin Parr' in *Our True Intent Is All For Your Delight* London: Chris Boot, pp.4–7

—— (2008) 'Exposing Our Tacky Selves' interview by Manami Okazaki *Japan Times*, available at http://search.japantimes.co.jp/print/fa20070705a1.html

—— and Badger, Gerry (2004) *The Photobook: A History Volume I* London: Phaidon

—— (2006) *The Photobook: A History Volume II* London: Phaidon

—— (2007) 'We Are All Photographers Now: Popular Photographic Modes in Great Britain' in Val Williams and Susan Bright (eds) *How We Are: Photographing Britain* London: Tate, pp.198–207

Paster, James E (1992) 'Advertising Immortality by Kodak' in *History of Photography* 16(2): 135–139

Peirce, Charles Sanders (1998) 'What is a Sign?' in Charles Sanders Peirce *Selected Philosophical Writings Volume 2* (1893–1913) Bloomington, IN: Indiana University Press, pp.4–10

Pepler, Tina (1998) 'Martin Parr: Vive le Bagatelle' in Michael L Sand and Anne McNeill (eds) *Continental Drift: Europe Approaching the Millennium* Munich/New York: Prestel-Verlag, pp.39–42

Phillips, Christopher (1989) 'The Judgement Seat of Photography' in Richard Bolton (ed.) *The Contest of Meaning: Critical Histories of Photography* Boston, MA: Massachusetts Institute of Technology, pp.14–46

Pinney, Christopher (1992) 'The Parallel Histories of Anthropology and Photography' in *Anthropology and Photography 1860–1920* New Haven, CT and London: Yale University Press and The Royal Anthropological Institute, pp.74–95

—— (1997) *Camera Indica: The Social Life of Indian Photographs* London: Reaktion

—— and Peterson, Nicolas (eds) (2003) *Photography's Other Histories* Durham, NC and London: Duke University Press

Pollock, Griselda (1988) *Vision and Difference: Femininity, Feminism and the Histories of Art* London: Routledge

Price, Derrick and Wells, Liz (2009) 'Thinking About Photography: Debates, Historically and Now' in Liz Wells (ed.) *Photography: A Critical Introduction* London: Routledge, pp.9–64

Rabia, Sarah (2008) '*Facebook* Alternatives' in *Facebook: Your Complete Guide to Social Networking* London: Dennis, pp.136–143

Radner, Hilary (2000) 'On The Move: Fashion Photography and the Single Girl in the 1960s' in Stella Bruzzi and Pamela Church Gibson (eds) *Fashion Cultures:Theories, Explorations and Analysis* Abingdon: Routledge

Ramamurthy, Anandi (2009) 'Spectacles and Illusions: Photography and Commodity Culture' in Liz Wells (ed.) *Photography:A Critical Introduction* London: Routledge, pp.205–256

Raney, Karen (2003) *Art in Question* London and New York: Continuum

Redmond, Sean (2006) 'Intimate Fame Everywhere' in Su Holmes and Sean Redmond (eds) *Framing Celebrity: New Directions in Celebrity Culture* Abingdon: Routledge, pp.27–43

Reinhardt, Mark (2008) 'Picturing Violence: Aesthetics and the Anxiety of Critique' in Mark Reinhardt, Holly Edwards and Erina Duganne (eds) *Beautiful Suffering: Photography and the Traffic in Pain* Chicago, IL: University of Chicago Press, pp.13–36

Rhodes, Kate (2008) 'The Elegance of the Everyday: Nobodies in Contemporary Fashion Photography' in Eugénie Shinkle (ed.) *Fashion as Photograph: Viewing and Reviewing Images of Fashion* London: IB Tauris, pp.200–213

Richard, Pierre (1998) 'Life in Three Dimensions: The Charms of Stereoscopy' in Michel Frizot *The New History of Photography* Cologne: Könemann, pp.174–183

Ritchin, Fred (1991) 'The End of Photography as We Have Known It' in Paul Wombell (ed.) *Photo-Video: Photography in the Age of the Computer* London: Rivers Oram, pp.8–15

—— (1999) *In Our Image:The Coming Revolution in Photography* (2nd edition) New York: Aperture

—— (2009) *After Photography* New York and London: Norton

Roberts, John (1997) 'Photography, Iconophobia and the Ruins of Conceptual Art' in John Roberts (ed.) *The Impossible Document: Photography and Conceptual Art in Britain: 1966–1976* London: Camerawork, pp.7–45

—— (1998) *The Art of Interruption: Realism, Photography and the Everyday* Manchester: Manchester University Press

Roberts, Pam (2004a) '"The Exertions of Mr.Fenton": Roger Fenton and the Founding of the Royal Photographic Society' in Gordon Baldwin, Malcolm Daniel and Sarah Greenough *All The Mighty World:The Photographs of Roger Fenton, 1852–1860* New Haven, CT and London: Yale University Press, pp.211–220

Roberts, Russell (2004b) 'Images and Artefacts: William Henry Fox Talbot and "The Museum"' in Bernard Finn (ed.) *Presenting Pictures* London: Science Museum, pp.4–20

Robins, Kevin (1995) 'Will Image Move Us Still?' in Martin Lister (ed.) *The Photographic Image in Digital Culture* London: Routledge, pp.29–50

Rocamora, Ágnes and O'Neill, Alistair (2008) 'Fashioning the Street: Images of the Street in Fashion Media' in Eugénie Shinkle (ed.) *Fashion as Photograph: Viewing and Reviewing Images of Fashion* London: IB Tauris, pp.185–199

Rojek, Chris (2001) *Celebrity* London: Reaktion

Rose, Gillian (2007) *Visual Methodologies: An Introduction to the Interpretation of Visual Materials* London: Sage

Rosenblum, Barbara (1997) *A World History of Photography* New York: Abbeville

Rosler, Martha (2003) 'In, Around, and Afterthoughts (On Documentary Photography)' in Liz Wells (ed.) *The Photography Reader* London: Routledge, pp.261–274

Rubinstein, Daniel and Sluis, Karen (2008) 'A Life More Photographic: Mapping the Networked Image' in *Photographies* 1(1), March: 9–28

Ruby, Jay (1995) *Secure the Shadow: Death and Photography in America* Cambridge, MA: Massachusetts Institute of Technology Press

Sagne, Jean (1998) 'All Kinds of Portraits: The Photographer's Studio' in Michel Frizot *The New History of Photography* Cologne: Könemann, pp.102–122

Said, Edward (1991) *Orientalism* Harmondsworth: Penguin

Salaman, Naomi (1993) 'Let's Talk About Sex' interview by Susan Babchick *Dazed and Confused* 4: 59

—— (1994a) 'Regarding Male Objects' in Naomi Salaman (ed.) *What She Wants: Women Artists Look at Men* London: Verso, pp.13–25

—— (ed.) (1994b) *What She Wants: Women Artists Look at Men* London: Verso

Santacatterina, Stella (2002) 'Jemima Stehli: Subject and Object of the Gaze' in David Burrows (ed.) *Jemima Stehli* Birmingham: ARTicle Press, pp. 24–27

Sassoon, Joanna (2004) 'Photographic Materiality in the Age of Digital Reproduction' in Elizabeth Edwards and Janice Hart (eds) *Photographs, Objects, Histories: On the Materiality of Images* Abingdon: Routledge, pp.186–202

Scharf, Aaron (1983) *Art and Photography* Harmondsworth: Penguin

Schreier, Christoph (1996) *August Sander: 'In Photography There Are No Unexplained Shadows'* London: National Portrait Gallery

Schwartz, Dona (1986) 'Camera Clubs and Fine Art Photography: The Social Construction of an Elite Code' in *Urban Life* 15(2): 165–195

Scott, Clive (1999) *The Spoken Image: Photography and Language* London: Reaktion

—— (2007) *Street Photography: From Atget to Cartier-Bresson* London: IB Tauris

Sekula, Allan (1982) 'On the Invention of Photographic Meaning' in Victor Burgin (ed.) *Thinking Photography* London: Macmillan, pp.84–109

—— (1989) 'The Body and the Archive' in Richard Bolton (ed.) *The Contest of Meaning: Critical Histories of Photography* Boston, MA: Massachusetts Institute of Technology, pp.342–388

Shinkle, Eugénie (2008) 'The Line Between the Wall and the Floor: Reality and Affect in Contemporary Fashion Photography' in Eugénie Shinkle (ed.)

Fashion as Photograph: Viewing and Reviewing Images of Fashion London: IB Tauris, pp.214–226

Shore, Stephen (2007) *The Nature of Photographs* London: Phaidon

Slater, Don (1991) 'Consuming Kodak' in Jo Spence and Patricia Holland (eds) *Family Snaps: The Meanings of Domestic Photography* London: Virago, pp.49–59

—— (1995) 'Domestic Photography and Digital Culture' in Martin Lister (ed.) *The Photographic Image in Digital Culture* London: Routledge, pp.129–146

—— (1997a) 'The Object of Photography' in Jessica Evans (ed.) *The Camerawork Essays: Context and Meaning in Photography* London: Rivers Oram, pp.88–118

—— (1997b) 'Marketing the Medium: An Anti–Marketing Report' in Jessica Evans (ed.) *The Camerawork Essays: Context and Meaning in Photography* London: Rivers Oram, pp.172–187

—— (1999) 'Marketing Mass Photography' in Jessica Evans and Stuart Hall (eds) *Visual Culture: The Reader* London: Sage, pp.289–306

Slyce, John (2001) 'Message in a Bottle: The Ethics of Representation Revisited' in *DPICT* 6: 34–39

—— (2002) 'Jemima Stehli: A Writer's Notes' in David Burrows (ed.) *Jemima Stehli* Birmingham: ARTicle Press, pp.10–19

Smedley, Elliot (2000) 'Escaping to Reality: Fashion Photography in the 1990s' in Stella Bruzzi and Pamela Church Gibson (eds) *Fashion Cultures: Theories, Explorations and Analysis* Abingdon: Routledge, pp.143–156

Smyth, Cherry (1994) 'What She Wants and What She Gets' in Naomi Salaman (ed.) *What She Wants: Women Artists Look at Men* London: Verso, pp.51–61

Solnit, Rebecca (2003) *Motion Studies: Edweard Muybridge and the Technological Wild West* London: Bloomsbury

Solomon-Godeau, Abigail (1991a) 'Reconsidering Erotic Photography: Notes for a Project of Historical Salvage' in *Photography at the Dock: Essays on Photographic History, Institutions, and Practices* Minneapolis, MN: University of Minnesota Press, pp.220–237

—— (1991b) 'Who is Speaking Thus? Some Questions About Documentary Photography' in *Photography at the Dock: Essays on Photographic History, Institutions, and Practices* Minneapolis, MN: University of Minnesota Press, pp.169–183

—— (1991c) 'Sexual Difference: Both Sides of the Camera' in *Photography at the Dock: Essays on Photographic History, Institutions, and Practices* Minneapolis, MN: University of Minnesota Press, pp.256–280

—— (1991d) 'Photography After Art Photography' in *Photography at the Dock: Essays on Photographic History, Institutions, and Practices* Minneapolis, MN: University of Minnesota Press, pp.103–123

—— (1991e) 'Canon Fodder: Authoring Eugéne Atget' in *Photography at the Dock: Essays on Photographic History, Institutions, and Practices* Minneapolis. MN: University of Minnesota Press, pp.28–51

—— (1991f) 'Playing in the Fields of the Image' in *Photography at the Dock: Essays on Photographic History, Institutions, and Practices* Minneapolis, MN: University of Minnesota Press, pp.86–102

—— (1991g) 'Living with Contradictions: Critical Practices in the Age of Supply-Side Aesthetics' in *Photography at the Dock: Essays on Photographic History, Institutions, and Practices* Minneapolis, MN: University of Minnesota Press, pp.124–148

—— (1991h) 'Introduction' in *Photography at the Dock: Essays on Photographic History, Institutions, and Practices* Minneapolis, MN: University of Minnesota Press, pp.xxi–xxxiv

Sontag, Susan (1978) 'The Avedon Eye' in (British) *Vogue* December: 174–177

—— (1979) *On Photography* London: Penguin

—— (2004) *Regarding the Pain of Others* London: Penguin

Spence, Jo (1986) *Putting Myself in the Picture: A Political, Personal and Photographic Autobiography* London: Camden Press

—— (1995) *Cultural Sniping: The Art of Transgression* London: Routledge

—— and Holland, Patricia (eds) (1991) *Family Snaps: The Meanings of Domestic Photography* London: Virago

—— and Martin, Rosy (1995) 'Phototherapy: Psychic Realism as Healing Art?' in Jo Spence *Cultural Sniping: The Art of Transgression* London: Routledge, pp.164–180

Spencer, Frank (1992) 'Some Notes on the Attempt to Apply Photography to Anthropometry During the Second Half of the Nineteenth Century' in *Anthropology and Photography 1860–1920* New Haven, CT and London: Yale University Press and The Royal Anthropological Institute, pp.99–107

Squiers, Carol (1999) 'Class Struggle: The Invention of Paparazzi Photography and the Death of Diana, Princess of Wales' in Carol Squiers (ed.) *Over Exposed: Essays on Contemporary Photography* New York: The New Press, pp.269–304

Stacey, Jackie (1999) 'Desperately Seeking Difference' in Jessica Evans and Stuart Hall (eds) *Visual Culture: The Reader* London: Sage, pp.390–401

Stanley, Jo (1991) 'Well, Who'd Want an Old Picture of Me at Work?' in Jo Spence and Patricia Holland (eds) *Family Snaps: The Meanings of Domestic Photography* London: Virago, pp.60–71

Starl, Timm (1993) 'A Short History of Snapshot Photography' in Joachim Schmid *Taking Snapshots: Amateur Photography in Germany from 1900 to the Present* (English supplement to *Knipsen: Private Fotografie in Deutschland von 1900 bis heute*) Berlin/Stuttgart: Institute for Foreign Cultural Relations, pp.7–13

Steadman, Philip (2002) *Vermeer's Camera: Uncovering the Truth Behind the Masterpieces* Oxford: Oxford University Press

Steichen, Edward (1955) *The Family of Man* New York: Museum of Modern Art

Stengel, Richard (2006) 'Now It's Your Turn' in *Time* 168(27/28): 6

Stern, Bert (1982) *The Last Sitting* London: Orbis

Stewart, Lindsey (2005) 'Market for Photographs' in Robin Lenman (ed.) *The Oxford Companion to the Photograph* Oxford: Oxford University Press, pp. 391–393

Stewart, Susan (1993) *On Longing: Narratives of the Miniature, the Gigantic, the Souvenir, the Collection* Durham, NC and London: Duke University Press

Stokes, Phillip (1992) 'The Family Photograph Album: So Great a Cloud of Witnesses' in Graham Clarke (ed.) *The Portrait in Photography* London: Reaktion, pp. 193–205

Sturken, Marita and Cartwright, Lisa (2001) *Practices of Looking: An Introduction to Visual Culture* Oxford: Oxford University Press

Sultan, Larry and Mandel, Mike (2003) *Evidence* New York: Distributed Art Publishers

Sutton, Damian (2005) 'Nokia Moments' in *Source: The Photographic Review* 43: 44–47

Szarkowski, John (2007) *The Photographer's Eye* New York: Museum of Modern Art

Tagg, John (1982) 'The Currency of the Photograph' in Victor Burgin (ed.) *Thinking Photography* London: Macmillan, pp. 110–141

—— (1988a) 'Democracy of the Image: Photographic Portraiture and Commodity Production' in *The Burden of Representation: Essays on Photographies and Histories* London: Macmillan, pp. 34–59

—— (1988b) *The Burden of Representation: Essays on Photographies and Histories* London: Macmillan

—— (1988c) 'A Means of Surveillance: The Photograph as Evidence in Law' in *The Burden of Representation: Essays on Photographies and Histories* London: Macmillan, pp. 66–102

—— (2009) 'Mindless Photography' in J J Long, Andrea Noble and Edward Welch (eds) *Photography: Theoretical Snapshots* Abingdon: Routledge, pp. 16–30

Talbot, William Henry Fox (1980) 'A Brief Historical Sketch of the Invention of the Art' in Alan Trachtenberg (ed.) *Classic Essays on Photography* New Haven, CT: Leete's Island Books, pp. 27–36

Taylor, John (1994) *A Dream of England: Landscape, Photography and the Tourist's Imagination* Manchester: Manchester University Press

—— (1998) *Body Horror: Photojournalism, Catastrophe and War* Manchester: Manchester University Press

—— (1999) 'Shock Photos' in David Brittain (ed.) *Creative Camera: 30 Years of Writing* Manchester: Manchester University Press, pp. 296–300

—— (2001) 'This is This' in *Source* 29: 4–6

Taylor, Roger (2004) '"A Most Enthusiastic Cultivator of His Art": Fenton's Critics and the Trajectory of His Career' in Gordon Baldwin, Malcolm

Daniel and Sarah Greenough *All the Mighty World: The Photographs of Roger Fenton, 1852–1860* New Haven, CT and London: Yale University Press, pp.199–210

Thomas, Ann (2006) 'Modernity and the Staged Photograph: 1900–1965' in Lori Pauli (ed.) *Acting the Part: Photography as Theatre* London/New York: Merrell, pp.100–131

Thorne, Scott and Bruner, Gordon C (2006) 'An Exploratory Investigation of the Characteristics of Consumer Fanaticism' in *Qualitative Market Research: An International Journal* 9(1): 51–72

Townsend, Chris (1998) *Vile Bodies: Photography and the Crisis of Looking* London/New York/Munich: Channel Four/Prestel–Verlag

Trachtenberg, Alan (ed.) (1980) *Classic Essays on Photography* New Haven, CT: Leete's Island Books

—— (1992) 'Likeness as Identity: Reflections on the Daguerrean Mystique' in Graham Clarke (ed.) *The Portrait in Photography* London: Reaktion, pp.173–192

Urry, John (1990) *The Tourist Gaze: Leisure and Travel in Contemporary Societies* London: Sage

Vestberg, Nina Lager (2008) 'Archival Value: On Photography, Materiality and Indexicality' in *Photographies* 1(1): 49–65

Walker, Ian (1995a) 'Documentary Fictions?' in *Art & Design: Photography in the Visual Arts* 10(44): 29–33

—— (1995b) 'Desert Stories or Faith in Facts?' in Martin Lister (ed.) *The Photographic Image in Digital Culture* London: Routledge, pp.236–252

—— (2002) *City Gorged With Dreams: Surrealism and Documentary in Interwar Paris* Manchester: Manchester University Press

Walker, John A (1997) 'Context as a Determinant of Photographic Meaning' in Jessica Evans (ed.) *The Camerawork Essays: Context and Meaning in Photography* London: Rivers Oram, pp.52–63

—— (2003) *Art and Celebrity* London: Pluto

Warhol, Andy (1979) *Andy Warhol's Exposures* London: Hutchinson

Warner, Marina (1999) 'Parlour Made' in David Brittain (ed.) *Creative Camera: 30 Years of Writing* Manchester: Manchester University Press, pp.220–225

Watney, Simon (1999) 'The Institutions of Photography' in Jessica Evans and Stuart Hall (eds) *Visual Culture: The Reader* London: Sage, pp.141–161

Weiser, Judy (1999) *PhotoTherapy Techniques: Exploring the Secrets of Personal Snapshots and Family Albums* Vancouver: PhotoTherapy Centre

Welch, Edward and Long, J J (2009) 'Introduction: A Small History of Photography Studies' in J J Long, Andrea Noble and Edward Welch (eds) *Photography: Theoretical Snapshots* Abingdon: Routledge, pp.1–15

Wells, Liz (ed.) (2003) *The Photography Reader* London: Routledge

—— (ed.) (2009) *Photography: A Critical Introduction* London: Routledge

Wells, Paul (1999) 'The Documentary Form: Personal and Social "Realities"' in Jill Nelmes (ed.) *An Introduction to Film Studies* London: Routledge, pp.211–235

Weski, Thomas (2003) 'Cruel and Tender' in Emma Dexter and Thomas Weski (eds) *Cruel and Tender: The Real in the Twentieth–Century Photograph* London: Tate, pp.22–27

West, Nancy Martha (2000) *Kodak and the Lens of Nostalgia* Charlottesville, VA and London: University Press of Virginia

Westerbeck, Colin (1998) 'On the Road and in the Street: The Post-War Period in the United States' in Michel Frizot *The New History of Photography* Cologne: Könemann, pp.640–659

Weston, Edward (2003) 'Seeing Photographically' in Liz Wells (ed.) *The Photography Reader* London: Routledge, pp.104–108

Wiggins, Colin (2005) 'Living in Hell and Other Stories' in Tracy Chevalier and Colin Wiggins *Tom Hunter: Living in Hell and Other Stories* London: National Gallery, pp.41–73

Williams, Linda (1995) 'Corporealized Observers: Visual Pornographies and "The Carnal Density of Vision"' in Patrice Petro (ed.) *Fugitive Images: From Photography to Video* Bloomington, IN and Indianapolis, IN: Indiana University Press, pp.3–41

Williams, Raymond (1988) *Keywords: A Vocabulary of Culture and Society* London: Fontana

Williams, Val (1994) *Warworks: Women, Photography and the Iconography of War* London: Virago

—— (1998) *Look at Me: Fashion and Photography in Britain 1960 to the Present* London: The British Council

—— (2002) *Martin Parr* London: Phaidon

—— and Bright, Susan (2007) *How We Are: Photographing Britain* London: Tate

Williamson, Judith (1988a) 'Family, Education, Photography' in *Consuming Passions: The Dynamics of Popular Culture* London: Marion Boyars, pp.115–126

—— (1988b) 'A Piece of the Action: Images of "Woman" in the Photography of Cindy Sherman' in *Consuming Passions: The Dynamics of Popular Culture* London: Marion Boyars, pp.91–113

—— (2002) *Decoding Advertisements: Ideology and Meaning in Advertising* London and New York: Marion Boyars

Winston, Brian (1995) *Beyond the Real: The Griersonian Documentary and Its Legitimations* London: British Film Institute

—— (1996) *Technologies of Seeing: Photography, Cinematography and Television* London: British Film Institute

Wolff, Janet (1993) *The Social Production of Art* London: Macmillan

Wombell, Paul (ed.) (1991) *Photo-Video: Photography in the Age of the Computer* London: Rivers Oram

—— (2000) *Sportscape: The Evolution of Sports Photography* London: Phaidon

—— (2008) 'The Britney Economy' in *The British Journal of Photography* 155(7700): 22–23

Wood, Paul (1996) 'Jackson Pollock and Abstract Expressionism' in Liz Dawtrey Toby Jackson, Mary Masterton, Pam Meecham and Paul Wood (eds) *Investigating Modern Art* New Haven, CT and London: Yale University Press, pp.109–128

—— (2002) 'Modernism and the Idea of the Avant–garde' in Paul Smith and Carolyn Wilde *A Companion to Art Theory* Oxford: Blackwell, pp.215–228

Zuromskis, Catherine (2009) 'On Snapshot Photography: Rethinking Photographic Power in Public and Private Spheres' in J J Long, Andrea Noble and Edward Welch (eds) *Photography: Theoretical Snapshots* Abingdon: Routledge, pp.49–62

INDEX